PLANET WAX

SCI-FI/FANTASY SOUNDTRACKS ON VINYL

by

AARON LUPTON JEFF SZPIRGLAS

DEDICATIONS

AARON

"To Cooper and Rachel, for all of your patience during another nerdy adventure."

●

JEFF

"For Danielle, Léo, Ruby...and Arg-Zon IV, the robot overlord who will dominate and control all of humanity 783 years from now (I have a time machine. I checked. I will do his bidding.)"

TABLE OF CONTENTS

FOREWORD

I owe my love affair with sci-fi music to my Uncle George, who took me to see *Star Wars* in the summer of 1977. Like many eight-year-olds at the time, it grabbed hold of my imagination and consumed my fantasies. Night after night I had X-wing dreams.

These were the days before home video, before Blu-ray, before streaming. At that time, the only way to relive the experience of seeing *Star Wars* was to voyage back to the theater. Which I did, a second time. And a third.

My parents, no doubt looking for ways to avoid too many more trips to the big screen, bought me the LP of "The Story of Star Wars," a 45-minute audio-only retelling of *Star Wars*, very heavily abridged, with narration, and John Williams' music underscoring all of it. It was essentially a radio play of the movie.

In the Montreal house where I grew up, there was a room we called the "Hi-Fi Room." This was a small loft overlooking the living room where I would spend hours lying down, eyes closed, listening to my favorite records. With the comfort of the shag carpet at my back, and the smell of my mother's beef stroganoff wafting through the air, I put that record on for the first time. I remember dropping the needle onto the edge of the vinyl and feeling that physical connection to the music that only vinyl can provide. And then, magic – Lionel Newman's classic 20th Century Fox logo music, narrator Roscoe Lee Brown's voice intoning portentously "A Long Time Ago...," and the first notes of Williams' iconic score exploding in a flurry of brass and timpani.

I wore out that record. And from it, a life-long fandom of sci-fi music was born, and perhaps more meaningfully to me personally, a rewarding and fulfilling career. If my music in films such as *Edge of Tomorrow* and *Ant-Man* means anything to anybody, it's because of that record.

I hope this book brings you as much joy and passion for science fiction scores as my uncle evoked for me.

●

CHRISTOPHE BECK

Composer
Ant-Man / Ant-Man and The Wasp
Frozen I / II
The Hangover I / II / III

INTRODUCTIONS

Like last year's *Blood on Black Wax: Horror Soundtracks on Vinyl*, the 1984 Publishing book that you are holding in your hands started with a call from my co-author Jeff Szpirglas: "*Blood on Black Wax* is doing really well, let's do a follow up book about sci-fi soundtracks!"

In some ways the concept made sense to me, not the least of which because 1984 Publishing had recently followed up Michael Gingold's brilliant *Ad Nauseum: Newsprint Nightmares from the 1980s* with a science-fiction themed one. But in some ways the idea didn't quite make sense to me. See, *Blood on Black Wax* was all about creating a more accessible book about horror scores by tapping in to the very thing that has given that form of music its unprecedented popularity - the vinyl reissue market. When it comes to the scores for *Star Wars*, *Dr. Who*, and *Blade Runner*, that same market just does not quite exist - not the same extent, anyway. The appeal of putting out old horror movie scores on vinyl has much to do with the genre's underdog status - most of the time you aren't talking about huge properties carrying massive licensing fees. With science fiction and fantasy however, you're often dealing with summer blockbusters. Where would an independent record label even begin?

There were a few things that made me feel like this was a project that had to happen however. First, who doesn't love them the classic themes from the world's biggest science fiction films? *Star Trek*, *Back to the Future*, *The Twilight Zone*, *Terminator*? These are some of the greatest music themes ever written, and for many of us, the soundtrack to our nerdy youths. See, for many a monster kid, when '80s horror films were just a little too frightening to digest, our first sip of the unusual was the wonder, imagination, and freakish fantasy promised by the sci-fi genre. The far away future and the outer limits of space were exciting because in our untapped minds, they could be anything. These films promised to feed our imagination with a glimpse of what's out there.

Second, while it's true that there aren't companies reissuing classic sci-fi scores on vinyl to the extent of Waxwork, Death Waltz, and Mondo, the way that I look at it is that the genre is an untapped mine for any labels willing to get involved. So as you read these entries of sonic imagination, you'll see the basic formula unfold. These soundtracks were originally released on vinyl, then later expanded upon on CD. Just as some of the aforementioned companies used previous horror soundtrack CD

releases as the basis for their colorful, deluxe vinyl, this book works like a catalog of suggestions for future wax releases, just in case any of them are paying attention.

Third, I could tell through Jeff's excitement during our initial conversations, just how passionate he was about the project. I knew that excitement would be infectious and that hopefully we'd have another winner on our hands.

I should mention some of the decisions that Jeff and I made in putting this book together. For one, although the idea was to talk about the classic sci-fi that we all know and love, from *Star Trek* to *Battlestar Galactica*, we wanted room for sword and sorcery film scores as well. Maybe that's just because I really wanted to write about Basil Polodouris' chest beating masterpiece *Conan the Barbarian*, but it always seemed to me that fantasy sits right next to science fiction in terms of its fan culture, unearthly creatures, and visions of a world that isn't quite like ours. Also, unlike *Blood on Black Wax*, which showcased scores for virtually no family-friendly content, *Planet Wax* actually contains an entire chapter of G-Rated content. After all, *Ewoks: The Battle for Endor* is no more or less sci-fi than *2001: A Space Odyssey* when you come right down to it, even if the intended audience is a little different. We also thought it was worth including superhero films. In a time long before CGI effects had come into their own, just seeing *Superman* and *Batman* come out of the pages of a comic book and into our world was a mind-blowing experience - hence their link to the science fiction genre. In today's world of the Marvel and DC Cinematic Universes, watching men and women fly across the screen is nothing special, so we chose to focus solely on the early capes and spandex epics. Besides, if we were going to cover modern superhero films, where do you even begin (and end)? Finally, we devoted an entire chapter to television scores, since there is no denying that's where some of science fiction's greatest achievements - and fanbases - reside, not to mention producing some of the greatest themes ever written.

There's one more point that you might notice the first time you flip through these pages, and that's the date ranges of the films we cover. For a variety of reasons the 'seventies, eighties, and early nineties represented a creative peak in motion pictures that will never be duplicated. Ask anyone over forty - "they don't make 'em like they used to." Then ask someone born in the 2000s - they still love the eighties movies. So yes, this book about vinyl is also about nostalgia. We hope that from the low budget, unintentionally hilarious films like *Red Sonja* and *Mac and Me* to the highbrow adult fantasy of *A Clockwork Orange* to the kick ass action/adventure of *Mad Max* to the cheesy goodness of *Running Man*, that you discover once again, there is a whole universe of fantastic music out there that makes each and every one of these films special.

●

AARON LUPTON

Picture, if you will, a six year-old boy. He's outfitted in a cape that his grandmother sewed together for him; he's in the basement, hands outstretched, crashing into walls and the sofa. His soundtrack: a 45 RPM record of the theme to TV's *The Greatest American Hero*, by one Joey Scarbury. There's something about the Mike Post-penned theme song (played in an era when you could have an FM-styled pop theme tune) that catapults this young kid – literally – across the room and into the wall, just as the foibled superhero played by William Katt does onscreen.

If you haven't caught on by now, that boy was me. I may have lost the cape (and the 7-inch) to time, but not my love of soundtracks, as evidenced by my first collaboration with Aaron Lupton about the exciting realm of horror scores in *Blood on Black Wax*, which you should go and buy if it's not already on your shelf. Although I've developed a rabid obsession with horror films and their music, it was not a genre Young Jeff was permitted to watch. Instead, I was completely absorbed in the big symphonic sound of 1980s science fiction extravaganzas: *Star Wars*, *The Black Hole*, and, yes, good old *Krull*.

I always considered myself fortunate to have grown up in an era when studios were spending grandiose amounts of money on full-bodied symphonic masterworks for fantasy and science fiction films. Some of these may have functioned as John Williams clones, but many composers were able to use their own unique voices, creating a decade's worth of thrilling music that holds up to this day. Because this was the 1980s, film soundtracks were often allowed to breathe in their respective movies, rarely drowned by dense sound mixes, so the themes could soar as high as Superman. And when the special effects didn't hold up, it was the majesty of these scores that elevated the films (that's right, I'm talking to *you*, *Metalstorm: The Destruction of Jared-Syn*).

Today, symphonies are embracing this style of film scoring. Increasingly, symphony orchestras are playing live shows consisting of not just a collection of excerpts from genre film scores but the *entire* score itself, played live to a film – with titles such as the *Star Wars* films, *Back to the Future*, *Ghostbusters* and beyond.

Putting this book together was akin to stepping back in time – not in a TARDIS or a flying DeLorean, mind you – but through the magic of the movies and their music. It was a real thrill to speak to the composers whose work formed the soundtrack to my childhood – think Craig Safan's gargantuan score for *The Last*

Starfighter, or Laurence Rosenthal's thrilling music for *Clash of the Titans*, or diving headfirst into the music of *Doctor Who* with Peter Howell. In this book, Aaron and I uncover the classics that most of you know and cherish, along with more obscure titles worth discovering (John Scott's *Yor, Hunter From the Future*, anyone?). But what defines the "classic era?" I knew we'd have to stretch back to include Bernard Herrmann's music for the films of Ray Harryhausen, as well as tap into the weird electronic experiments in Jerry Goldsmith's oeuvre.

As Aaron makes mention in his introduction, the trick to this book is that the sci-fi and fantasy genres are so vast, and with such an extensive back catalogue, that we had to set a hard limit to what could make it in, and we ended firmly at 1999, which means newer classics like *Harry Potter* and Howard Shore's *Lord of the Rings* didn't make the cut, but thankfully we took the red pill and let *The Matrix* in. And given the emphasis on vinyl, many '90s classics committed to CD (Howard Shore's *eXistenZ*, Michael Kamen's *Brazil*, and yes, Richard Band's 1983 opus *Metalstorm: The Destruction of Jared-Syn*) aren't represented, though hopefully some company will rectify this soon. You'll also note that truly early classics such as Bernard Herrmann's *The Day The Earth Stood Still* or Dimitri Tiomkin's *The Thing (From Another World)* – both of which have great CD representation but limited vinyl releases – also don't pop up here. Trust us, we know they're awesome.

Now, remember that six year-old boy I was telling you about? The great thing about these soundtracks is how well many of them stand the test of time, to the point where I've been introducing them to my own children, who are now about the same age I was when crashing into household furniture. One of the great pleasures

as a parent has been watching my kids embrace this music as I once did, whether to the whistled theme from *Buckaroo Banzai* (redubbed "The Animal Song" by my daughter), or piecing together the story of *The Secret of NIMH* via its soundtrack with my son. I continue to be amazed and delighted at how this music continues to inspire a new generation of listeners.

I hope this book will take you down Memory Lane to the same nostalgic slice of your own youth, or, better still, introduce you to a unique and vibrant world of sound and music that may be as new and alien to you as the films they accompanied. Strap on your space helmets and prepare to make the jump to lightspeed. You're going to love it.

•

JEFF SZPIRGLAS

CHAPTER

1

EPIC SCI-FI
INTERSTELLAR
ADVENTURES

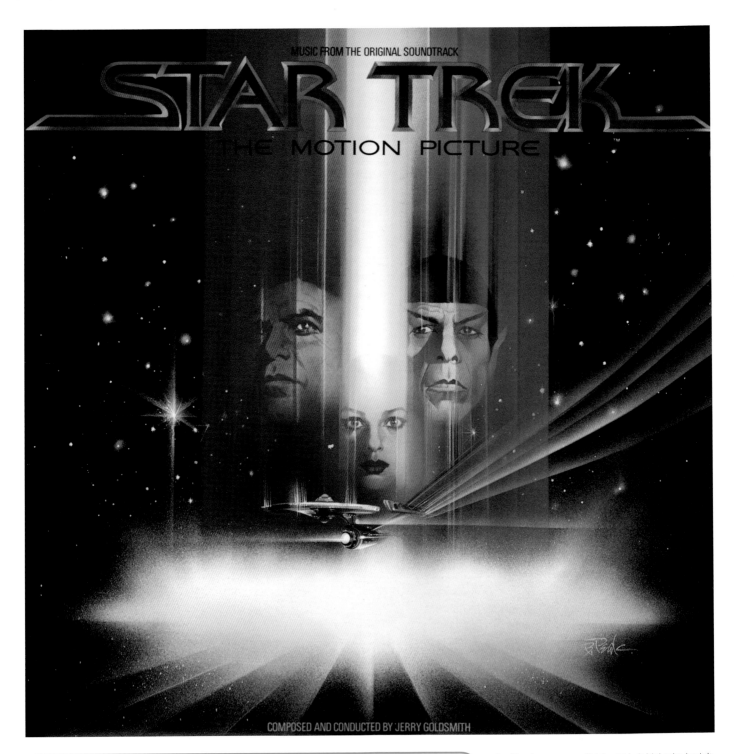

MUSIC FROM THE ORIGINAL SOUNDTRACK

STAR TREK
THE MOTION PICTURE

COMPOSED AND CONDUCTED BY JERRY GOLDSMITH

THE STAR TREK FILMS (I - VI)

By the late 1970s there was clearly a lasting demand for Gene Roddenberry's *Star Trek*, and so it was time for the franchise to boldly go beyond syndication, to the big screen! What followed was a series of films that hit various peaks and valleys as the original cast continued to battle aliens, the dangers of space and the curse of the odd-numbered sequels.

Musically, the original *Trek* films are a diverse group of six, with two composers getting more than one crack at the saga. First, and perhaps foremost, Jerry Goldsmith provided one of his most vibrant scores for *Star Trek: The Motion Picture* (1979). Departing from a more modernist approach he'd brought to earlier genre scores– including his work on sci-fi classics *Planet of the Apes* and *Logan's Run* – Goldsmith's score here is in line with the Romantic idiom that John Williams brought to *Star Wars* two years earlier. The music includes nods to the TV series theme by Alexander Courage, but Goldsmith weaves a new tapestry of material that matches the scale of the picture, particularly his insanely hummable march for "Enterprise." That music almost never made it to

the film, however, as Goldsmith's initial take hadn't impressed director Robert Wise, who demanded a more grabbing tune. After ten days of mulling it over, Goldsmith presented the music, on piano, and the result is a theme so memorable that it ended up getting reused nearly a decade later for *Star Trek: The Next Generation*. But the score is more than a one-theme pony. Goldsmith also establishes memorable themes for Ilia ("Ilia's Theme") and the Klingons ("Main Title / Klingon Battle"), and is notable for its use of Craig Huxley's resonant blaster beam effect for the "Vejur Flyover," which would carry over (sans Goldsmith) into James Horner's score for the third film (see our interview with Huxley on page 73).

Although Goldsmith had been given ample time to work through the soundtrack, the last-minute effects work meant that he sought additional

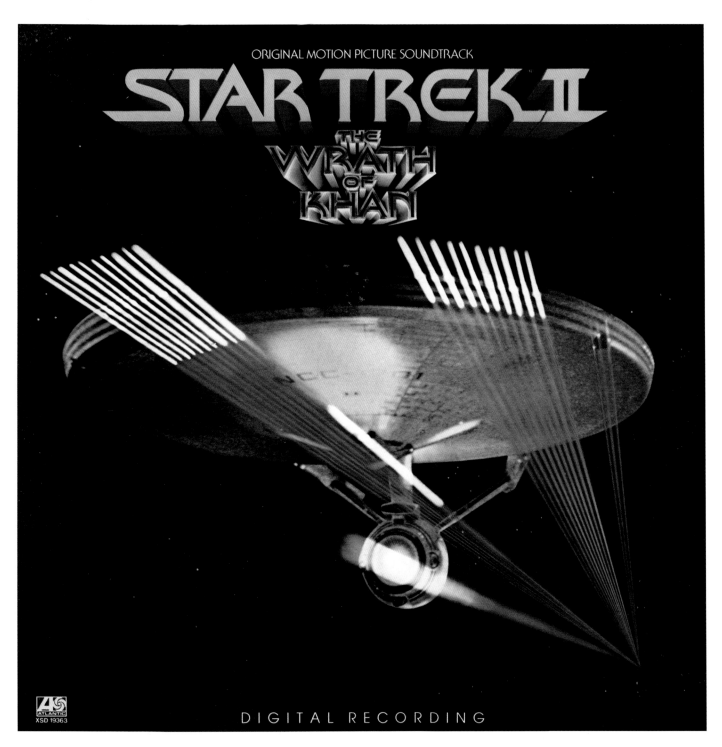

ORIGINAL MOTION PICTURE SOUNDTRACK

STAR TREK II

THE WRATH OF KHAN

ATLANTIC
XSD 19363

DIGITAL RECORDING

composing help from Fred Steiner, who had scored the original series. Despite the tumultuous process to get the movie made in time (the score was recorded on December 1st, and the film opened on the 7th), Goldsmith enjoyed the process. Interviewed by Kevin Courier in 1982, for CJRT-FM radio, he noted, "It was one of those great moments for a composer where there wasn't enough time to build the sound effects so the music had to take it all... But that's also an intelligent choice because when you're floating around in space, there is no sound; it's a vacuum. You either play it silent or let the music carry it. Whether you liked what Kubrick did with music in 2001, when the music played, by God, you heard the music."

Columbia issued the soundtrack in 1979; in 1999 it re-released an expanded CD of the music, with the

second disc featuring the documentary *Inside Star Trek*. Fans craving more got the complete score on three CDs from La-La Land in 2012 (the label later reissued a two-LP limited edition in 2017) – including unused cues, alternate takes and the vocal version of Ilia's theme, "A Star Beyond Time," with vocals from Shaun Cassidy.

Due to the first *Star Trek* movie's bloated budget, *Wrath of Khan* (1982) required a trimming of the fat, including Jerry Goldsmith's composing fee. Director Nicholas Meyer knew he'd come across his new composer after hearing James Horner's demo tape, and the two immediately hit it off. Interviewed for this book, director Meyer spoke to the musical palette for his sequel, stating, "In Horner's case, we chatted a great deal about the film itself and spoke conceptually about the idea of space as an endless ocean and Kirk as a sort

of latter-day Horatio Hornblower. Yes, [Claude] Debussy's "La mer" came into it. Later, Horner came to my house and played themes on my piano. There wasn't much discussion after that; there didn't need to be, it was so clear by that point how well I had made myself understood and how enthusiastically James had embraced and made my notions his own."

The Horatio Hornblower motif must have stuck with Horner, as Meyer recalls. "Interestingly, the fanfare itself seems to have been borrowed from Robert Farnon's rousing score for the Raoul Walsh movie *The Adventures of Captain Horatio Hornblower*. When I'd mentioned to Bill Shatner that Kirk reminded me of Hornblower, he became quite excited and said, 'That's exactly what Gene [Roddenberry] had in mind!'"

Label: Atlantic / SD 19363 Format: LP Year: 1982 Art: Bob Defrin

ORIGINAL MOTION PICTURE SOUNDTRACK

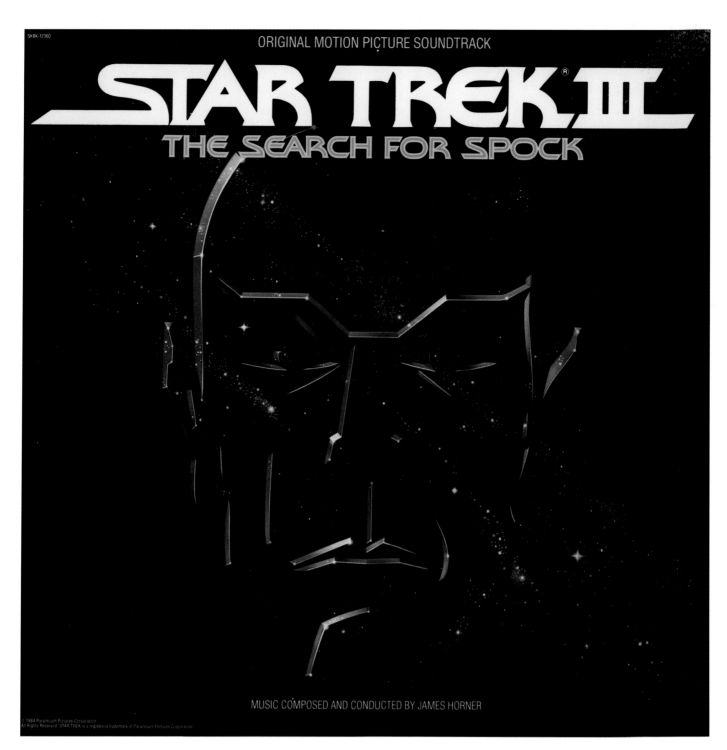

STAR TREK® III
THE SEARCH FOR SPOCK

MUSIC COMPOSED AND CONDUCTED BY JAMES HORNER

The soundtrack was initially released from Atlantic Records in 1982. In 2009, *Film Score Monthly*'s retrograde records reissued an expanded two-CD set that also includes Craig Huxley's music for the Genesis project sequence.

Horner returned to score the third installment in the series, *The Search for Spock* (1984), which allowed him to re-use the themes and approach he'd introduced in *Khan*, although the focus here is on the themes for Spock and the Genesis project. This sequel score does feel more intimate (taking place primarily on the Genesis planet) than the large canvas Horner was composing for *Khan*. He acknowledged this in an interview with Steven Simak for a 1985 issue of *CinemaScore*: "Lately I've been trying to do more and more small films, gentle films rather than this sort of epic blockbuster because I like what I can do with a

small film. I find it more interesting than what I can do, usually, in a large film." This probably explains the emphasis on the music for Spock, which Horner has commented was designed to soften the character.

Capitol Records initially released the soundtrack in 1984, which also features a single-sided 12" with a mid-'80s pop take on the theme by Group 97 (featuring Mark Isham). *Film Score Monthly*'s Retrograde Records released a double CD in 2010.

Tonally, *Star Trek IV: The Voyage Home* (1986) marks a departure from previous entries in the series. Leonard Nimoy, both star and director, took a much more humorous approach to the franchise with an ecologically-themed story involving the Enterprise crew going back in time to save humpback whales (in a film whose themes

continue to resonate strongly today, even if the hairstyles don't). The score, an abrupt departure from Horner's style, was composed by Leonard Rosenman, who was known primarily for his modernistic approach on soundtracks ranging from *Rebel Without a Cause* to Ralph Bakshi's *Lord of the Rings*. Rosenman, a longtime friend of Nimoy's, initially included an opening title with Alexander Courage's TV theme, but Nimoy liked his other material even more, hence the new thematic focus here. Interviewed by Randall D. Larson for *CinemaScore* in 1987, Roseman discussed his approach, "Aside from the main and end credits, which are quite thick, almost symphonic, there's a giant whale fugue that I use, which is a real cap off to a large scale cue that lasts eight minutes. That came off so well that I reprised it in a slightly different form in the end credits, which gave it

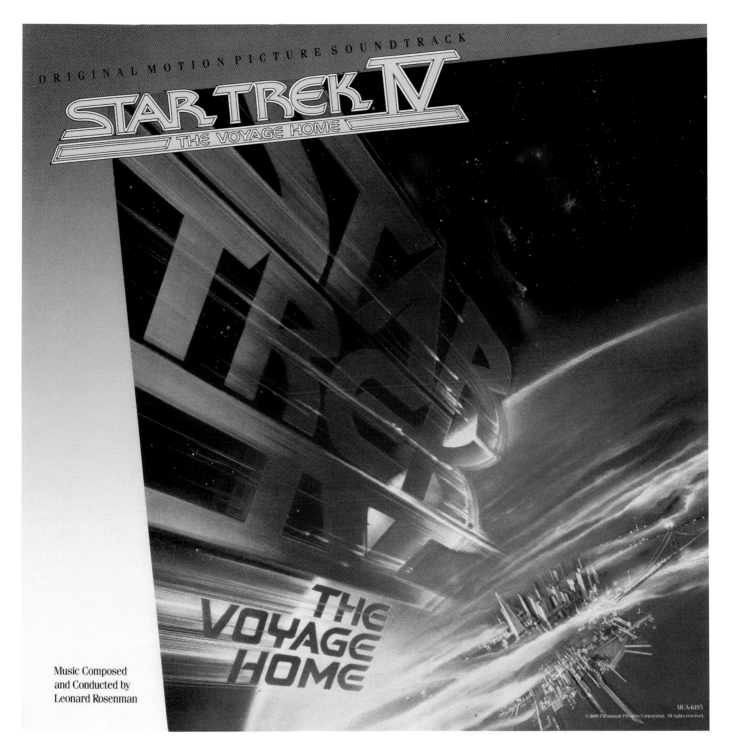

ORIGINAL MOTION PICTURE SOUNDTRACK

STAR TREK IV
THE VOYAGE HOME

THE VOYAGE HOME

Music Composed
and Conducted by
Leonard Rosenman

MCA-6195
© 1986 Paramount Pictures Corporation. All rights reserved.

almost another movement. It is quite long."

To accompany the 20th century setting of the bulk of the film, early San Francisco sequences feature jazz fusion music from the Yellowjackets, which feature on the soundtrack on tracks such as "Market Street" and "Ballad of the Whale." It was initially issued on vinyl from MCA in 1986, then Intrada reissued a double CD of the complete score in 2012.

Shatner himself took the director's chair for *The Final Frontier* (1989), and Jerry Goldsmith returned for scoring duties, revisiting some of his themes from the first installment. Here, he ups the ante on his Klingon music by incorporating a ram's horn, which is almost a callback to his work on *Planet of the Apes* (1968). Also noteworthy is a four-note motif for Sybok, Spock's half-brother,

first heard on the synclavier, it receives various treatments throughout the score.

One glaring weak spot on the original album is the inclusion of the song, "The Moon is a Window to Heaven" by Hiroshima, which plays over the sequence in which Uhura (Nichelle Nichols) does a sexy dance. The initial LP release was from Epic Records in 1989, while Intrada followed it up with a double CD release in 2012.

Meyer returned for the final installment to feature the show's full original cast: *Star Trek VI: The Undiscovered Country* (1991), this time commissioning a score from composer Cliff Eidelman, once again partly due to budgetary reasons. Meyer notes, "Originally, I had the idea of cannibalizing *The Planets* by Gustav Holst, but Paramount wanted exclusive rights to the music,

which is the composer's estate's cash cow, so there was no way that was gonna happen."

Additionally, the film was a change of pace from previous *Trek* films, as Meyer communicated to Eidelman that the film was "about the mysterious race of Klingons, a dark, brooding, warlike people, and I wanted the music to reflect that subject matter. In my discussions with Eidelman (again, I think, the result of demo tapes), I alluded to Holst but also to the opening bars of [Igor] Stravinsky's *The Firebird*. Eidelman was familiar with both scores and a day later returned with a very creditable amalgam that was also distinctly his own."

Label: MCA Records / MCA-6195 **Format:** LP **Year:** 1986 **Art:** Bob Peak

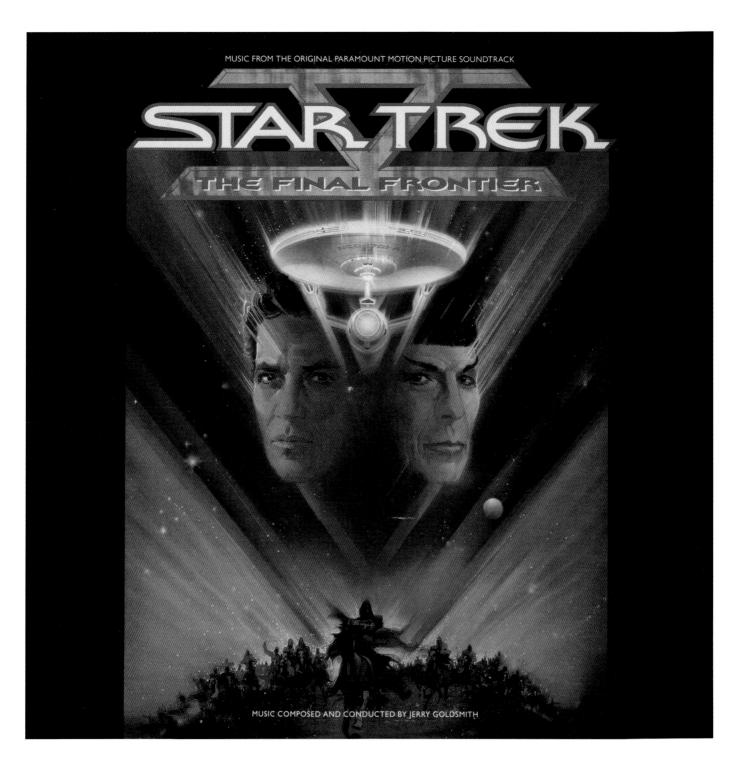

MUSIC FROM THE ORIGINAL PARAMOUNT MOTION PICTURE SOUNDTRACK

STAR TREK V
THE FINAL FRONTIER

MUSIC COMPOSED AND CONDUCTED BY JERRY GOLDSMITH

The album was released in 1991 by MCA, with an expanded CD reissue from Intrada in 2012.

The *Star Trek* films would continue beyond the classic era, beginning with *Generations* (1994) utilizing the cast of *Star Trek: The Next Generation*, and eventually getting rebranded with new actors taking on the roles of original cast members for J.J. Abrams' relaunch of the series in 2009, with music from new generation Hollywood juggernaut Michael Giacchino.

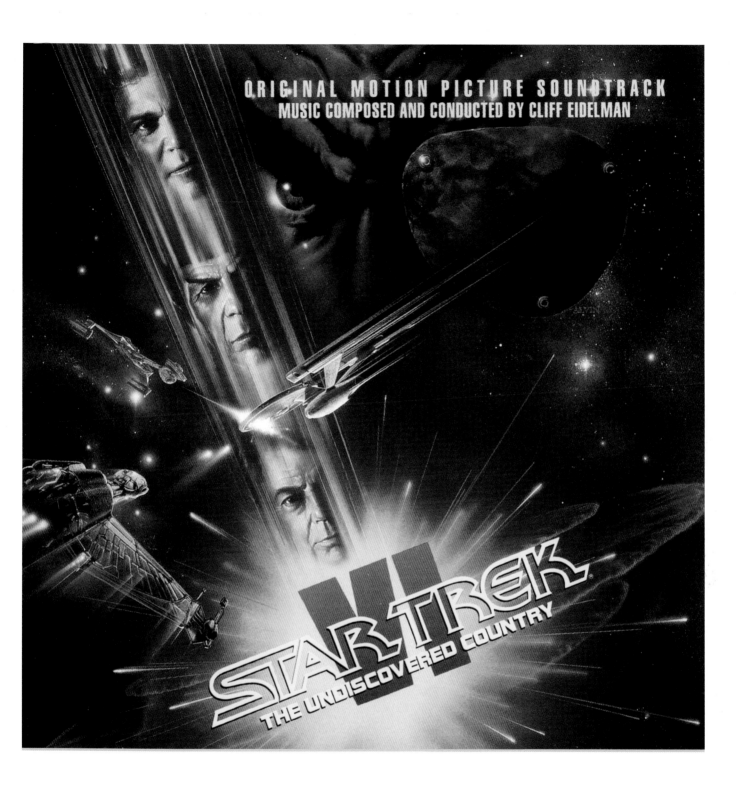

ORIGINAL MOTION PICTURE SOUNDTRACK
MUSIC COMPOSED AND CONDUCTED BY CLIFF EIDELMAN

STAR TREK VI
THE UNDISCOVERED COUNTRY

Label: MCA Records / 170.8053 Format: LP Year: 1991 Art: John Alvin

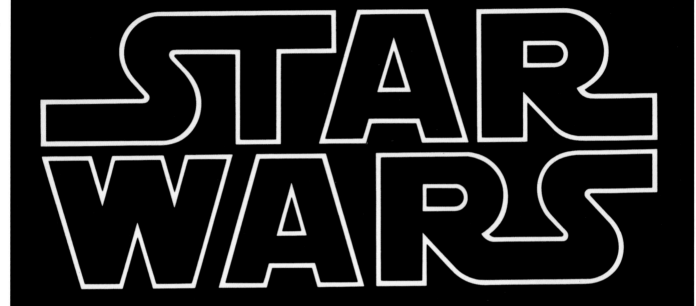

ORIGINAL SOUNDTRACK COMPOSED AND CONDUCTED BY JOHN WILLIAMS
PERFORMED BY THE LONDON SYMPHONY ORCHESTRA.

THE ORIGINAL STAR WARS TRILOGY

A long time ago (like, in the late 1970s), George Lucas and John Williams collaborated on what is arguably the most influential and lasting film score of all time, for a movie that Lucas' peers believed would flop. But they hadn't yet heard *Star Wars* with the accompaniment of Williams' stupendous score.

The resulting film blew up the box office. Coming at just the right time in American history, when audiences were reeling from a series of downbeat post-Vietnam-era films and sci-fi dystopias (sorry, *Logan's Run*, we still love you), *Star Wars*

succeeded in spite of the odds. The glue holding the space epic together, beyond Lucas' lived-in universe, is the Joseph Campbell-inspired mythological underpinning and Williams' music.

Star Wars announces itself with, ahem, force right after the pregnant pause between the 20th Century Fox Fanfare and the iconic *Star Wars* logo blazing across the screen. Accompanying the famous text crawl, Williams gives the audience, in essence, a musical overture, and in keeping with Lucas' "long time ago..." fairy tale opening, keeps the music in the vein of a late-Romantic-era composition, the

likes of which hadn't been used since the '40s, when Erich Wolfgang Korngold was scoring swashbucklers.

Speaking to Craig L. Byrd in a 1997 issue of *Film Score Monthly*, Williams noted that "the music for the film is very non-futuristic. The films themselves showed us characters we hadn't seen before and planets unimagined, and so on, but the music was – this is actually George Lucas' conception, and a very good one – emotionally familiar...which for

 Label: 20th Century Records / 2T-541 **Format:** 2xLP **Year:** 1977 **Art:** Suzy Rice

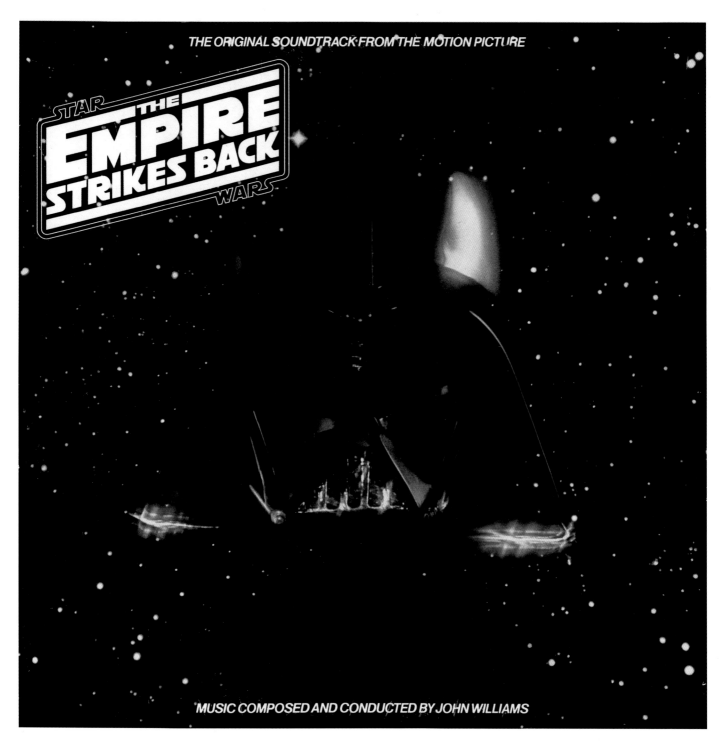

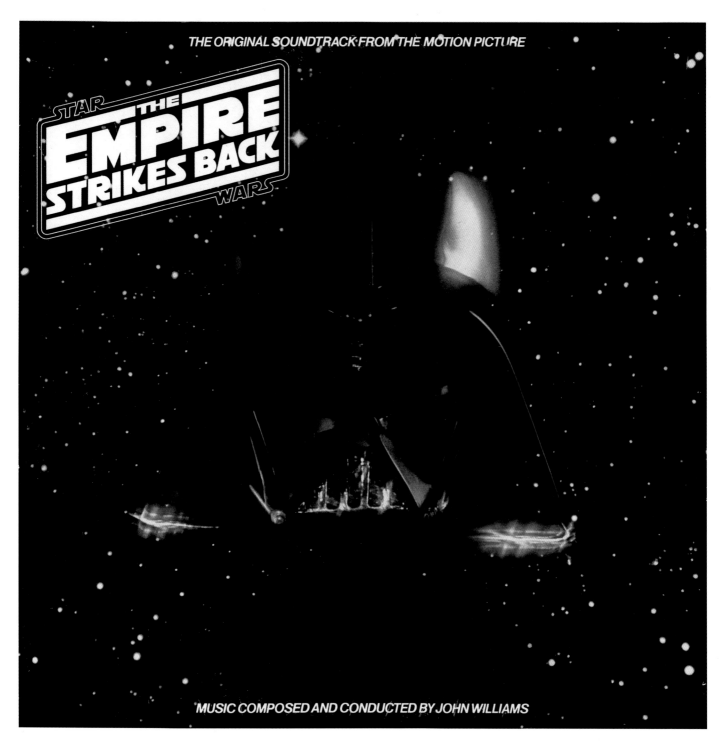

THE ORIGINAL SOUNDTRACK FROM THE MOTION PICTURE

STAR
THE EMPIRE STRIKES BACK
WARS

MUSIC COMPOSED AND CONDUCTED BY JOHN WILLIAMS

me as a musician translated into the use of a 19th century operatic idiom, if you like [Richard] Wagner and this sort of thing."

The music for the Cantina Band was the result of Lucas suggesting to Williams that the aliens play some variation on a Benny Goodman tune, and making use of a nine-piece band featuring steel drums and an Arp synthesizer for some unique tone colors. Other standout cues include the Korngoldian swagger in "Rescue of the Princess," in which Luke and Leia swing across a chasm (on the most precarious-looking piece of string in cinema), the climactic trench run music, and "The Throne Room and End Title." Williams, speaking with Lukas Kendall in 1993 for the four-CD anthology set noted, "I used Ben's theme as a triumphant parade fanfare as the group walks down the aisle. It represents the re-establishment

of the values that Ben believed in over the tyranny of the galactic Empire."

The original album was issued from 20th Century Records in 1977. The label would later reissue music for the first three films with extra tracks on the four-CD *Star Wars Trilogy* set in 1993. RCA Victor reissued the full soundtrack on CD in 1997 for the film's 20th anniversary.

The Empire, of course, came back with a vengeance (and bounty hunters) in 1980's *The Empire Strikes Back*, a sequel that matched, if not topped, the original, deepening the familial saga. Part of its power undoubtedly comes from what is arguably Williams' best score.

In addition to the existing material, Williams generated three new themes that would continue to run through the series. Jedi master Yoda

gets a theme, and there's a love theme for the blossoming relationship between Han and Leia (note: Han never gets his own "solo" theme). But it's "The Imperial March (Darth Vader's Theme)" that *Empire* is best known for, for which Williams incorporates brass and bass in their lower registers for dramatic effect. Williams also told Byrd in the aforementioned interview, "[The] brass suggests itself because of [Vader's] military bearing and his authority and his ominous look. That would translate into a strong melody that's military, that grabs you right away, that is, probably simplistically, in a minor mode because he's threatening."

Empire also features several exciting musical set pieces, such as the battle on Hoth (making use of xylophones), the asteroid chase sequence that plays like a scherzo, the escape from the

Label: RSO / RS-2-4201 **Format:** 2xLP **Year:** 1980 **Art:** Glenn Ross / Tim Owens

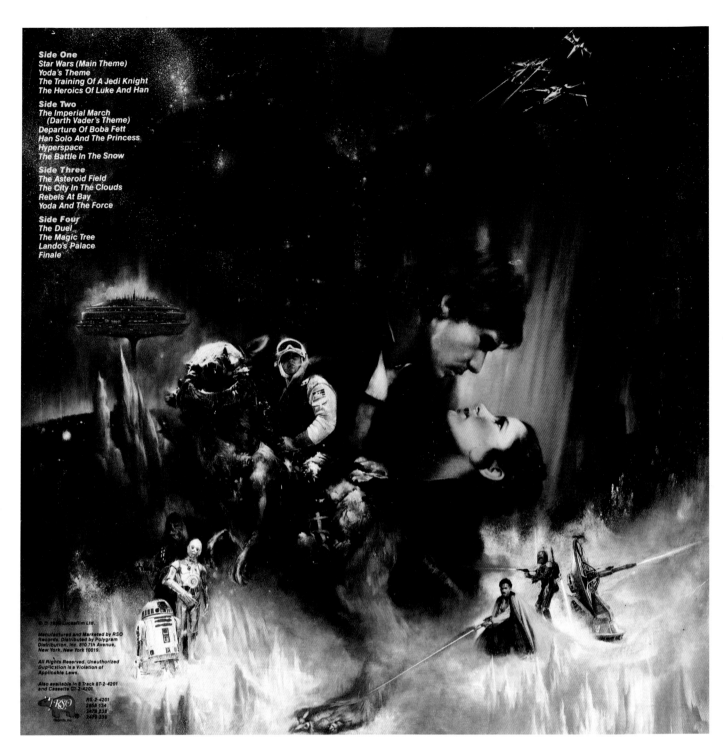

space slug, and the climatic duel between Vader and Luke, in which the film's revelation plays out amid drawn-out notes of the Imperial March. Williams does a good job of building musical tension throughout the film, hinting at the dark ending – notice how Han and Leia's theme doesn't really resolve until its final statement at the film's coda, in which Solo is already frozen in carbonite. Additionally, *Empire* has Williams entering the more impressionistic, atonal territory he explored in *Close Encounters of the Third Kind*. The "Magic Tree" sequence in which Luke enters the dream-like cavern to face Vader/himself makes distinctive use of a synthesizer, which is rarely heard in the series. And as the tide turns in the story and the Rebels are soundly beaten on Cloud City by the Empire, we get Williams' dissonant theme for bounty hunter Boba Fett, a counterpoint to the

romantic strains of the Han and Leia theme as Han is frozen.

RSO issued a 2xLP in 1980, and Chalfont Records dropped a single LP re-recording that same year. RCA Victor ported over the extended cuts from the four-CD boxed set onto its complete score CD in 1997.

The initial trilogy concluded in 1983 with *Return of the Jedi*, this time with director Richard Marquand at the helm. Porting over most of Williams' existing themes, *Jedi* includes new music for the Ewoks, Luke and Leia, Jabba the Hutt and, most memorably, the Emperor, using a male chorus to menacing effect.

The film's best sequence is the initial rescue from Jabba's lair, giving *Jedi* a top-heavy feel. Williams provides one of the best action cues in "Return of

the Jedi," in which Luke and company defeat Jabba over the Sarlaac, and with cues that tip a hat to the trench run and TIE fighter attack sequences from the original.

RSO issued its soundtrack in 1983, and while RCA's CD contains a more complete take on the score, it includes the "Jedi Rocks" song from Jabba's palace in lieu of the way better "Lapti Nek [see next page]," co-written with Williams' son Joseph (of Toto fame) and sung by Michele Gruska.

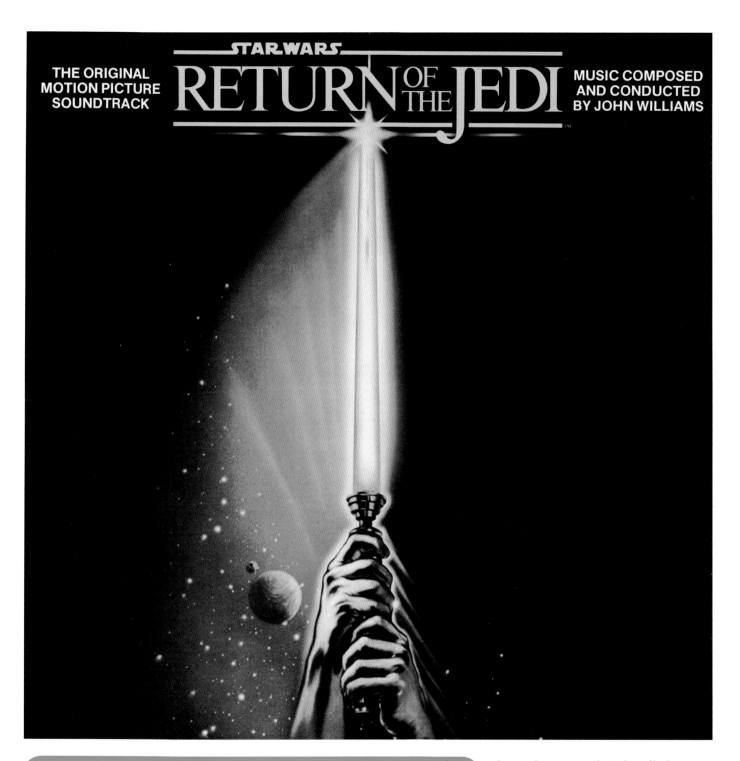

MICHELE GRUSKA ON "LAPTI NEK"

Michele Gruska has been a vocal coach for nearly twenty years, but is better known as the voice of Sy Snootles on the funky album track "Lapti Nek," which plays at Jabba's Palace in *Return of the Jedi* (before it was cut for the 1997 re-release and replaced with "Jedi Rocks," a crime almost as horrific as Greedo shooting first). Here, she discusses her role on the fabled cut.

How were you brought on board
Return of the Jedi?

Joe Williams [of Toto fame, and John's son] and I were family friends. I auditioned and went to 20th Century Fox and met Lionel Newman and went to the studio, and he literally handed me a foreign language written down [on paper]. He let me hear the song once or twice...and I sang it all the way through...Three or four days later he said, "We'd like you to sing the song for Sy Snootles. We'd like you to be her voice." I was ecstatic.

What do you recall about recording the track?

A month or two later, Joe, myself, Lionel Newman, and John Williams flew to San Francisco and the next day we were going to Lucasfilm in a limousine...[S]uddenly the limo was swerving, went into a ditch, and we realized that the driver was incredibly drunk! So we carried him to the back seat. Lionel ended up driving the limo. We finally got to the studio, and it was massive...with a double- or triple-sized movie theater screen. I was in front of a mic, and Sy Snootles came on in Jabba the Hutt's scene, and I overdubbed the song.

How difficult was it to sing in the invented language of Huttese?

When they wrote the language and we first read it, I thought, "How am I going to pronounce this?" I asked John where he wanted the accents to be, and what needed to be really pronounced, more importantly. It's a moment in time that will stay with me forever.

Label: RSO / 811 767-1 Y-1 **Format:** LP **Year:** 1983 **Art:** Tim Reamer / Paykos Phior

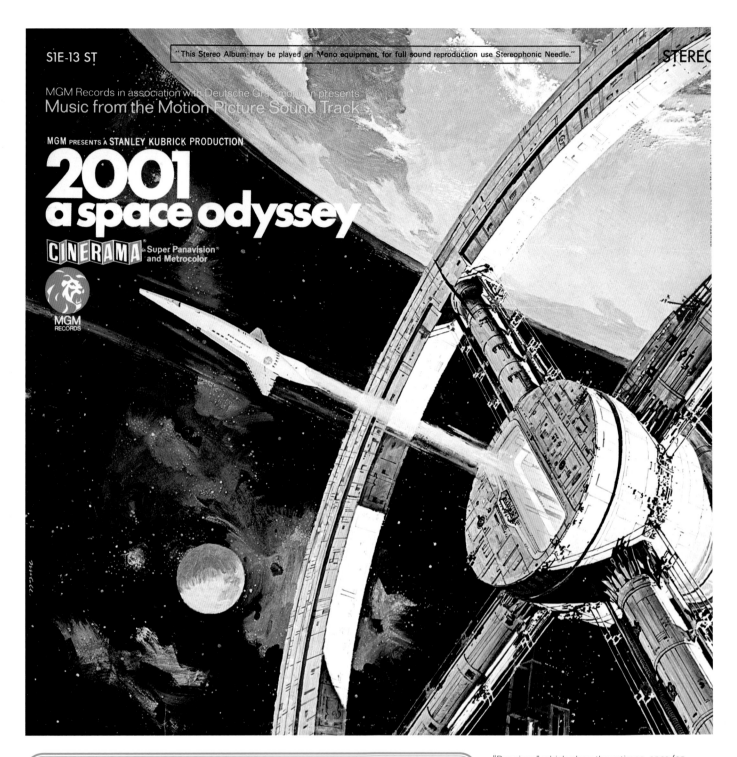

SIE-13 ST

"This Stereo Album may be played on Mono equipment, for full sound reproduction use Stereophonic Needle."

STEREO

MGM Records in association with Deutsche Grammophon presents
Music from the Motion Picture Sound Track

MGM PRESENTS A STANLEY KUBRICK PRODUCTION

2001
a space odyssey

CINERAMA® Super Panavision® and Metrocolor

MGM RECORDS

2001: A SPACE ODYSSEY

Do you want the actual score or the compilation soundtrack? With Stanley Kubrick's *2001: A Space Odyssey*, you get both! It's strange Kubrick used commercially available classical music in place of an actual professional composer for his sci-fi gem, and while the reasons for doing so were practical, the ultimate effect is part of what made *2001* a masterpiece.

Even if you haven't seen the film, the grand opening title music–Richard Strauss' "Also Sprach Zarathustra," which also plays during the famous "Dawn of Man" ape scene that follows – is now

woven into modern pop culture fabric. This tone poem is based on Friederich Nietzsche's book of the same name (translated into English: *Thus Spoke Zarathustra*), offering the idea that mankind will one day be surpassed by a new "superman," hence its inclusion in this evolution scene, as well as when man is reborn as a "star child." Elsewhere, Johann Strauss' famous waltz "The Blue Danube" is used during the docking scenes as a ship approaches the space port and again when it leaves for the Moon. Another recurring movement is a section of Hungarian composer György Ligeti's

"Requiem," which plays three times, once for every appearance of the strange black monolith, the significance of which is debated to this day. It's worth pointing out the interplay of music and dialogue in the film, with half the compositions heard before the first line and after the last line of dialogue, and none while characters are speaking.

In truth, a number of composers had been hired to score *2001*, beginning with the accomplished Frank Cordell, who Kubrick initially wouldn't even speak to for reasons that remain unknown. So that wasn't going to work. When MGM brass flew in to check on the progress of the film, the director told his assistant to use petty cash and purchase as much classical music possible, so that they could at least start laying in temp tracks. MGM pressured Kubrick to hire a composer instead, though, and he finally settled on award-winning

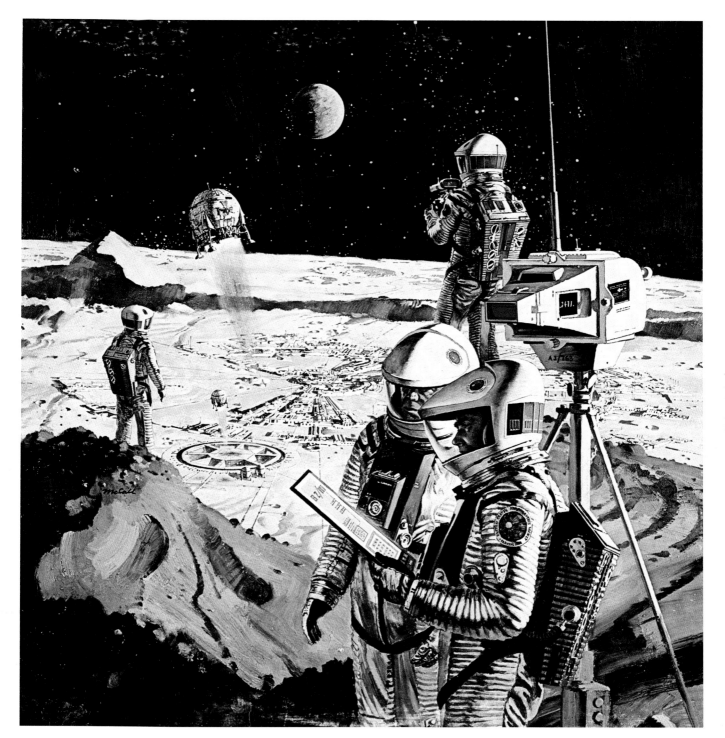

Alex North (he previously collaborated with Kubrick on *Spartacus*), who scored the first half of the film up to the intermission. "[Kubrick] was direct and honest with me concerning his desire to retain some of the "temporary" music tracks which he had been using for the past years," North was quoted as saying in the liner notes to the Varèse Sarabande recording of his score (conducted by Jerry Goldsmith and released after North's death).

And while it's hard to imagine *2001* without the Strauss and Ligeti pieces, North's score (clocking in at around 30 minutes) has some notable pieces, such as the bombastic "Eat Meat and Kill," which makes use of stabbing brass and thundering timpani to underscore the bloody battle between the apes from the Dawn of Man sequence. Unsatisfied with the results, Kubrick went ahead with the temp tracks anyway, later

citing that no film composer could be as good as Beethoven, Mozart or Brahms. What he didn't do was tell North he had nixed his score. The composer was invited to the premiere of the film, only to discover that his music had been replaced (classy move, right?). Thankfully, some of North's music was reused in his score for the 1981 fantasy film *Dragonslayer*. Varèse Sarabande issued a premiere recording of North's *2001* score in 1993 (making use of a surviving tape copy to keep the same tempos), and it eventually hit vinyl in 2014, thanks to Mondo.

MGM released an accompanying soundtrack LP with the film though it used a different version of "Also Sprach Zarathustra" than is in the film and left out some of the key Ligeti compositions. Regardless, it hit #24 on the Billboard 200 and was certified gold, selling over 500,000 copies.

In the early '90s Rhino released a CD version that included the missing material (including the version of "Zarathustra" from the film), and added bonus tracks. Perhaps this version will one day see a vinyl release. Meanwhile North's unused score has been released numerous times to mostly critical acclaim.

In his 1973 essay, *A Lecture of Film Music*, Bernard Herrmann famously chided Kubrick's use of pre-recorded music as underscore: "I think that *2001: A Space Odyssey* is the height of vulgarity in our time. To have outer space music accompanied by "The Blue Danube Waltz" and the piece not even recorded anew? They just used gramophone records. The best you can come up with for the whole epic of outer space is to play "The Blue Danube Waltz?"

Label: MGM Records / 1SE13 ST (back) **Format:** LP **Year:** 1968 **Art:** McCall **21**

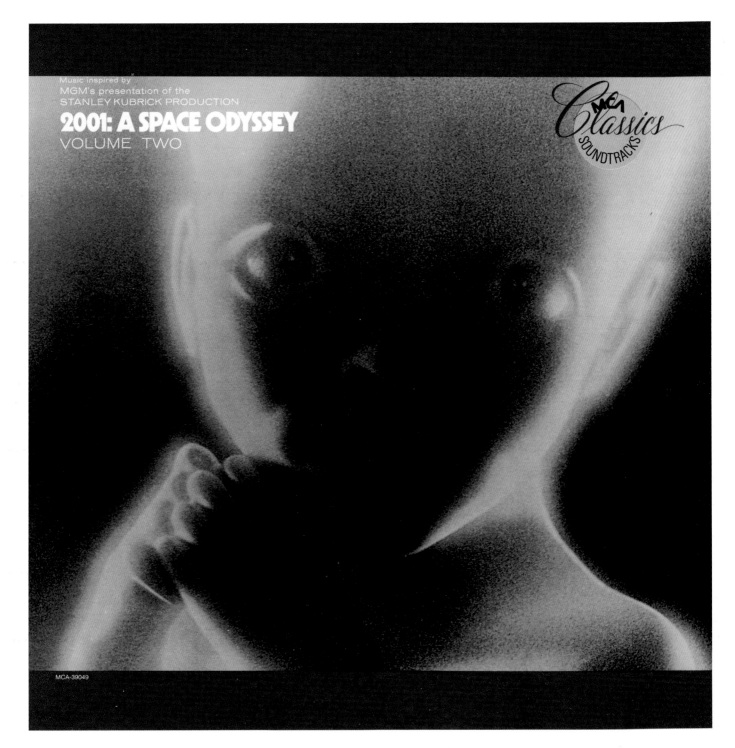

Music inspired by
MGM's presentation of the
STANLEY KUBRICK PRODUCTION

2001: A SPACE ODYSSEY
VOLUME TWO

MCA Classics Soundtracks

MCA-39049

Whether you agree or not with Herrmann, the film's impact is undeniable, both as a landmark genre film, as well as how it took existing music and assigned new meaning to it: Richard Strauss' "Also Sprach Zarathustra," was never intended for a film, let alone an epic sci-fi, but listeners of a certain age have forever tied the piece to the Kubrickian imagery, monoliths and all.

The success of both the film and soundtrack meant that a second volume of music was inevitable. And while it took years to release Alex North's original score for the film, MGM issued *2001: A Space Odyssey – Volume Two* in 1968, this time incorporating the film's iconic Star Child on the cover. The album ports over Strauss' "Zarathustra" again (presumably for listeners who hadn't purchased *Volume 1*). *Volume 2* also gives space for other pieces not used in the film, but

representative of the composers whose works were used, such as György Ligeti's "Lontano," which uses the same dense, micropolyphonic textures as on his choral work "Lux Aeterna," featured in the film. While the most substantial tracks were reserved for the initial soundtrack album, this is yet another exemplary collection of modern orchestral music, and a far cry from the inventive electronic approach taken by composer David Shire and producer Craig Huxley for the 1984 sequel, *2010*, profiled next.

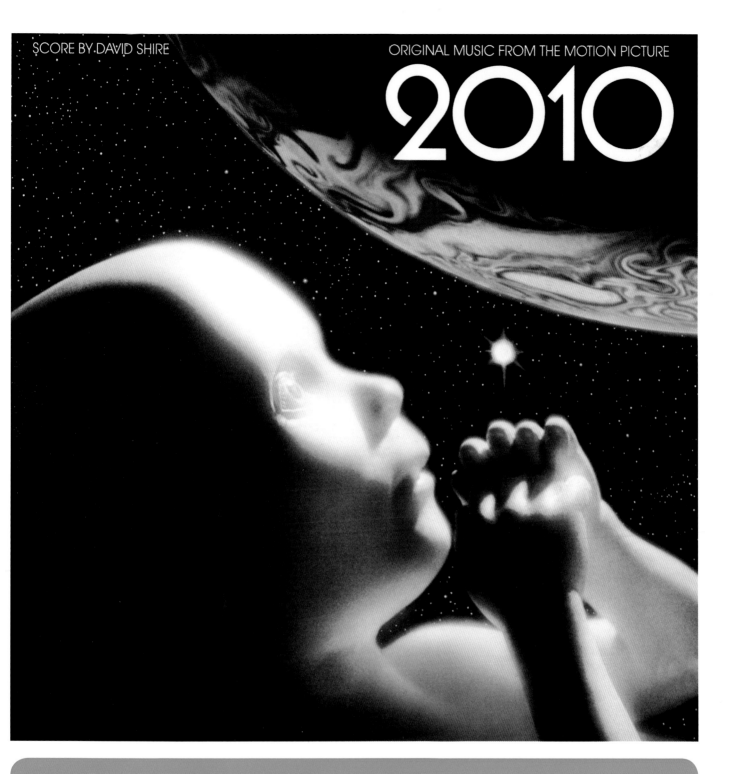

SCORE BY DAVID SHIRE

ORIGINAL MUSIC FROM THE MOTION PICTURE

2010

DAVID SHIRE ON 2010: THE YEAR WE MAKE CONTACT

A much more mainstream science fiction epic than *2001*'s existentialist art piece, the studio behind sequel *2010: The Year We Make Contact* originally enlisted Genesis keyboardist Tony Banks for composing duties but sacked him after being unimpressed with the results. Enter David Shire (*The Conversation*), who, along with producer Craig Huxley (*Star Trek: The Motion Picture*), used state of the art synthesizers to give the film a modern, grandiose atmosphere. Shire recalls crafting the soundtrack.

How did you feel about scoring the sequel to such a monumental film as 2001?

I was a little hesitant about doing it because clearly it wasn't going to be as good as the original, and I had already done a couple questionable sequels. I thought nothing was ever going to top *2001* but I also thought [director] Peter Hyamns would be a lot of fun to work with. Ultimately I thought *2010* was a pretty good science fiction film, and I was happy to get the job.

Did you collaborate with Hyams on the score at all?

The strange thing about Hyams is that he is his own cameraman. He's kind of a renaissance man of film. By the end of the movie, I realized that he really wished he could do the score as well –

I wrote what I thought were some pretty perfect cues, but he ended up redoing a lot of them himself. He just took my bass line and then inserted effects of the spaceship going above it, which was kind of disturbing when I saw the preview and saw how much my score had been reduced.

Label: A&M Records / SP-5038 **Format:** LP **Year:** 1984 **Art:** Chuck Beeson / Donald Krieger **23**

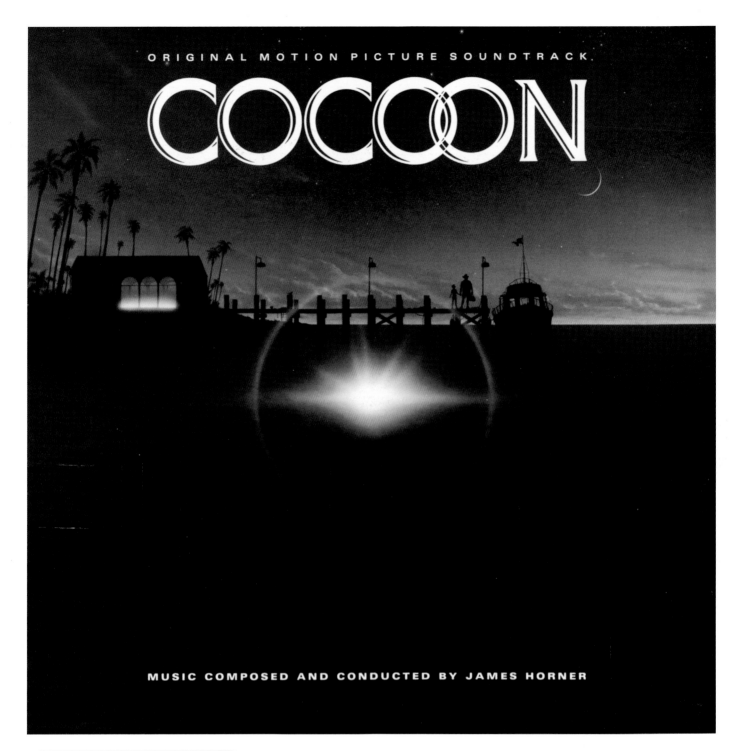

ORIGINAL MOTION PICTURE SOUNDTRACK.

COCOON

MUSIC COMPOSED AND CONDUCTED BY JAMES HORNER

COCOON

Cocoon (1985), in which aliens rejuvenate the residents of a retirement home, is a feel-good fantasy movie operating as a lovely parable for the cliché "You're only as old as you feel." The movie helped kickstart the directing career of Mr. Feelgood himself, Ron Howard, and a lengthy collaboration with James Horner (*Jumanji, Avatar*) as his go-to composer. On the surface, *Cocoon* is yet another major '80s sci-fi project for Horner, but in fact it's one of his first great dramatic scores, opening up another avenue in his career that he would later explore through films like *Legends of the Fall* (1994) and *Titanic* (1997).

Fluid and graceful throughout, *Cocoon*'s score is a relaxing listen mostly characterized by a recurring brass-led "mystery" theme highly evocative of '80s Spielbergian films, as well as more romantic, string-based themes. Deviations pop up along the way, including "The Chase," whose percussion and brass call back to Horner's more metallic sci-fi/action hybrids, while synth organ is used on "Discovered in the Pool House," and some suspense pops up in "The Lovemaking."

Then there's the one pop song featured on the original soundtrack release: "Gravity" by Michael Sembello, better known as the guy who did "Maniac" for Flashdance. Still, the overpowering arc of Cocoon's score is one of wonder and magic, best represented on "Ascension" and "Theme

From Cocoon," designed to communicate the film's overall message as opposed to individual narrative pieces.

Though beloved by soundtrack aficionados, *Cocoon* has suffered an unfortunate release history, with it's original 1985 Polydor album sounding muffled and poorly mixed. A 1997 CD on P.E.G. offered the same tracks with slightly improved sound quality, but *Cocoon*'s best release came in 2013 with Intrada's remastered CD featuring twenty minutes of extra material from the film. It's time to rejuvenate this version for old audiophiles with a new vinyl release.

 Label: Polydor / 422-827 041-1 Y-1 **Format:** LP **Year:** 1985 **Art:** John Alvin

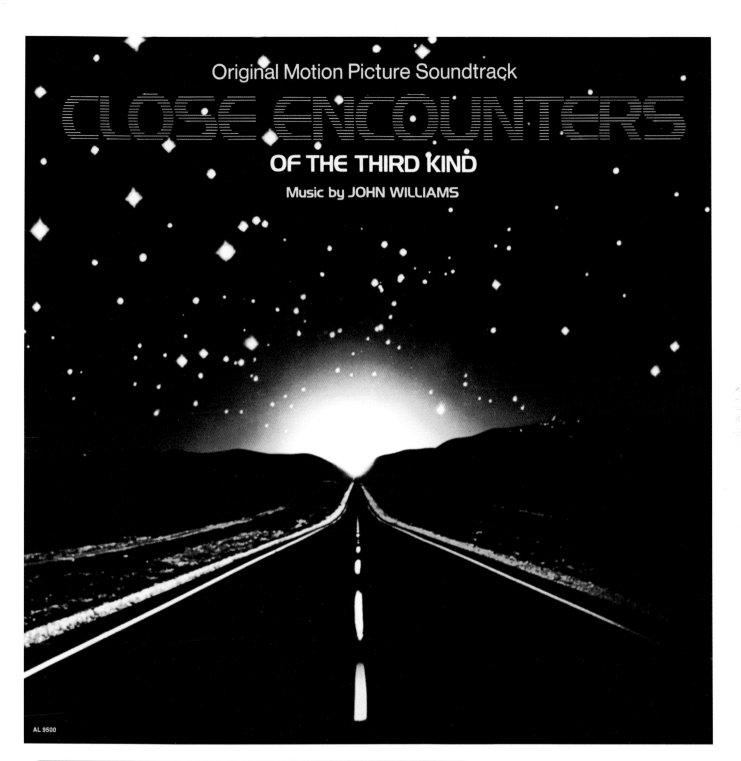

Original Motion Picture Soundtrack

CLOSE ENCOUNTERS

OF THE THIRD KIND

Music by JOHN WILLIAMS

AL 9500

CLOSE ENCOUNTERS OF THE THIRD KIND

The year 1977 witnessed legendary composer John Williams' crowning achievement: *Star Wars*. But as it turned out, that same year produced another of his film score triumphs, the optimistic alien encounter epic *Close Encounters of the Third Kind*. Though less famous and grandiose than Williams' score for the iconic space opera, *Close Encounters* remains one of the most unique and beloved works in the master's canon.

Music features prominently in the film's narrative, most notably with the five-note tonal phrase that is used as a communication tool between humans and the alien visitors (the fact that "hello" contains five letters is perhaps not a coincidence). Williams and director Steven Spielberg reportedly went through 300 different ideas before finally settling on one.

The rest of the score is deserving of praise, and now recognized as one of Williams' most complex. Divided into three main sections, the beginning of the film uses discordant and often frightening passages to detail the anxieties associated with meeting a new, superior race of beings. The middle of the score is mostly restrained with bursts of orchestral action cues that would form the basis of many future Spielberg/Williams collaborations, beginning with *Raiders of the Lost Ark*. The final act is where the score truly becomes more intricate, introducing listeners to the alien-communication motif and, perhaps more importantly, its true main theme, one that covers everything from the movie's darker opening act to the wonder and awe that the alien beings bring near the film's climax.

The *Close Encounters of the Third Kind* soundtrack was distributed around the world as a gatefold LP (through Arista) at the time of the film's release. Some editions included a bonus 7-inch containing a disco "Theme From Close Encounters of the Third Kind," which is terrible or brilliant depending on your perspective. More complete versions have been released on CD over the years.

Label: Arista / AL 9500 Format: LP + 7-inch Year: 1977 Art: N/A

CHAPTER

2

ADULT FANTASY

BLOODY BATTLES & LEGENDARY LOINCLOTHS

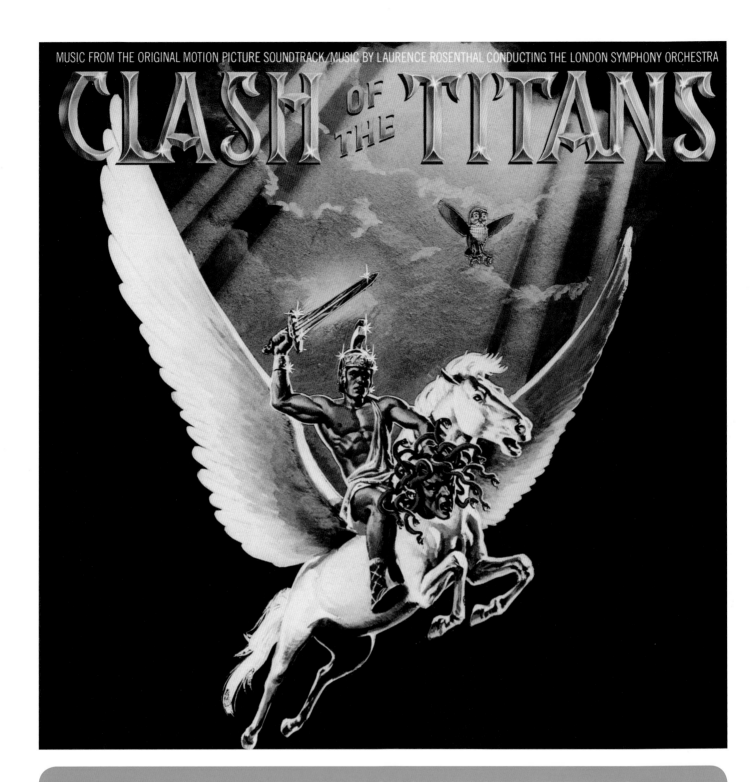

MUSIC FROM THE ORIGINAL MOTION PICTURE SOUNDTRACK/MUSIC BY LAURENCE ROSENTHAL CONDUCTING THE LONDON SYMPHONY ORCHESTRA

CLASH OF THE TITANS

LAURENCE ROSENTHAL ON CLASH OF THE TITANS

Clash of the Titans, released in 1981, marked the final collaboration between producer Charles Schneer and stop-motion effects pioneer Ray Harryhausen. For this film, which chronicles the Greek myth of Perseus, composer Laurence Rosenthal (*Meteor*, *The Miracle Worker*) created a vibrant, memorable score, which he discusses here.

You were instructed to incorporate the style of composer Richard Strauss into the score. What did you take from Strauss when composing this?

[Producer] Charley Schneer told me straight off that they had "temp-tracked" the film with Richard

Strauss's well-known tone-poem *Ein Heldenleben (A Hero's Life)* and that it worked perfectly, and of course I saw immediately what was going to be the character of the film and the kind of score he had in mind.

But at the same time, it seemed he wanted a skillful imitation of Strauss's masterpiece, although he never said that directly... This really stuck in my craw. Was I being invited to compose this score because I was an adept copy-cat? My mind was racing...and so, smiling and nodding politely, but thinking a mile a minute, I came to

this conclusion: I must compose a score that will accomplish musically, dramatically, emotionally, what the Strauss piece provided, but I will make all efforts to speak in my own voice. If there is an occasional little leak from "Ein Heldenleben," well, so be it. I will try to have my own take on this epic. So I accepted Charley Schneer's offer and was off to London.

What were your initial thoughts of the picture, before scoring it?

As I watched the rough-cut of the film for the first time, I felt an overall gesture. A sense of the sweep

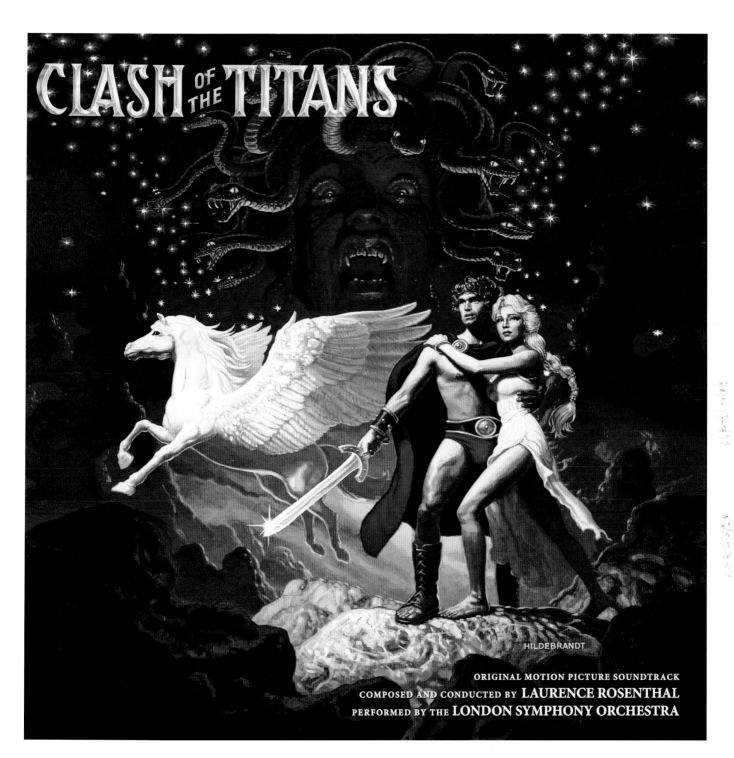

CLASH OF THE TITANS

HILDEBRANDT

ORIGINAL MOTION PICTURE SOUNDTRACK
COMPOSED AND CONDUCTED BY LAURENCE ROSENTHAL
PERFORMED BY THE LONDON SYMPHONY ORCHESTRA

of the music. This score could not be trivial; it had to be in the grand manner. Mythology speaks of major themes in the life of Man. The task was not as easy as I had hoped. But *Clash* is a film that simply demands music, and once I got underway, the notes came readily... Not only the soaring, heroic opening theme, but a very tender one for Andromeda, and many scenes which had a kind of "magical" content, movement into invisibility, the crazy little golden bird, and the unearthly scenes with the gods on Mount Olympus.

It turned out that the film provided many dramatic possibilities which took me quite far from the Straussian model. I am thinking of the strange, cursed world of Calibos, and the mysterious hall of Medusa, the snake-tressed creature whose merest glance will instantly turn you to stone. And then, of course, the wild, sky-riding taming of Pegasus

became almost a tone-poem of its own. It gave the possibility of actual thematic development, something which the limited length of most film music cues does not allow. So, a rich table of goodies. (The giant scorpions had such superb sound effects, that it was no problem for me to leave that moment to the sound team. I couldn't compete!)

How did you decide upon the orchestration and other themes for the film?

The musical ideas present themselves to me already in certain timbres. The use of the harpsichord here somehow enhanced and curiously made real the terrifying aspect of Medusa, the gorgon, in a tactile way. So when I compose in "short score" the ideas for instrumentation are already specifically indicated.

Even when I have the collaboration of a master orchestrator like Herbert Spencer, who assisted me on *Clash*, the indications for orchestration are already indicated in the sketch. Of course, Herb Spencer almost always added little genius touches. He knew more about the orchestra than I will ever know.

So all in all, what can I say about this score? It began as a kind of stylistic exercise. I wouldn't for a moment deny that as I got into it, the fire of my interest grew apace...Evoking a passed era in musical history was indeed a challenge, but it was familiar territory. Even though I knew that the idiom was a borrowed one, it was intriguing to see how much of my own language I could inject into it...I will always hold an affectionate place in my heart for this score, which so many people have found a pleasurable musical experience.

Label: Intrada / INT 3005 Format: 2xLP Year: 2016 Art: Tim and Greg Hildebrandt

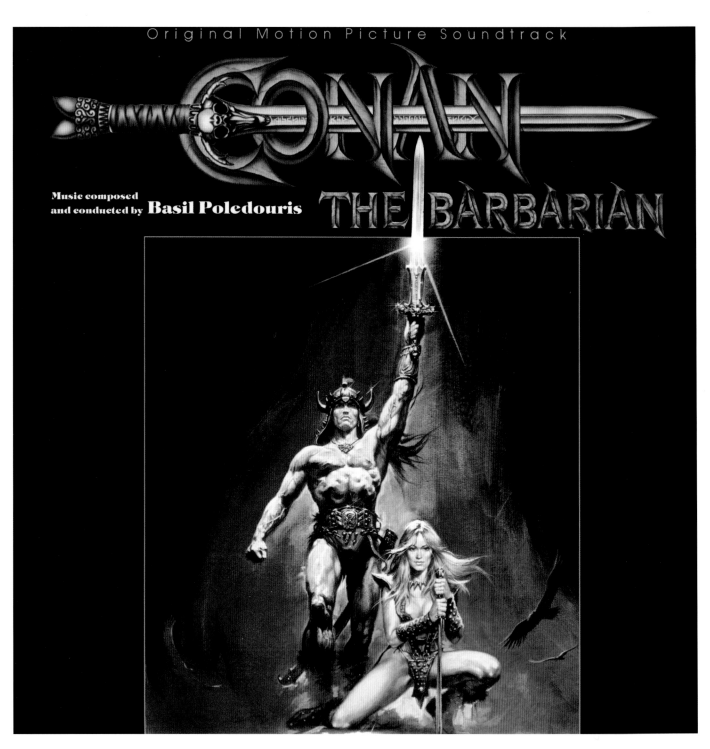

Original Motion Picture Soundtrack

CONAN THE BARBARIAN

Music composed and conducted by **Basil Poledouris**

THE CONAN SERIES

Conan the Barbarian (1982) is the king of all sword and sorcery films. Helmed by John Milius, a director too politically incorrect for today's Hollywood, the movie is as primitive and brutal as its titular character and could only be a product of Reagan's America. It made a star of Arnold Schwarzenegger, and though he performed an impossible training regimen for the role, his acting chops were still very raw. As such, Milius intended the movie to feature little dialogue, operating instead as an opera told through visuals and music. Since sound would play such

an important role in the film, the director hired friend and previous collaborator (on *The Reversal of Richard Sun* and *Big Wednesday*) Basil Poledouris, working with him every step of the way.

At the time it was the norm to hire a composer after principal photography, but for *Conan* Milius was able to secure the composer's services at the beginning of the project. Poledouris was to write music based on storyboards, then modify it as scenes were shot.

The film opens with the "Anvil of Crom," serving as the movie's main theme, featuring 24 French horns dramatically blaring, while pounding drums add rhythm as mighty as Conan's sword. This theme is repeated throughout the work and is today one of the more recognizable film music pieces of the '80s. Next comes "Riddle of Steel/ Riders of Doom," which kicks in during a speech delivered by Conan's father, on a mountaintop. This track serves partially as Conan's theme and is the grand, muscular musical identity of the entire film. For villain Thulsa Doom, Milus suggested that Poledouris tap Carl Orff's "Carmina Burana" as emotional inspiration, but when he learned Orff's work had been featured in similar sword and sandal film *Excalibur* the year before, Poledouris instead used a melody from *Dies irae*, a Catholic Mass for the Dead, and added Latin chants

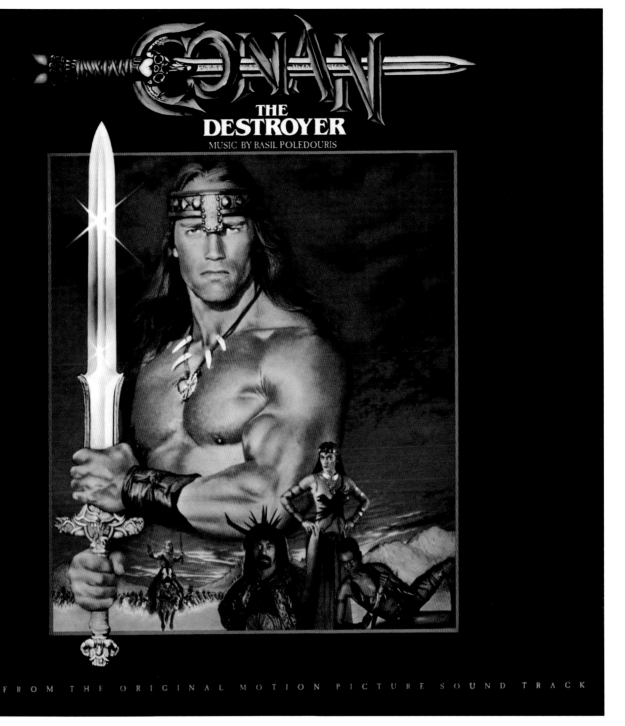

CONAN
THE DESTROYER
MUSIC BY BASIL POLEDOURIS

MUSIC FROM THE ORIGINAL MOTION PICTURE SOUND TRACK

that perhaps didn't quite make sense but sound ominous enough. *Conan*'s time setting is never defined, so Milius and Poledouris essentially cherry picked influences and styles – sometimes it was more about eliminating what was inappropriate, rather than deciding on a specific, historically correct musical palette.

Conan the Barbarian was released around the world on LP in 1982, and then reissued through Geffen in 2015. A Varèse Sarabande CD came out in 1992 with four extra tracks and liner notes, but the most complete version arrived in 2012 with a three-disc CD set featuring the complete score, bonus tracks, as well as the original 1982 release. Time for someone to build a vinyl box set as big as Conan's biceps.

Barbarian is a film music masterpiece, so it was always going to be tough for Poledouris to live

up to it for 1984 sequel *Conan the Destroyer*, but doubly so when you consider Milius would not return after serving as the guiding hand to the original film's musical identity. On top of all that, Poledouris was given a smaller, less talented orchestra with no chorus.

Conan the Destroyer's script was lighter and somewhat silly compared to the stark solitude of the original, and in some ways Poledouris' music in the sequel reflects that shift. The dominant themes from the original, namely "Anvil of Crom" and "Riders of Doom," do make appearances in *Destroyer* but more as cameos than anything else. Instead, the two new major themes appear on "Elite Guard Attacks" and "Crystal Palace," both of which emphasize confrontation and battle scenes – the former serving as a theme for evil Queen Taramis.

Though an overall competent score, *Destroyer* simply never lives up to its predecessor, and part of that can be attributed to poor performance from the players and an inadequately recorded release on LP (through MCA in 1984). Since then, the only improved version has come via Prometheus Records in Belgium. This 2xCD features a re-recording of the expanded score by Nic Raine, conducting the City of Prague Philharmonic Orchestra, and includes the chorus that Poledouris wanted but was never given for the film. Also included is a re-recording of the score for *The Adventures of Conan: A Sword and Sorcery Spectacular*, a twenty-minute live action Universal Studios stage show from 1983, originally scored by Poledouris. An expanded and remastered version of his work would be more than welcomed by fans.

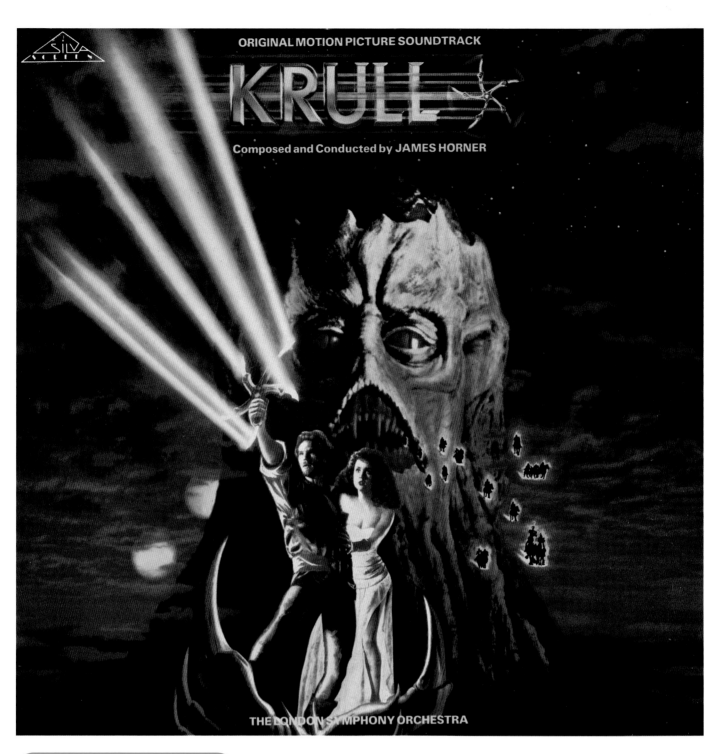

ORIGINAL MOTION PICTURE SOUNDTRACK

KRULL

Composed and Conducted by JAMES HORNER

THE LONDON SYMPHONY ORCHESTRA

KRULL

Say what you will about Peter Yates's 1983 cinematic flop *Krull,* but what makes this derivative sci-fi/fantasy epic most palatable for two hours is that it's underscored with nearly wall-to-wall music of the highest order. Much of it plays over a series of extended set pieces, such as the impossibly long title sequence of the Beast's castle/spaceship coming to land on the planet of Krull.

The score is one of those massive London Symphony Orchestra behemoths, and is filled out by some stunning choral work from the Ambrosian

Singers. The sheer scale of the music kicks the movie in the ass as it threatens to collapse under its own weight, notably the seven-minute sequence in which Colwyn climbs a mountain to retrieve the Glaive (the film's gimmicky bladed boomerang). Sadly, the film's effect is diminished on the small screen, where most viewers are destined to see it.

Krull sees a young composer full of ideas and ambition, even if some of those ideas are pilfered from earlier works (take a listen to *Battle Beyond the Stars,* the prototype for what would end up here). But *Krull* updates Horner's ideas, realizing the earlier music with a fuller sound, and a wider array of tone colors. The score utilizes both big fanfares for the brass, and deep, dissonant music employing the choir to suggest the demonic Beast, lending it more weight and menace than what the costume department could muster.

According to *Krull* lore, a physically ill and exhausted 29 year-old Horner had just five weeks and change to come up with the bulk of the score (totaling over 90 minutes), but you'd never know it from the finished product. That's partly due to *Krull*'s unsung hero, master orchestrator Greig McRitchie (*Invasion of the Bodysnatchers, Conan the Barbarian*).

The album was initially released in 1983 in the US from Southern Cross, then again by Silva Screen in 1986. It wasn't until 1998, though, that the Super Tracks label did everybody a favor and issued the complete score on CD. This expanded release was later reissued on vinyl by La-La Land (2015).

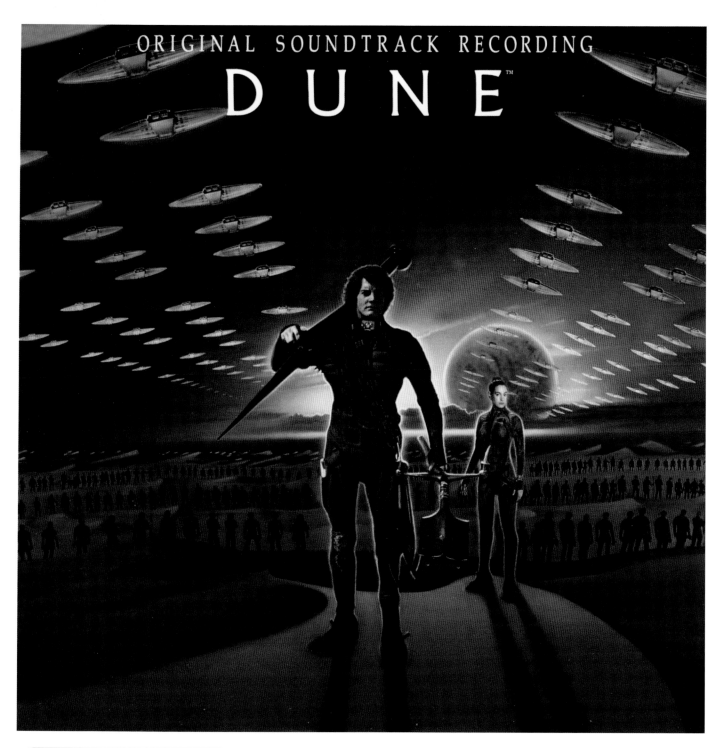

ORIGINAL SOUNDTRACK RECORDING
DUNE

DUNE

The 1984 film adaptation of Frank Herbert's *Dune* is one of those fabulous disasters: a big budget box office flop that, despite assembling an all-star cast and expensive special effects, turned out to be absolutely convoluted. The film was so complex that the studio even issued a glossary of *Dune* terminology to head-scratching filmgoers. In keeping with the movie's strangeness, while other space operas were hiring John Williams to compose grandiose orchestral scores, *Dune* employed rock band Toto to turn in a rock/electronic/orchestral hybrid that has gone on to become loved for the same reasons as the film: it's so bad it's good.

While the mix of smooth rock, electronic rhythms and orchestral outbursts is awkward, Toto did manage to compose some memorable main themes for *Dune*, particularly for the planet Arrakis. "Main Title" is a four-note progression that repeats throughout the film, perhaps too often (apparently at Lynch's insistence). A liturgical theme for protagonist Paul Atreides's call to destiny uses choir for added magnificence, while the Freman are given a downbeat theme that eventually transforms into one for the desert as they take back their planet.

Brian Eno contributed a lone track to the score, the synth-driven "Prophecy Theme." Toto guitarist Stephen Luthaker recalled the experience in an interview by Tom Murphy in 2016 for Westword.com:

"We did all of the music except for a 30-second part that Brian Eno did. That was an interesting project, because it was a legitimate score. It wasn't a rock-and-roll band going in to try and write a rock-and-roll album. It was a classical score with a little bit of rhythm section. We had been fans of David Lynch's early movies and remain fans of his films to this day. The movie ended up being so bad [that] it was funny, but David never got a chance to finish because of all the complications of the production of the film."

Dune was released on vinyl by Polydor in 1984, which was reissued by Music on Vinyl in 2014. An extended cut arrived on CD in 1997, courtesy of P.E.G. Recordings, then another version with improved sound quality came out in 2001.

Label: Polydor / 422-823 770-1 Y-1 **Format:** LP **Year:** 1984 **Art:** N/A

STV 81174

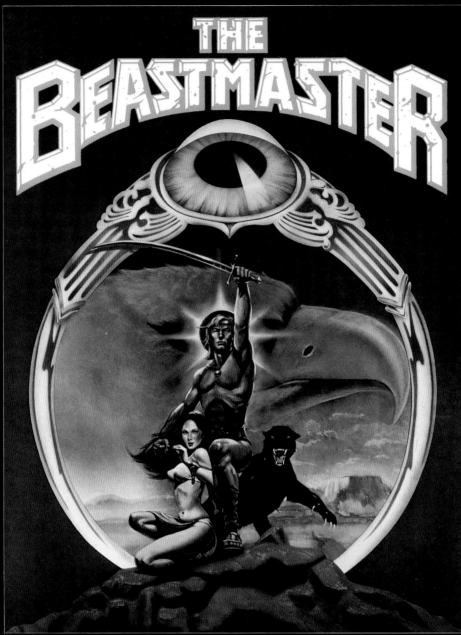

THE BEASTMASTER

MUSIC COMPOSED AND CONDUCTED BY
LEE HOLDRIDGE

LEE HOLDRIDGE ON THE BEASTMASTER

After kick-starting the *Phantasm* franchise, director Don Coscarelli tackled *The Beastmaster*, a 1982 sword 'n' sorcery movie about a warrior named Dar, who has the ability to communicate telepathically with animals. For the score, Coscaelli tapped Lee Holdridge, who had written extensively for Neil Diamond (!), and would go on to score numerous films TV series, including *Beauty and the Beast* (1987).

How did you come to work with Don Coscarelli?

Don had just heard the CD of my *Violin Concerto* No. 2 and felt that the work represented what he wanted music-wise for his new film. I went to meet with him at his editing studio and he proceeded to show me some footage. I instantly liked what I saw very much. It had a great sweeping look. I did notice that there might be some long sections without dialogue. I asked Don what happens in those sections and he pointed to me and said "You!" The good news was that he and the producer hired me to score the film, the other "good" news is that I would only have about two weeks to do everything. That kicked up my adrenalin, as I could see the score would be epic and there would be a lot of music!

How challenging was it to create something with an epic adventure movie sound to it?

I normally like to do my own orchestration, but in this case I knew I would need help. I contacted the legendary master orchestrator Greig McRitchie, who orchestrated *Conan* and had worked for years with the likes of Alfred Newman. Fortunately he said yes. I also benefited from his knowledge of the orchestra and the studio in Rome, where he had just done *Conan the Barbarian* with Basil [Poledouris]. In addition, I brought in my good friend, composer and orchestrator Alf Clausen. My process was to create around nine minutes of fully-sketched cues in six to eight line piano sketches a day and then distribute the cues out for orchestration, a third to each with me being the third orchestrator.

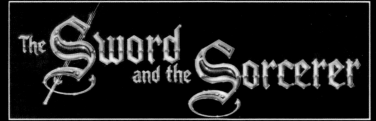

STV 81158

The Sword and the Sorcerer

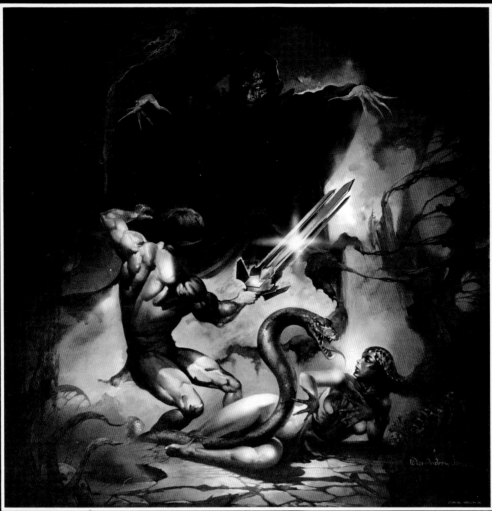

Music Composed and Conducted by
DAVID WHITAKER

THE SWORD AND THE SORCERER

The Sword and the Sorcerer (1982) is a B-movie fantasy in which a hefty chunk of the budget was seemingly poured into the evocative poster art. The film, released in 1982, a month apart from *Conan the Barbarian*, turned a healthy box office profit, and eventually made for a hilarious RiffTrax commentary. *Sword*'s plot elements don't linger in the memory as well as its peers, though the film's hero, Prince Talon, boasts a pretty cool three-pronged sword that spits out blades at his enemies.

Still, the score from U.K. composer David Whitaker (*Vampire Circus*, *Scream and Scream Again*) aims to please. RiffTrax points out the over-the-top nature of the incessant fanfares ("Ooh, his walking forward-looking smug theme; Bugs Bunny had subtler music"), but the score is all the better for it, lending the film a lightness of tone that belies the gore. In standout track "The Bordello," Whitaker channels the staccato brass bursts from Korngold's *Robin Hood* and *The Sea Hawk*, as the film sees Prince Talon (Lee Horsley) crashing through a window, Indiana Jones-style, into a

room of half-naked concubines, which probably explains why this entry isn't in the family-friendly chapter (yet fondly remembered by a generation of pubescent boys).

Interviewed by John Mansell for a 1994 issue of *Soundtrack Magazine*, Whitaker acknowledged that he wasn't working with the *Citizen Kane* of sword 'n' sorcery epics: "[N]ow the film was not that good, but I like to think my music helped it along on its way to being a watchable film. It desperately needed music, I actually wrote 75 minutes of score for that film, which ran for just over 100 minutes."

Of those 75 minutes, just under 40 appear on Varèse Sarabande's initial 1982 album release. The bulk of the score materialized on a 1999 Super Tracks CD, which was subsequently reissued from BSX in 2012.

ORIGINAL SOUNDTRACK

MASTERS OF THE UNIVERSE

CST 8029

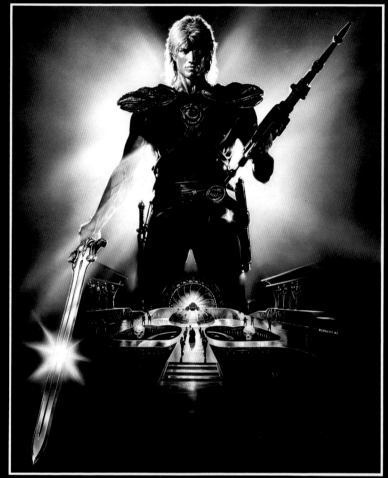

Musik komponiert von BILL CONTI

MASTERS OF THE UNIVERSE

Masters of the Universe was a dominant force in the '80s toy and children's television markets. Despite the animated series ending in 1985, He-Man and Skeletor action figures continued to sell well enough to warrant a live-action motion picture by 1987. Strange, though, that it was Cannon Films that picked up the Power Sword, given its preoccupation at the time with the B-action movie market, not major properties. The movie was a total flop, critically and commercially, but the production company must have had some up front money, because they were
able to hire none other than Bill Conti (Rocky, The Karate Kid) to score their affair, resulting in a masterful work in the vein of John Williams.

For various legal and financial reasons the score had to be performed by multiple orchestras across Europe, primarily Munich, with the less-than-satisfying results spliced together afterward by Conti and the mixer. Somehow they were able to make it work though, because from the opening "Main Title / Eternia Besieged," Conti's music comes soaring in triumphantly with brass and snare raising the hair on listeners' necks. Master

of the Universe remains one of Conti's most enduring works, as evidenced by the number of times it has been released.

Varèse Sarabande originally released the soundtrack on LP and other formats in a truncated, eleven-track version at the time of the film's release. It was improved upon in 1992 with a Silva Screen CD that added 27-minutes and five major cues. A 2008 double CD set from La-La Land followed, which finally presented the score in its entirety with the original 1987 album on disc two. With so much love being given to the Masters of the Universe score on CD, a 2xLP set would seem like a no brainer, even on Eternia.

ORIGINAL MOTION PICTURE SOUNDTRACK

YOR
The Hunter from the Future

Music by JOHN SCOTT • Additional Music by GUIDO and MAURIZIO DE ANGELIS

YOR, THE HUNTER FROM THE FUTURE

The Italian cottage industry of ripping off Hollywood movies knew no boundaries when it came to source material: *Jaws*, *Star Wars*, *The Exorcist*. Outside of spaghetti westerns, the results were dubious at best, but does it get any more ridiculous than *Yor, the Hunter from the Future* (1983), which was released in the wake of *Conan the Barbarian*? In drawing three Golden Raspberry Award nominations and appearing regularly on top worst movie lists, you might wonder what future Hollywood Symphony Orchestra artistic director John Scott is doing handling the score.

Ignoring the paper mache dinosaurs, Scott provides muscular, triumphant orchestral themes for the mighty Yor as he saves the day from all manner of evil and flashes his physique. Divorced from the film, *Yor*'s score is hair-raising in its might and conjures images of a much, much better Ray Harryhausen ripoff.

It gets better, though, because *Yor* was actually meant to be an Italian television series, so with more music needed, in came the dynamic duo of brothers Guido and Maurizio De Angelis, who had worked on all kinds of Italian genre rip-offs,

to provide an electronic score. The series never happened and was paired down into this one film, and as a result *Yor* features two completely different scores. There's nothing really wrong with the De Angelis boys' dark synths and cheap keyboards, other than they sound the complete opposite of Scott's masterful orchestral work.

Much of Scott's music was pulled from the film so the original LP soundtrack on Southern Cross Records only contained a smidgen of it, concentrating more on the De Angelis' work. A subsequent CD from BSX Records featured more complete scores by both artists, dividing the disc between them.

ORIGINAL SOUNDTRACK

STV 81248

RED
SONJA

Music Composed and
Conducted by
ENNIO MORRICONE

©1985 Famous Films B.V. All rights reserved.

RED SONJA

After the less than impressive *Conan the Destroyer* (1984), Arnold Schwarznegger wanted nothing more to do with the part, but with a contract to do three films, a compromise was reached in which he would appear in a supporting role in spinoff movie *Red Sonja* (1985), based on a character from Robert E. Howard's Hyborian mythology. The movie made *Destroyer* look like a masterpiece by comparison, with maestro Ennio Morricone's effective, if at times silly, score its only salvageable contribution to the burgeoning '80s sword 'n' sorcery genre.

As with the music for *Conan the Barbarian*, Morricone brought woodwinds and brass to the forefront of *Red Sonja*'s score, as well as an adult choir. Probably best remembered for its main title theme, a bouncing trumpet number that recalls Morricone's spaghetti westerns is used to represent Arnie's character, not Sonja, as he trains her and naturally becomes her lover. For *Red Sonja* herself, a surprisingly soft and romantic rising three-notes for woodwinds and strings were designed to represent the tragedy and pain that led to her quest for revenge, as opposed to the

action of the quest itself. The end credits sequence, representing Sonja's new badassery could be considered a controversial one for Morricone, but today's audiences will likely get a kick out of hearing electronic bass and drums coating the composer's orchestra with a smooth '80s feel.

The original 1985 Varèse Sarabande LP was an odd one, merging the entire score into two suites of music, one for each side. In 2000 Perseverance Records released a more proper version, remastered and divided up into actual tracks and cues. It's tough to know where to begin or end with Morricone, considering his numerous scores, but *Red Sonja* makes for an interesting and worthwhile entry, even if it's not exactly his best.

 Label: Varèse Sarabande / STV 81248 Format: LP Year: 1985 Art: Renato Casaro

MUSIC FROM THE FILM

EXCALIBUR

AND OTHER SELECTIONS

O FORTUNA FROM "CARMINA BURANA"
RIDE OF THE VALKYRIES (PRELUDE TO ACT III "DIE WALKURE")
SIEGFRIED'S FUNERAL MARCH FROM "GOTTERDÄMMERUNG"
PRELUDE "TRISTAN AND ISOLDE"
PRELUDE ACT III "LOHENGRIN"
PRELUDE ACT I "PARSIFAL"

EXCALIBUR

Before making his mark on films like *The Dark Crystal* and *Labyrinth*, Trevor Jones' first film composition of significance came through a dark telling of one of the world's most famous stories, that of the legend of *King Arthur and the Knights of the Round Table*, in 1981's *Excalibur*. Still, as a relative newcomer, Jones' music wasn't exactly at the front and center of *Excalibur*'s score. Instead the movie used grand classical themes from the likes of Richard Wagner and Carl Off as its main themes, while Jones' job was to tie it all together with his own unique underscore.

Indeed, the main theme from *Excalibur* is in fact Richard Wagner's "Siegfried's Funeral March," while other Wagner pieces are used including "Tristan And Isolde" and the often used epic "Ride Of The Valkyries." Carl Off's music is used frequently as well, namely his *Carmina Burana*, specifically "O Fortuna," which plays as King Arthur and his Knights ride into battle. Understandably these great classical works give *Excalibur* the grand atmosphere and weightiness that legendary tales such as these require.

Still, Jones' music is worth exploring in its own right, even though it primarily functions as mood-setting. Employing folk music, tin whistles, female chorus, and anything that sounds definitely antiquarian, Jones' underscore is eerie, dense, and powerful. The original Island Records 1981 LP focused solely on the classical works of Wagner

and Off, functioning as a sort-of greatest hits compilation for both composers. Jones' score has popped up on CD over the years, so it's high time someone creates as 2xLP containing *Excalibur*'s entire suite of music. A film so visually rich practically commands it.

Label: Island Records / ILPS 9682 **Format:** LP **Year:** 1981 **Art:** Bob Peak

BARBARELLA

Roger Vadim's *Barbarella* (1968) perfectly distills the '60s pop sensibilities that Mike Myers would parody 30 years later for his *Austin Powers* films. For a decade that began with the Beach Boys and ended by ushering in Led Zeppelin, the movie finds a comfortable middle ground with its lounge-based score from Charles Fox, featuring songs penned by Fox and Bob Crewe.

In his memoir, *Killing Me Softly: My Life in Music*, Charles Fox highlights the film's campy tone and recounts how Bob Crewe brought him on to help with the music after Paramount dropped Michel Magne's initial score, "which clearly needed to have a fun and futuristic approach to it, with a '60s musical sensibility... We wrote the main title song, 'Barbarella,' and four other songs that we would use in a scoring sense, over the action, as commentary on the film."

The film kicks off with a sexy, trippy opening mesh of sound and image as Jane Fonda's Barbarella strips out of her spacesuit, accompanied by the boppy earworm of a title song, with vocals provided by The Glitterhouse. (The lounge-influenced songs are at their best whenever Jane Fonda is in some state of semi-dress, such as in the dreamy "I Love All the Love in You.") Fox's score, meanwhile, emphasizes fuzzed out guitars that play over the psychedelic space scenes in which Barbarella's scanner screen reveals a starscape more closely resembling a lava lamp than a photorealistic cosmos. And Fox isn't above breaking out into some weird pop numbers to keep the film trucking along, orchestrating with jingle bells and a brass section as a manta ray-like creature pulls Barbarella along on skis over a wintry planet.

The album was released on Crewe's label Dynovoice Records in 1968, reissued in 2002 on the Harkit label in the UK, and then again from Varèse Sarabande as a 2000-copy limited edition Record Store Day picture disc in 2016. Soundtrack Classics' 2004 CD reissue tacked on bonus tracks from The Young Lovers and a few radio spots.

original
motion picture
sound - track
composed
by

**MARIO
NASCIMBENE**

ONE MILLION YEARS B.C.

The thing most people remember about *One Million Years B.C.* (1966) is Rachel Welch's animal hide fur-kini, but not to be outdone is Italian composer Mario Nascimbene's inventively symphonic, heavily percussive score.

In fact, an entire percussion section was built for the film, made up of instruments and objects both ordinary and otherwise, including, according to Howard Maxford's book *Hammer, House of Horror Behind the Screams* (1996), the jawbone of an ass. Music was of particular importance in this film, since the characters communicate via a series

of grunts (apparently it was deemed too much of a stretch to have cavemen speaking English but completely normal to have them co-existing with dinosaurs). As a result, Nascimbene's score was used to help keep the narrative going and to develop and define the various tribes. The Rock Tribe's theme is harsh and its clicking increases in intensity to reflect its savage culture, while the Shell People are accompanied by a more melodic theme that uses woodwind instruments. Though its overall lack of melody was disarming for some viewers, others realized the constant thumping

and click-clacking as being instrumental to the film's prehistoric template. In many ways, it's similar to Jerry Goldsmith's more highly-celebrated *Planet of the Apes* music.

One Million Years B.C. was released on vinyl in 1985 on the Italian label Intermezzo, complete with track titles in Italian. In 1994, Legend issued a CD that also included Nascimbene's scores to *When Dinosaurs Ruled the Earth* and *Creatures the World Forgot*. With these classic fantasy films eliciting such colorful visuals, it would be great to see the new vinyl market take note.

ORIGINAL MOTION PICTURE SOUNDTRACK

MUSIC COMPOSED BY PINO DONAGGIO
Conducted by Natale Massara

HERCULES

We're not sure which demigod fills out a loincloth better – Harry Hamlin's Perseus in *Clash of the Titans* or Lou Ferrigno as the title character in *Hercules*, but there's no match between which of the early-'80s Greek mythology fantasy films is more unintentionally hilarious. Golan-Globus's Cannon Studios produced this goofy 1983 fantasy romp, but at least they left something in their scoring budget to help give it a bit of muscle beyond Ferrigno's onscreen physique. To be fair, most Golan-Globus productions always left extra pocket change for the music, as evidenced by the

gargantuan scores for the likes of Bill Conti's *Masters of the Universe* and Henry Mancini's *Lifeforce*.

Directed by Luigi Cozzi (*Starcrash)*, as "Lewis Coates," the film sees Ferrigno's *Hercules* punching and flexing his way through all manner of mythic trials to rescue his beloved Cassiopeia (Ingrid Anderson). Given that it's an Italian production, it's fitting that the score fell to Pino Donaggio, who'd already scored successful films for both the Italian and American markets, such as Nicholas Roeg's *Don't Look Now* (1973) and Brian De Palma's *Carrie* (1976). In *Hercules*, you can hear Donaggio's trademark string writing, particularly during the early, almost impressionistic "Creation" cue, highlighting the formation of the universe over sober narration.

But what sets *Hercules* apart from these other thrillers is the mythic scope of Cozzi's pic, which provides an opportunity for Donaggio to go all out on this one, making the most of a 60-piece orchestra, conducted by Natale Massara. Here, Donaggio whips up a triumphant six-note motif that's usually heard when Hercules displays some feat of strength – even when baby Hercules is goring a pair of glowing-eyed snakes. The enhanced use of brass punches up sequences of Ferrigno bashing a bear, or taking swipes at a giant metal bird. In a move taken from the *Superman* films, the eventual sequel, *The Adventures of Hercules II* (1985), simply re-uses Donaggio's cues from this flick.

The album was originally released by Varèse Sarabande in 1983. Intrada followed up with an expanded collector's edition CD in 2007.

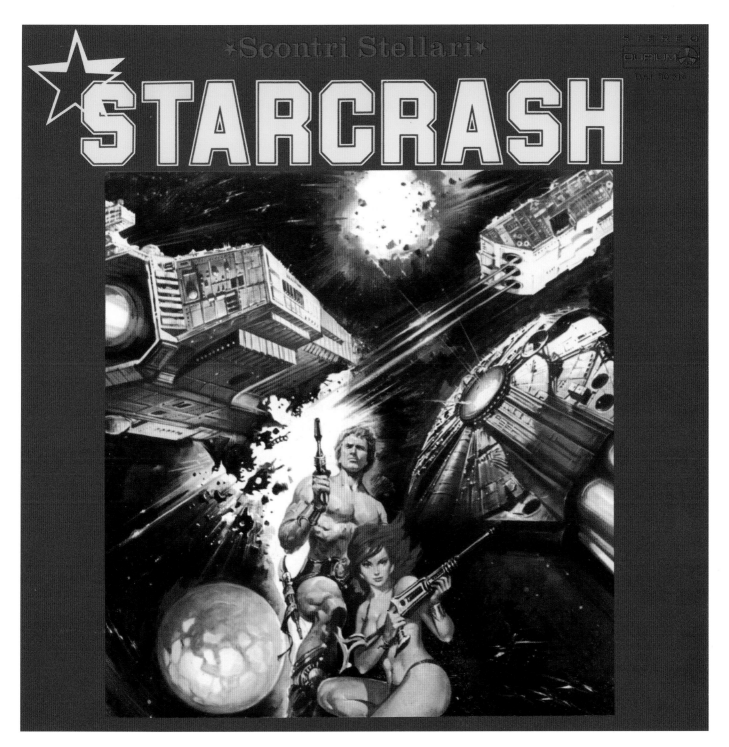

Scontri Stellari

STARCRASH

STEREO
DURIUM
DAI 30 314

STARCRASH

**Director Luigi Cozzi has long asserted that
1979's *Starcrash* was in development before
Star Wars hit theaters, but that doesn't make it
better. Despite being incomprehensible at the
best of times, the film boasts some well-known
performers (Christopher Plummer and David
Hasselhoff), along with music by none other than
John Barry, who would later score two more
genre films the same year (*Moonraker* and *The
Black Hole*).**

Barry initially thought he'd be scoring a larger
scale sci-fi epic in the vein of *Star Wars*, and

composed the music when looking at low-fi footage
of the film. Interviewed by Michael Schelle for his
book *The Score*, Barry stated, "When I saw some
rough cuts of *Starcrash*, it looked like it might turn
out all right, so I said I'd do it. But when I saw the
final cut, I cried, 'Oh, my God! What have I gotten
myself into?' I did the best I could with what it
was."

Although not in the same league as the music
for *The Black Hole*, *Starcrash* is still worthy. The
main title shows two sides of Barry's writing; the
first minute or so opens with the piano banging
out a repeating minor-key figure, punctuated by
punchy brass that sounds almost like a call-back
to his early days scoring James Bond films. But
the theme then segues to a romantic, wistful
phrase sounded out on trumpets and coupled with
a melody that looks ahead to his Oscar-winning

work on *Out of Africa*. The composer also plays
around with some interesting rhythmic techniques,
breaking down the 4/4 time signature into more
unusual chunks of 3-3-2 (such as the galloping
"Space War" cue).

The album was released with a surprisingly
diverse array of cover art through different labels:
Carrere in France, Polydor in Germany, and Durium
in Italy, whose poster art is replicated on the BSX
Records CD re-release from 2008. This version has
a tacked on seven-minute "suite" to round out
the album.

CHAPTER

3

DARK DYSTOPIA
MAYHEM & MISERY

STANLEY KUBRICK'S
CLOCKWORK ORANGE

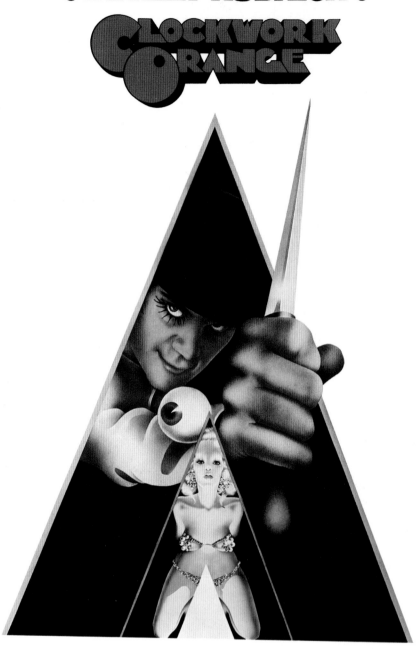

A CLOCKWORK ORANGE

Stanley Kubrick's 1971 adaptation of Anthony Burgess' dystopian novel *A Clockwork Orange* contains images of violence that remain shocking to this day, and like his previous sci-fi epic *2001: A Space Odyssey*, classical music is featured prominently. Unlike *2001*, however, this time Kubrick also employed an actual composer, Wendy Carlos (then known as Walter Carlos), whose work with Moog synthesizers brought her to fame after her best-selling album *Switched-On Bach*, which contains electronic renditions of works by the famed composer.

Opening with "Title Music from A Clockwork Orange," this well known droning main theme is Carlos' electronic rendition of Henry Purcell's "Music for the Funeral of Queen Mary," written for the Queen's 1965 burial at Westminster Abbey. Beethoven's music comes into play during the film several times, most notoriously during the violent Ludovico Technique that Alex is subjected to, when the "Ninth Symphony, Fourth Movement (Abridged)" is heard while he's forced to watch violent films. Rossini's music is featured in several abridged versions, including the lively "The Thieving Magpie" and "William Tell Overture." The movie's most glorious music, however, comes from Elgar's "Pomp and Circumstance" marches.

Still, listening to the *Clockwork Orange* soundtrack these days, it's Carlos' bizarre early electronic renderings that stand out, most notably her

sped up take on Beethoven's Ninth Symphony, Fourth Movement, "March from A Clockwork Orange" (which marks the first recording to feature a vocoder). Elsewhere, the electronic soundscape "Timesteps" marks the album's most unsettling moment, perhaps as frightening as the accompanying on-screen images.

Kubrick only used pieces of Carlos' original recordings for the film, leading to chilled relations, and the composer responding with her own *A Clockwork Orange: Wendy Carlos' Complete Original Score* a year after the original soundtrack release. This album features a full-length version of "Timesteps," as well as electronic versions of orchestral pieces used in the film, and "Country Lane," a piece originally recorded for a scene in which Alex is taken to the country and beaten by police.

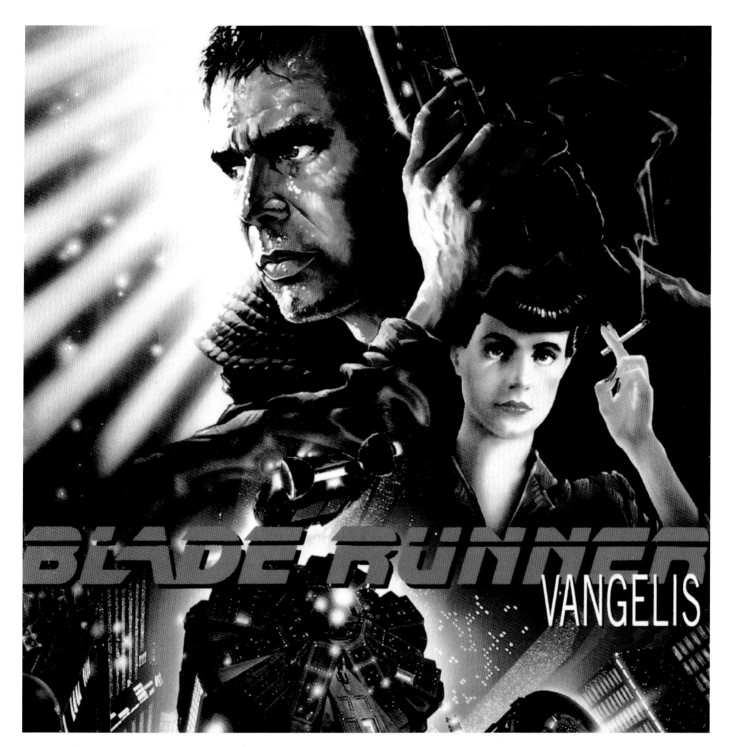

BLADE RUNNER

Ridley Scott's *Blade Runner* is a thematically-complex dystopian epic, highly influential on film, television and video games for its production design depicting a retrofitted noirish future. Deeply ingrained in its strikingly beautiful aesthetic is its synth score by Greek artist Vangelis. While the 1982 movie has a complex release history, with seven different versions in existence, Vangelis' score has suffered an equally bizarre and even more frustrating quest for an official release.

Having just won an Academy Award for his *Chariots of Fire* (1981) score, Vangelis tackled

Blade Runner in his London-based Nemo Studios using an army of synthesizers, notably the Yamaha CS-80, to create a mix of classical compositions and booming futuristic electronic ambience that would fit Scott's neo-noir vision perfectly. Highly acclaimed by fans and critics, the score was nominated for BAFTA and Golden Globe awards. The movie's closing credits promised a soon to be available physical release, but when that never happened, bootlegs began circulating, beginning with tapes at science fiction conventions.

Following this, The New American Orchestra produced an LP of orchestral interpretations of the soundtrack that's far removed from the music in the film. Then, in 1989, Vangelis released the compilation album *Themes*, which contains three tracks from the score, including the absolutely epic "End Titles" and "Love Theme," featuring swanky

sax courtesy of frequent collaborator Dick Morrissey.

Finally, in 1994, Vangelis put out the first official version of the score on Atlantic Records in the U.S., which was eventually pressed to vinyl by various labels, including Audio Fidelity and Warner. Even this version is iffy though, as it contains music not used in the film and is missing key tracks. Equally frustrating is the inclusion of film dialogue over certain tracks, including the eerie "Main Titles." In fact, the year before, a bootleg CD from "Off Shore Music Ltd" was released and is considered to be more comprehensive than this official version.

For *Blade Runner*'s 25th anniversary a three-CD set was released through Universal, containing the 1994 CD, a CD with previously unreleased material and a third disc of music inspired by *Blade Runner*.

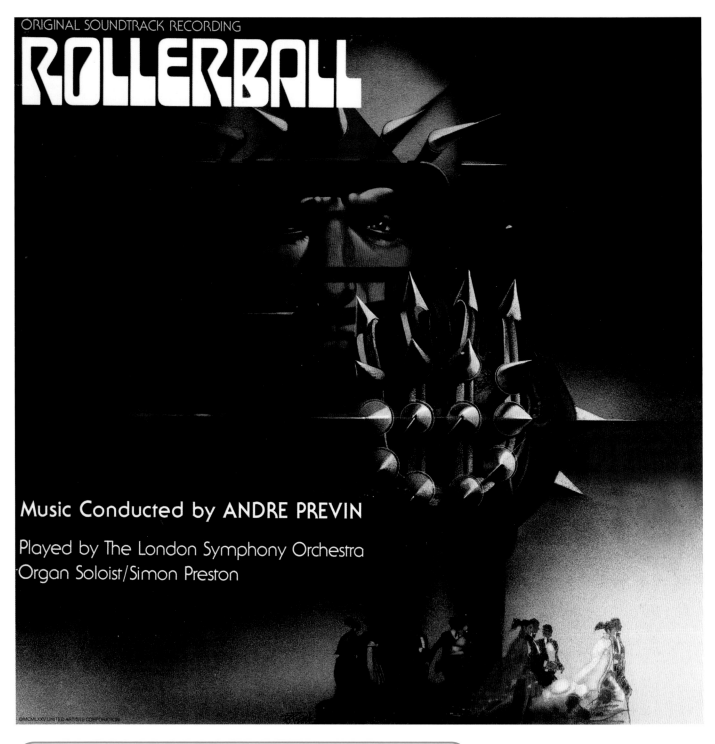

ORIGINAL SOUNDTRACK RECORDING

ROLLERBALL

Music Conducted by ANDRE PREVIN

Played by The London Symphony Orchestra
Organ Soloist/Simon Preston

©MCMLXXV UNITED ARTISTS CORPORATION

ROLLERBALL

Ever wonder what Patrick Batemen would have been doing in the '70s? Chances are you might find him taking in some *Rollerball*, a blood sport performed by the lower classes for the entertainment of the corporate elite, as vividly depicted in Norman Jewison's 1975 film set to the upper crust sounds of Bach, Shostakovich, Tchaikovsky and more.

Opening with Bach's infamous Toccata and Fugue in D minor performed on organ, the movie's soundtrack provides a sumptuously gothic start to its titular game of death. One might expect a futuristic vision like ths to be given an entirely electronic or synth score, but the studio apparently tapped into *2001* and *A Clockwork Orange*'s arty atmosphere instead. Conductor/composer André Previn, in one of his last major Hollywood efforts, provides a perfect rendition of Remo Giazotto and Tomaso Albinoni's "Adagio" as the film's main theme, and super theatrical versions of various movements from Shostakovich's "Symphonies," as well. Previn also contributes to the original score, breaking from the classical overtures with sleazy '70s funk and electro pop on "Executive Party,"

soundtracking scenes for tuxedoed businessmen to network, snort cocaine, and hit on girls half their age. For a film that provides violent slam-banging action while serving as a cautionary tale about the emergence of an increasingly compact upper class, *Rollerball* manages to touch both ends of the spectrum through inspired musical selections.

Rollerball was released on vinyl around the world in 1975 with only two selections by Previn. A Varèse Sarabande 2002 reissue on CD contained the extra track "Glass Sculpture," leaving one to wonder whether there is more of his '70s-sounding sleaze to unearth.

 Label: United Artists Records / UA-LA470-G **Format:** LP **Year:** 1975 **Art:** Bob Peak

ORIGINAL MOTION PICTURE SOUNDTRACK

CBS
73665

CONTAINS
JOURNEY'S
NEW
"ONLY SOLUTIONS"

TRON

MUSIC BY WENDY CARLOS

TRON

A classic Disney sci-fi/action film, *Tron* stars Jeff Bridges as a computer geek who manages to transport himself into a video game software program, where he's forced to do battle with the mainframe in an attempt to escape. This being 1982, let's just say Tron's video game visuals aren't exactly state of the art. Add early electronic music pioneer Wendy Carlos to this nerdy concept and you've got the most retro experience one can imagine this side of *Stranger Things*.

That computer technology was not nearly as ubiquitous in 1982 as it is today was a bonus

for Carlos and her partner Annemarie Franklin. Since no one really knew what software should *sound* like, they had more room in which to operate. The original idea was to use synthesizers for the computer world and an orchestra for everything occurring in the real world, but after reading the script, Carlos decided on a slightly different approach: a mix of symphonic sounds and electronics for the computer world and a purely string-based orchestra for the outside world. Unfortunately, because the studio was late delivering the final film footage, it became impossible for Carlos to write all of the necessary synth content, so she recorded the orchestral parts first, then wrote around it.

She ended up creating two mixes: one for the film soundtrack, and one for the soundtrack LP, noting the one for use in theaters needed to be a little

brighter. Released by CBS on July 9, 1982, the same day as the film, the album is rounded out by two songs from arena rock legends Journey. Their tracks "1990's Theme" and "Only Solutions" certainly up the retro appeal.

In 2014, Walt Disney Records re-pressed a remastered version of the original album on blue translucent vinyl, fitting the film's color scheme. Though the synth portions of the album are certainly dated by today's standards, *Tron* remains a nice revisit for nostalgia geeks, and a classic moment in Carlos' incomparable discography.

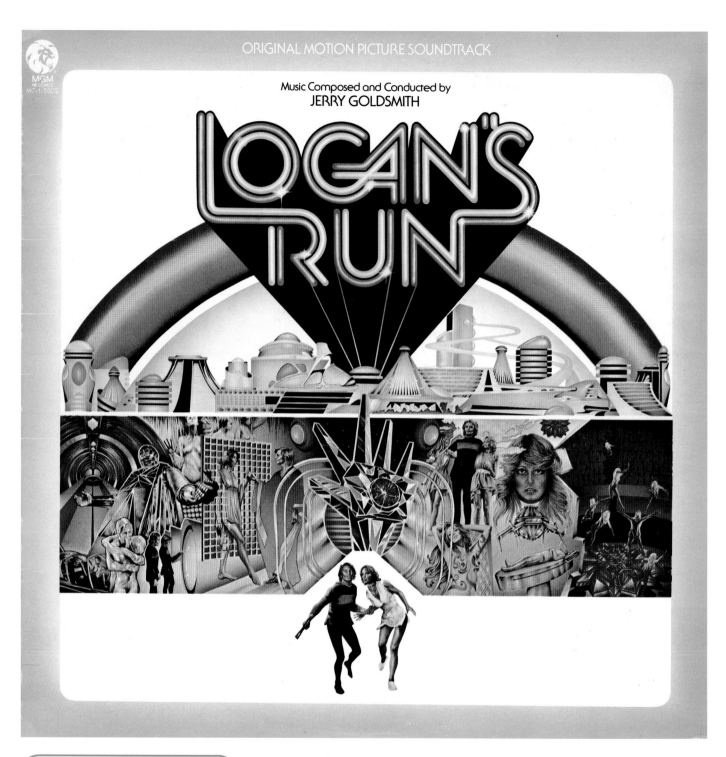

ORIGINAL MOTION PICTURE SOUNDTRACK

Music Composed and Conducted by
JERRY GOLDSMITH

LOGAN'S RUN

If you're over 30 and reading this, you know that Carousel is a lie! Jerry Goldsmith (also over 30 when he wrote the score for *Logan's Run*) was always up to the challenge of scoring sci-fi, often composing some of his most inspired work for the genre (*Planet of the Apes*, *Alien*, etc.), and 1976's *Logan's Run* is no exception.

Goldsmith takes the inventive approach of scoring the two halves of Michael Anderson's film completely differently. The sealed-off city inhabited by Michael York's Logan 5 is effectively rendered with electronic soundscapes (and

dissonant strings) that play with the divide between traditional music and sound design, as in the pulsating synth loop that opens the film, or the trippy "Love Shop." Goldsmith frequently weaves in a three-note ascending motif (often sounded on brass) that goes up by semitones, with no musical resolution, which suggests the tensions inherent in a society that's brainwashed its population into believing they'll be reborn after a sacrificial ceremony. Good news for you, though: this means you can add "Theme from Logan's Run" to your piano repertoire pretty easily!

As Logan 5 and Jessica 6 (Jenny Agutter) escape into the outside world, Goldsmith reverts to traditional symphonic scoring, though in fairness, Goldsmith was never a traditionalist. His muscular action writing favors rhythm and orchestral effects over more melodic Mickey Mousing, anticipating

the work he'd return to in films such as the following year's *Capricorn One*. But he also slips in a decent love theme for Logan and Jessica, as well as a stirring cue for a full orchestra as the duo step outside and encounter the sun for the first time in their lives.

This romantic approach was unintended by the film's producer, as Goldsmith recounted in a 1982 interview with Kevin Courrier for CJRT-FM Radio, "The whole last part of the movie was done very romantically and lushly. The producer told me, 'You made this into a love story,' and I said, 'Wasn't that always apparent?' He said, 'No.'"

The soundtrack was originally released on vinyl from MGM in 1976. Then, in 2002, *Film Score Monthly* brought an expanded soundtrack to life on CD. Waxwork followed it up with a double LP vinyl release in 2018.

Label: MGM Records / MG-1-5302 **Format:** LP **Year:** 1976 Art: Charles Moll

TURKEY SHOOT : Original soundtrack by BRIAN MAY

TURKEY SHOOT

Though his film was originally intended to be some sort of criticism of '80s corporate greed and Reagan ideals, when director Brian Trenchard-Smith learned he was losing nearly a quarter of his funding weeks before shooting, *Turkey Shoot* (1982) quickly became a small and sadistic depiction of a future death camp where wealthy individuals pay to hunt humans for sport. It's kind of like Lucio Fulci directing *The Most Dangerous Game* but with mutant werewolves. Composer Brian May, not far removed from the success of *Mad Max*, was forced to change his plan for a

sweeping orchestral score and focus mainly on electronics, with some help from his own ABC Show Band along the way. The result is one of the weirdest and most unique entries in the Australian's impressive career.

That said, the score is admittedly a little on the disjointed side, employing cues sometimes only a few seconds long in between more fully realized synth pieces. May then layered orchestral elements including brass horns, flute and percussion, giving this Ozploitation classic a bit more flair for the dramatic. Yet the opportunity to

hear May experiment with synth work becomes the focus of this score, as he creates strange atmosphere and unparalleled weird cues, as well as harsh, atonal sounds that are as unnerving as they are intriguing. Maybe the slashed budget was a good thing, as the synth strains naturally lend more to a futuristic shocker.

t took until 2014 for the *Turkey Shoot* score to see the light of day on vinyl and CD, courtesy of Duel Planet. The LP includes a limited edition yellow pressing housed in a gatefold sleeve with notes from the director, producer Antony J. Ginnane and actor Roger Ward, giving more insight into this nasty but essential slice of Australian grindhouse.

Label: Dual Planet / DUAL010LP **Format:** LP **Year:** 2014 **Art:** Luke Fraser

Bande Originale du Film / Original Motion Picture Sound track
de

QUAND LA VIOLENÇE S'EMPARE DU MONDE
PRIEZ POUR QU'IL SOIT LÀ...

PRIX SPÉCIAL
DU JURY
FESTIVAL
D'AVORIAZ

INTERCEPTOR

MAD
MAX

WARNER BROS A Warner Communications Company présente
MEL GIBSON ■ JOANNE SAMUEL ■ HUGH KEAYS-BYRNE ■ STEVE BISLEY
TIM BURNS ■ ROGER WARD dans "MAD MAX"
Produit par BYRON KENNEDY Réalisé par GEORGE MILLER
Musique de BRIAN MAY Ecrit par JAMES McCAUSLAND et GEORGE MILLER
Distribué par Warner-Columbia Film W
INTERDIT AUX MOINS DE 18 ANS

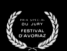

Musique composée par / Music composed by
BRIAN MAY

THE ORIGINAL MAD MAX TRILOGY

Mad Max raced into theaters in 1979, launching the career of a young Mel Gibson as its titular rogue cop at war with bikers in a dystopian wasteland. More importantly, as a violent, actionpacked genre film far removed from the serious dramas the country was known for, it changed the perception of Australian films forever. It also made so much money that it landed in the Guinness World Records, and so an enduring franchise was born, with the latest installment, *Mad Max: Fury Road*, having been released in 2015, and two more sequels and a spin-off film planned.

The original *Mad Max* was a very low budget affair, and director George Miller and producer Byron Kennedy were convinced they would never be able to afford the kind of dramatic Bernard Herrmann score they felt their frantic action film required. As chance would have it, the duo were having dinner with fellow Aussie director Richard Franklin when he put on the score to his film *Patrick* (1978). When Miller asked what Herrmann score they were

listening to and Franklin revealed it was the little known Brian May, the duo knew they had their man.

May's score goes a long way to creating *Mad Max*'s massive landscape, where life is short and danger lurks all around. Using mostly orchestral arrangements, May's score employs strings, brass, and percussion mixed with mechanical sounds, emphasizing the harsh post-apocalyptic setting in which everything is a weapon and machines are the key to survival. The film's music boasts very little in the way of harmony, concentrating instead on harsh and dissonant sounds. May won the Australian Film Award for Best Original Score, and today *Mad Max* has to be considered one of the greatest action scores of all time.

STV 81155
STEREO

Varèse Sarabande released *Mad Max* on vinyl in 1980 and reissued it on CD in 1993 with bonus outtakes. The label reissued the CD version as a red and gray haze-colored LP in 2017.

Mad Max 2, better known in the U.S. as *The Road Warrior*, was released the following year to critical acclaim. It's somewhat more optimistic film that's even more frenetic. Miller again went with May for the score, who this time turned in a suite that was less jagged and atonal, and far more smooth and grandiose in design.

The "Main Title" opens with an explosion of dark orchestral sounds, as a narrator recounts the events between the two films and details the fall of civilization and the survival of the solitary Max. Dialogue is sparse during *The Road Warrior*, so music and sound carry the narrative. Early on,

drums and brass combine with the mechanical sounds of Max's V8 Interceptor, reflecting the film's combination of western and science fiction genres. Throughout the score May emphasizes the human aspect of the story as much as the action through sweeping, epic soundscapes. Like Basil Poledouris' *Conan the Barbarian* score, it's impossible to listen to *Mad Max 2* without feeling like everything going on around you is critically important.

Unfortunately Varèse Sarabande's 1982 vinyl release was a bit of a disappointment, with the tracks presented out of order and sometimes mistitled, not to mention that it's missing a good chunk of the action cues. The album is remembered for ending with a suite of sound effects, which actually sound just as epic and badass as the rest of the score. Though it's been reissued several times, including a "spilt oil on

sand splatter" LP on Silva Screen in 2019, the content has never changed, leading to some "expanded edition" bootlegs along the way. Perhaps these will be officially pressed to vinyl some day.

Mel Gibson would reprise the role that made him famous for the final time in 1985's *Mad Max Beyond Thunderdome*, a somewhat optimistic film in which humanity attempts to rebuild after nuclear devastation. Unfortunately for Max, he's exiled to the desert by the evil Aunty Entity, played by Tina Turner.

For various reasons May would not return to score *Thunderdome*, and the production landed on Maurice Jarre instead, himself no stranger to desert soundscapes having composed the music for *Laurence of Arabia* in 1962. Jarre would turn

in another majestic score for this film, but one that was ultimately too odd to reach the status of May's work. His orchestral score included choral sounds, an Australian didgeridoo player, saxophone solos, an organ and low- sounding pianos.

Of course, Turner's presence inevitably meant that her music would be included in the film, as well, and so two songs were written. "One of the Living" actually replaced Jarre's opening titles music, and "We Don't Need Another Hero (Thunderdome)" plays over the end titles. The latter has since become an '80s staple and is synonymous with the film, and reached #2 on the Billboard Hot 100 (behind John Parr's "St. Elmo's Fire (Man in Motion)").

A soundtrack LP was released in 1985 on Capitol Records with Side A consisting of Turner's songs

and Side B condensing Jarre's score down to three suites. It has been reissued many times since. Finally, in 2010, a full version of Jarre's score was released on CD through Tadlow Music, which included cues that had been replaced in the movie by Turner's songs, as well as the three tracks from the original album. Perhaps this version will emerge as a double LP one day.

After nearly two decades of development hell, George Miller finally resurrected the franchise with *Mad Max: Fury Road* in 2015. May had long since passed on, and Miller chose Dutch composer Junkie XL (a.k.a. Tom Holkenborg) to score the film after hearing his work on *300: Rise of an Empire* (2014). It was no easy task, as the movie essentially functions as a nearly two-hour non-stop action chase scene. Indeed, the producer reportedly spent eighteen months working on it.

The result is one of the most mind-blowingly intense and completely unique film scores of this generation, fitting the film's extreme tone. Holkenborg was instructed not to watch or listen to the other *Mad Max* films but rather to think completely outside the box. After viewing a rough cut of the movie, he came up with the concept of an over-the-top-rock opera. Holkenborg employed electric guitars and hundreds of drums, and began writing music for the film's truck that carries war drummers on its back and mad guitarist The Doof Warrior suspended on the front, then built it all up from there. Considering *Fury Road*'s success at the box office, fans likely count on more *Mad Max* music and adventures to come.

Music JOHN WILLIAMS
THE FURY

AB 4175

THE FURY

Smack dab in the middle of John Williams' biggest run of blockbusters (*Star Wars*, *Close Encounters of the Third Kind*, *Superman*) comes along this Brian De Palma adaptation of the John Farris novel about a pair of telekinetics, featuring John Cassavetes' providing the best exploding head moment until David Cronenberg's *Scanners*.

The Fury (1978) sees Williams channeling Bernard Herrmann, who'd previously scored De Palma's *Sisters* (1973) and *Obsession* (1976). The resulting score is an interesting mashup of their styles, which can be heard right away in the whirling main title music, and perhaps most notably on the cue "Vision on the Stairs," with its ascending/descending piccolo figure that's a clear homage to the opening notes from Hitchcock's *Vertigo*. But Williams' voice runs just as strong in this. "For Gillian" sees him scoring a scherzo in the more pastoral style that he brought to early scenes in the *Jaws* films, before things got scary. And as evidenced with his *Jaws* scores, Williams does scary well here, employing a theremin to heighten the tension on the cue "Gillian's Power."

But *The Fury* isn't scored like a conventional horror film. De Palma is less concerned with moments of shock and awe than he is with infusing the movie with an operatic sense of dread, exemplified in cues such as "Gillian's Escape," which sees Carrie Snodgress' character killed in a sequence that's slowed down to the point where Williams' music makes it downright hypnotic.

The album was released by Arista in 1978, and is a re-recording performed by the London Symphony Orchestra. It may be a better recording than the original sessions – the depth of sound attributed to the fact that it was recorded in the same church that Herrmann recorded the *Obsession* score in. The original score was first released on CD in 2002 by the Varèse Sarabande CD club. In 2012, La-La Land reissued an expanded two-CD release, including Williams' source music cues, which was limited to 3500 copies.

Label: Arista / AB 4175 **Format:** LP **Year:** 1978 **Art:** N/A

ORIGINAL MOTION PICTURE SOUNDTRACK
MUSIC COMPOSED, ARRANGED AND CONDUCTED BY FRANCO MICALIZZI

THE VISITOR

The Visitor is a definitive cult film – in fact, it's stunning that it even exists at all. Get this: it's an Italian science fiction horror film from 1979 with a cast that includes John Huston (writer/director of *The Maltese Falcon*), Academy Award-winner Shelly Winters, Glenn Ford (*Superman*), Lance Henriksen, Franco Nero (star of the original *Django,*) and Sam Peckinpah (!) – all converging in a movie about a space traveller teaming up with a cosmic Christ figure to protect earth from an evil little girl and her pet hawk? This being an Italian exploitation film, audiences might be expecting

to hear a lot of exotic prog rock and synthwave; instead, Italian composer Franco Micalizzi turned in a badass heavy jazz-funk score with disco overtones, naturally.

Opening with "Stridulum Theme" (a reference to the film's original title in Italy), *The Visitor* conjures images of a gangster getting out of his limo in 1970s Harlem to bust heads, with a smashing horn section and heavy, deliberate funk rhythms. Before you can ask yourself WTF?!? kind of sci-fi score you're listening to, "Sadness Theme" offers '70s lounge lizard vibes with more brass and strange effects. The score makes its first tonal shift with "Distressing Sequence" as dark orchestral pieces more in line with the bloodcurdling horror of the decade take over. Then it's back to more funkadelic tunes before some truly disturbing synth and orchestrations pour in for "Atmosphere."

The Visitor remained a largely unknown oddity until Drafthouse Films picked it up for distribution in 2013, and, inevitably, subsidiary Mondo resurrected the score for a vinyl release. The original RCA LP goes for the price of a small hawk dipped in gold, and Mondo's version contains eight bonus tracks from a 2011 CD release on Digitmovies. Featuring art by Jay Shaw, the double LP came on standard 180-gram black vinyl, while sunburst variants were randomly inserted.

Label: Mondo / MOND-023 **Format:** 2xLP **Year:** 2014 **Art:** Jay Shaw

ORIGINAL MOTION PICTURE SOUNDTRACK
MUSIC COMPOSED AND CONDUCTED BY JERRY GOLDSMITH

COMA

MG-1-5403

COMA

In 1978, director Michael Crichton acquired the film rights to Robin Cook's 1977 novel *Coma*, a thriller that preyed on readers' fears of the medical profession and the inherent vulnerability in being a patient. In it, doctors induce patients into comas who go in for relatively routine procedures, becoming subjects to their experiments. Crichton brought in frequent collaborator Jerry Goldsmith for the score, which turned out to be one of his most unusual and bone-chilling pieces of film music.

One of the more interesting decisions made by Goldsmith this time was to leave the first hour or so of the film unscored, letting the narrative itself create suspense. When the music finally kicks in, Goldsmith uses a strange combination of instruments: strings, woodwinds and keyboards (little or no brass and percussion) and creates an overall eerie atmosphere through dissonance. More otherworldly effects are created with the use of an echoplex, meant to imitate the cold inhuman medical instruments wielded by the doctors. There's not much in the way of melody on *Coma*,

just a mass of clanging suspense cues, though "Love Theme from Coma" does offer an easier listening experience. Goldsmith turned the theme into a disco version for use in the film, placing the film firmly in the late '70s.

Coma was released on vinyl by MGM, concurrently with the film, the LP kicking off with the love theme then diving into a heavily truncated version of the score. A complete version of the score finally appeared on CD by Film Score Monthly in 2005. Fans of Goldsmith's darker moments are waiting to hear this version of one of his more disturbing suites on glorious 180-gram vinyl.

 Label: MGM Records / MG-1-5403 Format: LP Year: 1978 Art: Paul Bacon

WAVELENGTH

Music Composed and Performed by
TANGERINE DREAM

ORIGINAL SOUNDTRACK

© 1983 WAVELENGTH FILM CO

WAVELENGTH

Wavelength **is a little-seen 1983 sci-fi flick starring the dream team of Robert Carradine and Cherie Currie, about a young couple who discover that child-like aliens are being captured and subjected to government experiments. With no official DVD or Blu-ray release, the film is perhaps best known today for its score by German electronic gods Tangerine Dream, who were in the thick of the soundtrack period of their career.**

Unlike other Tangerine Dream soundtrack albums, *Wavelength* does not contain a reworking of the music from the film into lengthier electronic excursions. Instead, the album reflects more or less how the music is used in the film, meaning that it's a collection of shorter cues running between one and four minutes in length. Unfortunately, several of the tracks are simply remixes of music released on other early '80s TD albums, including a self-titled live album, *Tangram* (1980) and *Exit* (1981) – all excellent entries from the band's most fun and accessible days when Edgar Froese, Chris Franke and Johannes Schmoelling created epic soundscapes that would go on to influence today's generation of *Stranger Things*-esque synthwave artists.

The score's "Wavelength Main Title" opens with pulsing electronics similar to Goblin's plodding score for zombie epic *Dawn of the Dead*. "Desert Drive" features a beautiful piano melody, spooky mellotron appears on the ambient "Healing," and dark, robotic effects and synths provide the aura of the alien threat on "Spaceship." In between, however, lighter pop bursts provide the record with uplifting and more optimistic emotions on "Mojave End Title" and "Breakout." Though diehard Tangerine Dream fans will never classify *Wavelength* as an essential listen, it nevertheless provides plenty of enjoyment through cosmic ambience and that classic ethereal quality that only the band can provide.

Varèse Sarabande dropped the score on vinyl at the time of the film's release, and though it's appeared on CD since then, the content has not changed. A 2014 CD on La-La Land Records was remastered, however, and came with a twenty-page booklet.

SCANNERS

Scanners was Howard Shore's second score for David Cronenberg, after their first collaboration on *The Brood*. But whereas Shore scored *The Brood* (1979) as a moody piece of chamber music for strings, recalling Bernard Herrmann's *Psycho*, *Scanners* (1981) was a step into the near-future, fusing strings with a stunning array of synthesized sounds.

The music begins with the string section playing a descending phrase that's a call-out to plainchant *Dies Irae*, a staple in the horror genre, before playing out its theme, a four-note motif on the strings. But acoustics are frequently drowned out by the experimental use of electronics that really get in your head (but won't make it explode, we promise). They help to establish a futuristic vibe to the film's location in and around Montreal and Toronto. The electronic portion of the score doesn't just sound cool, but emulates the telekinetic vibes created by the scanners themselves.

Interviewed by Michael Schelle for his 1999 book *The Score: Interviews with Film Composers*, Shore explained how his day job as bandleader on *Saturday Night Live* proved helpful when crafting the electronic music for the film. "I played all the electronics myself on whatever instruments I had available from *SNL*. Sometimes, I would order a new electronic instrument for some guest performer or for the *SNL* band knowing that I'd be experimenting with it myself, late at night, for my own movie scores."

During this process, Shore ended up creating hours of material, from which he culled various tape loops that were printed onto a 24-track machine, drawing on techniques from tape music of the '50s and '60s. He used this when writing the rest of the orchestral portion of the soundtrack.

A suite of the soundtrack music originally appeared on Silva Screen's 1992 CD compilation *Dead Ringers: Music From the Films of David Cronenberg* before being coupled with Shore's "Shape of Rage" suite from *The Brood* for a Mondo LP in 2015, with cover art by Sam Wolfe Connelly.

 Label: Mondo / MOND-040 **Format:** LP **Year:** 2017 **Art:** Rob Jones / Sam Wolfe Connelly

THE NEW BARBARIANS

The Italians, always looking for a successful genre to imitate in the wake of a Hollywood success, turned their attention to post-apocalyptic fare after *Mad Max* and *Mad Max 2* nuked the box office, releasing predictably dubious titles such as 1983's *The New Barbarians*. Fortunately, with these sorts of exploitation films you could usually count on a kick-ass score, and here director Enzo G. Castellari and company brought in Goblin founding member Claudio Simonetti to deliver the goods with one of his patented rock-flavored electro suites.

Minimalist and high energy, *The New Barbarians'* music is propelled by non-stop drum machine action that dishes out out a rocking beat while cheap-ass synths fuel the ridiculously over-the-top violence. The stage is set with opener "Nuke is Over," a hypnotic loop playing over a basic beat that is oh-so '80s, painting a barren landscape just waiting to be leveled further by warring gangs. There are beautiful moments along the way too, though such as "Alma the Amazon," likely intended to be a romantic interlude but sounding dreamy and ethereal enough to start a debate as

to whether this shlock could also be considered art. Then we're back to the rocking drum machine beats, as electronic effects add a sparkle and shine. You may not believe your eyes when watching *The New Barbarians*, but you won't stop bopping your head either.

In 2000, Beat Records first released *The New Barbarians* on CD along with Castellari's other *Mad Max* rip-off, *1990: The Bronx Warriors*. Death Waltz Recording Company picked it up for a vinyl release in 2015, and pressed it on glorious 180-gram black vinyl, along with a Sand Transparent and Cream variant with grey, black and red splatter. This handsome package includes liner notes by Simonetti, an interview with Castellari and perhaps best of all, cover art by extreme metal album designer Wes Benscoter.

PR5023

ORIGINAL SOUND TRACK

MUSIC CONDUCTED AND COMPOSED BY
JERRY GOLDSMITH

CHARLTON HESTON
in an ARTHUR P. JACOBS production
PLANET OF THE APES

20TH CENTURY-FOX
PRESENTS
AN UNUSUAL
AND IMPORTANT
MOTION PICTURE
FROM THE PEN
OF PIERRE BOULLE,
AUTHOR OF
"THE BRIDGE
ON THE
RIVER KWAI"

Project 3

CO-STARRING
RODDY McDOWALL · MAURICE EVANS · KIM HUNTER · JAMES WHITMORE · JAMES DALY · LINDA HARRISON AS NOVA INTRODUCING
PRODUCED BY APJAC PRODUCTIONS · ASSOCIATE PRODUCER MORT ABRAHAMS · DIRECTED BY FRANKLIN J. SCHAFFNER · SCREENPLAY BY MICHAEL WILSON AND ROD SERLING · MUSIC BY JERRY GOLDSMITH · BASED ON A NOVEL BY PIERRE BOULLE · PANAVISION · COLOR BY DELUXE

THE PLANET OF THE APES SERIES

Inspired by Pierre Boulle's 1963 novel, *Planet of the Apes* became the biggest sci-fi franchise of its time (at least, until George Lucas came around with some other spacey concept), spawning five films, both a live-action and animated television series, an attempt to reboot the franchise by Tim Burton in 2001, and an all new series rebooted by Fox in 2011 that currently has three films in it, with more planned.

The concept of a future turned upside-down, with apes usurping humans as the dominant species on the planet, works as a tense dystopian fable

as well as social satire, and inspired some of the most unique and progressive soundtracks in the genre. A particular standout is Jerry Goldsmith's groundbreaking work on the original 1968 film.

Interviewed for his commentary on the *PotA* DVD in 2004, Goldsmith noted, "[H]umans are being hunted and those usually hunted are the predators; it's a shocking statement...I always want to preserve a primitive feel in the music, but the style of the music is quite modern." As such, he incorporated techniques drawn from serialism, such as the use of twelve-tone rows to provide the

dissonance and tension to accompany the far-flung future setting.

What's also striking about the music is the unusual orchestration and techniques used by Goldsmith, such as having French horn players blow through their instruments with reversed mouthpieces. In addition, the augmented percussion section includes gongs, vibraslap, stainless steel mixing bowls and, most notably, the Brazilian cuíca drum, with a high-pitched sonority that emulates monkey calls.

There's a remarkable amount of space in the recording for the instruments to be heard, with the sparseness of the sound enhanced by the use of an Echoplex to create a hypnotic effect for plucked strings. When needed, Goldsmith creates tension through a more cacophonous sound, such

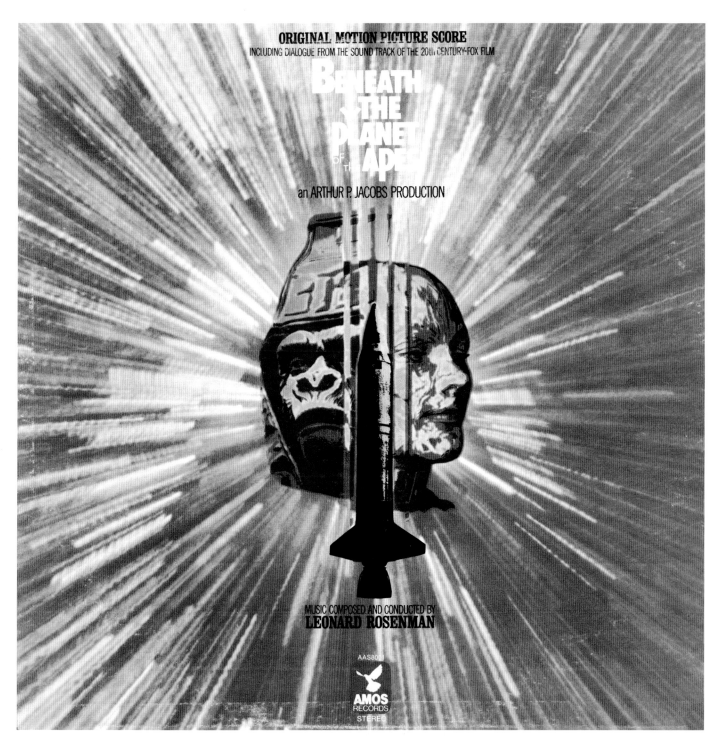

as on one of the most famous cues, "The Hunt," in which Taylor (Charlton Heston) is first captured by hyper-intelligent apes. It features a ram's horn, as wielded by the captors, and startling use of the cuíca for the first reveal of the planet's new masters.

The album was initially released in 1968 from Project 3, though without "The Hunt," which was later inserted onto Intrada's 1992 CD. The complete score followed on disc in 1997 from Varèse Sarabande, with Mondo reissuing it on vinyl in 2016.

Goldsmith would return to score *Escape From The Planet of the Apes* (1971), but it was another musical innovator, Leonard Rosenman, who came aboard for 1970's *Beneath the Planet of the Apes*. Rosenman had cut his teeth scoring classic

James Dean films (*East of Eden*, *Rebel Without a Cause*), but was no stranger to genre pictures, having scored *Fantastic Voyage* in 1966. Here, he continues to write in his unique voice, building on the modernist approach that Goldsmith brought to the first film.

Rosenman doesn't deviate drastically from his distinctive style, and it fits the film's dystopian setting perfectly. Notable cues include "Hail the Bomb," a choral piece for the mutants in the film, which quotes Cecil Alexander's "All Things Bright and Beautiful."

The 1970 album from Amos Records mixes Rosenman's strangely pop-infused re-recording of the score with dialogue snippets from the film – check out the psychedelic "March of the Apes," complete with rhythm section and fuzz guitar.

A full presentation of the original soundtrack appeared on CD from *Film Score Monthly* in 2000.

Ironically, as the *Apes* saga moves back to a less far-flung Earth future for *Escape From The Planet of the Apes* (1971), Goldsmith's score adds a funky backbeat to the proceedings that seems more in place with the Amos Records re-recording. A sixteen-minute suite from the third film was tacked on to the 1997 Varèse Sarabande reissue of the original score.

In 2019, La-La Land Records dropped a limited edition five-CD set of the music for the entire first run of *Apes* films, including Tom Scott's full score for *Conquest of the Planet of the Apes* (1972), a full presentation of Goldsmith's score for *Escape*, and Rosenman's second crack at the series in *Battle for the Planet of the Apes* (1973).

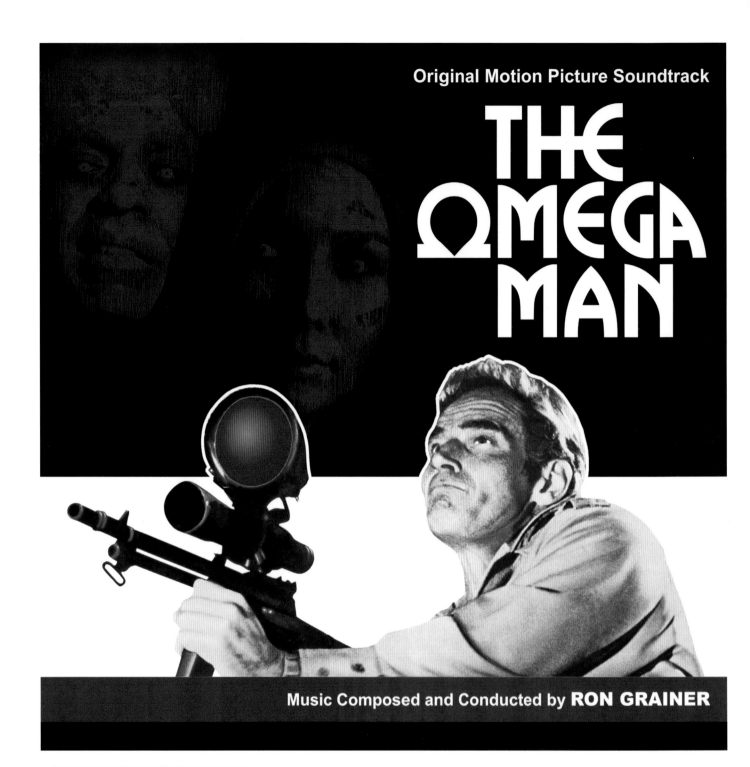

Original Motion Picture Soundtrack

THE ΩMEGA MAN

Music Composed and Conducted by **RON GRAINER**

THE OMEGA MAN

Opening with the laid-back Max Steiner classic "A Summer Place," which plays over a scene of the last man on Earth driving around a deserted Los Angeles (who else but Charleston Heston?), 1971's *The Omega Man* isn't scored with the orchestral doom and gloom we tend to associate with the apocalypse, but is graced with a breezy, melancholic score by Ron Grainer.

Grainer's name is perhaps best associated with his theme for TV's *The Prisoner* or *Doctor Who*, although for that show, he was aided by BBC Radiophonic Workshop staffers Delia Derbyshire

and Brian Hodgson to bring mysterious ambiance to his melody. It's a world apart from what we hear on *The Omega Man*, where his approach is to treat the music like a wistful elegy for the sounds of the 20th Century, incorporating jazz and cocktail music, such as Thelonius Monk's "'Round Midnight" and Cole Porter's "All Through the Night." Grainer's contribution is best experienced in the haunting title theme, which uses a minor-key string flourish that anticipates the one forming the backbone to the Eurythmics' "Here Comes the Rain Again."

The score is also notable for its use of the waterchime, a modern instrument created by Emil Richards (the sound is generated from immersing a bell in water), and is also featured in other genre soundtracks of the era, including *Colossus: The Forbin Project*. The brass section here features no tuba or trumpet, instead incorporating trombones

and French horns, and a string section with limited use of violins. Fun fact: Grainer ended up scoring two takes on the final sequence with the (spoiler alert) dying Heston; the distributor insisting on using the more upbeat take.

The soundtrack went unreleased until *Film Score Monthly* saved the day with a limited edition CD in 2000, which was reissued in 2008. Silva Screen finally committed the score to wax in 2018.

 Label: Silva Screen Records Ltd. / SILLP1561 **Format:** 2xLP **Year:** 2018 **Art:** Stuart Ford

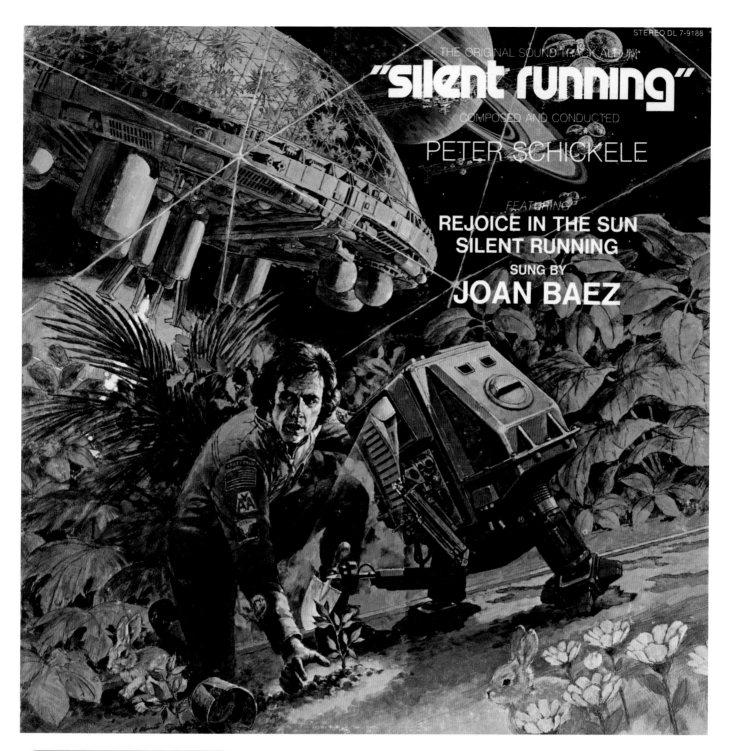

STEREO DL 7-9188

THE ORIGINAL SOUND TRACK ALBUM

"silent running"

COMPOSED AND CONDUCTED

PETER SCHICKELE

FEATURING

REJOICE IN THE SUN
SILENT RUNNING
SUNG BY

JOAN BAEZ

SILENT RUNNING

Climate change is the number one problem facing the world today, but as early as 1972 we were being warned of a bleak environmental future through sci-fi films like *Silent Running*, in which the only remaining plants from Earth are housed in an off-planet greenhouse to keep them from extinction. Though it was directed by Douglas Trumball, the special effects supervisor on *2001: A Space Odyssey*, the score went in a much different direction, with composer Peter Schickele employing a lush, ultra light score washed between hippy dippy tracks from folk legend Joan Baez.

Silent Running marked one of Schickele's only forays into film music, the composer finding more success in a series of musical comedy albums in which he plays the fictional P.D.Q. Bach, a "forgotten" member of the Bach family. On the score, Schickele uses a number of light, twilly instruments, including harp, glockenspiel, left-hand piano, bells and triangle. Repeated thudding percussion adds a doomy, foreboding flavor to the proceedings, but overall the music is highly delicate for such a dark tale. The two songs by Baez, written by Schickele, deserve praise for their haunting beauty, and both capture the sadness of humanity's inability to course correct from self destruction. "Rejoice in the Sun" remains a memorable, and ironic, ballad in cinema history.

Silent Running was released on vinyl in 1972 on Decca, and due to the brevity of the score, both it

and the songs could fit on one LP. In 1978 Varèse Sarabande reissued it in a regular edition, as well as one pressed on green vinyl (a rarity for soundtracks in the '70s), then reissued the same version in 2017. Curiously, by the time Intrada set out to release a remastered CD in 2016, almost every master element to the score had vanished. The label finally agreed to create a CD using the original vinyl release, but because Schickele used so many light and "high end" instruments, the sound had a difficult time being transferred into the quieter digital world. Intrada made it happen but the results were imperfect. Even if *Silent Running* sees the reissue treatment, no version will likely match the '72 or '78 LPs.

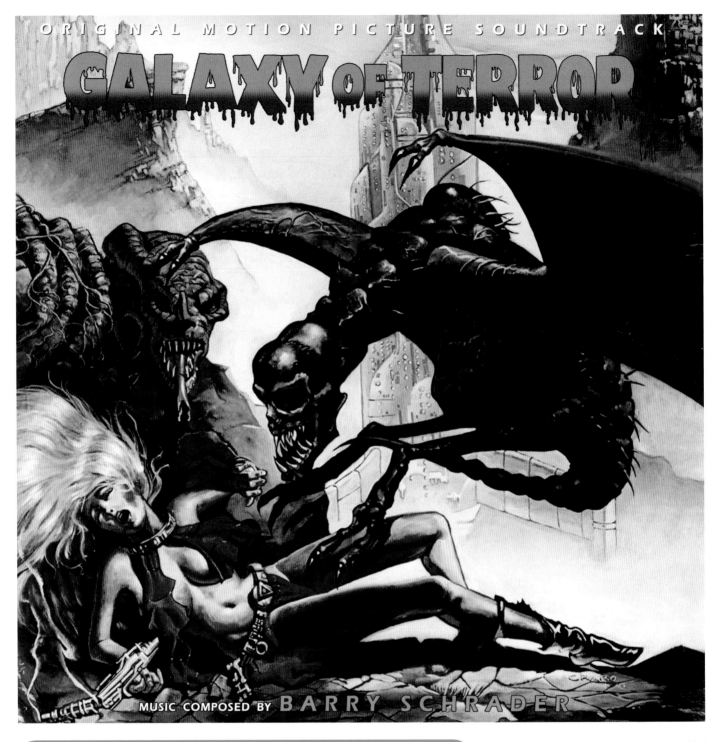

ORIGINAL MOTION PICTURE SOUNDTRACK

GALAXY OF TERROR

MUSIC COMPOSED BY BARRY SCHRADER

BARRY SCHRADER ON GALAXY OF TERROR

One of many science fiction-horror hybrids from of Roger Corman's New World Pictures, *Galaxy of Terror* (1981) boasts production design by a young James Cameron, an early role by Robert Englund and a unique Buchla-engineered electronic score courtesy of unheralded American electronic music innovator Barry Schrader, in his only true movie score. We tracked down Schrader to find out more.

How did you first become interested in electronic music?

I saw *Forbidden Planet* when I was around ten. The score was the first time I heard electronic music and I watched it so many times my father had to come and drag me out of the theater. By 1969 I was running a studio. I moved to California in the '70s and began teaching at CalArts, using all analog and the Buchla synthesizers.

I understand Galaxy of Terror *was done completely using the Buchla line of synthesizers.*

I did the entire score at CalArts because they had access to very expensive systems. We had two

studios that were set up the same way, then a third studio that was used for multimedia, and a fourth studio that had early digital technology. As far as I know, this was the only commercial film score that was done with the Buchla. At the time it was the most advanced system that was out there but it wasn't easy to use. You couldn't play it. It has no keyboard. You had to program it even though it was analog.

How involved was Roger Corman in the movie and the score?

Corman had bought a lumber yard down in Venice, California at that time, which is where the movie studio would be. CalArts was in Valencia, California, so a one-hour drive away. I had to go to meetings almost every day. I did the music over a period of about three weeks. The meetings included Roger,

 Label: Pure Destructive Records / PDR 004 **Format:** LP **Year:** 2018 **Art:** Mattias Westerfors

GALAXY OF TERROR

MUSIC COMPOSED BY *BARRY SCHRADER*

Side A

Main Titles and Death of the Remus
Crewman In the Master's Study
Quuhod's Death
Damia's Death
Exploration Music;
Discovery of the Spaceship Remus
Alluma's Death

Side B

The Cathedral Chamber;
Magic Stairway to the Inner Chamber
Monsters of the Red World
Discovery and
Exploration of the Pyramid
The Commander's Death
Baalon's Death

WRITTEN AND PRODUCED BY
BARRY SCHRADER
EXECUTIVE PRODUCER
DAVID GIBSON
ARTWORK DESIGN BY
MATTIAS WESTERFORS

Licensed from BMG.
All sections ASCAP.

DEDICATED TO THE MEMORY OF
ERIN MORAN

http://puredestructiverecords.bigcartel.com/

the main director – although James Cameron ended up being the second unit director because the main director had problems shooting – and the writer. I would have to take in what I had done on reel to reel tapes and play it against whatever film clip [they had]. Then they would critique it. Sometimes they were happy, sometimes they were not happy but I would say the main person I had to deal with, and with whom I really had no problems, was Corman. I found him very easy to deal with. The director I didn't get along with.

What was the process like working with label Pure Destructive on the first ever release of Galaxy of Terror's score?

Some British company contacted me a few years ago wanting to put the LP out but they had a really hard time finding who owned the music so that

died. Then [the label owner of] Pure Destructive called me. He couldn't figure it out either so I told him to contact Sony because Sony had occasionally sent me cheques for the music. Through that, then double checking with ASCAP, it looked like BMG owned the music. So Pure Destructive bought a license from BMG, but nobody knew where the original tracks were. I had some of the tracks on a tape that hadn't been played since 1981, so I did a digital transfer of that and I remastered it because of the quality of the tape, and that's what came out on the record. There were enormous problems with vinyl production, though, and it was severely delayed. They made a liquid-filled one that never sold to the public and it's worth a lot now.

A Ralph Bakshi film
WIZARDS

Original Motion Picture Soundtrack by
Andrew Belling

WIZARDS

Ralph Bakshi made a career directing animated films for adults, from 1972's *Fritz the Cat* (1972) to 1992's *Cool World*. His 1977 feature *Wizards*, dubbed "an epic fantasy of peace and magic" appealed to stoners, geeks and weirdos with its android assassins, scantily clad fairies and two wizard brothers battling it out in a post-apocalyptic landscape, all set to a funky, jazzy and otherworldly soundtrack courtesy of Andrew Belling.

Belling's score was composed entirely using analog synthesizers, mostly the ARP 2500 and

2600, which is amazing considering how much it sounds like genuine instrumentation, with elements of jazz and psychedelic rock bridging more obvious electronic arrangements. *Wizards* score takes advantage of its fluid visuals by offering several crazy and inventive set pieces, and Bellings music inventively takes viewers to all of those places. Loose jazz accompanies images of smoky bars and dimly lit streets as fairy hookers await their clients, while military drums let you know it's time for the assassins to begin their business. In one scene, main wizard Avatar transforms a creature into a jukebox, and Belling sets it to piano lounge tune "Jukebox Junky Blues." Then, on "Battle & Peewhittle's Death," fuzzy guitar, heavy-slapped bass and thundering drums combine to create one of the score's many funk tunes, oddly contrasting an epic scene of war and death.

Wizards closes with "Time Will Tell" by actress/singer Susan Anton, a haunting easy-listening tune consisting of light harp, sparse drums, and bass guitar. Though it's celebrated amongst '70s soundtrack aficionados, the song never had a release beyond this film, and an album for the score never saw the light of day until La La Land's 2012 CD, which featured a longer version of the track, as well as the one originally used in the film. Missing from the disc is the opening main title melody as well as some shorter cues, but a significant chunk of unused music appears in their place. In 2017, Wyrd War released this same version on LP including a red splatter variant that was sold at a 40th Anniversary screening of *Wizards* in Portland, Oregon.

68 Label: Wyrd Ward / WYRD WAR 8 Format: LP Year: 2017 Art: William Stout

ORIGINAL MOTION PICTURE SOUNDTRACK

DRAGONSLAYER

COMPOSED AND CONDUCTED BY ALEX NORTH

DRAGONSLAYER

It was the early '80s, which meant *Dungeons & Dragons* was at its height of popularity (and controversy) and theaters were about to be besieged by the likes of *Conan the Barbarian, Excalibur,* and *Krull*. Fitting right in with the sword and sworcery trends was 1981's *Dragonslayer*, a co-production between Paramount and Disney that earned an Academy Award nomination for Best Original Score by Alex North. In retrospect, the unsuccessful nomination makes sense, because while North's score was absolutely brilliant, it was also incredibly atypical for the time.

North was a bit of an odd choice to score the film, as he was a legend of old Hollywood, known for *A Streetcar Named Desire* and *Who's Afraid of Virginia Woolf*. Recommended to the *Dragonslayer* braintrust by Steven Spielberg himself, North turned in a bizarre tapestry of dark brass chords, triumphant woodwinds, dissonant noise bursts, and a tendency to shift things into light, comedic directions that simply sound out of place with the tone of the film. Overall however, *Dragonslayer*'s score is dark, violent, and completely chaotic, so much so that to the untrained ear it would sound as though North threw a bunch of notes at the wall and walked away. (In fairness, *Dragonslayer* does contain reworkings of North's rejected score for *2001: A Space Odyssey* so it's not like it came about by design.) The studio edited the score in several scenes, including those with the dragon, to

make it more accessible (much to North's dismay). Bottom line, if you're not a musicologist a lot of *Dragonslayer* is tricky to process, but if you're willing to give it some time you might just discover its power. Talk about slaying a dragon.

Dragonslayer was released as a badass 2xLP in 1983 on Southern Cross Records, limited to 2,500 copies. It is now worth about as much as a +1 magic sword. Though the film offers an opportunity for a highly visual reissue, the original design already boasts maximum retro appeal.

SYMPHONIC SUITE

GEINOH YAMASHIROGUMI

AKIRA

Likely the most influential anime film of all time – and perhaps the best known outside of Japan – *Akira* (1988) was a rare moment in which the writer/artist, in this case Katsuhiro Otomo, was also brought on to direct the film. Consistently ranked as one of the greatest genre films of all time, animated or otherwise, the 1988 release depicts action and massive destruction in the newly rebuilt Neo-Tokyo of 2019, all set to a truly unique soundscape of music written by Dr. Shoji Yamashiro and performed by his Japanese musical collective Geinoh Yamashirogumi, based

around traditional Indonesian gamelan music, as well as Japanese noh compositions.

Both Otomo and Yamashiro considered *Akira*'s score to be the film's sonic architecture, so to that end they built the film up around it, and not vice versa. Otomo wanted two musical "pillars" to prop up the film, the first to represent the violence and destruction in Neo-Tokyo, and the second a "Requiem" that would bring peace and stability to the proceedings. As the film opens and main character Kaneda prepares to lead his gang into a bloody street fight, Yamashirogumi's

music kicks in with a massive thunderclap followed by percussion courtesy of an Indonesian jegog (a sort-of xylophone-type instrument built from bamboo trunks) and a chanting choir. Experimental throughout, *Akira*'s score constantly manipulates human voices and instruments to create sounds that are sometimes nightmarish and sometimes smoothly transcendent. By the score's finale "Requiem," angelic voices and pipe organ combine to create liturgical ambience.

Yamashirogumi's score was released in 1988 on LP by Invitation, as *Symphonic Suite Akira*. A 2017 2xLP reissue by Milan features more music and came in a variety of color variants. If Neo-Tokyo is going to explode, you're going to need some good music for the ride.

ORIGINAL SCORE BY OSAMU SHOJI

WICKED CITY

If you were never really a fan of anime and remain skeptical about listening to their soundtracks, *Wicked City* is the perfect place to cast cynicism aside and jump right in. Based on *Black Guard*, the first of six *Wicked City* novels by Hideyuki Kikuchi, the film depicts a world inhabited by both humans and demons, with the boundary protected by a secret police force known as the Black Guard. Creating the soundscape for this 1987 dark fantasy is one Osamu Shoji, a prolific synthesizer performer and programmer who released a number of records in the late '70s and

'80s, characterized by electronic disco and funk tunes.

In 2015, anime soundtrack label Tiger Lab launched with a reissue of the *Wicked City* score, previously released at the time of the movie by Columbia in Japan, and now a very expensive collector's item. Shoji provides a multi-layered, often erratic score that includes dark ambient sounds, synth atmosphere, '80s new wave/pop and jazz-funk.

Lacking a true recurring main theme, *Wicked City* is really track-by-track adventure, yet the constant injections of sound effects and quick shifts in direction don't detract from its listenability. *Wicked City*'s score is rooted deep in '80s synth atmosphere, its bass lines and retro vibe calling to mind any number of monster or horror flicks from

that decade. The remastering of *Wicked City* for vinyl is superb, resulting in huge, pulsating sounds that pulls the listener into the movie's world of shapeshifters and secret police. Divorced from the wild visuals of the film, *Wicked City* will appeal to '80s devotees and newer fans of experimental synth rock. If you ever doubted that anime movies could result in some seriously great music, look no further than *Wicked City*.

THE ORIGINAL SOUND TRACK ALBUM

MGM Presents

WESTWORLD

Music Composed,
Conducted & Arranged
by
FRED KARLIN

MGM
RECORDS

WESTWORLD

For Michael Crichton's 1973 android-theme-park-gone-violently-wrong movie *Westworld* composer Fred Karlin was challenged with the task of writing music that played to both the robotic nature of the androids inhabiting *Westworld*, along with traditional source music that would be heard in the artificial surroundings.

Karlin's background as a jazz trumpet player can be heard in the album's opening cue, and he's certainly able to play up to the different musical styles for the different theme parks. For example, he uses detuned honky-tonk pianos, banjos and

strings for Westworld, and for Medieval World a jaunty Medieval melody using period instruments and simple percussion. This source music helps create the illusion of these theme parks, but to sell that this is a world inhabited by robots, Karlin employed the Arp 2600 synth, along with an Echoplex, heard on tracks such as "Robot Repair." The music here is vague and unsettling as the movie shifts from the illusion of antiquated societies to the reality that the characters are trapped in a realm of robots gone amok. The two approaches come together in the chase sequence featuring Yul Brunner's gunslinger robot, with a hurtling tempo that suggests old West tropes but is layered with detuned instruments, wailing trumpet and an eerie use of echoes.

Interviewed by Daniel Mangodt in a 1994 issue of *Soundtrack Magazine*, Karlin spoke to the film's

use of both traditional and electronic approaches. "My feeling was to use almost completely acoustic instruments but manipulate them electronically so they weren't quite human... For instance, I had a single violin – I played all this music incidentally – that captured this horse galloping, but it was manipulated so that it sounded like much more than one violin and, secondly, it didn't sound like any violin, because I wanted that shrieking, primitive quality."

MGM released the soundtrack in 1973, with an expanded edition on CD from *Film Score Monthly* (coupled with Jerry Goldsmith's *Coma*) in 2005.

ORIGINAL SOUNDTRACK

BATTLE BEYOND THE STARS

Rhino Records
RNSP 300

CRAIG HUXLEY INTERVIEW

After beginning his career as an actor (including a role on the original *Star Trek* TV series), and working later as a jazz musician, composer and music producer Craig Huxley, has had a major hand in popular music over the years. One of his most important contributions to the sci-fi genre is his Blaster Beam, an 18-foot-long metal beam strung with wires and played like a massive slide guitar, creating deeply resonant, otherworldly sounds, sometimes achieved by striking it with unusual objects such as shell casings. The Beam has been featured in numerous soundtracks in

this book, as well as on classic pop tracks such as Michael Jackson's "Beat It." Here, he discusses his collaborations on numerous sci-fi classics with Maurice Jarre, Jerry Goldsmith and James Horner.

You were at the Star Trek: The Motion Picture *scoring sessions. What was the energy on the scoring stage like during this time?*

Jerry Goldsmith called *Star Trek* "a concerto for blaster beam and symphony." He had a 100-piece orchestra of all the top players, with Vincent

DeRosa leading the French horns, and Emil Richards on percussion, who had been featured so much on *Planet of the Apes*. It was by far the longest, biggest symphonic movie score that I was ever involved in, and I've done over 6000 sessions myself. [T]here was nothing else like it. In the middle of it all, Goldsmith quit and then later came back with the revised romantic theme [that we hear in the film now]. I remember that at the very end, in front of the orchestra, [Goldsmith] said, "There's nothing more I can do, there's only a few days left, and it's up to Craig at this point." I then improvised [music for the Blaster Beam] for the optical effects, various cues for those extraordinary scenes that were the equivalent of *2001*'s psychedelic trip into space. They set up a cot for me to sleep in on the Fox stage. We went around the clock.

Label: Rhino Records / RNSP 300 **Format:** LP **Year:** 1980 **Art:** Gary Meyer

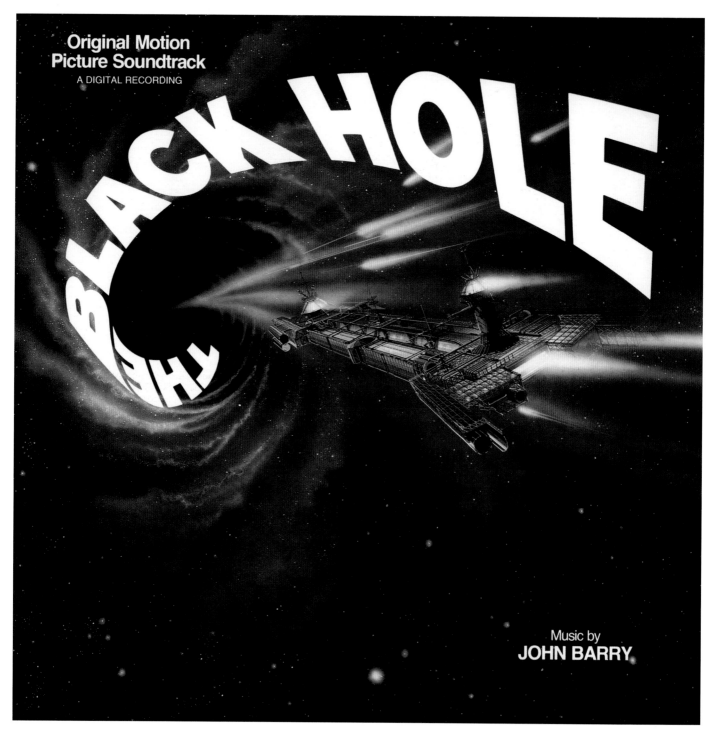

Original Motion
Picture Soundtrack

A DIGITAL RECORDING

BLACK HOLE

Music by
JOHN BARRY

Please tell us about your relationship with James Horner – your collaborator on Battle Beyond the Stars, and later on his Star Trek films.

James Horner and I were very close and he was a personal friend. [He] sat with me throughout the *Star Trek: The Motion Picture* sessions; he served as my page turner. And Goldsmith was mentoring him. He had copies of the scores I was featured on, and they were intense, long, long cues. Goldsmith did everything live. I was playing the Blaster Beam, which was eighteen feet long, and then running to my microtonal clavichord, and then to the piano, and then to the third modular synth – all of which was being done live. It was insane. Horner was there watching the scores, learning from them, and turning pages for me for four different instruments.

Then, when *Star Trek* was successful, but not a big hit like *Star Wars*, they continued the franchise, and they brought in producer Harve Bennett, who thought they could do it much cheaper. Ironically, they made what was still considered the best *Star Trek* film of all. That was quite interesting because I then got to compose the Genesis Project sequence and other cues in that movie, and I was featured by Horner, who really replicated [the sound with a] similar orchestra, but much quicker...*Star Trek II* was a great achievement for him at that young age.

During *Star Trek II*, or it might have been *Star Trek III*, I actually fell asleep [in the middle of a recording session]! I was producing a movie at night and doing all day sessions with Horner. In the middle of a cue I laid down on the floor and fell asleep in the middle of the symphony. Leonard

Nimoy and James Horner came over, they were laughing so hard. But, you know, you've got to grab your naps when you can!

So you just literally slept on the soundstage?

Yes! I would improvise and multitrack. And that was that. Immediately after *Star Trek*, I built my home studio, which was the first 24-track home studio in L.A., which is where I worked on the 2010 sequel score with David Shire, which was mixed back here.

How do people tend to write for the Blaster Beam when composing? Is it sketched out, or do you improvise?

John Debney is a wonderful composer, and uses the Blaster Beam on TV's *The Orville*. I've worked with him for decades in different ways...He lets me,

Original Soundtrack Composed by
MAURICE JARRE
DREAMSCAPE

when I feel inspired, to jump in with an 85-piece orchestra. I love doing that because it's like my jazz background, where I can bring improv into the symphonic cinema milieu. It's a thrill. But with the Blaster Beam, sometimes people also write out [parts for it], like in *10 Cloverfield Lane*; Bear McCreary would write out the pitches that he wanted and different effects, and I showed him how it could be done – the vibratos and overtone clusters. Sometimes I do get it written out.

Another score that features your Blaster Beam is John Barry's The Black Hole, a film and a score you can't imagine Disney green-lighting today.

With *The Black Hole*, John Barry would sit here [in my home studio], and his score was so luxurious and so slow moving, but it was capturing the film's whole milieu – the vast expanse of that location.

That's what he was scoring, rather than [scoring the beats], like every little electronic switch, or every time a door shut. He wasn't Mickey Mousing, or catching the action. He would be scoring the big picture. At first I was baffled by the music, how was this going to fit with what's on the screen? But it's a beautiful score. I was really happy to be involved in that one.

How did you get involved with the Dreamscape soundtrack?

I worked with Maurice Jarre for about five years, and I even went with him to France when he was knighted in Paris – he chose me as his single witness to be there! So, anyway, *Dreamscape* was an attempt to really do some interesting things. Bob Moog built us a special keyboard. My colleagues in the microtonal world were trying

to create new sounds and new sound structures. *Dreamscape* was also pulling on some of Maurice's early studies he had done in Paris in the '40s with those guys who later developed IRCAM [Institute for Research and Coordination in Acoustics/Music].

How did he find the balance between electronic and traditional acoustical instruments in the score?

In *Dreamscape* we tired to go all electronic, and sample in acoustic effects. I was using the synclavier and we were able to do some of the things we do now, but in those days, only the synclavier could do it. And the score really had a *musique concrete* feel that Maurice had been around when he was younger. He was about 30 years older than me and...he said I was his

ORIGINAL Soundtrack

Cat People

Music by GIORGIO MORODER

BSR 6107

honorary son. So he would stay here sometimes.
He loved experimenting and it was a new phase
for him. With *Dreamscape* we tired to create a new
world inside of analogue and digital synths.

What was your role on Cat People*?*

I was the producer of the score...I created most
of that score while Giorgio Moroder was over in
Europe producing disco. He would call on the
landline and I would hold the phone up in the air
[and play him the music]. He'd check in once a
week. That's how we managed to get that score.
done. Moroder had sent themes over, I got to
compose some of it, and realized the whole score.
We really tried to enhance the mystery [of the film]
through the music.

 Label: MCA Records / MCA-37263 Format: LP Year: 1982 Art: Djb Barnao

THE WITCHES OF EASTWICK

What happens when you take the Hollywood superstar power of Jack Nicholson, Cher, Susan Sarandon and Michelle Pfieffer, kick-ass director George Miller, and a celebrated John Updike novel? A bit of a flop, as it turns out, but no one can fault *The Witches of Eastwick* (1987) for not trying, particularly with its spritely score from John Williams.

It sounds like he had a field day writing the music, opening the picture with "The Township of Eastwick," which introduces the theme for the witches, and interestingly for Williams,

incorporates some synths bubbling under the melody. The film's most memorable theme remains the "Dance of the Witches," a jaunt of a cue heard to accompany Jack Nicholson's entrance into the picture, making use of woodwinds and fiddles, and once again incorporating synths. Meanwhile, "Maleficio" is a playfully diabolical Williams track in which the maestro toys with various levels of dissonance and effects from strings and winds, along with several nods to his "Well of Souls" cue from *Raiders of the Lost Ark*. Interestingly, the film's musical standout doesn't even get fully

heard in the film. "The Seduction of Suki and Ballroom Scene" was replaced with a Puccini opera aria in the movie, but you get to hear it in its full glory on the album. The seven-minute set piece opens with solo flute that adds strings and piano before coalescing into one of Williams' most lyrical melodies.

The score ended up nabbing Williams' 21st Oscar nod for best score, and the album was released from Warner Bros. in 1987; for years the concurrent CD release was the holy grail for Williams completists. It was finally re-released in 2006 on CD from Collectors' Choice Music.

CHAPTER

4

ACTION

ADVENTURE

RUN, DON'T WALK

SCHWARZENEGGER

ORIGINAL MOTION PICTURE SOUNDTRACK

TOTAL RECALL

MUSIC COMPOSED AND CONDUCTED BY
JERRY GOLDSMITH

VSD-5267

VARÈSE SARABANDE

TOTAL RECALL

With a filmography that includes *Robocop* and *Showgirls*, the legacy of director Paul Verhoeven will probably long be debated, but you can't deny that he always got the best composers and their best music in his films. Case in point, *Total Recall* (1990), an Arnold Schwarznegger summer blockbuster based on a Philip K Dick story, which features one of Jerry Goldsmith's most celebrated scores of all time, which is quite the statement when you consider just how many there are to his name.

Though he came from an older Hollywood that tended to rely on more traditional orchestral scores, with *Total Recall* Goldsmith embraced his skills in electronics wholeheartedly, delicately balancing them with more conventional compositions. Like Alan Silvestri's hugely influential *Predator* score, *Total Recall*'s music is overwhelmingly present in the film, its razor-sharp edges pushing the action and special effects to the next level (the latter of which did in fact win an Academy Award). Fast-paced slashing brass fuels the film's constant chase scenes, but it's the futuristic and sometimes dreamy electronics that fans tend to remember more fondly. Perhaps this is overreaching, but the dynamic of styles does pair nicely with the main character's struggle with his identity.

A truncated 40-minute version of the *Total Recall* score came out on vinyl and CD from Varèse Sarabande upon the film's release, but given the acclaim it received, fans demanded an expanded version. They finally got it with a deluxe edition on CD from the same label a decade later. For the film's 25th anniversary, in 2015, Quartet Records released a massive, remastered 2xCD version containing the 2000 album (with a new mix of the end credits), the 1990 version and a pile of source cues and alternate takes. Let's see that version become a deluxe vinyl package one day.

ORIGINAL MOTION PICTURE SOUNDTRACK

UNIVERSAL SOLDIER

MUSIC COMPOSED BY
CHRISTOPHER FRANKE

VARÈSE SARABANDE

KM-019

UNIVERSAL SOLDIER

Before he became notable as the musical force behind hit series *Babylon 5*, Christpher Franke was a member of one of the most notable names in genre film music, Tangerine Dream, beginning with the 1977 William Friedkin film *Sorcerer* and eventually titles such as *The Keep* (1983) and *Legend* (1985). When he finally went solo, his first gig was the Jean-Claude Van Damme/ Dolph Lundgren sci-fi actioner *Universal Soldier* (1992). Though this electronic-orchestral hybrid bears little resemblance to Tangerine Dream's experimental soundscapes, it remains an important jumping off point in Franke's career.

Opening with "Vietnam Jungle," *Universal Soldier* immerses the listener in a grand orchestral cacophony, creating suspense that belongs in the same musclebound world as Alan Silvestri's *Predator* (1987). "Unisols on Fire," "McGregor" and "Grand Canyon" all feature the same unrelenting darkness, while "The Fight" provides unique industrial electronics to fuel the film's action-packed climax. Truthfully, as an album *Universal Soldier* does not make for the most exciting listen, nor one of the more brilliant compositions in Franke's career. Instead it serves

as a launching pad for his more accomplished and complex television work on *Stranger Things* and *Black Mirror*, hinting at what was to come. As it is, *Universal Soldier*'s score does what it needs to do, mainly create a sonic landscape of cold, hard electronics, thumping percussion and evil orchestral suites.

Universal Soldier was released around the world on every format by Varèse Sarabande at the time of the film's release. If action movie soundtracks on vinyl ever become a thing, Franke's solo debut would be a solid reissue given the historical significance of the composer if nothing else.

THE TERMINATOR

ORIGINAL SOUNDTRACK

BRAD FIEDEL ON THE TERMINATOR AND T2

Is there a more badass sci-fi theme than Brad Fiedel's iconic ostinato that made viewers reimagine Arnold Schwarzenegger as muscle-bound Conan to the lethal T-800 cybernetic organism from 1984's *The Terminator*? And then from the heavy to the hero in the sequel, 1991's *Terminator 2: Judgment Day*? Feidel, whose oeuvre includes other genre hits such as *Fright Night* (1985) and *The Serpent and the Rainbow* (1988), discusses the creation of his two unforgettable scores from the beginning of the franchise.

How did you come aboard The Terminator *in the first place?*

One of my agents, Beth Donahue, got wind of the project and had a good feeling about the director James Cameron. She sent a tape of some of my music to him and I guess he listened to it in his car for a while and then set up a meeting. Jim and [producer] Gale Anne Hurd came to my studio and screened the film for me. I played a piece of dark personal music I'd been working on with piano and synths and Jim decided to hire me.

How did that propulsive rhythm for the theme come to be?

The equipment I was using for *The Terminator* score were standalone synths made by different companies and did not have a digital way of communicating with each other. This meant that there wasn't a way to keep them in perfect sync. The Prophet-10 had a little onboard sequencer that could play back notes that you performed into it. You could not program the notes and quantize them perfectly, like you could on later equipment, so it was actually playing back the live performance, flaws and all. When I performed that ostinato part into it and hit stop on the little sequence recorder I was a little early. It was a little less than a full measure, so when I looped it, it created a slightly offbeat time signature. I actually liked the slightly unsettling effect of it not being

 Label: Enigma Records / 7 72000-1 **Format:** LP **Year:** 1984 **Art:** N/A

A JAMES CAMERON FILM

THE TERMINATOR

ORIGINAL MUSIC BY BRAD FIEDEL

the perfect 6/8 time it could have been, so I kept it and played everything else in relation to that.

How did you go about searching for the sound palette for the scores?

The process in my studio was kind of like a mad scientist running around and trying things. Experimenting. I saw the film, and the next morning sat at the piano and the main theme just evolved out of improvisation. Then it was a matter of finding sounds that matched what I was hearing in my imagination. At any given moment in the soundtrack of a film choices are made as to what element is being emphasized, be it dialogue, sound effects or music. Often, if the music is acoustic, there is a clear difference between it and any other sounds. In the *Terminator* films we were entering a different realm where there was often a blending

and crossing over of music and ambient sound effects, as well as some more pronounced sound effects. When I created some of the droning and ambient sounds, as well as sounds like the T-800's presence, aura and stylized musical heartbeat, the boundary between music and SFX no longer really existed. This worked well in some instances, where the whole was more powerful than the parts, and it got a bit muddy in others. It is always the director's choice, moment by moment, to decide what balance best supports his vision for the film. I know there were places where I felt the SFX buried the music and I know that the SFX designers felt that at times the music compromised the sounds they had created. On the mixing stage it's always the good fight that hopefully results in the best film.

The love theme seems to be one of the few cues

that doesn't rely on synths. Did you devise a plan for how you were going to orchestrate for humans vs. cybernetic robots?

I think that those choices came about organically. Playing the love theme featuring solo piano was one of the choices that surprised Jim and he ended up really loving it.

***Ross Levenson is the violinist on both* Terminator *scores, and* Fright Night*; how did you come to work with him?*

I met Ross in New York. I heard him playing in a band and was blown away by the expression of his playing and the variety of sounds he was getting. I started flying him out to L.A. to play on various scores. At that time electric guitar was extremely popular in scores and I was excited to use something different in my scores. Also, Ross

Label: Milan / MLN1-36747 **Format:** LP **Year:** 2016 **Art:** Nicolas Winding Refn / AllCity Media / Ben Ib

ORIGINAL MOTION PICTURE SOUNDTRACK

SCHWARZENEGGER

TERMINATOR 2
JUDGMENT DAY

MUSIC BY **BRAD FIEDEL**

has such soul in his musicianship that I felt it brought a lot of heart and spontaneity to the scores to balance the inhuman tendencies of the synths.

T2 *retains the key themes from the original, but the electronic soundscapes you use are different. Had the tech noticeably changed between the two films?*

Music technology was changing rapidly on many fronts. This expanded my capabilities in a way that allowed me to be more in sync with the much larger production values of the film. The story was also very different and needed a fuller, warmer sound, and the technology allowed me to create a vocabulary of sounds that largely originated with samples of acoustic orchestral instrument that I

manipulated electronically.

T2 *really pushed the envelope in terms of advancing special effects through CGI. What did this mean in terms of post-production, and how did you approach the music?*

I tried to have the music be supportive of some of the very disorienting visual effects that had not been seen before by not being too "normal."

It was the most expensive movie at the time of its release, and yet, I understand it was scored in your garage. Is that true?

Yes, I did score it in a converted garage, and no longer have any of the gear that I used back then.

Label: Silva Screen / SILLP1337 **Format:** 2xLP **Year:** 2015 **Art:** Stuart Ford

ORIGINAL MOTION PICTURE SOUNDTRACK

RoboCop

MUSIC BY **Basil Poledouris**

©1987 Orion Pictures Corporation. All rights reserved.

STV 81330

ROBOCOP

Basil Poledouris had already created one of the all time great works in film music with *Conan the Barbarian* in 1982, and five years later he proved to be no fluke with *Robocop*. The film itself is an '80s masterpiece, its biting and brilliant social commentary on greed and capitalism marching step in step with heavy metal violence and gore. The story's a classic: police officer Alex Murphy (Peter Weller) is killed in the line of duty by murderous thugs and brought back as a cybernetic crime fighting project by OCP, a megacorporation that runs the Detroit Police

Department. To capture the essence of the character, Poledouris blended the sounds of the Sinfonia of London Orchestra with a stack of synthesizers elements. True, many other composers took a similar approach in the '80s and '90s, but in such a thoughtful film, one has to believe Poledouris was operating with purpose.

Of course, it all comes down to *Robocop*'s main theme, one of the most hair raising and iconic in movie history. It's first heard as Murphy dies, then it explodes with might when Robocop hits the streets for the first time in an epic crime-annihilating montage. The theme is all comic book heroism but with the determination of man seeking revenge on his murderers, with the help of his Auto 9 firearm (the clanging effect is reportedly Poledouris tapping a fire extinguisher with a metal hammer). The score's coolest moment might just

come when Robocop decimates a coke dealer's warehouse, blasting everything in site with the theme cranked to 11. Elsewhere, the terrifying Clarence Boddicker gets his own rumbling six-note brass theme, and law enforcement droid ED-209 receives a cold, industrial motif with brass flares.

The original 1987 *Robocop* LP was released by Varèse Sarabande, which presented the score in 40 minutes. The label put out an expanded version of the score on CD in 2003, with the addition of the film's hilarious television commercials as bonus tracks. Finally, in 2010, Intrada released the complete score on CD, as it plays in the movie, including a complete title sequence. Milan pressed this version to a 2xLP in 2015.

Label: Varèse Sarabande / STV 81330 **Format:** LP **Year:** 1987 **Art:** Mike Bryan

MEN IN BLACK

"Here come the Men in Black!" In the summer of 1997, Will Smith scored a one-two punch by both starring in *Men in Black* and performing the title song for director Barry Sonnenfeld's successful adaption of Lowell Cunningham's comic book series.

Men in Black: The Album is notable in that *none* of the songs actually appear in the movie (!), with the album built around selling Smith the rapper, in addition to the movie. It did a great job at both, moving over three million copies and scoring a hit video for breakout single "Men in Black," in which

Smith does a choreographed dance with a CGI alien. Despite its lack of overlap with the film, the album is a solid auditory time capsule of where hip hop and pop music were in the late '90s, and also acting as an early career launchpad for Alicia Keys and Destiny's Child, each of whom are given a track on the album. Also appearing is Snoop Dogg on "We Just Want to Party With You," which pretty much sums up the album's artistic agenda.

The compilation also features two cuts from Danny Elfman's score, which marked the composer's first Academy Award nomination. Driven by a propulsive four-note ostinato, the infectious main theme never evolves into a full-fledged melody, but the catchy nugget perfectly encapsulates the heroics of the anonymous J and K as they do battle with Vincent D'Onofrio's interstellar cockroach – and while the fictional duo wipes the memories of

the general public clean, you can't erase Elfman's thudding *MIB* hook.

Columbia issued separate albums of both the song compilation (which went triple platinum in the U.S.) and the extended score. In 2017, Enjoy The Ride Records reissued the score on vinyl, including a 500-copy limited edition LP with a "Galaxy Splatter" pattern. Smith and Sonnenfeld would team up again in 1999 for *Wild Wild West*, sampling Stevie Wonder's "I Wish" for his title track. Sadly lightning couldn't be bottled twice; the song nabbed a Golden Raspberry Award for worst song that year.

Label: Columbia / C 68536 **Format:** 2xLP **Year:** 1997 **Art:** Doug Erb

THE MATRIX

By the time 1999's *The Matrix* overtook the millennial Zeitgeist, it's fair to say at least one of this book's authors was spending more time with Bernard Herrmann on his stereo than raving to Rob Zombie and Marilyn Manson, both of whom feature prominently on the song compilation from (and "inspired by") the Wachowskis' groundbreaking film.

Most of the prominently-placed songs come from earlier recordings – Manson's glammy "Rock is Dead" (playing over the end credits) stems from his 1998 album *Mechanical Animals*, while

Zombie's "Dragula" (from his *Hellbilly Deluxe* album) plays in the first nightclub sequence. Featured more prominently, scoring the film's action, is the Propellerheads' 1998 big beat break "Spybreak!," heard when Neo (Keanu Reeves) and Trinity (Carrie-Anne Moss) blow shit up real good in the lobby sequence.

But the song that gives the movie the final kick-in-the-ass is in the film's coda, in which Neo literally tells the audience to wake up, is Rage Against the Machine's "Wake Up." Taken from the group's 1992 self-titled first album, the song's political overtones and badass drop D guitar riff mesh nicely with the movie's themes of taking down oppressive systems (in Rage's case, it's the American government; in *The Matrix*, it's evil computers, but you get the idea).

The Matrix song compilation found its way onto many a raver's CD shelves in 1999 (via Madonna's Maverick label). In 2017 Real Gone Music committed the compilation to wax.

Label: Real Gone Music / RGM-0541 **Format:** 2xLP **Year:** 2017 **Art:** Kevin Reagan / Stefan G. Bucher

ORIGINAL MOTION PICTURE SOUNDTRACK

BRANDON LEE

THE CROW

THE CROW

Alex Proyas' 1994 adaptation of James O'Barr's comic books *The Crow* ended up being a major sleeper hit at the box office, and ultimately a cultural phenomenon. It was a dark, gritty film that captured the zeitgeist of the mid-'90s, a time when mainstream and "alternative" cultures were beginning to merge. Of course a big part of the film's attitude came from its soundtrack, consisting of goth, metal and then-alternative rock stalwarts like The Cure, Rollins Band, and Nine Inch Nails. These days, this soundtrack concept hardly seems revolutionary (and you might even argue the band lineup simply dates the film), but in 1994 it was fairly groundbreaking to feature a who's who of Lollapalooza artists on a major film soundtrack.

Goth heavyweights The Cure and Joy Division both made appearances in *The Crow* comic, contributing to the character's goth icon status. Even some of the comic series' characters, Sergeant Albrecht and Captain Hook, were named after Joy Division members Bernard Albrecht (now Bernard Sumner) and Peter Hook. Both bands appear in the soundtrack, with The Cure's "Burn" serving as the movie's main theme, while NIN covers Joy Division's "Dead Souls."

Elsewhere, Pantera remade hardcore punk band Poison Idea's "The Badge," Rollins Band covers "Ghost Rider" by electronic duo Suicide, about the Marvel Comics character, and Rage Against the Machine provides a new version of "Darkness of Greed," appropriately naming it "Darkness." Also of note is the track "It Can't Rain All the Time" by Canadian singer/songwriter Jane Siberry, co-written by the film's composer Graeme Revell, an orchestral version of which plays throughout the film.

The CD soundtrack was arguably as successful as the film, peaking at #1 on the Billboard 200 and selling over three million copies. The vinyl resurgence caught up with it for Record Store Day 2019, releasing *The Crow* as a 2xLP on one white and one black disc, etched on side four with cover art.

 Label: Atlantic / 603497854387 Format: 2xLP Year: 2019 Art: Darren Crawforth / Geezer

ORIGINAL MOTION PICTURE SOUNDTRACK
Ladyhawke

LADYHAWKE

Richard Donner had Jerry Goldsmith for *The Omen*, John Williams for *Superman*, but apparently had The Alan Parsons Project in mind when working on the medieval fantasy/romance *Ladyhawke*, and therefore approached band member/composer Andrew Powell to write the music for his 1985 fantasy.

The score is an often-contentious blend of classical and pop idioms. Does it work? It's not as if *Ladyhawke* is the first time a composer has blended synthesizers with the orchestra – Jerry Goldsmith was a huge proponent of incorporating electronics, and often did so (*Legend*, *Logan's Run*, for example). And it's not as if an orchestra can't add depth to funky tracks, as evidenced from the works of Roy Budd or even the strings and brass that flesh out Curtis Mayfield's *Superfly*.

The challenge is that Powell's pop sensibilities often pull the music in two directions at once. The clash of these two styles, coupling symphonics with rock beats, makes for a weird mashup of styles that has divided listeners, particularly for a fantasy film (and one that involves young Matthew Broderick with goofball comic relief). But the two approaches sometimes fuse effectively, as on "The Search for Phillipe," and there's something endearingly geeky about the two "Tavern Fight" cues, which feel stuck somewhere between a large-scale orchestral fantasy score and Wang Chung's "Everybody Have Fun Tonight." And at least Powell is working with some nice thematic material. His development of the soaring main theme, underscoring the sad romance between Navarre (Rutger Hauer) and Isabeau (Michelle Pfeiffer) gives the movie the gravitas it needs, whether played out with wind, strings, piano or guitar.

Initially released from Atlantic in 1985, an expanded score was issued on CD from GNP Crescendo a decade later. Then, in 2015, La-La Land put the final word out with its hugely expanded 2-CD "archival" edition.

Label: Atlantic / 7 81248-1-E **Format:** LP **Year:** 1985 **Art:** N/A

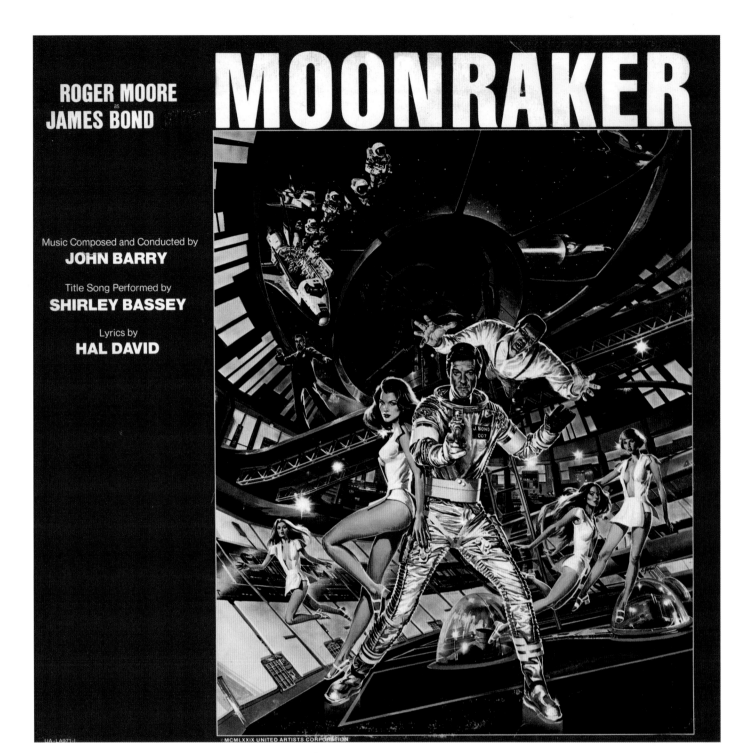

ROGER MOORE as JAMES BOND

MOONRAKER

Music Composed and Conducted by
JOHN BARRY

Title Song Performed by
SHIRLEY BASSEY

Lyrics by
HAL DAVID

UA-LA971-I © MCMLXXIX UNITED ARTISTS CORPORATION

MOONRAKER

In *Moonraker,* James Bond is delivered his loopiest plot yet, and that's no small feat. The 1979 film sees Roger Moore's 007 visit a giant space colony orbiting the Earth as arch-villain Hugo Drax (Michael Lonsdale) attempts to annihilate all humans and create a new master race.

The title song is Shirley Bassey's third (and final) entry for the series, although she was an eleventh hour replacement for Frank Sinatra and, later, Johnny Mathis, yet it's hard to imagine anyone but Bassey's warm, syrupy vocals over John Barry's

thick string arrangement. (That said, we prefer the disco-infused version used for the end title).

Moonraker also marks the point in Barry's Bond scores where he began to push into a more symphonic, string-laden sound that he'd later employ on scores for *Octopussy* (1983) and *The Living Daylights* (1987). You can hear this in his take on the secondary 007 theme that's featured on "Bond Arrives in Rio," in which he eschews his more hard-hitting original instrumentation that emphasized brass and percussion.

The pace of the music is also slower than on earlier Bond films, with an emphasis on romantic refrains of the title music. Barry either avoids scoring the action sequences, or uses a more relaxed tempo, which gives the film its dreamy vibe – as evidenced during the six-minute

standout track "Flight Into Space," which utilizes synthesizers and a female choir for a unique sound.

The score is not without some humorous touches, though, such as Barry's quotation of Tchaikovsky's *Romeo and Juliet* overture, used when the hulking, steel-toothed Jaws (Richard Kiel) meets the love of his life (the best joke might be the musical keypad to Drax's secret lab, which literally plays out the five-note alien motif from *Close Encounters of the Third Kind*).

Moonraker was recorded in Paris' Studio Davout, and the whereabouts of the master tapes are currently unknown. It may take a double-0 agent to retrieve them for an expanded release, but for now, you'll have to make do with the 30-minute LP that United Artists released in 1979.

Original
Motion Picture
Soundtrack

Music Composed
and Performed by
John Carpenter

BIG TROUBLE IN LITTLE CHINA

Conceptually, *Big Trouble in Little China* might just be the best film of John Carpenter's career. Carpenter had built a reputation as an independent filmmaker who scored his own films, and here that continued into the studio system. Though most often associated with minimalist synth scores, on *Big Trouble* he mixed rock 'n' roll with more intricate and progessive electronics peppered with Asian flourishes. Like the film, the score is a mash up of genres that doesn't completely make sense but – like awkwardly arrogant hero Jack Burton (Kurt Russell) – fans have come to embrace regardless.

The movie opens with a bang, thanks to "Pork Chop Express," its heavy blues riffs fueling Jack's rig as he barrels through the stormy night spouting his trucker gospel over the CB radio. ZZ Top's "I Just Got Paid Today" was used as a temp track for this scene, and the song ended up inspiring Carpenter's composition. From there, the synths come in, written in a makeshift studio in the garage behind Carpenter's new home with programming and sequencing courtesy of then-creative partner Alan Howarth. Perhaps the best sequence from the score's suite is "The Great

Arcade." The track's melody was inspired by a rallying cry from when the Japanese invaded China in World War II, and was introduced to Carpenter by actor Victor Wong, As the film concludes, the "Big Trouble in Little China" theme song kicks in, a corny but immensely enjoyable number.

Originally released as an LP (from Enigma) featuring a truncated score, *Big Trouble in Little China* was released on CD in 1999 from Super Tracks Music Group. In 2009 La-La Land Records released a remastered 2xCD of the score in its entirety, and it was subsequently pressed as a double LP by Mondo in 2018.

Label: Enigma Records / SJ-73227 **Format:** LP **Year:** 1986 **Art:** N/A

RAIDERS of the LOST ARK

DCC
Compact Classics

THE ORIGINAL INDIANA JONES TRILOGY

It began with the famed meeting of Steven Spielberg and George Lucas on a beach in Hawaii, while they were taking a break from their respective hits *Close Encounters of the Third Kind* and *Star Wars*. The filmmakers tossed ideas around about archaeologist/adventurer Indiana Jones (with input having already been thrown in by writer Philip Kaufman), a 1930s-era hero with a bullwhip and a penchant for procuring artifacts with supernatural, even cosmic powers. The saga was born with the release of *Raiders of the Lost Ark* in 1981. Despite the series' insensitive depictions of other cultures, the three films (we're

not counting 2008's disappointing *Kingdom of the Crystal Skull*) stand as hallmarks of the action/ fantasy genre.

Crucial to their success are John Williams' musical scores. His brassy "The Raiders March" is one of his best-known themes, used frequently in the saga to rouse the audience during Indy's moments of triumph. Williams spent days with various permutations of the notes for the theme until he got two that he felt really worked, and Spielberg liked them much he had him use both motifs in the theme.

Beyond that piece, *Raiders* is a treasure trove of thematic material. There's the mysterious theme for the Ark itself, a three-note descending phrase in the minor key that signifies the film's mysterious MacGuffin, while Indiana and Marion get a love theme that ranks with Williams' best. But it's also the range of textures and timbres that add flavor to the score; the dissonant strings for the film's opening in Peru, a brass-heavy call-out of the theme as Indy boards the Nazi sub, or the snake-like strings to signify the Well of Souls and its reptilian inhabitants. In many ways, it marks a high point for the blockbuster scores that he started with in 1975, with Spielberg's *Jaws*.

Another triumph here, of course, is the film's dramatic (and musical) centerpiece: truck chase. The eight-minute track ("Desert Chase") is one of the best shot, edited and scored sequences in the

DIGITAL RECORDING
THE ORIGINAL MOTION PICTURE SOUNDTRACK

INDIANA JONES
and the
TEMPLE
OF DOOM ™

ORIGINAL MUSIC COMPOSED AND CONDUCTED
BY JOHN WILLIAMS

action genre. Speaking to Lukas Kendall in 1995 for the DCC Compact Classics disc liner notes, Williams said, "I look at it as a kind of musical number that has a beginning, a middle and an end, and try to calculate a series of tempos, and a series of changing tempos. I will try to design it almost in the same way as you would a balletic number, which may contribute a certain aspect of fun and adventurousness in this Harrison Ford character."

The soundtrack was originally issued on vinyl from Columbia Records in 1981; DCC Compact Classics issued a more complete edition in 1995, which found its way onto vinyl from Concord Records in 2017. (Concord's 2008 CD boxed set, *Indiana Jones: The Soundtrack Collection*, may still be the last word on a commercial release of the scores.)

Spielberg opens the 1984 prequel, *Indiana Jones and the Temple of Doom*, with future wife Kate Capshaw's Busby Berkley-style Shanghai dance number "Anything Goes" before letting loose with more action sequences in which our hero humorously tries to exchange a diamond for an antidote held by the nefarious Lao Che. Here Williams lets loose with "Indy Negotiates" and "Fast Streets of Shanghai."

With the adventurers whisked away to India, Williams develops a new palette of thematic material. Indy's young sidekick, Short Round, is given a lyrical theme, while a love theme is developed for the romance between Jones and Willie Scott (Capshaw), best heard in the lighthearted "Nocturnal Activities" cue, which incorporates some of the pizzicato strings as a nod to the basket chase in *Raiders*. This leads right up

to one of the film's best setpieces, in which Indy and Short Round are trapped in a booby-trapped cave while Willie is forced to contend with a release mechanism guarded by a horde of insects.

The film's more disturbing (and, let's be honest, racist) elements take place within the bowels of the Temple of Doom itself, in which Thuggee leader Mola Ram rips out the heart of a sacrificial victim, over which chants of "Mola Ram, Suda Ram" are heard by a male chorus, which helps to underscore the film's final action sequence on the rope bridge.

Polydor issued the original soundtrack LP in 1984.

Indiana Jones and the Last Crusade (1989) sees Spielberg directly addressing series inspiration James Bond with the casting of Sean Connery as Jones' father, and the film goes back to its roots with the return of Sallah (John Rhys-Davie) and

Marcus Brody (Denholm Elliot), as Indy and the gang team up to find the Holy Grail.

Less reliant on the "The Raiders March" as in previous scores, Williams develops a wealth of new material here, in particular the four-minute "Scherzo for Motorcycle and Orchestra," which opens with a new theme signifying the adventurous theme for both the Nazis and Jones Sr., while action cue "Escape From Venice" utilizes mandolin flourishes for whimsical effect. There's a lightness of touch on *Last Crusade* that sets it apart from the doom and gloom of the previous installment. Musically, the film's biggest moment of humor comes from the deliberately pacey string work on "No Ticket," which underscores the sequence in which a disguised Jones punches out a Nazi baddie and throws him off a zeppelin; it would later be adapted as the Gilderoy Lockheart

music from *Harry Potter and the Chamber of Secrets* (2002). But the musical heart of the film is really the contemplative theme for the Grail itself, or rather the quest to reach it, which helps reunite Indy with his estranged father.

Warner Brothers released the original soundtrack LP in 1989. Though the Indiana Jones films helped to usher in a new era of action/adventure filmmaking, what sets them apart from the movies that followed it is the commitment to creating action that's defined by music. Whether it's the

angular brass stabs in Raiders' "Airplane Fight" sequence, or sustained action cue of "Belly of the Street Beast" in *Last Crusade*, these films exemplify the importance of flow and drama to action music that doesn't need to be buried under a cacophony of sound effects and choppy editing.

 Label: Warner Bros. Records / 1-25883 **Format:** LP **Year:** 1989 **Art:** Drew Struzan / Diane Painter

ORIGINAL
SOUNDTRACK
SCORE BY
JERRY GOLDSMITH

KING SOLOMON'S MINES

If you ever thought Jerry Goldsmith played second fiddle to John Williams, especially when it comes to '80s genre films, look no further than *King Solomon's Mines*. This 1985 effort from the low budget mavericks at Cannon is an obvious parody of the *Indiana Jones* films, and Goldsmith's music was clearly designed to play off Williams' iconic themes from that series. That said, it actually makes for a pretty good, if not totally serious, score in and of itself.

Goldsmith's score is dominated by overly positive cartoon heroism, most obviously in its main

theme for hero adventurer Quartermain (Richard Chamberlain). This galloping brass theme is a not-so-subtle take on Williams' *Raiders of the Lost Ark* score, and it pops up constantly throughout the film. Still, it's such an enjoyable, fist-pumping listen that it's impossible to hate. There's also an enjoyably yearning romantic theme for the (admittedly awkward) relationship between Quartermain and love interest Jesse (Sharon Stone), an old fashioned orchestral piece written for strings and woodwinds. One of Goldsmith's more unusual choices is the theme for the

villainous Colonel Bockner, which is actually just Richard Wagner's "Ride of the Valkyries" popping up throughout the film, thanks to the Colonel, who carries around a gramophone and plays it whenever he needs some epic background music.

Initially released on vinyl by Restless Records at the time of the film's release, the score for *King Solomon's Mines* received an expanded 60-minute edition on CD from Intrada in 1991, and then again as a 70-minute edition with bonus tracks by Prometheus in 2006. In 2014 it was released as a two-CD set from Quartet Records that included the expanded version, bonus tracks and the original album. If someone is looking to reissue a classic Goldsmith score where the master is simply having fun, they've got options.

JURASSIC PARK

In 1993 found Steven Spielberg made the most successful fantasy/sci-fi blockbuster of his career with *Jurassic Park*, which earned more than $1 billion at the global box office, making it the most successful film ever until *Titanic* came along in '97. It was also Spielberg's first "monster movie" (news outlets warned parents not to take their kids it was so frightening) since *Jaws* (1975), and as such offered musical partner John Williams another opportunity to blend wonder with suspense. As with their other collaborations, Williams' score for *Jurassic Park*

is now considered a classic and one of the most recognizable of his career.

Before today's age of non-stop CGI action fests that appear in theaters every week, *Jurassic Park* offered what many blockbusters promised throughout the '80s: the chance to believe in the impossible: that dinosaurs could once again roam the Earth. Williams tapped into that sense of wonder and imagination for his score, writing a central theme for the park itself. The theme is initially heard as the characters see the dinosaurs for the first time, reflecting their feelings of joy at

seeing these magnificent creatures come to life.

Of course, *Jurassic Park* does indeed become terrifying in its final 30 minutes, as the characters, including children, are hunted by prehistoric beasts, notably the Tyrannosaurus Rex. Though it never matches the iconic status of the *Jaws* shark theme, the score certainly reaches down into far darker and more frightening tones for these moments.

Jurassic Park's composition took place at George Lucas' Skywalker ranch in tandem with sound

JURASSIC PARK

Original Motion Picture Soundtrack
Music Composed and Conducted by **John Williams**
Album Produced by **John Williams**

Side A
1. Opening Titles — 0:33
2. Theme From Jurassic Park — 3:27
3. Incident At Isla Nublar — 5:20
4. Journey To The Island — 8:53

Side B
5. The Raptor Attack — 2:49
6. Hatching Baby Raptor — 3:20
7. Welcome To Jurassic Park — 7:55
8. My Friend, The Brachiosaurus — 4:16

Side C
9. Dennis Steals The Embryo — 4:56
10. A Tree For My Bed — 2:12
11. High-Wire Stunts — 4:09
12. Remembering Petticoat Lane — 2:48
13. Jurassic Park Gate — 2:04

Side D
14. Eye To Eye — 6:32
15. T-Rex Rescue & Finale — 7:40
16. End Credits — 3:26

A STEVEN SPIELBERG FILM
UNIVERSAL PICTURES PRESENTS AN AMBLIN ENTERTAINMENT PRODUCTION SAM NEILL LAURA DERN JEFF GOLDBLUM AND RICHARD ATTENBOROUGH "JURASSIC PARK"
LIVE ACTION DINOSAURS STAN WINSTON FULL MOTION DINOSAURS BY DENNIS MUREN, A.S.C. DINOSAUR SUPERVISOR PHIL TIPPETT SPECIAL DINOSAUR EFFECTS MICHAEL LANTIERI
MUSIC BY JOHN WILLIAMS FILM EDITED BY MICHAEL KAHN, A.C.E. PRODUCTION DESIGNER RICK CARTER DIRECTOR OF PHOTOGRAPHY DEAN CUNDEY, A.S.C.
BASED ON THE NOVEL BY MICHAEL CRICHTON SCREENPLAY BY MICHAEL CRICHTON AND DAVID KOEPP PRODUCED BY KATHLEEN KENNEDY AND GERALD R. MOLEN
DIRECTED BY STEVEN SPIELBERG

GEFFEN UNIVERSAL MUSIC Special Markets AMBLIN ENTERTAINMENT SPECIAL VISUAL EFFECTS BY INDUSTRIAL LIGHT & MAGIC dts DIGITAL SURROUND A UNIVERSAL PICTURE UNIVERSAL MOND-017

editing for the film, and as a result, Williams incorporated the dinosaur "voices" created by sound designer Gary Rydstrom into the score. In an interview appearing in the 2004 book *The Dolby Era : Film Sound in Contemporary Hollywood*, Rydstrom explained the process. "I was able to play [Williams] some of the dinosaur vocals that I had created early on. He thought of them in terms of the pitch, so he would say 'That dinosaur is a cello, this dinosaur feels more like flutes,' and then he was able to think about it in terms of writing the music and orchestrating it for those scenes. This is pretty rare, but it works well when it happens."

Williams' work is synonymous with larger than life orchestrations, and *Jurassic Park*'s score is indeed as enormous and roaring as the movie's prehistoric stars, using percussion, harps, horns, choir and exotic woodwinds for something

expansive. Synthesizers also play a major role, however, sometimes up front in the mix and sometimes acting as an emotional undercurrent or doubling for various instruments.

Jurassic Park was released in 1993 through MCA, mainly on CD which was befitting of the time, though some vinyl editions made their way out there as well, including a European picture disc. This version of the score stitched many of the film's cues into longer passages and included music that never actually appears in the film. A digital edition containing four bonus tracks selected by Williams was released in 2013 for the film's 20th anniversary and to coincide with a 3D theatrical re-release. The following year, Mondo began releasing numerous vinyl LPs of *Jurassic Park*. While the musical content mirrors the original 1993 edition, this is not surprisingly the

most beautifully packaged version of the score, with artwork by J.C. Richard. Collectors have their choice of variants, but a green and yellow with red splatter version remains one of the most sought after. Meanwhile, a four-CD set from La-La Land Records that contains an expanded version of the score, along with that of sequel *The Lost World*, came out in 2016. Clearly there is more of Williams' music preserved, and ready to live again on vinyl.

The Philadelphia Experiment

An adventure beyond time.

RHINO RECORDS
RNSP 306

ORIGINAL SOUNDTRACK

THE PHILADELPHIA EXPERIMENT

Composer Ken Wannberg might be better known as the music editor to the stars. He began his career working for the likes of Bernard Herrmann, on *Journey to the Center of the Earth* (1959), and has worked with John Williams on most of his projects, including the *Star Wars* and *Harry Potter* films.

The Philadelphia Experiment (1984) is one of Wannberg's few genre films as composer (he also scored Canadian horror films *Of Unknown Origin* and *The Changeling*). Opening with sustained, dissonant strings – perhaps taking a cue from

Williams' intro to *Close Encounters* – the music segues to period jazz cues to establish the film's 1940s setting. Wannberg employs snare drums and horns to provide military ambiance, and maintains his use of discordant strings in the background of early cues to suggest that something is awry with the group of sailors, among them rising '80s star Michael Paré. Largely orchestral, Wannberg judiciously inserts electronic effects on some cues (e.g., "Time Slip," found on the expanded CD) to suggest the fantastical nature of the story, as Paré's character is warped through

time. (Speaking with David Hirsch for *Soundtrack* magazine in 1995, Wannberg explained his use of synth in the film: "Maybe the audience doesn't consciously realize it, but subconsciously it's there.")

The album was released by Rhino Records in 1984, then in 2011 BSX Records issued the complete score (plus some source cues) on CD, coupling it with Wannberg's work on *Of Unknown Origin*. Still, the most curious recording might be an electronic pop single from Germany's The Splash Band, which cut a 12-inch in 1984 titled "Das Philadelphia Experiment" (ZYX Records), in which they use executive producer John Carpenter's name to sell their record, even going so far as to erroneously list him as the composer (!).

STV 81282

THE MANHATTAN PROJECT

Music Composed by
PHILIPPE SARDE

THE MANHATTAN PROJECT

Made at the height of the Cold War movie trend, which gave birth to all kinds of fantasies involving tensions between the American and Russian superpowers and their nuclear toys, *The Manhattan Project* is essentially a kids-in-peril fable. In the 1986 film, a gifted high school student builds an atomic bomb with some pilfered plutonium and enters it into a science fair, exposing a secret weapons program and creating a slew of other problems in the process. The movie bombed at the box office (pun completely intended), though certain critics praised it as a

clever and sophisticated little thriller. Director Marshall Brickman, as a student and collaborator of Woody Allen, was no hired schmuck, and for *The Manhattan Project* he brought in respected French composer Philippe Sarde with whom he had worked on romantic comedy *Lovesick* (1983).

Though not frequently discussed among critics, Sarde's work on *Manhattan* is deceptively complex and rises above the sort of standard genre fair you would expect in this sort of '80s flick. Yes, *The Manhattan Project* includes drama, suspense, science experiment montages, romance and

coming-of-age tropes, but instead of simply creating individual musical themes for each of these narrative arcs, he concocts a suite of music that encapsulates it all. Beginning with dark, suspense-laden electronics, the score quickly gives way to a swirling, enveloping orchestral suite dominated by woodwind and brass instruments. Glowing themes in "Ithaca" and "The Gadget" invoke the listener with deep varied emotions, which raise Saarde's work above your typical action thriller.

In the 2010 CD reissue of the score from Varèse Sarabande, the composer explained his approach as "music should only add something extra that the images haven't provided." The label issued the score as an LP at the time of the film's release, and it waits to be rediscovered.

Label: Varèse Sarabande / STV 81282 Format: LP Year: 1986 Art: N/A

STV 81349

THE HIDDEN

MUSIC COMPOSED BY MICHAEL CONVERTINO

1987 New Line Cinema Inc. All Rights Reserved

THE HIDDEN

Appropriate given its title, no one really talks about *The Hidden* these days, though it's considered a cult classic in underground circles. Starring a young Kyle MacLachlan in a body snatchers-type premise, the 1987 movie has an orchestral-electronic score by the similarly obscure Michael Convertino, a reclusive composer whose work on the film is considered somewhat of an overlooked gem.

Opening with the electronic "Main Title" carrying tinges of Brad Fiedel's *Terminator* score, Convertino creates an ominous melody that

warns of the dangers beneath the surface in the film's narrative. The composer later shifts things into more elegant territory using harps and strings within the track "Transference." Both sides to *The Hidden*'s instrumentation work to create a world where no one really knows what to expect or believe. According to director Jack Sholder, Convertino's inventiveness wasn't initially appreciated.

"He turned in a score that seemed to perversely ignore the rules of the genre, and we all hated it but New Line didn't have enough money to throw it out and get a new one," he told *Paracinema* in 2014. "I did a lot of work on the score, re-editing some of it and overdubbing to push it more toward the genre, but the mixers hated it so much they mixed it way down. When we heard the final mix I said you can't have music that low, and they

brought it back up. Five years later I watched *The Hidden* at a film festival and realized Michael's music was part of what made the film feel original, and I wrote him a letter to apologize."

While the score was released with the film through Varèse Sarabande in 1987, the movie credits advertised a soundtrack would be available through I.R.S. Records covering the number of goth and alternative rock songs used in the film by The Lords of the New Church, Hunters and Collectors and Concrete Blonde (the band's "Over Your Shoulder" also appeared on I.R.S.' *Texas Chainsaw Massacre 2* soundtrack). Reportedly these tracks were chosen to replace others that were initially used in the film until New Line Cinema realized they were too expensive to license.

 Label: Varèse Sarabande / STV 81349 Format: LP Year: 1987 Art: N/A

THE ORIGINAL MOTION PICTURE SOUNDTRACK

TRANCERS

MUSIC COMPOSED BY
MARK RYDER AND PHIL DAVIES

TRANCERS

A rare foray into pure sci-fi by Charles Band, better known as the B-movie maven behind the *Puppet Master* and *Subspecies* films, *Trancers* has a unique premise: cops from 2023 travel back in time to the 1980s by possessing the body of an ancestor. A retro-present cop movie set in 1984 you say? Cue the synth score performed on low budget keyboards, this time courtesy of relative unknowns Phil Davies and Mark Ryder.

Overseen by Charles' brother and frequent composer Richard Band, *Trancers*' music took

some inspiration from the '40s film noir genre that influenced lead character Jeth Deth. No, there are no smoky sax solos to be found here but there is a certain sultry moodiness to Davies and Ryder's lush synth pads and steady beats, which touch the same territory as Harold Faltermeyer's *Top Gun* music. Minor keys play a role throughout the film, from the romance between Deth and ancestral girlfriend Leena (played by Helen Hunt, who unbelievably returned for two sequels) to even the harmonies used in action cues. *Trancers* is the first in a franchise of six films (and counting), so much

of the series' main themes are developed here, including a haunting, buzzing number that sears over the opening and end credits.

It took until 2015 for the *Trancers* score to be released on LP, through Full Moon Records. The following year Intrada released a 2xCD that covers the first three films in the series but, oddly, features a truncated version of Davies and Ryder's first effort, the reverse of what you'd expect when going from vinyl to CD.

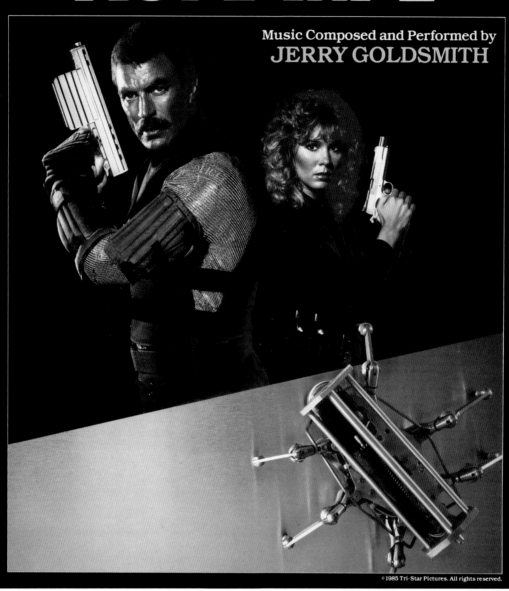

RUNAWAY

Science fiction master Michael Crichton never quite found success directing movies like he did with writing novels, but his career as a director did result in some cult classics along the way. Case in point: *Runaway* (1984), about a future where robots have replaced all illegal immigrants in the USA by performing domestic tasks and working the fields. Gene Simmons plays an evil scientist who wishes to reprogram the droids to help him take over the world, and despite all this silliness there was Jerry Goldsmith handling composing duties, this time with his first all-electronic score.

Goldsmith aimed to create a traditional orchestral score simulated by electronics (with the assistance of his son Joel). One might suspect this choice was based on budgetary reasons, but in a movie where humans are being replaced by robots, there could be legitimate thematic reasons at play. Though some of *Runaway*'s score does indeed reflect a synthetic version of organic orchestral playing (and thus contributes a respectable amount of atmosphere), much of the score uses badly outdated samples that are far too harsh. Whether it's the action set pieces or suspense cues, the notes seem to jump out of the screen instead of melding with the story. One could imagine the far less revered composer John Carpenter doing a much better job with this material. Still, while *Runaway*'s score doesn't beg to be enjoyed as an album, it does contribute significantly to the

film's '80s VHS rental nostalgia. The final credits sequence offers the most enjoyable, neon-colored '80s track of the entire film.

The original Varèse Sarabande LP was released shortly after the film in 1985 and presented the score in a truncated 38-minute version. In 2006 and 2014 the label released identical, deluxe 44-minute editions on CD, but this version has yet to make it to vinyl.

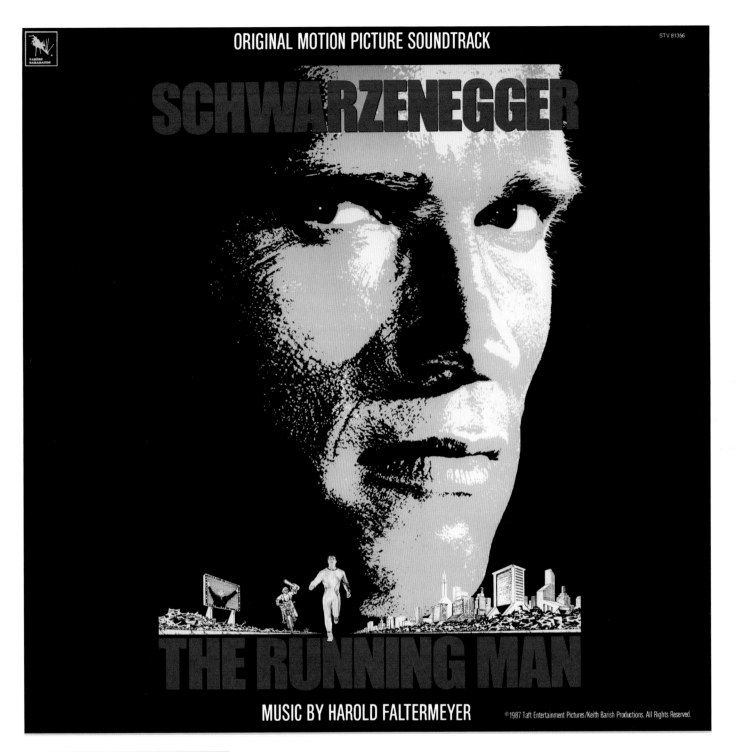

THE RUNNING MAN

In *The Running Man*, based on a Stephen King story in name only, Arnold Schwarzenegger is forced into a deadly futuristic gladiator game show. It's the quintessential '80s film, full of over-the-top WWF-esque characters (one of whom is played by actual wrestler Jesse "The Body" Ventura), brutal violence and eye-rolling puns. As such, the 1987 film needed the ultimate synth-score. Enter Mr. Synth himself, Harold Faltermeyer, who had achieved fame composing memorable anthems for *Beverly Hills Cop* (1984) and *Top Gun* (1986), his music now inspiring

modern synthwave artists such as Carpenter Brut.

Opening with "Intro – Bakersfield," *The Running Man* makes its presence felt with dark synth pads over a fantastic hook. Evoking moonless summer nights in a world populated by high tech military assassins, Faltermeyer's atmospheric score is right up there with Brad Fiedel's *The Terminator*. We're then treated to "Main Title – Fight Escape," a higher energy number that approaches outrun territory.

What's even more fun is that each of the colorful villains Schwarzenegger's character fights gets his own intro theme. Buzzsaw gets some appropriately loud heavy metal riffs, Fireball's "Fireball Intro" is slightly more symphonic, while Subzero's theme is cold whooshing ambience before some of the

cheesiest keys this side of *Tango and Cash* kick in. One particularly inspired moment is "Captain Freedom's Workout" – you can practically feel the leg warmers brushing through your speakers. Faltermeyer also manages to cover several works of classical music, including Richard Wagner's "Ride of the Valkyries," updating them for the cocaine and palm tree set.

Released on vinyl by Varèse Sarabande in '87 and by Colosseum (Germany) in '88, *The Running Man* LP is today a highly-sought after collector's item, even though it's missing the movie's power ballad, "Restless Heart" by Faltermeyer and John Parr ("St. Elmo's Fire (Man in Motion)"). Thirty years later, Faltermeyer's keys still bring the neon.

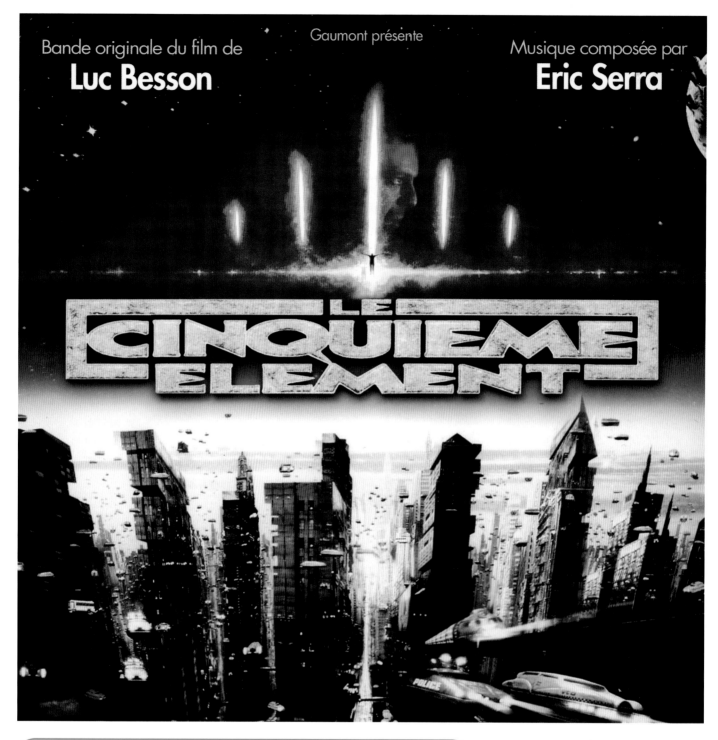

Bande originale du film de
Luc Besson

Gaumont présente

Musique composée par
Eric Serra

LE CINQUIEME ELEMENT

THE FIFTH ELEMENT

If ever there was a divisive sci-fi summer blockbuster, Luc Besson's *The Fifth Element* most definitely is it. Yes, the 1997 movie made a gazillion dollars at the box office and most people remember it fondly, but those who hated it hated it a lot, some even sliding it into "so-bad-it's-good" territory. But that's what happens when you blend sci-fi, western and comedy, load a story with larger than life characters and take artistic inspiration from comic books. The score had to match the utter insanity of the film, so likely your opinion of composer Eric Serra's music will match your overall impression of *The Fifth Element*.

Music is a prominent storytelling device in the film, meaning there is a lot of it and it's completely all over the place. Though grounded in steady orchestral pieces to augment battle and sense-of-wonderment scenes, *The Fifth Element*'s score also manages to include military suites, reggae, rap, techo and even Hawaiian hula music. There's even an entire two-part opera performance taken from a diegetic moment (meaning the characters in the movie can hear the music): "Lucia Di Lammermoor" and "The Diva Dance," based on a classic 19th century tragic opera. If that's not enough, the album finishes with "Aknot! Wot?,"

a reworking of main character Korben Dallas' theme, complete with dialogue and sound effects from the film, including female orgasms. The enjoyment derived from a score is so often tied to viewers' opinion of the film, and perhaps through no other score is the impact of that statement felt greater. As absurd as Eric Serra's music may be, it's the only score that would work in Luc Besson's kaleidoscopic vision.

A late-'90s staple, *The Fifth Element*'s score was originally released on CD by Virgin Records, where it achieved #99 on the Billboard 200. The vinyl resurgence saw it appear on double LP in France on Wagram Music, and then via Mondo in the US (this version included a white-with-orange-stripes variant that referenced Milla Jovovich's character), both released in 2017.

 Label: Wagram Music (France) / 3346816 **Format:** 2xLP **Year:** 2017 **Art:** Laurent Lufroy

THE BROTHER FROM ANOTHER PLANET
ORIGINAL SOUNDTRACK MUSIC BY MASON DARING

A Film by JOHN SAYLES

THE BROTHER
FROM ANOTHER PLANET

An A-TRAIN FILMS, INC. Production

Cinecom

MASON DARING ON THE BROTHER FROM ANOTHER PLANET

In John Sayles' allegorical *Brother From Another Planet* (1984), a mute alien slave of unknown origin (Harlem-born actor Joe Morton) crash lands in Harlem, where he's pursued by Men in Black. The filmmaker wanted a multi-ethnic score that would touch on the various immigrant groups who made up Harlem at the time, so he turned to composer Mason Daring to write a number of thematically appropriate, Motown-inspired songs, as well as the incidental score. Daring recalls their collaboration.

What conversations did you have with Sayles when designing the score for this film?

Well it was a $300,000 film, and since the protagonist doesn't speak, Salyes didn't need a sound guy, so he was able to shoot it cheap. He took the money he saved and put it into the music. So the music budget for that film was $30,000. That's 10 percent of the overall budget! I have never heard of that in a movie. He said he did it because he needed a slick sounding score. He said "I need strings, I need songs, and I need the songs to be produced so that they sound like pop hits."

You collaborated with a number of artists on the soundtrack. Who were some of your favorites to work with?

There were a number of them. "Burning My Heart Out" by Ren Woods was great. Woods sang "Age of Aquarius" in the movie *Hair*. She is a great studio singer from L.A. I got her because I needed something that sounded like a hit and oddly enough that song later became a dance hit at something called American Dance Club down the east coast.

Label: Daring Records / DR 1007 **Format:** LP **Year:** 1984 **Art:** N/A

CHAPTER

5

POP

**GROOVES FROM
ANOTHER GALAXY**

The Goonies..'R'Good Enough
Cyndi Lauper

I Got Nothing
Bangles

Wherever You're Goin' (It's Alright)
REO Speedwagon

She's So Good To Me
Luther Vandross

What A Thrill
Cyndi Lauper

14K
Teena Marie

Love Is Alive
Philip Bailey

Save The Night
Joseph Williams

Eight Arms To Hold You
Goon Squad

Theme from The Goonies..
Dave Grusin

STEVEN SPIELBERG Presents
THE GOONIES™
A RICHARD DONNER Film
ORIGINAL MOTION PICTURE SOUNDTRACK

THE GOONIES

Admittedly, *The Goonies* falls at the very edge of the spectrum of the criteria for this book - there's nothing overtly supernatural or fantastical about Richard Donner's 1985 film, assuming you can get past the improbable series of subterranean booby traps leading to One-Eyed Willy's treasure and concealed ship, or the arsenal of gadgets created by "Data" Wang. But, the hell with it, we love *The Goonies* and its soundtrack.

Anchoring the album is the title track, Cyndi Lauper's infectious Top 10 single "The Goonies 'R' Good Enough." (Note that Cyndi originally titled the song "Good Enough," but Warner Brothers tacked on "The Goonies 'R'" for marketing appeal.) Lauper, who served as the film's musical consultant, appears in a tiny cameo in the film in an MTV-style clip, singing the title song on TV as a young Josh Brolin is busy exercising. That snippet appears to be an outtake from Lauper's extended two-part music video, which was also directed by Richard Donner. The video is perhaps even more entertaining than the film, as it uses the same sets, silent film subtitles, a Steven Spielberg cameo and featuring general craziness involving Captain Lou Albano and other WWF wrestlers. It plays like a fermented version of the movie's plot, channeling the fantastical energy of *The Goonies* in a completely different way.

The remainder of the album is filled with a solid roster of '80s talent. REO Speedwagon is represented with the mid-tempo "Wherever You're Goin' (It's Alright)," which is punctuated with bright keyboards and a hummable anthemic chorus. That's essentially the case for the bulk of the songs, which are given less emphasis in the film than Dave Grusin's score, but they cohere nicely on the album. Standouts include Philip Bailey's "Love Is Alive" and Goon Squad's synth-heavy "Eight Arms to Hold You."

The soundtrack was issued by Epic Records in 1985 and does feature one cut from Dave Grusin's score, "Theme from The Goonies," although the lively music that everybody remembers can be found on the album, which was released by Varèse Sarabande on CD in 2010, and later on vinyl in 2018.

Label: Epic / SE 40067 Format: LP Year: 1985 Art: Drew Struzan

MUSIC FROM THE MOTION PICTURE SOUNDTRACK

FEATURING:
OINGO BOINGO
THE BROKEN HOMES
CHEYNE
WALL OF VOODOO
WILD MEN OF WONGA
TAXXI
MAX CARL
KIM WILDE
THE LORDS OF THE NEW CHURCH
KILLING JOKE

WEIRD SCIENCE

At the time Danny Elfman got his big break scoring *Pee-Wee's Big Adventure* for Tim Burton, he was simultaneously fronting New Wave band Oingo Boingo, which provides the infectious title track to John Hughes' 1985 cult comedy *Weird Science*. The punchy brass fills, Frankensteinian call-out "It's Alive!" and Elfman's refrain of the title are still bouncing around our brains some 35 years later.

Interviewed in 2014 by Sean O'Neal for *A.V. Club*, Elfman explained that the song came quickly after a call from director John Hughes and a commute

home. "I literally wrote it [in my head] while I was talking to him...And by the time I got home, I pretty much had it in my head. I ran down to my studio and recorded it and sent it out. That and *The Simpsons* were created the same way. I mean, literally from a conversation that was in my head, I managed to not lose it or turn on the radio and have it erased long enough to get down to my studio and record it."

The balance of the soundtrack is another '80s pop compilation album, which the Hughes films helped to popularize, though given the film's silly premise (teen boys use computers to create Kelly LeBrock to boost their popularity and win girlfriends), the emphasis is not on the kind of longing romanticism that buoyed soundtracks such as *Pretty in Pink* or *The Breakfast Club*. Instead, the album is rounded out with agreeably bouncy New Wave music and

power pop. Cheyne scores a solid take on "Private Joy" with the requisite amount of groove to salute original artist Prince; Taxxi's "Forever" is full of big, shiny guitar licks; and Killing Joke's "Eighties" is a loud, rambunctious stomper. That's not to say the album is without a few wistful power ballads: Max Carl's tuneful "The Circle" and Kim Wilde's mid-tempo "Turn It On" are both worthy of a slow dance.

MCA released the initial album in 1985; it was subsequently re-released by Geffen in 2015. Warning: listening to it might make you strap a bra to your head; we're not judging.

Label: MCA Records / MCA-6146 **Format:** LP **Year:** 1985 **Art:** Duane Meltzer

BACK TO THE FUTURE

Be careful to keep that turntable set on 33 1/3 RPM and not 88 – because there are so many gigawatts of pure power pop in the hot-selling *Back to the Future* soundtrack that listening to it may zap you back to 1985.

Anchored by two killer songs from Huey Lewis and the News, the big hit here is "Power of Love," featured prominently in Robert Zemeckis' 1985 film. The punchy synthesizers and tight percussion keep the record rocking around a riff that won't leave your head.

Reminiscing about the song in a 2015 interview for *People* magazine, Lewis recalled that the inspiration came from his own family. "It was 1985, and I was married in '83 and had two kids, one born in '84 and one in '85. And that was what that was about." The song gave the band its first number one *Billboard* hit, and was nominated for an Academy Award. Just as good is their other contribution, "Back in Time," which kicks off with a piano crescendo that segues into yet another killer hook, this time punctuated with guitar and saxophone.

The album also devotes tracks to the period music heard in the film. For example, Etta James' "The Wallflower" nicely underscores Crispin Glover's nervous attempts to ask Lea Thompson out on a date.

Best of this bunch are the trio of songs from The Starlighters, that fictional band playing the "Enchantment Under the Sea" dance, with vocals from "Marvin Berry" (cousin to Chuck), played and sung by Harry Waters, Jr. Interviewed for the book, Waters recalled how his vocals ended up on the finished soundtrack, which began with listening

Label: MCA Records / MCA-6144 Format: LP Year: 1985 Art: Drew Struzan / Jeff Adamoff / Georgopoulos / Imada Design, Inc.

FROM THE MOTION PICTURE *BACK TO THE FUTURE*

to the original recording by The Penguins a few times. "I wasn't trying to do their version of it, because I have a different kind of voice. It was a whim. [The filmmakers] had to record me for the click track while we were shooting so there would be something we could be responding to. Alan Silvestri asked if I would be interested in singing for the soundtrack. I said, sure, why not. It was just another gig. I had no idea that it was actually going on the soundtrack and the album." Waters, who'd only been given script pages concerning his scenes, also had no idea about the scope or scale of the picture. "The orchestra coming in with the band [for the coda of the song] was not something that was even heard [on set]. It was a big surprise and nobody knew it was going to happen."

Although not the radio hit of the film, "Earth Angel" still resonates years later. "It's great when I go

to conventions and fan events," Waters recalls, "people walk up to me and say they got married to my version of 'Earth Angel.'" Working now as a university professor, Waters is usually questioned by his first year students if he's the same person as the one in the film. "Yes, I can still sing the song. Usually there's a moment at the end of the semester, when I usually have a [party] – sort of last moment when they're filling out student evaluations and if they're good, then I will sing the song."

"Earth Angel" segues to Marty McFly's inspirational take on Chuck Berry's "Johnny B. Goode." The track plays conventionally on the finished album, but in the film builds through several styles and eras of rock, including Pete Townsend-like power chords and some Van Halen-inspired finger tapping. Waters notes that "Michael J Fox also

played it [on set]. He was a musician and he could play the song, and in the film, Michael was singing the track, but then they had Jack Mack [aka Mark Campbell] on the finished track." The song itself only got green-lit at the eleventh hour, Waters recalls. "They even told me we're not sure we can do this song until we hear from Chuck Berry. It was less than two weeks [before filming] when he finally said "yes." Chuck Berry made sure he got his money."

MCA released the compilation soundtrack in 1985. Intrada then devoted a CD to Alan Silvestri's score in 2015, which was followed by a vinyl release from Mondo in 2018.

Label: Chrysalis / VS4 42876 **Format:** 7-inch **Year:** 1985 **Art:** N/A

FROM THE ORIGINAL MOTION PICTURE SOUNDTRACK

XANADU

FEATURING

ELECTRIC LIGHT ORCHESTRA OLIVIA NEWTON-JOHN

XANADU

Xanadu might be one of the bigger WTF moments in music history. The 1981 musical fantasy film is actually a remake of the Rita Hayworth musical comedy *Down to Earth* (1947), starring Olivia Newton-John and Gene Kelly in his final film role. The film was received so poorly by audiences it became one of the inspirations for today's infamous Golden Raspberry Awards. And yet the soundtrack album, which teamed Newton-John with British prog rockers Electric Light Orchestra (!), was a massive commercial success, going double platinum in the U.S. Today this ubiquitous

record is still beloved by many, though almost always as some sort of guilty pleasure.

Side A was written by long-time Newton-John producer John Farrar (the man behind "You're the One That I Want" from *Grease*) and features her solo contributions, as well as collaborations with Kelly, Cliff Richard and The Tubes. If you blush at the sight of Newton-John, this sugary pop will be up your alley, in particular the memorable "Magic," as well as "Dancing," in which she trades sultry vocals with The Tubes' high energy rock before the two collide in a glitter tsunami.

Side B of *Xanadu* will appeal to a different set and is revered by ELO fans as some of the group's best work, though completely written by co-founder Jeff Lynne. The cheese factor remains the same, however, with bubblegum tracks such as "I'm

Alive," though the more melancholy "Don't Walk Away" offers something weightier. The record ends with Newton-John and ELO collaborating on the film's title track, which would go on to become a number one hit – the only time Lynne ever had one.

Because Newton-John and ELO were signed to separate labels at the time, a deal was reached in which MCA could release *Xanadu* in North America while ELO's Jet Records would handle it everywhere else.

The soundtrack actually resulted in a number of singles, arguably the most successful of which was "Magic." The first track released from the album, it reached #1 on the US Billboard Hot 100 where it remained for four weeks during the summer of 1980. Because MCA and Jet Records still held joint

rights, the B-side for the MCA 7-inch was "Fool Country," another song from the film that does not appear on the soundtrack album while Gene Kelly's "Whenever You're Away from Me" appears on the B-side of the Jet release.

The title track by Newton-John and ELO was reportedly Lynne's favorite song he ever wrote, and reached #1 in the UK. In 2000 Lynne re-recorded the song, using his own vocals, for the ELO box set *Flashback* as well as the compilation *All Over the World*. Speaking of which, the track "All Over the World" by ELO also charted well. More recently, audiences may have noticed the song playing during the trailer and the climax of Simon Pegg/ Nick Frost sci-fi alien comedy *Paul*.

So if you crave some classic roller boogie, you've got options. Don't be embarrassed, pick up the *Xanadu* vinyl, and dust off your skates. It's time to get busy.

Original Motion Picture Soundtrack
by Giorgio Moroder and Klaus Doldinger

LIMAHL ON THE NEVERENDING STORY

Lost in our school time memories of watching *The NeverEnding Story* – a prototypical '80s children's fantasy film if there ever was one – is that it's actually a German production by Wolfgang Petersen, the same guy who was nominated for a couple Academy Awards for *Das Boot* (1981). In the original German version, Klaus Doldinger, a jazz musician who scored Petersen's masterpiece, composed an effective though not particularly striking orchestral score with added synth work. In its U.S. release, *The NeverEnding Story* (1984) was partially rescored by Giorgio Moroder

who was on fire at the time as a Hollywood composer, known for his groundbreaking work with synthesizers and electronic dance music, representing the '80s style better than a Pac-Man arcade machine.

Without a doubt Moroder's main contribution, and what '80s kids all remember, is a newly composed theme song sung by English pop star Limahl, fresh from being fired by new wave band Kajagoogoo after their breakthrough hit "Too Shy." "The NeverEnding Story" lives on in immortality, especially after being featured prominently in

Stranger Things Season 3's most obnoxiously retro moment. In an exclusive interview for this book, Limahl discussed how the song came to be.

How did you come to work with Giorgio Moroder on "The NeverEnding Story"?

After Kajagoogoo broke up, my first single was called "Only for Love" and the record label, EMI, suggested I perform at the Tokyo Music Festival, which Giorgio was involved with. My manager was an Irish guy named Billy Gaff who had been the manager of Rod Stewart through his heyday. Billy was kind of a mogul, really, in the music industry. Very flamboyant. He went to dinner with Giorgio and probably told Giorgio "Limahl's going to be the biggest thing since sliced bread." Well, Giorgio's studio was in Munich, and in Germany Kajagoogoo were on the front cover of practically

LIMAHL

every magazine including these massive teen magazines called *Bravo* and *Pop/Rocky*. Because *NeverEnding Story* was a kid's movie, and based on a kid's book, Giordio made the connection. He called my manager and asked "Does Limahl want to come over and try this?"

What was the recording experience with Moroder like?

The night before I flew to Munich I was up all night partying, I was smoking cigarettes, drinking, and got about four hours sleep. I just barely made it to the flight and arrived in Munich with no voice. I was 23, and when you're that age you think you're indestructible. We tried to sing the song in the afternoon about three or four o'clock, and I couldn't really do it. Giogio was very calming in his successful, authoritative, knowing way. He'd

say "Hey Lim, don't worry. We have some dinner, a little wine, and we try again. Don't worry." Looking back now he was probably worried.

How familiar with Moroder were you at the time?

Are you kidding? I was all over the Donna Summer stuff he produced. I was a geek at school. I saved my money from delivering papers or delivering bread or whatever to buy records. I would go into the record shop all excited and be, like, "What record am I going to buy this week?" It was usually a single, it was all I could afford.

What was it like the first time you saw the film?

I was invited to the premiere in Europe somewhere. It was nice, I saw it on the big screen, I heard my song. The press was there and it was a bit of a red carpet thing, there was a party

afterward with drinks and canapes. It was fun. I was 23, I just had a song and an album that went #1 all over the world. So there I was, this kid from a small town, with a very poor family, and suddenly I was riding this crest of a wave and really enjoying the fact that I set out to make a living in entertainment, as a job. Because I remember when I used to buy the records I would think, "This must be work to somebody, so I want to do that work." I met all these other stars, Tina Turner, Sting from the Police. "NeverEnding Story" was just another chapter in that three-to-fouryear period in my life. Andy Warhol said everyone gets fifteen minutes of fame in their life, I got three-to-four- years, which was great fun.

FROM THE ORIGINAL SOUNDTRACK OF THE JIM HENSON FILM

Labyrinth

FEATURING
DAVID BOWIE

Underground

Magic Dance

Chilly Down

*As the World
Falls Down*

Within You

AND
ORIGINAL SCORE
BY
TREVOR JONES

©TRI-STAR PICTURES, INC. ALL RIGHTS RESERVED

SV-17206

LABYRINTH

Though the genesis of Jim Henson's *Labyrinth* is often recounted as beginning with a meeting between Henson and artist Brian Froud, it's possible that the catalyst for the 1986 film might well have been composer Trevor Jones. According to Jones, during their junket interviews to promote *The Dark Crystal* (1982), Henson asked him about what kind of film they might next collaborate on. Interviewed in 2017 by Gorka Oteiza for SoundTrackFest.com, Jones told Henson, "Let's do a rock movie. Your muppet formula works for the big star and the

animatronics and puppetry, so why don't we find a rock star and build a movie around [him or her]? We could use a couple of human beings and the rest animatronics."

Apparently, it was Jones' suggestion to approach David Bowie, who took on the role of Jareth the Goblin King. Bowie, who had disappeared into various fantastical stage personas and guises such as Ziggy Stardust and Aladdin Sane, easily slips into the ambiguous role. Bowie seems to be having a great time in the film (panto-tights, frizzy hair, codpiece and all), and he explained his enthusiasm for the project in a 1986 interview for *Movieline*. "I'd always wanted to be involved in the music-writing aspect of a movie that would appeal to children of all ages, as well as everyone else, and I must say that Jim gave me a completely free hand with it."

Henson was also keen to give the musical side of the film over to Bowie after the larger symphonic approach he'd taken with *The Dark Crystal*. Interviewed in 1985 for the *New York Times*, Henson noted, "[The] *Dark Crystal* had a symphony orchestra. *Labyrinth* will have the funkier sound of David Bowie's music."

As such, Jones' score becomes more of an accompaniment to Bowie's songs. Jones eschews the large orchestral canvas from *Crystal*, making use of synthesizers, and various pop textures, such as adding drums and bluesy saxophone to cues like "Hallucination," which culminates with the wistful piano chords that open Bowie's "As the World Falls Down."

To perform the pop tracks, Bowie and producer Arif Mardin assembled a roster of top-notch session

 Label: EMI America / SV-17206 Format: LP Year: 1986 Art: Ted Coconis / Chris Werner / Henry Marquez / Carol Chen

Album version can be heard on the soundtrack of the Jim Henson film

Labyrinth

Executive Producer
George Lucas
Director
Jim Henson

DAVID BOWIE
UNDERGROUND

musicians, including Robbie Buchanan, who you'll hear playing the bending synth figure that gives a mysterious intro to "Magic Dance." Buchanan, in an interview for this book, recalls his time working with Bowie a particular delight: "David was a dream to work with very supportive and interested in everything that was done. He would pretty much let us do our thing and wait for the outcome. Arif, David and I went out to dinner one night at a great restaurant in New York. I was so spellbound by him that I could hardly contribute to the conversation. He was a true gentleman and incredibly charismatic. This has rarely ever happened to me. A real treat for sure!"

"Magic Dance" remains the catchiest number in the film. In fact, the movie stops for the raucous party song, with Bowie leading a dungeon full of muppets, making use of Buchanan's punchy synth work to keep things peppy. The cut heard on the soundtrack album thankfully restores Bowie's vocals, swapped out in the film so that the goblin cronies can sing along, too.

The film is bookended by two takes of Bowie's other pop number, "Underground," which really shines in the gospel-infused version that plays over the end credits. Running nearly six minutes, the song continues to expand on the "plastic soul" sound Bowie experimented on with *Young Americans* (1975) through to the pop experiments on *Let's Dance* (1983).

The balance of the songs work nicely around Bowie's haunting vocals, particularly on the mournful "As the World Falls Down," and the minor-key-driven "Within You." And then there's "Chilly Down," the one cue lacking Bowie's vocals, but still an equally boppy/disturbing number featuring trickster muppets who menace poor Sarah (Jennifer Connelly) by pulling their eyes out and kicking their heads around like soccer balls.

The album was released in 1986 from EMI, which also issued a 7-inch of Bowie's "Underground." The album was reissued in 2017 from Capitol Records.

ORIGINAL SOUNDTRACK MUSIC BY QUEEN

HOWARD BLAKE ON FLASH GORDON

Though actor Sam J. Jones, who plays the titular intergalactic superhero in Dino De Laurentiis' moderately successful *Flash Gordon*, insists they all played it straight, it's difficult to believe this 1981 sci-fi comicstrip adaptation was ever intended to be more than a camp classic. Perhaps serving as proof was the hiring of Queen to compose the score, a band known for its wild theatricality.

Still, for Queen guitar great Brian May, it was an opportunity that the band took seriously. As he explained in John Tobler and Stuart Grundy's 2013

book *The Guitar Greats*, "We would be writing a film score in the way anyone else writes a film score, which is basically background music, but can obviously help the film if it's strong enough. That was the attraction, because we thought that a rock group hadn't done that kind of thing before, and it was an opportunity to write real film music. So we were writing to a discipline for the first time ever, and the only criterion for success was whether or not it worked with and helped the film, and we weren't our own bosses for a change."

The result is a soundtrack album that was

probably better received than the film itself, and the most unique entry in Queen's discography. Released on December 8, 1980 by EMI Records in the U.K., and in February 1981 by Elektra Records in the U.S., the *Flash Gordon* album only featured two actual songs with lyrics: "Flash" (now used to sell smartphones) and "The Hero." The rest is surprisingly moody and atmospheric instrumental tracks that do in fact function as a bonafide sci-fi score, and not the rock opera one would expect. There is one caveat, though. Howard Blake was also hired to compose a score for *Flash Gordon*, and the English composer receives songwriting credit on two of the album tracks, including "The Hero."

He takes us back to working on the film at the dawn of the '80s.

You're credited as the co-arranger with Queen for the instrumental portions of Flash Gordon. How did the collaboration work?

I wrote the whole orchestral score. I was somewhat misrepresented afterward by Queen and their lawyer. The "flying in" scenes and all that, that's all me and the National Philharmonic Orchestra. There are many other cues. I think towards the end it goes more and more Queen. On the album *Flash Gordon*, the credits I have are "The Hero," but I did a considerable amount of music in the film.

I heard you were brought onto the film at the 11th hour, replacing a composer who'd penned 1.5 minutes of score?

Queen had said they would provide the score. I was called in at the very last moment because in fact

they hadn't written the score. They farmed it out to an arranger who said he would do it and he only managed to produce a minute and a half of music by the time they got to the sessions. I was called in by Dino De Laurentiis and people from Universal, and they were all in a terrible panic. They asked if I could write a complete musical by Monday. I said no one on Earth could do that. I worked on it that summer and I had a terrible time because there was a huge amount of music to finish and there was no time, and afterwards I collapsed from exhaustion.

Were there any positives in working with Queen?

There is a section of the score called "Flight to Arboria," which is a very nice theme. That was written half by Freddy Mercury and half by me. Freddy called me and said "I have a tune in my

head and I wonder if you can do anything with it." He sang it and I told him that it's a great tune. I finished it for him.

Your music eventually ended up getting a release, along with your score for Amityville 3D, on CD from Super Tracks in 2000 – was it gratifying to finally get to have a record of the score as a physical release?

Yeah. Super Tracks Music did it and it's coupled with my music for *Amityville 3D*. It's a pretty good score. Recently a girl produced a documentary called *Life After Flash* about *Flash Gordon* and on that; I am given equal billing with Queen. I think she's trying to set the record straight.

Label: EMI (UK) / EMI 5126 Format: 7-inch Year: 1980 Art: N/A **119**

Ray Parker Jr.

GHOSTBUSTERS

The Blockbusting Theme from the Ghostbusting Movie

GHOSTBUSTERS / GHOSTBUSTERS II

Audiences have known the answer to the question "Who you gonna call?" for the past 36 years, thanks to Ray Parker Jr's Academy Award-nominated #1 hit theme song for the summer of 1984's biggest movie, *Ghostbusters*. (Note the backwards ghost featured on the UK single cover above.) Given how much the song contributed to the film's success, it was appropriate that Arista's 1984 soundtrack LP kicked off with Parker Jr.'s immortal Halloween party classic and featured only two tracks from Elmer Bernstein's under-discussed incidental score: the quirky "Main Title

Theme" and a theme for Dana Barrett (Sigourney Weaver). Recently there's been more interest in Bernstein's dark and masterful score however, highlighted by a 2019 2xLP from Sony Classical.

Bernstein was a legend from Old Hollywood in 1984, having scored the likes of *The Ten Commandments*, *The Magnificent Seven*, and *The Great Escape*. At the time he had been working in somewhat lesser fare, including *Ghostbusters* director Ivan Reitman's *Meatballs* and John Landis' *Animal House*, which Reitman produced, and was the obvious choice. As with Reitman's previous comedies, the director wanted Bernstein to play it serious and not create anything too obviously comical. To produce the eerie sounds that play frequently in the film, including in its opening moments, Bernstein used the ondes Martenot,

essentially a keyboard version of the similarly spooky sounding theremin.

Ghostbusters was a unique film for its time – a mix of comedy, blockbuster action, fantasy and horror – and Bernstein reportedly struggled to create the right balance. Along with the ondes Martenot' ghostly sounds, the composer came up with a janky semi-ragtime theme for the actual *Ghostbusters*, as well as much Spielbergian wonder and magic in other tracks.

Of course, Reitman intended all along to use pop songs in the film, and when it was realized he had a winner on his hands, Bernstein's main theme was quickly swapped for Parker Jr.'s soon-to-be-classic. Though the rest is history, as they say, and there is no questioning the popularity of the song, it does seem that audiences are ready to rediscover

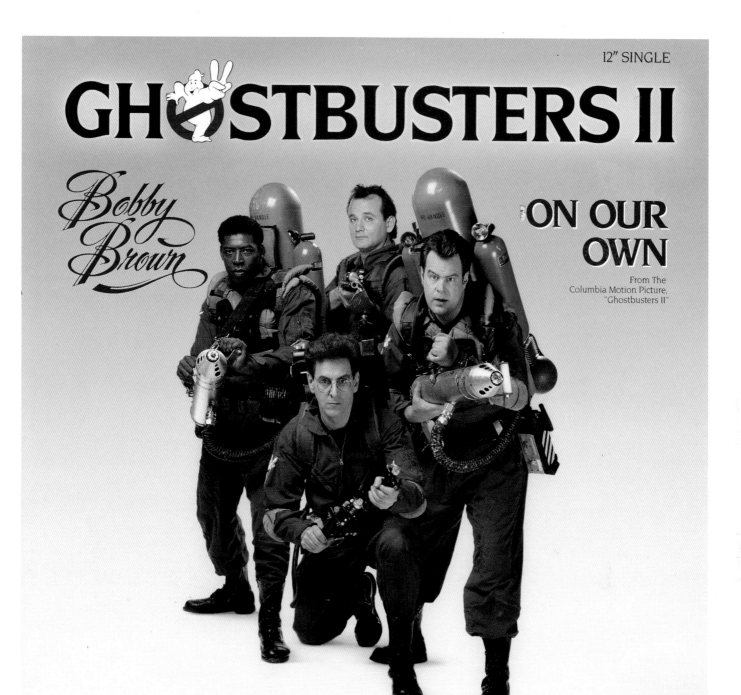

GHOSTBUSTERS II

Bobby Brown

ON OUR OWN

From The
Columbia Motion Picture,
"Ghostbusters II"

MCA-23957

COPYRIGHT © 1989 COLUMBIA PICTURES INDUSTRIES, INC. ALL RIGHTS RESERVED

Bernstein's score as an imaginative hit in its own right.

Given *Ghostbusters'* success, a sequel was inevitable, and it came five years later, but this time it was up against the likes of Batman, Indiana Jones and the Last Crusade and more. Knowing of course that so much of the original movie's success was tied to a killer theme song, the *Ghostbusters II* braintrust set out to create a similarly successful soundtrack. First off, Parker Jr. helped rework his original hit to be performed by Run-DMC, luring in a hipper crowd. (The song popped up as the B-side on Legacy Recordings' 2014 marshmallow-scented 12-inch.) However, the king of pop at the time, or perhaps New Jack swing, was Bobby Brown, who was coming off a series of hits, including "Every Little Step,"

"Don't Be Cruel" and "My Prerogative." His label, MCA, was offered the exclusive rights to the *Ghostbusters II* soundtrack in return for Brown's services. Realizing he was the lynchpin to the deal, Brown agreed to perform a new song if he could get a part in the film. Though shooting had mostly wrapped, director Ivan Reitman wrote a bit part for Brown to play the mayor's assistant, in which he even got a few lines to showcase his acting chops. Though it never matched the success of Parker Jr's song, Brown's *Ghostbusters II* theme "On Our Own," in which he raps about proton packs and the evil ghost Vigo, reached #2 on the Billboard Hot 100 for three weeks and remains a staple of his shows to this day.

"On Our Own" is also remembered for its epic video with cameos from Rick Moranis, the Ramones and

Donald Trump! Other sweet rap tracks that pop up on the album include Brown's other contribution "We're Back," "Spirit" by Doug E. Fresh & The Get Fresh Crew and "Flesh N' Blood" by Oingo Boingo, which actually barely appears in the film, something that angered a certain Hollywood composer named Danny Elfman.

Though it made over $200 million, *Ghostbusters II* brought in less than the original, and when you combine that with the generally poor reviews it received, the sequel is now remembered mostly as a flop. Brown's track is probably one of the film's only true successes and can be found on MCA's 1989 LP and the 2014 reissue. It was also released as a 7-inch and 12-inch single when the film came out.

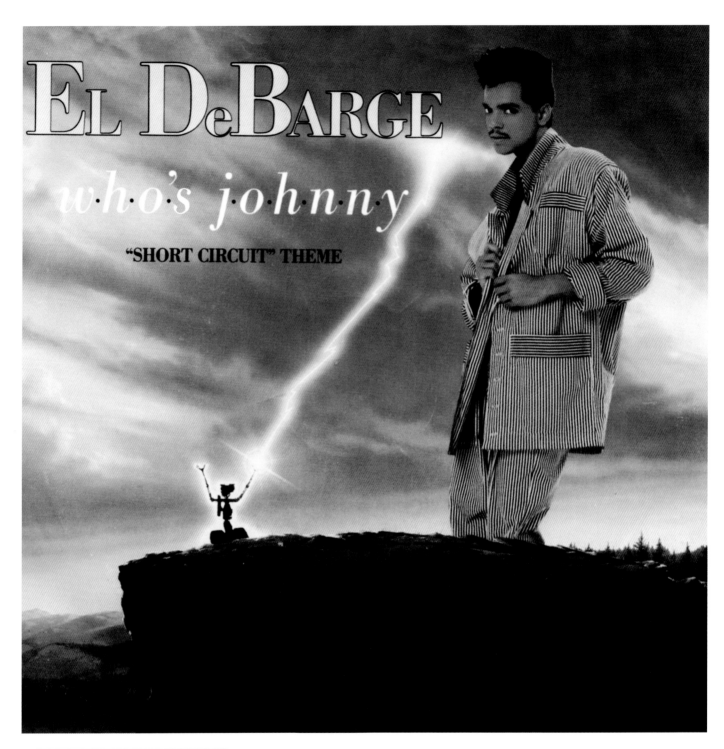

EL DeBARGE

who's johnny

"SHORT CIRCUIT" THEME

SHORT CIRCUIT

Breaking away from his original pop group of siblings (who'd had success with "Rhythm of the Night"), El DeBarge scored a solo hit with "Who's Johnny." The single was featured in the 1986 film *Short Circuit*, centered around Johnny 5, the cutest robot until *Wall-E.*

The song plays in the film as a military robot "Number 5" — struck by lightning and given a conscience — escapes in a van, proceeds to flip through the radio, past some country twang, and lands on a station playing — you guessed it — El DeBarge's "Who's Johnny." Cranking up the tune,

the robot takes its hands off the wheel to dance and shake its hands, causing the van to swerve from lane to lane. By the film's conclusion, the song has inspired Number 5 to change its name to "Johnny" Five.

The bouncy pop tune was courtesy of producer/ arranger Peter Wolf and co-written with his partner Ina, who also scored pop movie hits with Go West's "King of Wishful Thinking" from *Pretty Woman*, and Kenny Loggins' "Playing With The Boys" from *Top Gun*. Interviewed in Adam White's 1993 *The Billboard Book of Number One Rhythm & Blues Hits*, Wolf recounted that "I wrote the song one morning, literally lying in bed. I woke up and I was toying with the idea and the whole thing was right there."

The accompanying video, in which El DeBarge

seems to be defending escaped robot Johnny Five in court, managed to recruit the film's female lead Ally Sheedy for a role in the courtroom proceedings (with a black-and-white cardboard cutout of a seemingly jailed Steve Gutternberg, conspicuously absent from the video - in addition to the titular robot, only seen in video "evidence").

The film itself featured a score from David Shire, teaming up again with director John Badham after their previous pop-based collaboration on *Saturday Night Fever* (1977's other big soundtrack to beat). Shire's score was eventually released on CD from Varèse Sarabande in 2008, while El Debarge's single was released as both a 7" and 12" from Gordy/Motown in 1986.

 Label: Gordy / 1842 GF **Format:** 7-inch **Year:** 1986 **Art:** N/A

STARSHIP
NOTHING'S GONNA STOP US NOW

FROM THE TWENTIETH CENTURY FOX
MOTION PICTURE

Mannequin

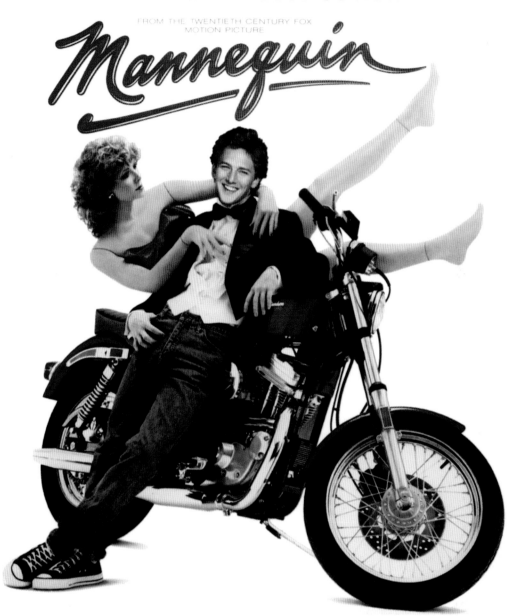

MANNEQUIN

If you ever watched *Lars and the Real Girl* (2007) and wished for an earlier incarnation of the story, only slightly more sanitized and fantastical, look no further than the 1987 fantasy *Mannequin*. Here dreamy Andrew McCarthy falls in love with a department store mannequin he assembled, and which appears to him (and him only) as the dazzling Kim Cattrall. Cue all kinds of hysterical mishaps, in which McCarthy is seen riding around on his motorcycle with a leggy store prop.

One of the things helping to solidify the romantic verve of the film is Starship's hit single, "Nothing's

Gonna Stop Us Now," written by Albert Hammond and Dianne Warren, and with the distinctive vocals from Grace Slick and Mickey Thomas. Thanks to radio airplay, the song has outlasted the film in our collective memories, hitting the top spot on Billboard's Top 100 in 1987, and nabbing an Academy Award nomination for Best Original Song (losing out to *Dirty Dancing*'s "(I've Had) The Time of My Life.")

The song makes repeated use of a yearning, descending chord sequence that's replicated in both verse and chorus – and thankfully doesn't wear out its welcome for the duration of the song. Hammond himself re-recorded the song (as a duet with Bonnie Tyler) in 1989, and Filipino duo MYMP provided a decent acoustic cover in 2006.

Despite the huge success of the song itself, no soundtrack album was ever released, save for the hit single in 1987 from Grunt Records – which is a bit of a shame, given that Sylvester Levay's score does much to capture the unorthodox romance of the movie. The song would later pop up at the conclusion to the 1991 sequel *Mannequin Two: On The Move*, this time starring future *Buffy* film star Kristy Swanson as Jessie the mannequin.

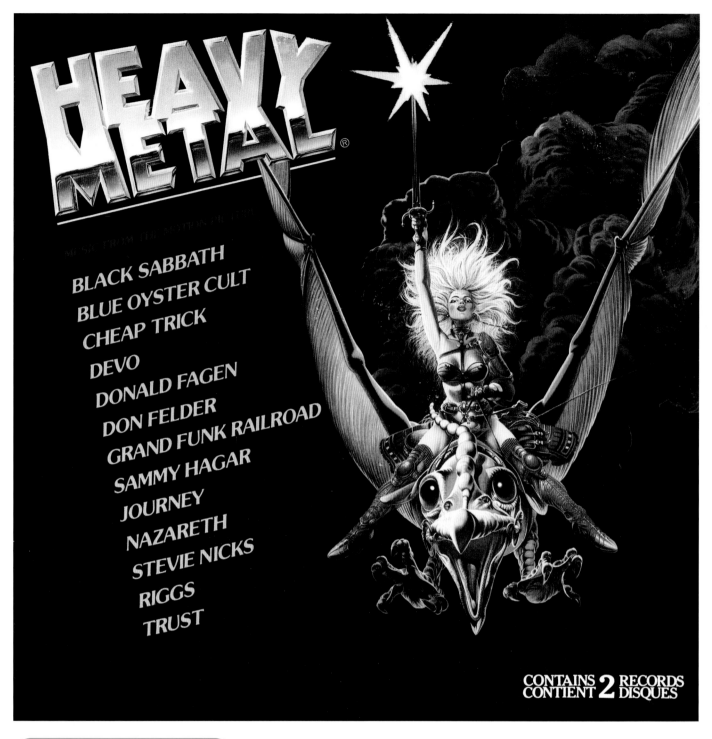

BLACK SABBATH
BLUE OYSTER CULT
CHEAP TRICK
DEVO
DONALD FAGEN
DON FELDER
GRAND FUNK RAILROAD
SAMMY HAGAR
JOURNEY
NAZARETH
STEVIE NICKS
RIGGS
TRUST

CONTAINS **2** RECORDS
CONTIENT **2** DISQUES

HEAVY METAL

The summer of 1981 was a hesher's highlight, as producer Ivan Reitman brought an animated version of American adult sci-fi/fantasy comic magazine *Heavy Metal* to theaters. The comic was known for gratuitous sex and violence, and the film brought enough of that to the screen (it was shocking to see all those cartoon boobies at the time) albeit set to tunes that existed more on the periphery of actual heavy metal, and sometimes right outside of it. Then again, the genre was still in its relative infancy.

The soundtrack featured not one but two title tracks, with Don Felder (of the Eagles) providing the main theme song "Heavy Metal (Takin' a Ride)" which hit #43 on the Billboard 100, though Sammy Hagar's "Heavy Metal" is probably better remembered as it kicks off the album (a different version appeared on Hagar's 1981 *Standing Hampton* LP). Blue Oyster Cult contributed "Veteran of the Psychic Wars" after the group had originally written "Vengeance (The Pact)" for one of the segments, both of which appeared on the band's recent *Fire of Unknown Origin* record. Devo appears with a cover of "Working in a Coal Mine," which offers listeners a chance to step outside and smoke a doob or just lift the needle entirely. Cheap Trick's "Reach Out" is a rockin' good time and might capture the energy of the film better than

any other. Finally, Black Sabbath, the band that essentially wrote the book on heavy metal, needed an appearance so "The Mob Rules" from the then-upcoming second Dio-era album plays during a bloody battle scene. This version was again different than the one on the *Mob Rules* album and is generally considered to be superior.

Any time big name bands and movies mix, there is the potential for trouble, and sure enough, due to licensing issues, *Heavy Metal* could not be released on CD until 1995 and the movie itself didn't make it to home video until 1996. Fortunately, the 1981 2XLP through Asylum Records worked and sounds great, especially over a night of beer, weed and headbands. The label released a 140-gram version in 2017.

MUSIC FROM THE ORIGINAL MOTION PICTURE SOUNDTRACK

REPO MAN

BANDE ORIGINALE du FILM

IGGY POP

BLACK FLAG

SUICIDAL TENDENCIES

THE PLUGZ

JUICY BANANAS

THE CIRCLE JERKS

BURNING SENSATIONS

FEAR

REPO MAN

Alex Cox created perhaps the greatest punk rock movie of all time with 1984's *Repo Man*. In it, a typical suburban punk (Emilio Estevez) and a grizzled repossession agent (Harry Dean Stanton) team up in pursuit of a car that turns out to be connected to aliens. The film captured the early '80s punk vibe perfectly – drunkenness, violence, extreme cynicism and nihilism – and it needed a soundtrack that could capture that zeitgeist. The result is a snapshot of the L.A. hardcore punk scene, peppered with songs from punk's past and outer limits.

The opening title sequence plays to the song "Repo Man" written for the film by Iggy Pop, after the Godfather of Punk saw an early film print (also cool: Sex Pistols guitarist Steve Jones plays on this track, effectively connecting the genre's beginnings to its then-evolved state in L.A.). Other tracks come in that were staples of the scene, including "TV Party" by Black Flag, "Institutionalized" by Suicidal Tendencies and "Coup D'Etat" by Circle Jerks, making the soundtrack serve as a primary resource in Punk Rock 101 for those whose first exposure to this music was through the film. If you were already hip to the scene, *Repo Man* made for a pretty good mixtape. Meanwhile, L.A. new wave band Burning Sensations provides a weird cover of The Modern Lovers "Pablo Picasso," indicating that in the case of *Repo Man*, "punk" was an

attitude that could extend to anything outside the mainstream, as opposed to a strict musical style.

MCA (technically subsidiary San Andreas Records, developed to market and make the album appear more punk rock than a major label would) released the *Repo Man* soundtrack, and it did surprisingly well, as did the quirky film. Whether or not you have a copy on your shelves remains the litmus test of your true punk cred.

MIKE RENO AND BILLY SQUIER ON METROPOLIS

When Giorgio Moroder produced his release of Fritz Lang's *Metropolis* in 1984, it was considered a partially lost film, with major portions of the original 1927 print having been excised and subsequently gone missing. But Moroder's effort works well as a tight 83 minutes, and uses subtitles along with color tinting to provide a "modern" feel and look, with much of the effect coming from a completely updated synth-based and song-driven score, using a range of artists such as Freddie Mercury and Bonnie Tyler. All of the songs play out for their entire duration,

effectively underscoring Lang's visionary world, making it undeserving of the Golden Raspberry nomination it picked up in '84.

Billy Squier, who had been in Germany with producer Reinhold Mack, met with Moroder, which led to his performance of "On Your Own," heard as privileged hero Freder (Gustav Fröhlich) helps one of the workers in the subterranean realm under the titular city. "Giorgio gives me a copy of the film," Squier recalled when interviewed for this book. "He'd basically [already] written the music for it. He'd done little demos – synthesizer/

drum machine demos of the music...I looked at it and thought it was a great film. I was definitely interested and Giorgio left me this music, so I heard something I liked. I said 'I could work on that one.' He said, 'Great, it's yours.' ... I redid some of the other parts, I redid the drums, [but] I was true to his original [take]."

Squier was in the minority of artists able to rework existing lyrics. "With all due respect I didn't buy all of [the original lyrics]," he says, "I didn't feel that it was all it could be. I wanted to make the song more of my own, which is not a pun based on [track title]

Also On Cassette

7464-39526-1

"Metropolis" Was Reconstructed And Adapted By
GIORGIO MORODER

Director: Fritz Lang/Screenplay: Thea von Harbou
Starring Gustav Fröhlich, Brigitte Helm, Alfred Abel
Executive Producers: Michele Cohen, Keith Forsey,
Laurie Howard, George Naschke

Music Composed And Produced
By GIORGIO MORODER*
Lyrics By PETE BELLOTTE*

*Except: "Love Kills" Music and Lyrics: Freddie Mercury.
Giorgio Moroder; Produced By Freddie Mercury, Giorgio Moroder & Mack.
"Destruction" Produced By Giorgio Moroder & Paul Dean.
"On Your Own" Music And Lyrics: Giorgio Moroder, Billy Squier;
Produced By Giorgio Moroder, Billy Squier & Mack.
"Here's My Heart" Produced by
Neil Geraldo, Peter Coleman and Giorgio Moroder.
All Songs Published by GMPC (ASCAP); Except "Love Kills" Published by
GMPC (ASCAP)/Queen Music Ltd. (BMI). Administered by GMPC (ASCAP).
Original film provided by
Transit Film/F.W. Murnau-Stiftung

Columbia

℗ 1984/CBS Inc./ ℗ 1984 CBS Inc. Manufactured by Columbia Records/CBS Inc./51 W. 52nd
Street, New York, N.Y./ "Columbia," ⌾ and ⌾ are trademarks of CBS Inc. /WARNING: All rights
reserved. Unauthorized duplication is a violation of applicable laws.

Is A Trademark Of GME. Ltd.

NIKOSEY

The year is 2026, a Dickensian "best of
times, worst of times," where total oppression
and manipulation of the masses is wielded by the
unquestionable power of the few.
Far below the City of Metropolis is the Underground City
where machines are operated by the workers who live even
further below. Day after day, in mechanical routine, they are
forced to the limits of human endurance.
Fritz Lang made this film in 1926. Against his wishes the film was
subsequently shortened for its American release which left the
story disjointed, difficult to comprehend and caused the loss of
many scenes, most of which have disappeared forever.
By following the original script, the novel of the film, recently
discovered missing pieces of the film and photographs,
Metropolis has been restored as close to its original conception
as possible.
Lang once said: "To begin with I should say that I am a visual
person. I experience with my eyes and never, or only rarely, with
my ears—to my constant regret."

Metropolis is now presented with a contemporary score, sound
effects and colour.

'On Your Own.' I tried to keep whatever I could of what was there and take my impression of where I knew where he wanted to put the song. I wanted to try to inject my insights as a songwriter, hopefully to take it a step higher, which I did."

Loverboy also got involved with the soundtrack. The group's song "Destruction," plays as the robotic Maria leads a revolt of the subterranean workers to tear down the city. Interviewed for this book, lead singer Mike Reno remembers getting the gig. "First of all, if somebody named Giorgio Moroder calls, you just say 'yes' to what he's asking. He was in the big leagues. He couldn't do anything wrong. Basically, he called and we said 'yes' before we heard anything more about it. We were in Chicago because Loverboy was on tour at the time. What we did is take a couple of days to

go into the studio and bang this song off and mix it, [though] it got remixed by Giorgio."

Squier also enjoyed collaborating with Moroder. "I learned something that was quite significant from working with him. He is a master delegator. Giorgio is a producer, a writer, a composer, and he has his fingers in a lot of the aspects of making great records."

After flying into L.A. to mix his track at Moroder's studio, Squier remembers Moroder disappearing shortly after they got there. "We went up to his studio and his engineer was there, the track was up, and he introduced me. 'I've got to go do a couple of things,' [Giorgio] said, I'll be back in a while.' I start working with [the engineer] and [Moroder] doesn't come back. We mixed the track. The thing was done, and I'm waiting. Giorgio comes

back. He listens to it and says, 'It needs a little more bass,' and he leaves and that was it. So I didn't get any of the magic. I was so excited about getting to work with this genius, and this isn't a put down, because his genius is getting people who knew what they could do, and to let them do it. He got exactly what he wanted. After I got over that, I thought, well, he's got it together. He knows what he wants. It enabled him to do a lot of things and have a lot of irons in the fire."

EURYTHM!CS

1984

for the love of
big brother

1984

Based on George Orwell's famous novel of the same name, the film *1984* (also called *Nineteen Eighty-Four*) was released that titular year, dramatizing a dystopian society where individual thought leads to persecution. Perhaps ironically, the movie's score created some controversy, as Virgin Films financed the movie and pressured director Michael Radford to use a pop album by the Eurythmics that they had commissioned instead of the original score by Dominic Muldowney. The director refused to back down and eventually the label exercised their

right to final cut of the film and inserted the band's music against the director's wishes. Admittedly the Eurythmics' music made for an odd pairing with the film's dark subject matter, but it did result in a pretty solid album for Annie Lennox and Dave Stewart.

In November, 1984, a month after the film's release, Virgin (and RCA in the U.S.) released the Eurythmics' songs as the album *1984 (For the Love of Big Brother)*, which reached Gold status in the UK on the strength of single "Sexcrime (Nineteen Eighty-Four)." Like many of the tracks on the album, "Sexcrime" makes heavy use of a stuttering effect on Lennox's vocals while Stewart repeats "1984" through a vocoder. If the title seems odd, it refers to a Newspeak word, the language of the novel's fictional totalitarian world, and because of

its inherent controversy, the single didn't do nearly as well in the U.S.

1984 certainly makes for an experimental pop album, but with no memorable singles outside of "Sexcrime." "Doubleplusgood" (another Newspeak word) is likely the strongest track with its mix of world music drumming, cold synths and a TV news reporter voice. "Julia," another shimmering, mournful synth track, which plays over the film's closing credits, is based entirely around Lennox's haunting vocals. The songs on the album are all far more electronic sounding than they are in the movie, and it can be said that *1984* in some ways marked the end of the Eurythmics' electro-pop era before they became a more organic-sounding band.

In 2018 Virgin and RCA reissued *1984*, remastered and pressed on red vinyl.

Label: Virgin / VL 2318 Format: LP Year: 1984 Art: Sarah Quill / Howard Brown / Assorted iMages

ELECTRIC DREAMS

ORIGINAL SOUNDTRACK FROM THE FILM

CULTURE CLUB · GIORGIO MORODER
GIORGIO MORODER WITH PHILIP OAKEY
JEFF LYNNE · HEAVEN 17 · HELEN TERRY
P.P. ARNOLD

ELECTRIC DREAMS

Putting a digital spin on *Cyrano de Bergerac*, 1984's *Electric Dreams* is a fascinating time capsule showcasing the infancy of home computers. The film is eerily prescient about our reliance on them – though in lieu of Siri or Echo, we get the voice of Bud Court as a sentient desktop.

The soundtrack album never broke the same ground as other pop-oriented mixes from the era (*Flashdance*, *Footloose*, etc.), but is certainly worthy. It's kicked off by P.P. Arnold's title track, a sunny piece of pop that literally tells the story

of the movie, and is bolstered by Arnold's strong vocal performance, along with a cool guitar solo from Peter flipping Frampton! Sadly, pretty much all of Arnold's singing is dropped as the film opens with Miles (Lenny Von Dohlen) bumbling around the airport, but you can still hear the uncut vocals on the album.

It's a shame because Arnold's title song surpasses what ultimately became the soundtrack's hit new wave song, "Together in Electric Dreams," by The Human League's Philip Oakley and music producer/composer Giorgio Moroder (who has a cameo as a radio station bigwig right near the end credits). The album is ripe with other tuneful moments that are well interpolated in the film, such as a great bit in which Edgar the computer, given instructions to put a song together, manages to fiddle with tempo and a reversed Pepsi

commercial to create Jeff Lynne's catchy "Video," which plays over the film's falling-in-love montage, or Culture Club's dreamy "Love is Love." The movie does reach a point where it feels like director Steve Barron was cutting a demo reel to pitch MTV videos with, but that's part of the film's antiquated charm.

Largely dismissed by critics, *Electric Dreams* was favorably reviewed by Roger Ebert, who cited the music as one of the factors that set it above average, noting that Moroder "seems to compose the scores for half the films in Hollywood these days, but who has certainly found the right tone for this one." The album was released in 1984 from Epic.

THE GOLDEN CHILD

ROBBIE BUCHANAN ON THE GOLDEN CHILD

The 1986 Eddie Murphy fantasy *The Golden Child* features a fairly diverse pop soundtrack. For instance, metal group Ratt shares space with Heart's Ann Wilson. After initial composer John Barry bowed out, Michel Colombier stepped in to complete work on the score, with support from Robbie Buchanan on orchestration and synthesizers. Buchanan recounts his experience working on the soundtrack.

How did you get involved with The Golden Child?

Michel and I were very close friends. We did most of our projects together whenever possible, which generally meant that I would play on his arrangements and projects in the world of records, and produce/arrange/play on his movie projects.

You're the credited performer for "The Chosen One," Colombier's spritely theme. How did that come about?

The Golden Child was given to Michel when something went awry with John Barry, the previous composer for the movie. For the theme song, he asked me to produce the whole track.

I ended up playing most of the parts, except the guitars and horns.

Given John Barry's exit from the film, how quickly did the material have to be written and recorded?

Michel had only a few weeks to compose and record the entire score, and he called me to help with the arrangements and [to perform it]. I would go to Michel's house and go through the cues he wanted me to arrange. He would tell me how he wanted the treatment to be, [such as sounding] aggressive because [there was] no dialogue and the scene was violent; funky when appropriate; heavy rock when necessary, etc. The arrangements were all done to video. You'll notice certain changes that sync with camera angles/shots. It's tricky when you have comedy *and* fear mixed together.

EARTH GIRLS ARE EASY

Earth Girls Are Easy is a musical comedy science fiction B-movie mashup, but perhaps more than anything it's a product of its 1989 release date, loaded with neon colors, big hair and every '80s cliche you can think of. Heck, this movie is so '80s it was co-written by Julie Brown and features a couple of her songs, including an irrelevant mid-film music video for "'Cause I'm a Blonde," shot to pad the film's running time after too many scenes were cut during the editing process.

Indeed, the movie was a troubled production from the get-go and failed at the box office, yet it has retained a minor cult following for its silliness and pure '80s aesthetic – a big part of which comes from the songs that make up the *Earth Girls* soundtrack. Producer/songwriting god Nile Rodgers performs the title track, though it was written and originally performed by Brown on her 1984 *Goddess in Progress* album. Two songs from the film were released as singles, Royalty's "Baby Gonna Shake" (if it sounds like an unused early Madonna song, it was written by her ex Stephen

Bray) and Hall & Oates' cover of the O'Jays' soul classic "Love Train" ("Earth Girls Are Easy" was its B-side.) Interestingly, while star Geena Davis sings "The Ground You Walk On" in the film, on the album it's handled by Jill Jones, a backing vocalist for Prince.

Earth Girls Are Easy has its share of pointless songs, including Information Society's monotonous "Hit Me," but this film wasn't exactly aimed at Rhodes Scholars. When Julie Brown once sang "I Like 'em Big and Stupid" she could have been talking about this movie: goofy, loud, sexy fun. The soundtrack was released on vinyl and other formats at the same time as the film by Sire, and has yet to be reissued.

MUSIC FROM THE MOTION PICTURE

POPEYE

ROBIN WILLIAMS is POPEYE

SHELLEY DUVALL is OLIVE OYL

POPEYE

Popeye was a major studio production that makes one wonder how it ever came to be. Directed by Robert Altman who was in the midst of a major career slump, the lighthearted 1980 movie features Robin Williams in his first major role, as the spinach chomping sailor, and Shelley Duvall, fresh off her role in *The Shining*, as his love interest Olive. Oh, and did we mention it was a musical, with the actors singing live to film, and the songs were written by Harry Nilsson, who was well into a career nosedive, his voice destroyed by alcohol abuse? It all kind of worked

however, as a collection of misfits who came together and made movie magic.

Nilsson's songs use folk as their base, jazzed up with additional instrumentation including piano, banjo, horns, drums and violins, all combining to form the comic book tapestry of port town Sweethaven, where the action and romance takes place. The track "Sweethaven" is the closest Nilsson comes to his more accomplished past, with rich orchestration and tongue-in-cheek lyrics, while "He Needs Me" is a charming tune sung by Duvall, and "Blow Me Down" has Williams doing his best Nilsson impression. The actual score by Thomas Pierson deserves some praise as well; showcasing a surprising amount of darkness, and even horror, on tracks such as "Skeleton Cave."

The original soundtrack LP by Boardwalk Entertainment Co. contained slightly different versions of the songs in the film since those ones were recorded live while shooting, and it leaves out the hilariously simplistic "Everything is Food" but adds in the unused track "Din' We." Pierson's music wasn't released until Record Store Day 2016 when Varèse Sarabande released an LP on Black Friday that contained his score tracks "Rough House Fight" and "End Title Medley." The following year the label released a 2xCD containing the songs, score and even demos sung by the cast and Nilsson himself, often revealing the damage that had been done to his voice. The track "He Needs Me," actually features Nilsson teaching Duvall how to sing the song. Let's see a 2xLP of this release one day.

 Label: The Boardwalk Entertainment Co. / SW-36880 **Format:** LP **Year:** 1980 **Art:** Chris Whorf / Art Hotel

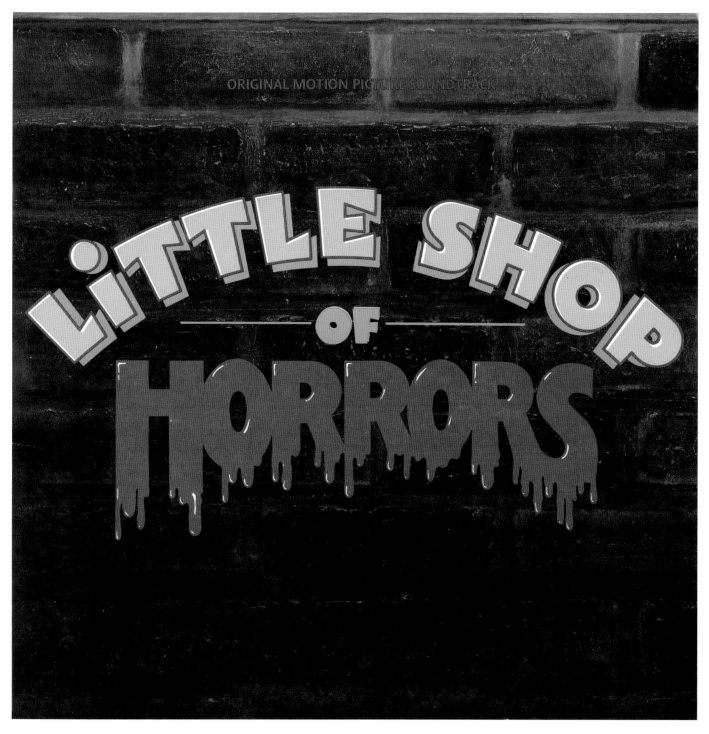

ORIGINAL MOTION PICTURE SOUNDTRACK

LITTLE SHOP OF HORRORS

LITTLE SHOP OF HORRORS

Before they helped spearhead the early '90s Disney animation revival with *The Little Mermaid*, *Beauty and the Beast* and *Aladdin*, the songwriting team of Howard Ashman (lyrics) and Alan Menken (music) scored a big off-Broadway hit in 1982 with their adaptation of Roger Corman's 1960 film *Little Shop of Horrors*. Co-produced by David Geffen, the play had a successful run at the Orpheum Theater in New York before Geffen and director Frank Oz adapted the musical into a successful 1986 film, although this meant re-shooting the original downbeat ending (which didn't sit well with test audiences, who wanted Rick Moranis's Seymor Krelborn to emerge as a hero, rather than plant food).

Interviewed for Playbill.com in 2015, Menken spoke about the tone he and Howard Ashman were trying to establish from the get-go: "Go for the first song. We wanted to establish a vocabulary. What is this show about? What's the tone? The show is a Faustian tale, sort of about the end of the world in a sort of laughing way. Look at Howard's lyrics – they're saying, oh, no, sturm und drang...and [yet] the music is saying this is fun."

The film drops several numbers from the original play, such as "Mushnik and Son" and dentist Orin Scrivello's "Now (It's Just the Gas)." But this gives the movie enough breathing space for the Levi Stubbs showstopper "Mean Green Mother from Outer Space," apparently the first song with some swears to get nominated for an Oscar.

The film's cast is top-notch, porting over Ellen Greene (Audrey) from the original stage production, and providing a hugely memorable role for Steve Martin as the sadistic dentist (whose hilarious take on "Dentist!" is so great that it warranted its own 7-inch single). But the soundtrack gets its biggest boost from Four Tops vocalist Levi Stubbs, whose deep baritone lends both humor and menace to intergalactic weed Audrey II.

Label: Geffen Records / GHS 24125 Format: LP Year: 1986 Art: Gabrielle Raumberger

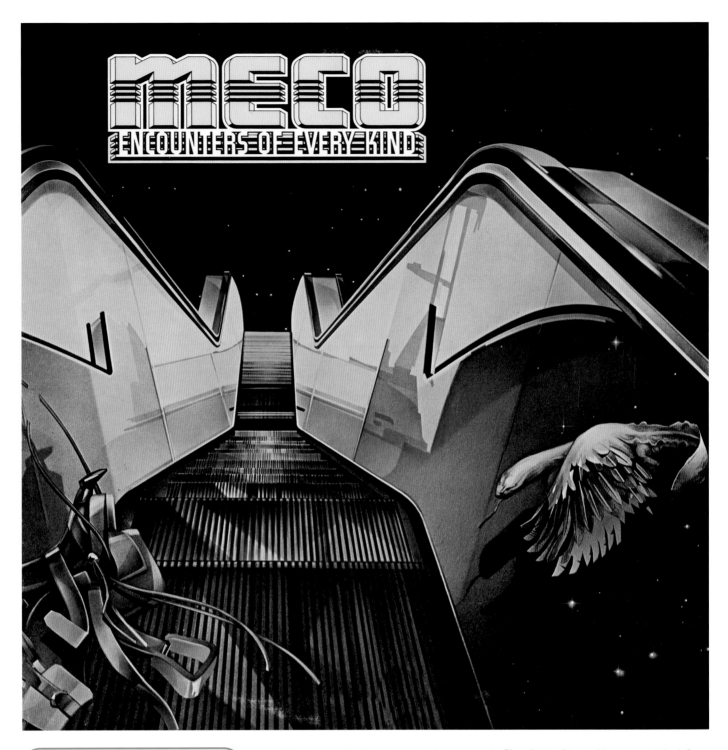

SCI-FI GOES DISCO

Space age sci-fi like *Star Wars* not only launched a whole new wave of orchestral soundtracks, it was perfectly poised to seize upon the disco trend encapsulated by 1977's other big hit, *Saturday Night Fever.* Often featuring evocative covers, thanks to disco, sci-fi became sexy again, helped in part by the most ubiquitous space disco album of them all, Meco Monardo's *Music Inspired by Star Wars and Other Galactic Funk* (Millennium, 1977).

Monardo, a session musician turned producer, struck gold (actually, platinum) with his *Star Wars*

record. Featuring an A-side with an extended medley of *Star Wars* music, including the main theme, Force theme, Princess Leia's theme and cantina band cues, the album also featured a B-side with the unrelated but sublime grooves of the three tracks "Other," "Galactic" and "Funk." Interviewed by Shane Turgeon in 2005 for Theforce.net, Meco spoke about generating his own futuristic synth-style sounds.

"The thing that made my record sound like I used synthesizers was that I would use certain tricks. For instance, every single time that the trumpets played the melodies, which they played quite a lot, I doubled that with an electric guitar. That kind of thing, the unusual doubling of instruments, led to the sound that people thought was synthesizers." The album sold over two million copies, landing Monardo in the *Guinness Book of World Records*

for "Best Selling Single of Instrumental Music." Both him and Williams were nominated for Grammy awards in the same category for their respective takes on the *Star Wars* music, with Williams beating out Monardo.

Meco followed up the album with a *Close Encounters*-inspired record (above) before tapping the Williams vein once again with a 10-inch titled *Meco Plays Music From The Empire Strikes Back* (RSO, 1980). Although not as big a seller, it's a solid disco representation of the *Empire* soundtrack, and Monardo gets some mileage out of cues you wouldn't imagine ever playing on the floors of dance clubs, including his take on Hoth action sequence "Battle in the Snow."

In the coming years, Meco looked beyond George Lucas epics to produce a number of other genre-

Label: Millennium / MNLP 8004 **Format:** LP **Year:** 1977 **Art:** Peter Palombi / Gribbitt!

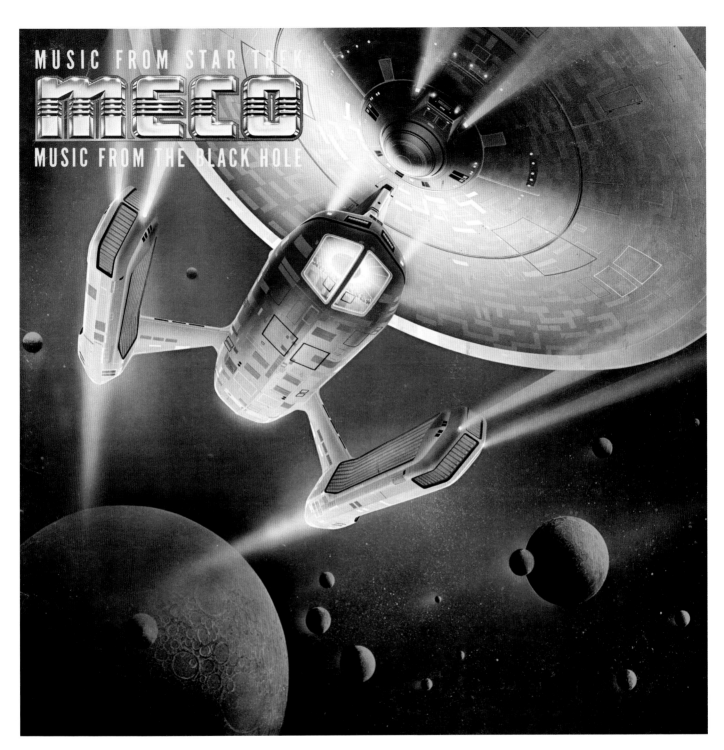

MUSIC FROM STAR TREK
MECO
MUSIC FROM THE BLACK HOLE

based albums; including *Meco Plays The Wizard of Oz* (1978, Millennium), *Superman & Other Galactic Heroes* (Casablanca, 1979), and, perhaps most notably, *Music From Star Trek and Music From The Black Hole* (Casablanca, 1980).

But Meco didn't have a monopoly on the space disco craze. Vincent Montana Jr. put out *A Dance Fantasy Inspired by Close Encounters of the Third Kind* (Atlantic, 1978), a mostly original composition that fleetingly plays with Williams' music, incorporating musical ideas from the movie, such as a sitar representing the cutaway in India, or the use of "When You Wish Upon a Star" for the film's culmination. Meanwhile, that same year, Giorgio Moroder produced *Music From Battlestar Galactica and Other Original Compositions* (Casablanca, 1978), featuring provocative wraparound cover art and his own fifteen-minute standout "Evolution."

The *Galactica* suite actually comes courtesy of Harold Faltermeyer (see Stu Phillips interview, page 186). And over in the U.K., Kenny Denton successfully fused Jerry Goldsmith's theme for *Alien* with dancehall beats under the moniker *Nostromo* (Bronze, 1979), as well as singles "The Black Hole" (Bronze, 1979) and "The Imperial March" (Bronze, 1980).

TV sci-fi also made great fodder for disco grooves, given that the themes for many of these series tended to be based around instantly recognizable hooks. British band Mankind was inspired by Meco's success and scored a hit on the U.K. singles chart with its take on Ron Grainer's theme in *Dr. Who?* (Pinnacle Records, 1978). That same year, The Universal Robot Band released its album *Freak in the Light of the Moon* (Red Gang Records, 1978), featuring the immortal "Disco Trek

(Star Trek Theme)" complete with spacey guitars riffing on the Alexander Courage title theme. Also appearing Stateside was Manhattan Transfer's "Twilight Zone/Twilight Tone" from the album *Extensions* (Atlantic, 1979), which begins with Maurice Constant's theme before breaking out into a vocal section with Rod Serling-inspired lyrics such as "When I hear this melody, this strange illusion takes over me; through a tunnel of the mind, perhaps a present or future time.... ."

With the onset of punk and heavy metal taking over the airwaves, the strange coupling of disco and sci-fi faded into obscurity, but at its peak, the space disco craze extended beyond movie and TV themes, such as Billy Preston's 1971 entry "Outa Space" or Manzel's 1977 "Space Funk." Dig it, baby!

CHAPTER

6

FAMILY FEATURES
MAGIC, WONDER & AMICABLE ALIENS

THE·ORIGINAL·SOUND·TRACK

THE DARK CRYSTAL

COMPOSED·BY·
·TREVOR·JONES·
PERFORMED·BY·
·THE·LONDON·SYMPHONY·ORCHESTRA·
·CONDUCTED·BY·
·MARCUS·DODS·

THE DARK CRYSTAL

Jim Henson and Frank Oz took a dark ride away from Muppets territory when they released *The Dark Crystal* in 1982, a feature-length animated puppet fantasy that lured children into theaters then delivered something a little more frightening than they expected. It also offered a fantastic orchestral score by Trevor Jones, which has garnered a dedicated cult following that led to a recent revival as a show on Netflix.

Jones got involved early during pre-production, which allowed him to see the development of the characters as they were being constructed.

Jones' music for the Skeksis and Mystics went down so well with Henson that it was played on set. Interviewed in 2004 by Sergio Benitez for bsospirit.com, Jones noted that "having the music underscoring all the shooting was fantastic into creating an ambient to the overall experience. It was perfect because it put everyone into the right mood, from the cameramen to the puppeteers." Ultimately, the lengthy eighteen months Jones had to compose the music meant that the finished product isn't at all rushed; and helps to add a sense of grandeur to the picture.

Jones initially wanted to approach the film with music that was as odd as the animated characters themselves, combining acoustic and electronic elements. Fearing the movie's concept was already strange enough, producer Gary Kurtz didn't want to alienate audiences further, so he

insisted instead on a more traditional orchestral score. Though on the surface *The Dark Crystal* is overpowering with its grand, sweeping suites, the score is also incredibly intricate, made up of a multitude of original themes that represent the numerous colorful characters in the film. Additionally, Jones was still able to remain true to Kurtz's request while integrating traditional instruments such as the double-flageolet, recorder, as well as utilizing Prophet 5 and Fairlight synthesizers.

One interesting cue is "The Pod Dance," a bouncy piece of diegetic music played as Kira takes Jen to see the Podlings, which originally featured finger cymbals, hurdy-gurdy (a medieval wheeled instrument), and vibraslap, amongst others. Several takes were recorded over March, April, and May of 1981, with instruments and melody

Label: Warner Bros. Records / 1-23749 **Format:** LP **Year:** 1982 **Art:** Brian Froud

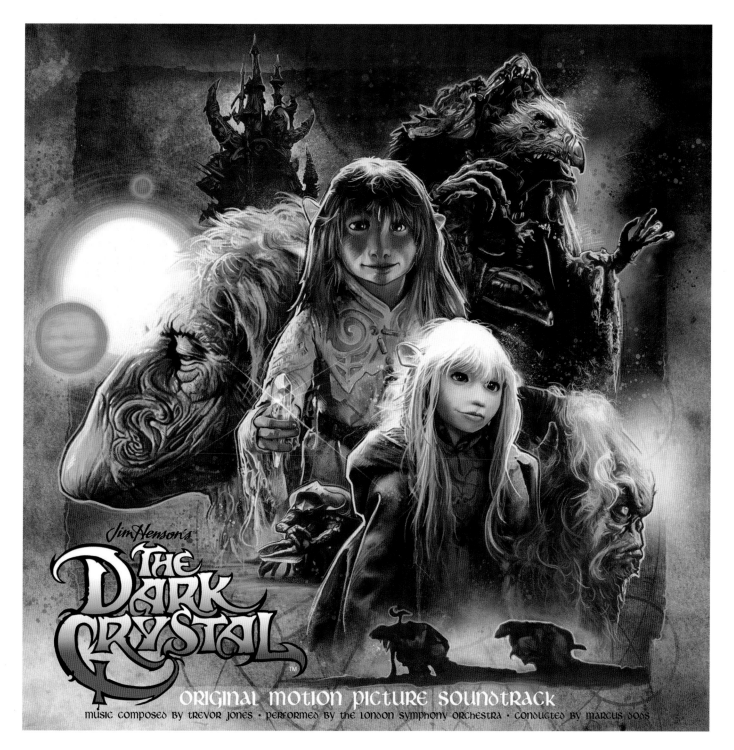

Jim Henson's

THE DARK CRYSTAL

ORIGINAL MOTION PICTURE SOUNDTRACK

MUSIC COMPOSED BY TREVOR JONES · PERFORMED BY THE LONDON SYMPHONY ORCHESTRA · CONDUCTED BY MARCUS DODS

changing before getting locked down for the picture.

In a brilliant move, Jones uses two primary, similar-sounding themes separately, allowing them to converge at the end of the movie when the titular crystal is unified and repaired, thus fulfilling the elf-like Jen's quest. Elsewhere, electronics are used to create sound effects, funereal cues and the religious-style chants during the film's climax. Overall, The Dark Crystal's score is heavy on romanticism and drama, never allowing itself to become too fantastical or accessible to children, and boasting more than its share of dark moments.

Ultimately, Jones delivered, according to his interview with Sergio Benitez, "one of the most exciting scores I've done in my career. Jim [Henson] knew that and that is was he was so

trustful. He knew how great the score would be, he just wanted me to discover it for myself."

The score was put out on vinyl by Warner Bros at the time of the film's release, in a 40-minute version rearranged for listening purposes. In 2003, Numenorean Music released a double CD containing a remastered 40-minute version, as well as a complete, expanded score, while in 2017, Enjoy The Ride Records reissued the original LP (pictured above). Clearly it's time for Jim Henson's colorful epic to get its due as a double LP.

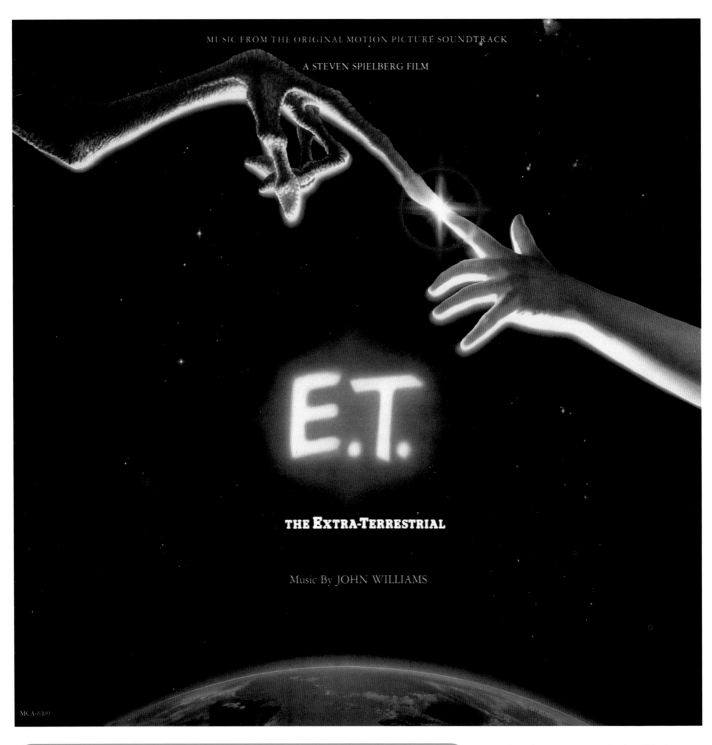

MUSIC FROM THE ORIGINAL MOTION PICTURE SOUNDTRACK

A STEVEN SPIELBERG FILM

E.T.

THE EXTRA-TERRESTRIAL

Music By JOHN WILLIAMS

MCA-6109

E.T. THE EXTRA-TERRESTRIAL

Steven Spielberg's *E.T. the Extra-Terrestrial* (1982) needs little introduction, other than to say it was one of the biggest movies of the '80s, has been ranked the greatest science fiction film of all time, and netted four Academy Awards, including John Williams' fourth, for Best Original Score. *E.T.* can probably be considered the height of Spielberg and Williams' collaborative relationship, when the two could seemingly do no wrong together, and after *Jaws* (1975), *Close Encounters of the Third Kind* (1977), and *Raiders of the Lost Ark* (1981), who could argue?

Williams' score for *E.T.* is perhaps the ultimate expression of Hollywood movie magic. The film itself is a timeless story of friendship in the face of abandonment, and Williams' music represents that spectrum of emotion through eight major themes delivered via precision orchestration using woodwinds, pipe organ, piano, harp and brass. In terms of audience recognition, however, "Flying" likely ranks number one, making its debut during the Halloween portion of the film and re-appearing over the end credits. The relationship between Spielberg and Williams was so close at this point,

that when the composer was having difficulty timing the music with the film's final chase scene, the director told him to just write what he wanted, and the movie would be edited around it.

Given the popularity of the film, it's not surprising that *E.T.*'s score has seen several releases since inception, beginning with an LP featuring 40 minutes of music that was a different recording (still by Williams) from what was used in the film. In 1996 MCA released a CD containing 31 extra minutes of music, but unfortunately left out some of the key selections from the original album. In 2002 Universal released a nearly complete CD for the film's 20th anniversary, but the ultimate version came in 2017, courtesy of La La Land – a double CD so complete that it even contains four minutes of music that Williams recorded for an amusement park ride. The label released a double LP the following year.

Label: MCA / MCA-6109 **Format:** LP **Year:** 1982 **Art:** John Alvin

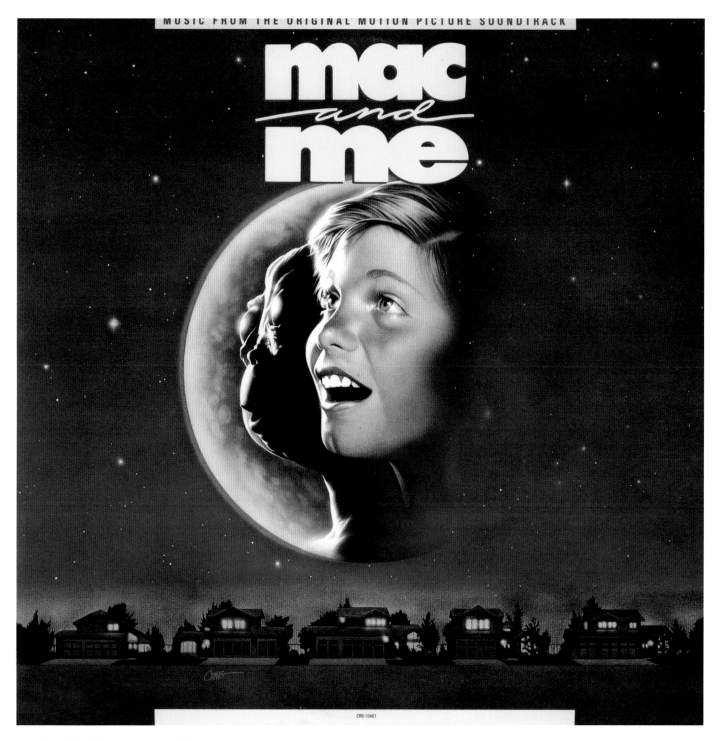

MUSIC FROM THE ORIGINAL MOTION PICTURE SOUNDTRACK

mac and me

CRB-10401

MAC AND ME

Ah yes, *Mac and Me*, the infamously panned, not so subtle rip-off of *E.T. the Extra-Terrestrial* that also doubled as an advertisement for McDonald's and Coca-Cola (Ronald McDonald appears as himself, and there's a five-minute dance scene in the fast food restaurant). Today, the 1988 film holds a 0% rating on Rotten Tomatoes. Somehow they snagged Alan Silvestri to do the score, while the rest of the soundtrack is made up of typical pre-teen '80s fluff. If you're an '80s pop culture aficionado, though, that's not such a bad thing.

Jara Lane (who?) leads things off with the main theme track "You're Not a Stranger Anymore," opening with a spacey suite that then descends into a fairly embarrassing pop ballad about finding friendship. One of the soundtrack's only recognizable names, Bobby Caldwell, who once had a hit in the '70s with with "What You Won't Do for Love," does his best Peter Cetera impression on "Take Me, I'll Follow You." (Both songs were actually co-written by Silvestri, so yeah, maybe conducting large orchestras is really his forte.)

Other notable names include Ashford and Simpson, a songwriting duo who wrote for Ray Charles and gave the world titles like "Ain't No Mountain High Enough" and "Ain't Nothing Like the Real Thing." Here they offer "Down to Earth," a high-energy number with just the right amount

of drum programming for an epic montage scene – produced by none other than Danny Sembello (brother of Michael Sembello, known for "Maniac"). Elsewhere, obscure names such as Marcy Levy offer great '80s summer make-out anthems ("You Knew What You Were Doing"). There's some true fromage on *Mac and Me*, which is to be expected, but it's impossible not to smile at some of the jewels along the way.

The soundtrack was released on Curb Records in 1988 and contained "Overture (Theme From Mac and Me" from Silvestri's score. The score itself came out on CD on Quartet Records in 2014. Perhaps a vinyl LP courtesy of McDonald's is forthcoming.

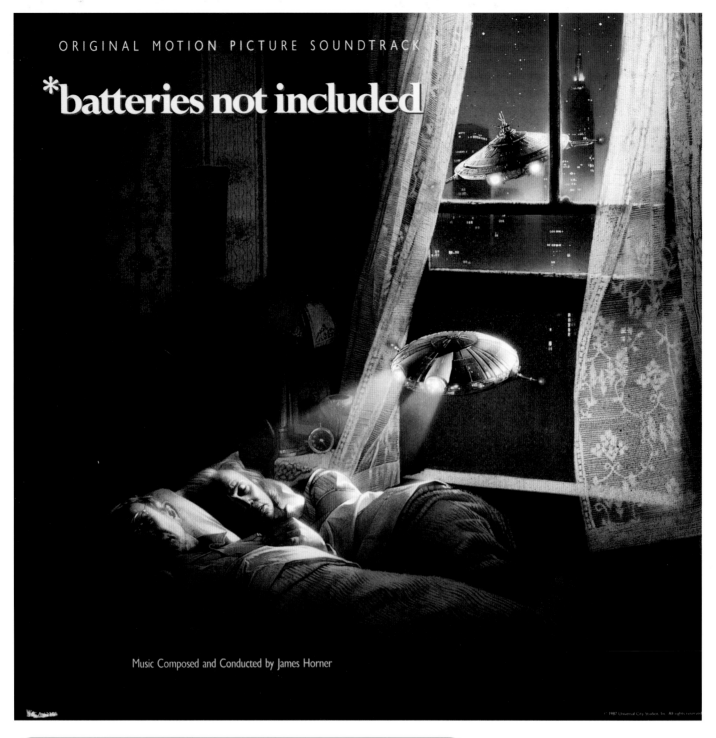

*BATTERIES NOT INCLUDED

batteries not included was originally intended as a segment in Steven Spielberg's horror/sci-fi/fantasy series *Amazing Stories*, but the Hollywood powerhouse liked the concept so much he decided to produce it as a full length feature in 1987. Indeed, this is classic Spielberg stuff: friendly aliens help out an elderly couple from losing their home to corporate greed. James Horner was brought in to do the music, no stranger to cute sci-fi movies after his work on *Cocoon* two years earlier, and the composer would pluck some ideas from that score on his

work here (coincidentally *batteries*' two principal actors appear in *Cocoon: The Return*).

The score opens with old time jazz in the vein of big band icon Glenn Miller, establishing the age of the film's protagonists. The rest of the music is dominated by robotic drumming and jovial woodwind instruments that represent the alien flying saucers, and a string-based theme for the frequent heartstring tugging that makes up much of the film. In between come standard Horner suspense and action cues, notably on "Arson,"

consisting of dark, rumbling noise that builds to a cacophony of distress and anguish. Overall, the mix of jazz and orchestral elements will be of interest to hardcore Horner fans, even if *batteries not included* doesn't necessarily add up to a groundbreaking score.

The soundtrack came out on vinyl by MCA at the time of the film's release, and eventually Intrada put out the complete score on a double CD in 2018, which included the original version. Another classic slice of sentimental '80s sci-fi, this one would look good as a double LP.

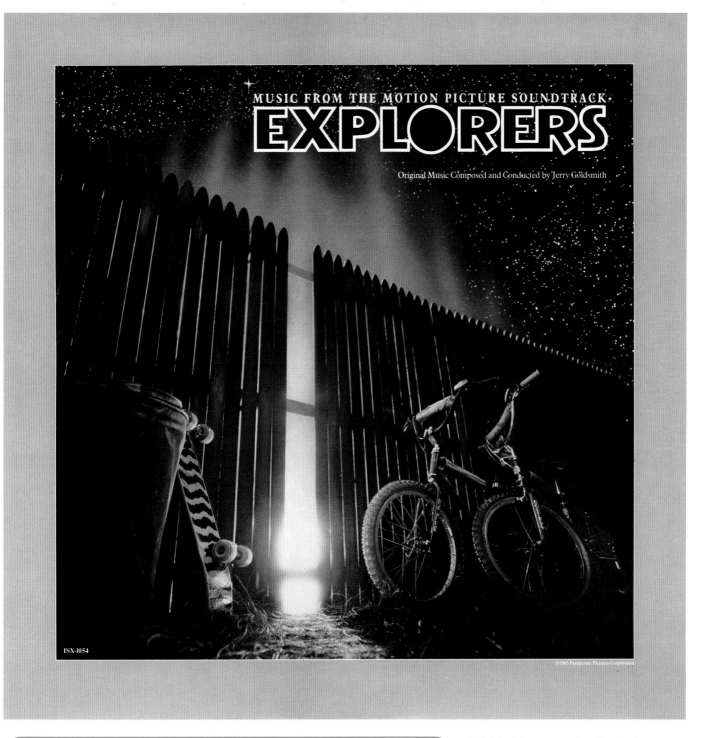

MUSIC FROM THE MOTION PICTURE SOUNDTRACK
EXPLORERS

Original Music Composed and Conducted by Jerry Goldsmith

ISX-1054

©1985 Paramount Pictures Corporation

EXPLORERS

Explorers was released at the height of the '80s kid-focused sci-fi movie trend, in 1985, and marked the debut performances of Ethan Hawke and River Phoenix. It also marked the third collaboration between director Joe Dante and Jerry Goldsmith, after _Twilight Zone: The Movie_ (1983) and _Gremlins_ (1984). Unlike those two films, _Explorers_ was a commercial flop after being rushed to the theaters, and has gone largely forgotten by movie goers, yet it did produce one of the most underrated scores of Goldsmith's considerable career, and one of his best of the decade.

As a children' fantasy tale, _Explorers_' score emphasizes warmth and lighthearted adventure. The score's main theme, "The Construction," is introduced with light piano, followed by swooshing strings providing that classic feel of wonder and discovery before a full orchestra takes over, giving the film an epic, rousing anthem that actually sounds better divorced from the admittedly poor film., It promises a more exceptional tale than _Explorers_ delivered and remains the great forgotten Goldsmith movie theme of the era.

As Goldsmith was apt to do at the time, he incorporated plenty of synthesizers into his orchestral suite, often for the film's dream sequences, as well as the space exploration scenes. The boys' encounter with aliens is greeted with a brand of synth rock, which sounds far less objectionable in the movie than it does on paper.

Explorers came out on vinyl, from MCA, at the time of the film's release with selections from Goldsmith's score (starting with "The Construction," even though this music appears closer to the middle of the film), as well as songs by Red 7, Night Ranger, and Robert Palmer's "All Around the World," though it's the Little Richard version that appears in the film. Intrada released a much more expanded score in 2011 featuring a number of short cues.

Label: MCA Records / MCA-6148 **Format:** LP **Year:** 1985 **Art:** N/A

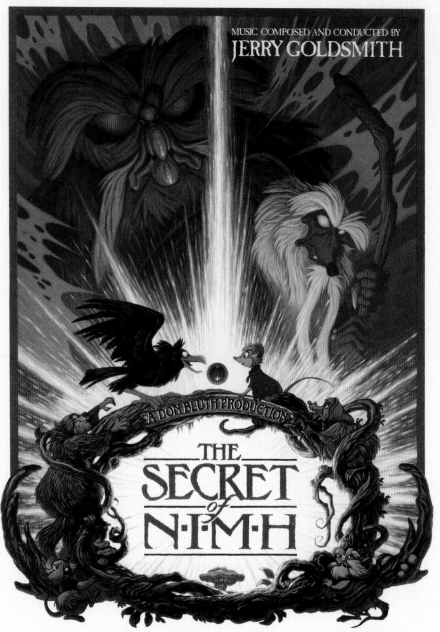

MUSIC COMPOSED AND CONDUCTED BY
JERRY GOLDSMITH

A DON BLUTH PRODUCTION

THE
SECRET
of
N·I·M·H

THE NATIONAL PHILHARMONIC ORCHESTRA

Mrs. Brisby Ltd 1982

THE SECRET OF NIMH

Jerry Goldsmith's first animated score – he would later score *Looney Tunes: Back in Action*, and Disney's *Mulan* – was for Don Bluth's *The Secret of NIMH*. The 1982 film is one of a handful of early-'80s fantasy "family" films that successfully scared the crap out of a generation of kiddies (also see *The Last Unicorn, The Dark Crystal, Labyrinth* and *The Witches*).

In his liner notes for the original album release, Goldsmith explained his attempts to score the film as if it were live action to make the hand-cel animation feel more tangible and believable. As

he recounted in an interview with Randall Larson for *Cinemascore* in 1983, "It had been my intention from the very beginning, as I told the producers, that if they wanted a Disney-like, synchronize-every-cut type of score, I couldn't do it. I wanted to score it as a live-action film, and they agreed."

Goldsmith admitted that writing the score posed its own set of challenges, given that he was sometimes only given pencil sketches or drawings to work to, as opposed to finished dailies or rushes. Still, he created a vibrant soundscape with numerous motifs, ranging from impressionistic to

Romantic idioms. In his interview with Larson, he referred to the music as "an animated *Peter and the Wolf*, but it all hangs together cohesively... [I]t's still diversely styled, musically." Employing a large choir adds an air of majesty (and mystery) to the use of the magical amulet, which ultimately allows Mrs. Frisby to levitate her cinder block home safely away from the farmer's plow.

Capping off the score is the lovely "Flying Dreams,"which uses Goldsmith's melody with vocals and lyrics from Paul Williams. It plays during the end credits, and Sally Stevens sings a version of it for Elizabeth Hartman's Mrs. Frisby in the film. The album was released in 1982 by Varèse Sarabande and Intrada issued an expanded CD in 2015.

ORIGINAL Motion Picture Soundtrack

W·I·L·L·O·W

Music Composed And Conducted By
JAMES HORNER

WILLOW

There are some people who love the *Willow* soundtrack like a brother, but quite frankly, we're way more into *Krull*. Still, the 1988 film is yet another example of James Horner writing a massive action score for the London Symphony Orchestra, this time augmented by the King's College Choir. He also begins to play around with bagpipes, pan pipes and the Japanese *shakuhachi* bamboo flute for a more exotic flavor – which he would later use for scores such as *Titanic*, and the tone colors here are quite similar.

Over the course of the score, Horner plays with a lot of ideas, some of which we've heard before (the percussive hits are a callback to his score for *Aliens*, as is a four-note brass motif that sounds throughout the score), while in "Escape From the Tavern," Horner introduces an action melody he would later develop in *The Rocketeer* (1991). Also notable here is the theme for baby Elora Danan, who is prophesied to bring down the evil Bavmorda. Both of these themes have received their fair share of criticism that Horner was being a bit too liberal with his influences,

such as the first movement of Schumann's third symphony for Willow's theme, and a Bulgarian folk song ("Mir Stanke Le") for Elora Danan. The score is best enjoyed if you leave your Horner hangups at the door and sit back to take in the breadth of the music, warts and all. What *Willow* lacks in originality is compensated by the kind of swashbuckling orchestral fireworks that Horner excelled at.

Label: Virgin Movie Music / 7 90939-1 Format: LP Year: 1988 Art: John Alvin

Original Motion Picture Soundtrack
BEETLEJUICE
Music Composed by Danny Elfman

BEETLEJUICE

From *Edward Scissorhands* to *Batman* to *The Nightmare Before Christmas*, Tim Burton's early films showcase lush fantastical worlds, and a big part of that dark artistry should be credited to Danny Elfman's music. You might argue, though, that *Beetlejuice* (1988) was the pair's ultimate collaboration. After that film, it was difficult to imagine a Burton film without the carnivalesque whirrings of Elfman's compositions.

The *Beetlejuice* soundtrack is no easy listening experience. A complex score, it piles layer upon layer of sound and instrumentation played

seemingly at hyperspeed, like the demented nightmares of a clown after midnight. Piano keys, brass instruments, organs, wind instruments and electronics kickstart the big top madness on "Main Titles." Of course, the movie itself is a non-stop barrage of ghostly hijinks, crazy monsters and wisecracks by the devious Beetlejuice himself, so it's natural Elfman's music should match its mischievous intensity.

But no *Beetlejuice* discussion is complete without mentioning the use of Harry Belafonte's songs, namely "Day-O" and "Jump in the Line (Shake, Shake Señora)." The former is a particularly inspired choice for the film, as both its ghostly and festive qualities match the attitude and energy of the film perfectly, even though calypso music doesn't tend to evoke images of netherworld inhabitants.

Geffen, which produced the film, released the soundtrack album at the same time as the movie, and it surprisingly spent six weeks on the Billboard 200 chart. For the film's 30th anniversary, Waxwork Records released a deluxe 180-gram version that came pressed in a variety of variants including a black and white split, clear smoke, purple swirl and white with green/purple Beetlejuice swirl versions, all featuring new artwork by Justin Erickson of Phantom City Creative.

 Label: Geffen Records / GHS 24202 Format: LP Year: 1988 Art: Carl Ramsey / B.D. Fox Independent

ORIGINAL MOTION PICTURE SOUNDTRACK
edward
SCISSORHANDS

MUSIC COMPOSED AND PRODUCED BY
Danny Elfman

EDWARD SCISSORHANDS

By the time Danny Elfman and Tim Burton collaborated on *Edward Scissorhands* (1990), they were at the top of their game with *Batman* and *Beetlejuice* already under their belts. The fable, concerning the misunderstood Edward descending from a castle laboratory on the hill and completely failing to mesh with suburban values, is aided immeasurably by Elfman's music, which is given room to breathe and soar in the sound mix.

For *Scissorhands*, Elfman provides one of his most memorable themes, based around a three-note motif sung by a children's choir. It's best heard in the ethereal "Ice Dance" cue, in which Winona Ryder dances in the snow created as Edward sculpts ice with his scissors. Speaking to Vulture. com in 2015, Elfman noted, "There was nothing to indicate what music should be played for this movie. I had two themes for Edward Scissorhands but no themes for anybody else. That's just the way it came together...I don't know what made me want to use children's voices other than telling the story and the fairy tale."

In playing both to the comedy and pathos of the movie, the score never wears out its welcome. Other standout cues include "The Cookie Factory," underscoring a delightful sequence of the Rube Goldberg-like assembly line created by Vincent Price's character. Essentially, it's an update of the breakfast machine sequence from *Pee-Wee's Big Adventure* that plays like a musical ode to Carl Stalling's music from Warner Bros. cartoons.

The original MCA LP release from 1990, coming out at a time when the industry was making the switch to CD, is a tough find, and it's easier to track down the Geffen Records 2015 25th anniversary re-release (mimicking the original album breakdown into the two titled sides, Side A: "Edward Meets the World," and Side B: "Poor Edward"). The same year, Intrada re-released the score on CD with extra tracks.

Label: Geffen Records / B0023646-01 Format: LP Year: 2015 Art: Vartan / DZN, The Design Group

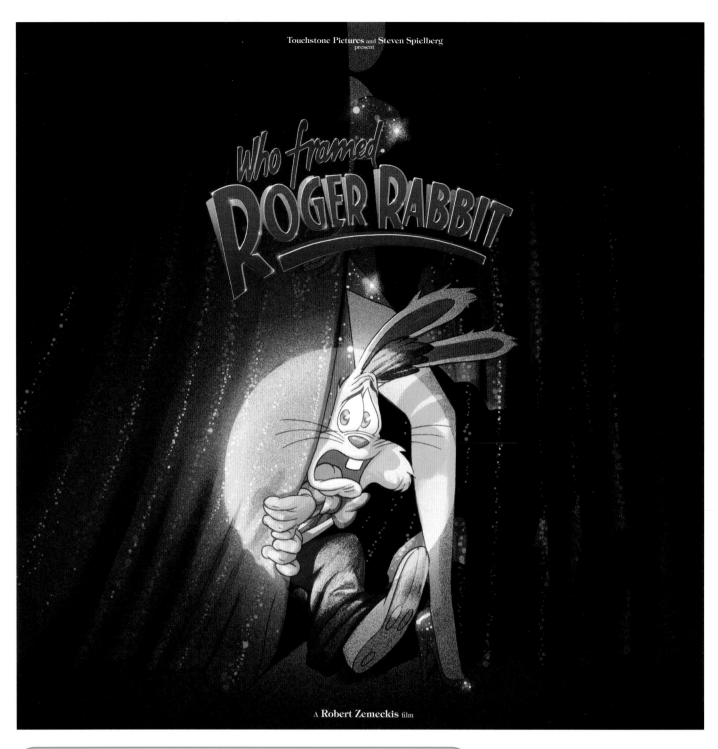

Touchstone Pictures and Steven Spielberg
present

Who framed
ROGER RABBIT

A Robert Zemeckis film

WHO FRAMED ROGER RABBIT

Who Framed Roger Rabbit, which blended popular animated characters with live actors, was a technological marvel at the time of its release in 1988. Director Robert Zemeckis, who hit paydirt with *Back to the Future* in 1985, brought along his composer from that film, Alan Silvestri, who stirred up a brilliant concoction of cartoon orchestral mayhem with film noir sensibilities.

On the surface, *Roger Rabbit*'s score is standard Looney Tunes animation music, full of breakneck beats and whirling slapstick, which reportedly presented a challenge for the London Symphony

Orchestra who performed it (the musical themes for Jessica Rabbit were apparently improvised by the players). Detective Eddie Valiant (Bob Hoskins) receives a noirish theme, though exaggerated for comedic effect, keeping with the Saturday morning tradition. Similarly, Christopher Lloyd's Judge Doom is accompanied by a low-end string motif to match his over-the-top villainous performance. Silvestri's music is in some ways a slightly more mature adaptation of the upbeat, semi-ridiculous scores that accompany Warner Brothers' animated features, which were famously handled by that

studio's Carl Stalling. Again, noir, romantic elements give the film a bit more gravity, including the well-known trumpet piece "Valiant & Valiant," as well as Jessica Rabbit's famous vocalization on "Who Don't You Do Right?"

Who Framed Roger Rabbit was released on LP and other formats when the film hit theaters, through Touchstone Records, featuring 46 minutes of music. It was later reissued by Mondo, in 2019, featuring art by Stan & Vince. The year before Intrada released a 3xCD set presenting the wacky suite at its most full blown. Perhaps a larger LP set is forthcoming.

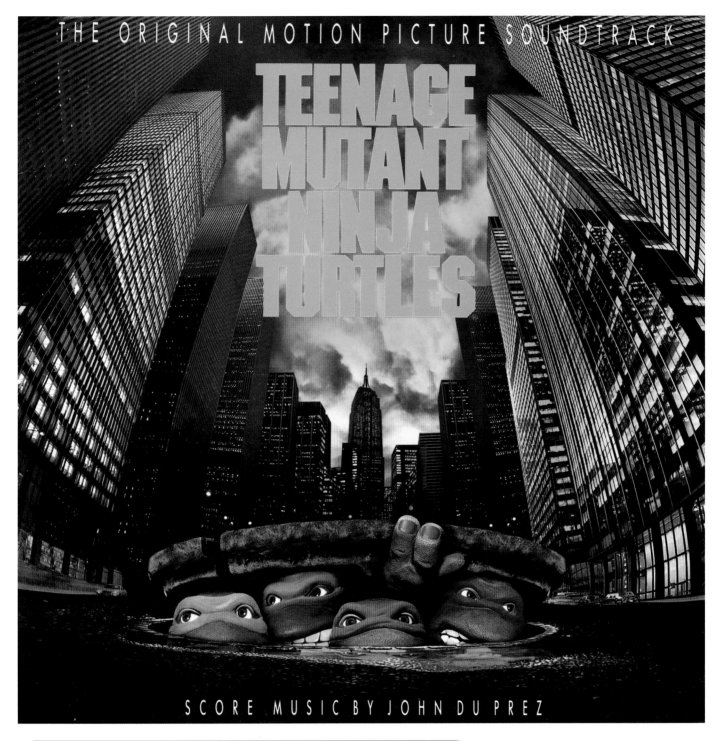

THE ORIGINAL MOTION PICTURE SOUNDTRACK

TEENAGE MUTANT NINJA TURTLES

SCORE MUSIC BY JOHN DU PREZ

TEENAGE MUTANT NINJA TURTLES

It is 1990. Your sister has a crush on Leonardo, you think Casey Jones is badass, and all your friends talk like Michelangelo. That's right, Teenage Mutant Ninja Turtles were *the* pop culture property of the time, from comic books to cartoons to action figures, so a live-action film was inevitable. Predictably, the movie was loaded with hip hop and new jack swing aimed squarely at the kids, including "This is What We Do" by M.C. Hammer, and the righteous "Turtle Power" by hip hop duo Partners in Kryme. This closing credit song made it to #1 on the U.K. charts,

even though its' lyrics embarrassingly proclaim Raphael the leader of the gang, when everybody who actually watched the cartoon knew it was Leonardo. Way to do your homework, guys.

In any case, presumably because this was such an obviously youth-oriented film, no one thought there would be any interest in giving composer John Du Prez's film score a proper release, relegating it to a few tracks on SBK and Geffen Records' accompanying 1990 soundtrack compilation album. That is until the good folks at Waxwork Records brought it up from the sewers in 2018, pressed

on a total of eight different variants, each one appropriately colored after a different character from the film, not unlike the original 1990 cassette releases that came in red, blue, purple and orange.

Upon reevaluation, Du Prez' music actually makes for a serious piece of film scoring, often surpassing the clunky action in the film that it's designed to set up. Indeed, on tracks such as "Trouble," Du Prez harkens back to Ennio Morricone's spaghetti western epics, creating string-based soundscapes for the heroes in a halfshell as they prepare for war against Shredder. Meanwhile, synthscapes, guitar rock, new wave and surf rock all collide in a mishmash of jams, proving Du Prez to be an underrated and multi-talented instrumentalist who was willing to leave no shell unturned, all in a bid to please the kids. Cowabunga, dudes!

Label: SBK Records / K1-91066 **Format:** LP **Year:** 1990 **Art:** Alan Markfield / Chip Simmons / Timothy White

ORIGINAL MOTION PICTURE SOUNDTRACK

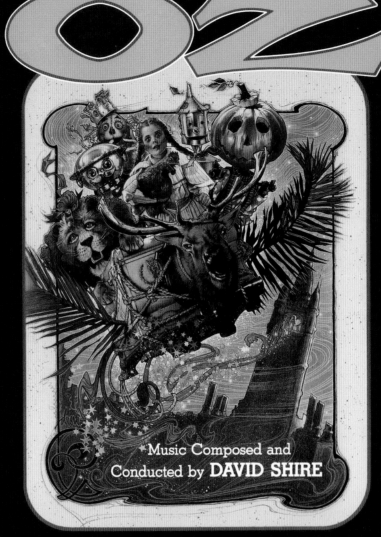

Music Composed and Conducted by **DAVID SHIRE**

THE LONDON SYMPHONY ORCHESTRA

DAVID SHIRE ON RETURN TO OZ

Although *Return to Oz*, an unofficial sequel to the MGM classic, bombed, with critics remarking that the 1985 film was far too frightening and intense for children, the film score by David Shire, went on to be universally praised as a classic, beloved by soundtrack geeks for its detailed and inventive themes created for each colorful character. In an exclusive interview for this book, Shire revisits *Return to Oz.*

How was your overall experience on Return to Oz?

It was a peak experience in terms of working with a director. [Walter Murch and I] worked together for four months, having conversations, [me] playing him themes. He had wonderful ideas and really helped me as a composer. For example, I had written the Dorothy theme but I hadn't written the Ozma theme. If you remember, in the movie Ozma is the Shadow Dorothy and has to integrate herself in that scene when she looks in the mirror and realizes Dorothy has gone down to Oz in order to recapture that part of herself so she can go on with her life. Walter said it would be wonderful if

the Ozma theme could go in counterpoint to the Dorothy theme so that when it gets to that final moment, the Dorothy theme and the Ozma theme play together, becoming a musical metaphor for what is happening thematically.

Return to Oz is remembered for the individual themes you created for each character.

Yes, Walter Murch wanted a separate theme for each character. I think there were six or seven of them, so I had a Tik-Tok theme, a Dorothy them, an Ozma theme and a Jack Pumpkinhead theme. We recorded it with the London Symphony, which was a high point. I used *Peter and the Wolf* as the model, where each character had its own theme, and Walter hoped that when the soundtrack album was released it would form a suite and it would be a piece of music that would stand on its own.

ORIGINAL MOTION PICTURE SOUNDTRACK

THE LAST STARFIGHTER

Composed and Conducted by Craig Safan

CRAIG SAFAN ON THE LAST STARFIGHTER

Smack dab in the middle of a run of epic 1980s sci-fi scores comes Craig Safan's *The Last Starfighter* (1984), possibly the ultimate movie about video game wish fulfilment. Craig Safan speaks to coming up with his classic score.

I understand Sibelius influenced The Last Starfighter. What about it caught your attention?

It was clear I had to do a big late-era Romantic score or I would have gotten fired immediately! I thought, what can I do that might sound a little different than [John Williams'] stuff, which sounds a lot like composers [Gustav] Holst and [Richard] Strauss, and so I was listening to [Swedish composer Jean] Sibelius. What made [*Starfighter*] unique was the warm relationship between the two lead characters, and that keeps the story going. I wanted to play to Alex's longing for adventure and to Maggie's longing to be with Alex and finally have the courage to go off with him.

What sort of conversations did you have with director Nick Castle about the score?

I played the themes on the piano and he loved that. I talked about the "heart" themes of the film and how that would work. Once we decided on the kind of music, Nick really pretty much left me alone. He was quite busy and I was the least of his problems, in a way. This was the first film that was really CGI from top to bottom. It was a mammoth undertaking.

What did the CGI mean for you as a composer?

For all those CGI scenes, there'd be a black screen and a white dot that would travel from one side to another. Nick would tell me, "That's the Kodan warrior ship!" So I thought, I'll write huge brass parts for warships. Other than that, I played it totally real. [Playing the score in that manner] brings reality to animation.

Label: Southern Cross Records / SCRS 1007 Format: LP Year: 1984 Art: Ron Wong

STAN BUSH ON TRANSFORMERS: THE MOVIE

The Transformers: The Movie is notable for many things: Orson Welles' last recorded performance, the death of Optimus Prime and a killer soundtrack featuring, among other things, Weird Al Yankovic's "Dare to Be Stupid," and Spectre General's "Nothin's Gonna Stand in Our Way." But even more notable is a pair of fist-pumping glam rock tracks from Stan Bush, "Dare," and "The Touch," which is the musical heart of the 1986 film. Bush talks about the enduring success of the song.

I understand that "The Touch" was inspired by a line from Iron Eagle *but it took a while for it to find its way into* Transformers. *How did it end up in the film?*

It was a line in *Iron Eagle 2*, actually. There's a young fighter pilot and Lou Gossett Jr. turns to him and says "Kid, you've got the touch!" It was like "Wow, that's great inspiration for a song!" We wrote it with the [the Sylvester Stallone film] *Cobra* in mind but the record label ended up getting into the *Transformers* movie instead. It was just written as a pitch for *Cobra*, with no exact moment in mind.

That's how a lot of things work, you take a shot and if it lands, then great.

What are your thoughts on the song all these years later?

The song has taken on a life of its own. I'm known for this one song. A lot of people don't know who I am but they know the song. The other thing that is really cool is that it got me into this genre where I am writing these songs with inspirational messages, like "Go for it," "Believe in yourself" and that kind of thing. Every album I've done since

THE TRANSFORMERS
THE MOVIE

ORIGINAL MOTION PICTURE SCORE BY **VINCE DiCOLA**

then, there's been a couple of those on there, like anthems about winning. It's a positive message for people; it helps the world a little bit to have that kind of feeling out there. It's motivational rock. An attorney told me he used to listen to "The Touch" before he went into a trial.

I heard you found out about the song's inclusion in Boogie Nights *only after the film came out. What was your initial reaction to it?*

I didn't know the song was in *Boogie Nights* until after the fact. This was typical of that time period, but I was in a really crummy record deal with Scotti Brothers. It was a bad distribution deal and they had the publishing rights for that album, which included "The Touch." I still made money as a writer, and of course the success of the song has helped my career over the years so things have a

way of working out.

Was there ever a reaction to it from Boogie Nights *star Mark Wahlberg?*

A couple years ago I was at a *Transformers* convention back east and I was backstage. Wahlberg comes walking by, he had just done a panel at the *Transformers* convention Hascon and he turns to me and says, "How did I do in the movie?" and I said, "You did great." He comes over a couple minutes later with his iPhone and we just start singing the song together. He posted it on his social media and it instantly had like 600k views. He's a nice guy.

I love that "The Touch" gets some airplay in a really funny way in Bumblebee – *how did that come together?*

I met the director, Travis Knight, backstage at Comic-Con last summer when they did the *Bumblebee* panel and I was asked to be a part of that. I thought I was just going to be one of the people on the stage on the panel but they wanted me to sing "The Touch." They had the track and I sang live to the track. There were about 7000 people watching. Before I got on stage Travis Knight told me he was a really big fan. I am sure it was his idea to put the song in there.

Label: Intrada / INT 3006 **Format:** 2xLP **Year:** 2015 **Art:** Kay Marshall **155**

Original Filmsoundtrack

DAS LETZTE EINHORN

»THE LAST UNICORN«

Composed and arranged by
JIMMY WEBB
Performed by
AMERICA

THE LAST UNICORN

The Last Unicorn – both the original novel and film – never pandered to its audience, young or old. The 1982 movie adaptation succeeds both as a gorgeous fairy tale with evocative imagery (unicorns melting into crashing waves, a luminous red bull thundering through a dark forest), and note-perfect vocal performances from a gravely Christopher Lee as King Haggard, Mia Farrow as Unicorn/Amalthea and Alan Arkin as the bumbling magician Schmendrick.

The film's unique, dreamy tone is captured in the animation from Japan's TopCraft studio (which would later go to work for Hayao Miyazaki) and in the score from Jimmy Webb, with memorable songs performed by folk-rock act America. Both songs and score catch the air of melancholy hanging over the proceedings. The score is surprisingly varied; piano and solo violin underscore the trickster of a cat living in King Haggard's castle, and orchestration is fleshed out with Medieval timbres, along with a full orchestra for the film's set pieces with the unicorn-hunting Red Bull. Webb uses resonant brass, strings and cymbals to evoke King Haggard's windswept oceanside castle, while the unicorn's enchanted forest is suggested with winds and chimes.

But what most people remember are the songs, also written by Webb, and performed by America. The wistful title track encapsulates the film's themes of loss and regret, and balances folk guitar with a lush string arrangement – it clearly resonated enough with audiences, as it resulted in a number of covers over the years, by acts ranging from Kenny Loggins to Ninja Sex Party. Just as good is the more upbeat "In The Sea" and the mournful "Man's Road," which does much to lend the film its solemn tone. Interviewed for *The Austin Chronicle* in 2013, author Peter S. Beagle humorously noted that Jimmy Webb's song score "opened his work up to an entirely new audience of seven-year-old girls."

The album was released in Germany, in 1982, by Virgin Records, incorporating both the songs and score. However, Mia Farrow's vocals in the film are performed by Katie Irving (of the *Carrie* soundtrack fame) on the album.

ORIGINAL MOTION PICTURE SOUNDTRACK

SPACECAMP

Music Composed and Conducted
by
JOHN WILLIAMS

SPACECAMP

Many an '80s child remembers the Space Shuttle Challenger disaster that occured on January 28, 1986, the shocking footage playing over and over again on television. Unfortunately for the people who made *Spacecamp*, in which bratty kids are accidentally hurled into space in a NASA shuttle and have to figure their way back down, the disaster occurred shortly after filming wrapped. When it was released later that year, it bombed – a victim of bad timing, as well as its wildly implausible premise, but hey, at least it had the great John Williams to give it a thumpingly

patriotic score. Wait... what is John Williams doing on this movie?

The period of 1985-86 was actually quiet for Williams in terms of scoring films; he had taken a job in the Boston Pops and was more preoccupied with writing uplifting themes for events such as the Olympics and NBC News. An obviously very American film, Williams was the perfect choice to give *Spacecamp* that good ol' patriotic pomp and polish. The score's "Main Title" and "Home Again" both exude the same hopelessly optimistic grandeur, albeit it packaged more like

a TV commercial than, say, the main title in *Star Wars*. What happens in between the opening and end credits is a fairly straightforward underscore punctuated with subdued brass solos. Even weirder is the "Training Montage" track, an overtly '80s-style rock cue with a drum machine that sounds out of place in the canon of a multi-Academy Award winner. Still, there is no denying that Williams' music helps raise the film's spirits, and its heroic cues simply represent more great output from a true master.

RCA released the *Spacecamp* soundtrack on vinyl at the time of the film's debut, though it was reportedly pulled from shelves due to the marketing, um, challenges, after the Space Shuttle disaster. It has been released on CD more recently, and these versions remain identical to the original release.

LEGEND

Ridley Scott's *Legend* put an end to the director's run of acclaimed early genre pictures, suffering from a troubled production, including having a key soundstage burn down before filming could be completed. The challenges of this ambitious 1985 fantasy film continued into post-production. The first cut came in at slightly over two hours, which was then whittled down to 113 minutes and given the green light from Scott. However, after test screenings, an additional twenty minutes were cut. Ultimately, the film did not fare well critically or at the box office, although its ambitious art

direction, makeup effects and music have earned it a following. The film is notable for having two versions released: one scored by Jerry Goldsmith, and a re-scored version by Krautrock group Tangerine Dream.

Goldsmith spent six months working on the score, beginning during pre-production, collaborating with John Bettis, who wrote the lyrics for songs performed in the film by Lili (Mia Sara) and the faeries. *Legend* also shows the influence electronics had on the composer by the mid-1980s, and employs a range of synthesizers with orchestra, including a Yamaha DX-7, Oberheim OB and Prophet T-8. The synthesizers help to emphasize the strangeness of the fantasy world, in particular the goblins Blix, Pox and Blunder, whose unicorn-hunting antics are underscored by distorted, bending notes on the synths, which

stand in contrast to the acoustic orchestra and chorus that play as Lili frolics in the forest.

Due to the film's hasty edit down to 95 minutes for the international version in which Goldsmith's score appears, cues were cut and spliced to fit the truncated running time, and lingering bits of temp music, such as music from Goldsmith's own *Psycho II*, were kept in the final cut – not unlike Goldsmith's previous experience working with Scott on *Alien*. Interviewed by Jonathan Benair in 1986, for the *Los Angeles Reader*, Goldsmith stated, "Working on *Alien* was one of the most miserable experiences I've ever had in this profession...I was on the picture for four months and I talked to [Ridley Scott] three times...So on Legend we communicated like crazy and the score went right out the window."

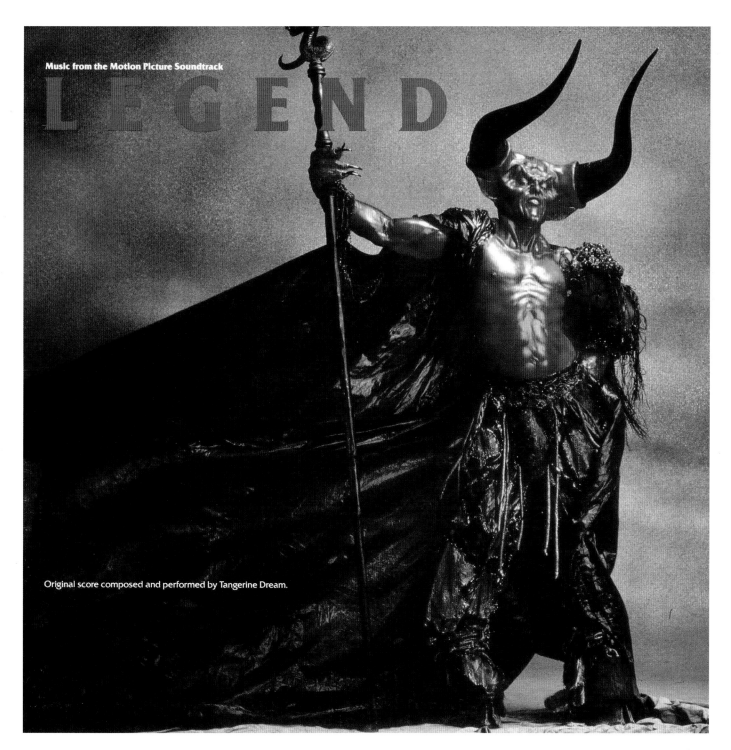

Music from the Motion Picture Soundtrack

LEGEND

Original score composed and performed by Tangerine Dream.

Scott told P.M. Sammon, for his 1999 book *Ridley Scott: The Making of His Movies*, "I felt awful about having to replace Jerry Goldsmith's music on the American version, because Jerry had given me exactly what I'd asked for." Nevertheless, it was determined that to help sell *Legend* in the U.S. market, one of the things that had to go was Goldsmith's rich, impressionistic score, which was deemed less marketable than a more pop-based approach.

Replacing Goldsmith's music was the more contemporary score from Tangerine Dream, who were screened a version of the film with the Goldsmith score already intact and given instructions to write nearly wall-to-wall music (there's around 80 minutes of music for the 90 minute cut). They did so in an astounding three

weeks. Here, 35 types of synthesizers were used, including the Fairlight and PPG System.

Interviewed by Randall D. Larson for *CinemaScore* in 1987, Tangerine Dream's Edgar Froese spoke to how the band approached the score, noting, "The whole film is produced on different levels, and that's what we've tried to follow in creating the music. There are parts of music which could be called pure entertainment, parts of music which follow a more spiritual line, and there is some music which has just a few nice melodies in it which relate a bit more to other sequences which could be called part of a fairy tale."

In addition to the Tangerine Dream score, two songs appear in this U.S. edition of the film. Vocals from Jon Anderson were added to Tangerine Dream's finale after the fact, and the end credits

feature Bryan Ferry's "Is Your Love Strong Enough?" with guitar work from David Gilmour.

Goldsmith's score was initially released on vinyl in 1985 from Filmtrax. Silva Screen released an expanded CD, before reissuing the score on vinyl in 2015. Meanwhile, Tangerine Dream's score (featuring a near-identical cover of Tim Curry under Rob Bottin's makeup) was released by MCA in 1986.

Label: MCA Records / MCA-6165 **Format:** LP **Year:** 1986 **Art:** Annie Leibovitz / Mike Fink / Vartan

BRUCE BOUGHTON ON HARRY AND THE HENDERSONS AND THE MONSTER SQUAD

Bruce Broughton is no stranger to genre film scoring, with a resume that includes westerns (*Silverado*), adventure films (*Young Sherlock Holmes*), and an early career Emmy earned by scoring for *Buck Rogers*. Here, he speaks to two of his well-known 1987 film scores, both aimed at family audiences.

In Harry and the Hendersons, *your opening title music is reminiscent of a Mozart piece; was he an influence on setting the tone?*

It's more than reminiscent; it actually includes a huge section of Mozart's overture to his opera *Ascanio in Alba*. It was used as a temp track for the main title and everyone liked it. A *lot*. So I suggested making Mozart an invisible character in the movie and having the family listen to Mozart whenever the radio was on. I recorded bits of symphonies, overtures, piano concertos, but by the time the movie was done, this was about the only piece that was actually left as part of the soundtrack. The main title begins with my music

in Mozart's style and introduces the Harry theme. When the scene cuts to the interior of the car with the family, the music plays as source music, but now it's really Mozart. It's very hard to tell unless you know the original opera overture.

How did you approach the material in terms of establishing the emotional beats?

When we first meet Harry, we don't know anything about him, except that he's a Bigfoot. With the exception of the main title, which indicates the

 Label: MCA Records / MCA- 6208 Format: LP Year: 1987 Art: N/A

movie to follow is a light comedy, the music that plays under Harry takes shape as his character and our knowledge of it takes shape. When he's lying in the road, having just been hit by the car, the music is mysterious and a bit suspenseful. It's not until he gets to the house that we realize what Harry can do and who he is. All of it takes time and the music helps that.

Joe Cocker's song, "Love Lives On," replaced your initial end credits cue, but is based on your music. How did that track come about?

The producers/studio wanted a song, so the great songwriting team of Barry Mann and Cynthia Weil, who have written many big hits together, was brought in. My material was adapted as part of the song's structure. Joe Cocker sang the song as the end credits.

The Monster Squad, like Harry and the Hendersons, also walks that fine line of comedy and horror. Musically, how do you approach the material?

I wrote the score as a broad comedy, which it essentially was; as a result, I intentionally overplayed the "horror" moments. I think Fred Dekker, who directed and co-wrote the script, wanted a big Universal movies-like score for the movie, which is why he called me. When the film played actual horror, such as in the main title with the first appearance of Dracula, I went that way, with musical scary effects and all that.

The movie didn't perform well at the box office but over time has become a cult hit. Do you feel vindicated by the eventual success of the film and score?

Well, I don't feel vindicated, but I imagine Fred does. Over the years, I've heard from many people who saw some of my movies as a kid, this being one of them. Some of these films are really influential as a part of their growing up and they can get quite emotional when talking about them. For instance, I met a guy at a university film department who literally jumped out of his chair when he found out I did the score to *Monster Squad*. Other people simply get very emotional; a little weepy, even. I find that to be a very pleasant and gratifying thing to happen, especially after so many years.

Label: Mondo / MOND-081 Format: 2xLP Year: 2016 Art: Gary Pullin

MUSIC BY MARK KNOPFLER

THE PRINCESS BRIDE

THE PRINCESS BRIDE

Rob Reiner's *The Princess Bride* lives on in the hearts of many '80s pre-teens, thanks to the film's imaginative set pieces, a colorful cast that includes Cary Elwes, Chris Sarandon, and André the Giant, and highly quotable lines such as: "You killed my father. Prepare to die!" Although it's a quintessential fantasy adventure film set in an unspecified fairy tale time and place, the 1987 movie brims with a modern pop sensibility, and so instead of going the classical route for its score, Reiner chose Mark Knopfler – better known as the frontman for Dire Straits – for the job. Knopfler

turned in an '80s classic of his own, a score fondly remembered for its romantic ballads and dreamy synthesizers.

The soundtrack opens with two wonderfully romantic cues, "Once Upon a Time...Storybook Love" and "I Will Never Love Again," which are both warm and pastoral with gently- plucked guitar over a steady whoosh of keyboards. (Another version of "Storybook Love," sung by Willy DeVille, also appears and would go on to be nominated for Best Original Song at the 60th Academy Awards.) Things become even more overpoweringly electronic on

"Morning Ride," a definitive "easy listening" track with soothing synthesizers that imitate the sounds of Medieval times. There are also a few wacky action cues (e.g. "Cliffs of Insanity") that use utterly dated effects but still manage to squeeze out a certain amount of creativity, making them fun to revisit away from the film.

Knopfler's score was released on vinyl by Vertigo when the film came out and has been reissued on CD over the years, yet all versions remain the same. Given the movie's place in '80s pop culture history, a deluxe LP revisitation of this fondly remembered suite should not be far away.

Label: Warner Bros. Records / 25610-1 Format: LP Year: 1987 Art: Clive Coote

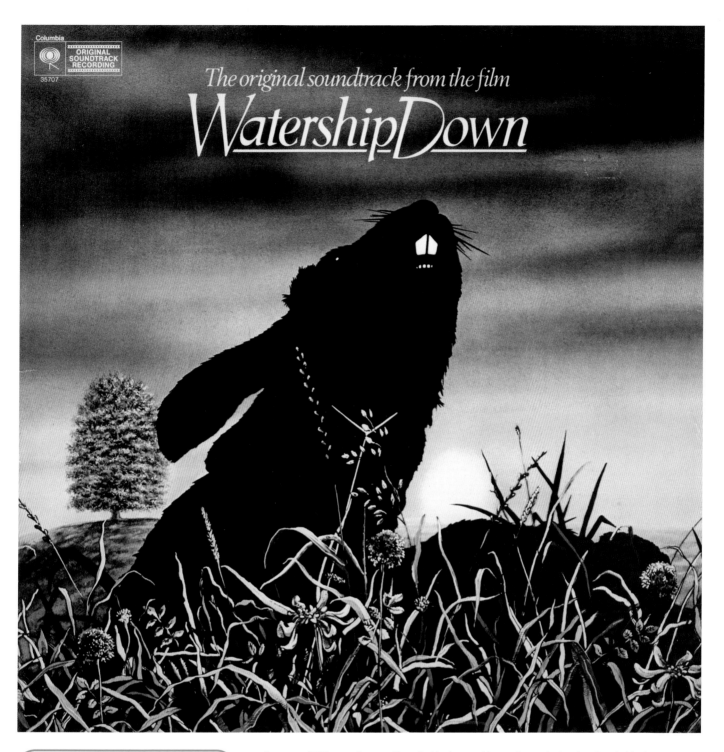

The original soundtrack from the film

WatershipDown

WATERSHIP DOWN

Remember that animated children's film about cute bunny rabbits that's also filled with blood and violence? If you went into British animated feature *Watership Down* (1978) expecting *Bambi*, you were probably too shocked to pay attention to the absolutely gorgeous music composed by Angela Morley.

As the story goes, the production had originally hired the Master of the Queen's Music himself, Malcolm Williamson, one of England's most respected composers, to provide a score in three weeks. Unfortunately, taking on far too much

work at once, Williamson became ill, and with the deadline looming all he had been able to compose was six minutes of music, covering two sketches, one of which was the main title theme. So Morley was called in and asked to orchestrate and record one of the sketches, which she managed to do, and was then offered the job to complete the score. Though hesitant to take on such a commitment on short notice, after viewing the film Morley was convinced this was a job she needed to take.

She composed themes for the story's major characters, including General Woundwort, Kehaar, the vicious Efrafans, as well as darker music for the movie's frequent scenes of brutality, including the near-death of Hazel. *Watership Down* is also known for featuring the haunting ballad "Bright Eyes," sung by Art Garfunkel and written by Mike Batt.

It's worth mentioning that Angela Morley was a transgender pioneer who faced bewilderment in the music industry after her transition in the 1970s. After withdrawing from the recording world, it was the chance to do *Watership Down* that drew her back. For one, it was a high profile gig, but Morley reportedly also felt a connection to its story about a quest for a new home. The critical acclaim that came with the score led to opportunities in Hollywood, including scoring TV shows *Dallas* and *Wonder Woman*, and even working with John Williams on blockbusters such as *E.T.* Her story was detailed in the BBC Radio 4 drama *1977*.

Watership Down was released on vinyl by CBS in 1978. It remains a score waiting to be heard in a far more accepting time.

Label: Columbia / JS 35707 Format: LP Year: 1978 Art: Maurice Wilson / Simon Cantwell

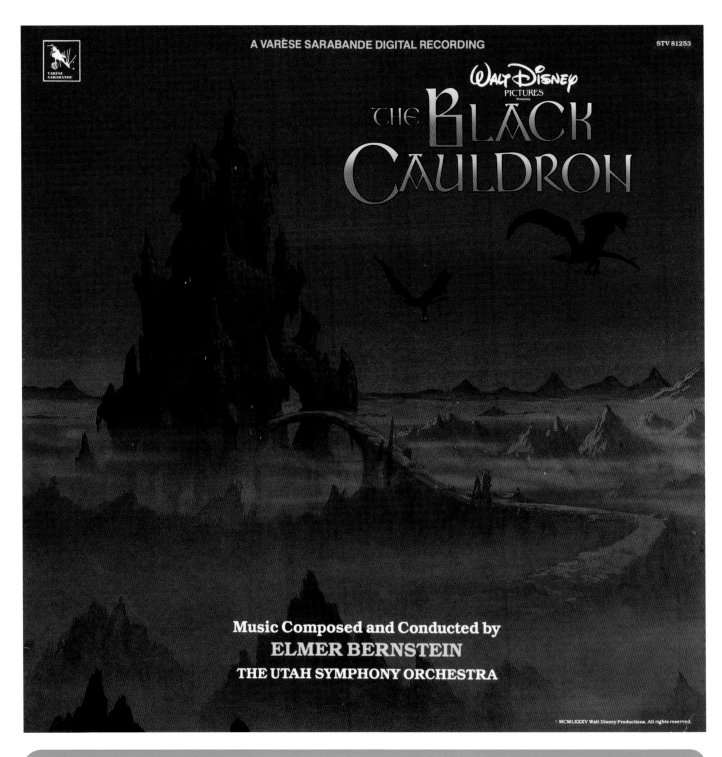

STV 81253

WALT DISNEY
PICTURES
Presents
THE BLACK
CAULDRON

Music Composed and Conducted by
ELMER BERNSTEIN
THE UTAH SYMPHONY ORCHESTRA

PETER BERNSTEIN ON
THE BLACK CAULDRON AND THE EWOK MOVIES

Peter Bernstein is the son of legendary film composer Elmer Bernstein (*Ghostbusters, Heavy Metal*) and a notable composer in his own right, having penned the scores for numerous films and TV series, such as *My Science Project, Weird Science* and *21 Jump Street*. Here, he discusses orchestrating for his father as well as composing the score for *Caravan of Courage: An Ewok Adventure* (1984) and *Ewoks: The Battle for Endor* (1985).

You orchestrated scores such as Ghostbusters *and* The Black Cauldron *for your father, both of which feature electronic instrument the Ondes Martenot. What's it like arranging for an orchestra with that kind of unique instrumentation?*

Honestly, it was very simple. The only thing you had to do was stay away from instruments that would sound like it and play in the same range. It was another member of the orchestra, and no different than orchestrating for, say, a flute melody. The [Ondes Martenot] was much more powerful

sonically, so it could soar over the orchestra without much help from an engineer or sound mix [the way] that a woodwind might need.

You began orchestrating for your father on a string of science fiction and fantasy films, including Spacehunter, Ghostbusters, Heavy Metal *and* The Black Cauldron; *did you find that projects like these differed in any notable way from some of the others?*

I would say that in the sci fi scores [Elmer Bernstein] felt a little freer to go further afield

EWOKS ™

Music Composed by
PETER BERNSTEIN

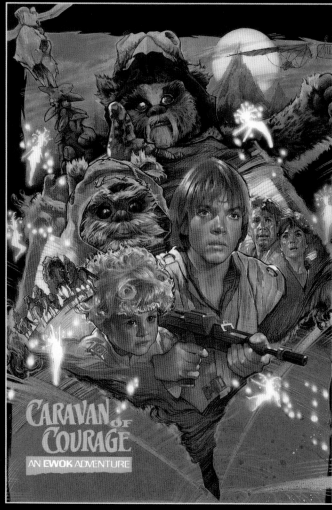

CARAVAN OF COURAGE
AN EWOK ADVENTURE

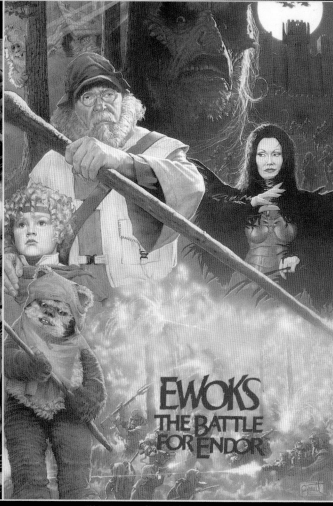

EWOKS THE BATTLE FOR ENDOR

from his standard setups and sound mainstays that he used composing. If you listen to *Heavy Metal*, it's an amazing, huge score that goes harmonically, melodically and sometimes sonically places that he hadn't been before. Not so much with *The Black Cauldron*, which was animated, and yet [he] didn't really take it seriously. But with *Slipstream*, *Spacehunter*, *Heavy Metal* – even though that was also animated – that was serious stuff. He took it as far as he was comfortable with, at least. The one thing those three have in common is that they used giant orchestras, getting up towards 100 musicians. For some of those, the original orchestration lineup was from Christopher Palmer – he started orchestrating these big orchestras to set them up and so you'd have six horns and six trombones and big brass sections all

kinds of extra instruments that aren't part of the normal orchestral lineup to flesh out the sound.

How did you get the gig for the Ewok movies?

I sent a demo to Lucasfilm. Most of my early work came through my old rock and roll contacts who dispersed into the wider world and other careers. This was a benefit from that. It had nothing to do with my father.

Was there any desire to work in John Williams' Ewok music from Jedi?

Not on my part. There's a fifteen-second quote in one of them from his Ewok theme, but other than that, the last thing in the universe I wanted to do was sound like John Williams or my dad. It was an interesting position to be in for a young composer; I was 33 at the time.

How the fact that these are children's films influence your approach?

It was an alternate reality in the same way that the *Star Wars* movies are, but this was a different reality. It was a gentler, sweeter world than what you had in the *Star Wars* movies. [In *Star Wars*], the force is a galactic thing. With the *Ewok* movies, the magic I'm addressing is more localized – it's about the trees, the streams – it's a completely different outlook, a different magic. [Musically], if John Williams is looking towards post-Romantic European music and my father was looking towards Americana, then I'm looking at a different place when I'm writing the Ewoks, which was more Russian: [Sergei] Prokofiev, [Nikolai] Rimsky-Korskakov, those folks.

CHAPTER

7

COMIC BOOK
SUPERHEROES
CAPES & SPANDEX

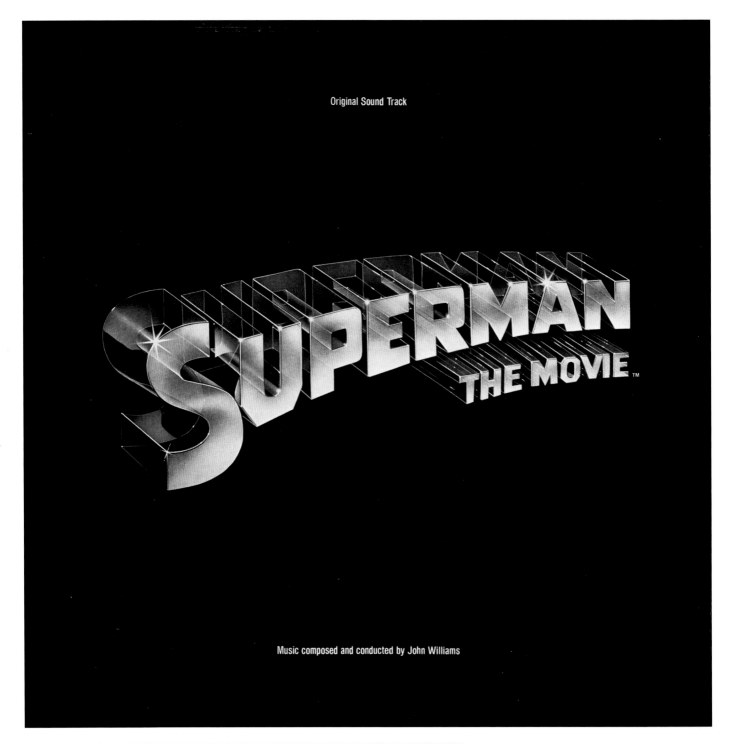

Original Sound Track

Music composed and conducted by John Williams

RICHARD DONNER ON SUPERMAN

Superman may not be the first comic book film to grace movie screens, but it was the first American superhero film given a blockbuster budget. Featuring star-making performances from Christopher Reeve and Margot Kidder, along with Marlon Brando (who got top billing for what amounts to a cameo), the 1978 film is notable for its epic score from John Williams, who brings his signature sound to *Superman* off the heels of *Star Wars* and *Close Encounters*. Director Richard Donner discusses how he came to work with Williams, and his thoughts on the use of music in the film.

You'd worked with Jerry Goldsmith on The Omen, *who I understand was initially going to score* Superman. *How did you end up using John Williams?*

When we were ready to get into composers, which was at the completion of the film, I called Jerry about *Superman* and he loved it, and he committed – and shortly thereafter we were delayed on making the film, as you can well imagine, and I lost him. And of course John Williams was also uppermost in my mind. I went to John and he liked it and he committed, and shortly thereafter I

lost him because we were going to be going over schedule. And I went back to Jerry, and I lost Jerry again! Three times we went back and forth [before ending up with John].

What were your first impressions of that iconic theme?

The first time I heard it I went out of my mind; it was just perfect! Even in those opening titles, if you really listen, he actually says "Superman" with the music [in that three-note motif]. Amazing! And how long it took him, I don't know. He's the genius behind that.

I read somewhere that you messed up the initial recording of the Superman *theme.*

I opened the door to the recording studio to tell John how much I loved it and screwed up the take.

 Label: Warner Bros. Records / 2BSK 3257 Format: 2xLP Year: 1978 Art: N/A

Record 1
SIDE ONE
Theme From Superman (Main Title)
The Planet Krypton
Destruction Of Krypton
The Trip To Earth
Growing Up

SIDE TWO
Love Theme From Superman
Leaving Home
The Fortress Of Solitude

Record 2
SIDE THREE
The Flying Sequence &
Can You Read My Mind
Super Rescues
Lex Luthor's Lair
Superfeats

SIDE FOUR
The March Of The Villains
Chasing Rockets
Turning Back The World
End Title
2BSK 3257

ALEXANDER SALKIND PRESENTS **MARLON BRANDO GENE HACKMAN** IN A **RICHARD DONNER FILM**
SUPERMAN STARRING **CHRISTOPHER REEVE**

NED BEATTY JACKIE COOPER GLENN FORD TREVOR HOWARD MARGOT KIDDER
VALERIE PERRINE MARIA SCHELL TERENCE STAMP PHYLLIS THAXTER SUSANNAH YORK
STORY BY MARIO PUZO SCREENPLAY BY MARIO PUZO, DAVID NEWMAN, LESLIE NEWMAN AND ROBERT BENTON CREATIVE CONSULTANT TOM MANKIEWICZ MUSIC BY JOHN WILLIAMS
DIRECTED BY RICHARD DONNER EXECUTIVE PRODUCER ILYA SALKIND PRODUCED BY PIERRE SPENGLER AN ALEXANDER AND ILYA SALKIND PRODUCTION
PANAVISION® TECHNICOLOR® DISTRIBUTED BY WARNER BROS. Ⓦ A WARNER COMMUNICATIONS COMPANY TMs & © DC COMICS Inc. 1978.

MUSIC PERFORMED BY THE LONDON SYMPHONY ORCHESTRA MIXING ENGINEER: ERIC TOMLINSON RECORDED AT ANVIL RECORDERS, DENHAM, ENGLAND

That opening credit sequence goes on for a substantial amount of time. Was that always planned out like that? Or had you heard the music first?

I had decided I was going to give a lot of credits on that picture, because a lot of people worked a lot of time, and they were geniuses and they are the ones that brought the picture to fruition. So I was going to give credit and John did the score for the credits. And at that point, it was most unusual [for such a long title sequence]. But I almost wish I had more credits to give; the music was so good.

The Superman *score evolves and shifts, from the majestic music for* Krypton *to the almost pastoral music for* Smallville, *and the comedic march for* Lex Luthor. *What were your discussions with*

John Williams about how the music should come into play?

We sat down with John a bunch of times. When you're editing the picture you cut it with temp music. You take pieces from other films or classic scores. [Y]ou lay up the music to the edit that you're doing. That helps you hear the whole thing. Sometimes you let the composer hear what you had in mind by temp scoring, and other times you don't because you don't want to impose anything on them. In John Williams' case, you certainly didn't. But at the same time you did discuss where the big moments were. When we ran the film for him, we sat around with Stuart Baird, a brilliant film editor who originally started as a music editor. We'd sit with John and say that there should be something to happen at one specific point or

another. He would say "Yes" or "No" or "I'll give it a try." You never knew what the music was going to be until you sat in that [recording] room as I did that first time, and it was quite magical.

Superman II *was beset with challenges, and we did get your cut of it sometime later. Had you planned to work with John again on that one?*

Oh, for sure. Certainly. Ken Thorne worked on the sequel. I had so little to do with the producing and production staff after, when we parted ways.

ORIGINAL SOUND TRACK

Music Composed and Conducted by Ken Thorne
From Original Material Composed by John Williams
TM & © DC COMICS Inc. 1980 All Rights Reserved.

SUPERMAN II / SUPERMAN III

Producers Alexander and Ilya Salkind had always envisioned their *Superman* saga in two parts, but the behind-the-scenes politics of the production resulted in on-set tensions. While director Richard Donner had shot a considerable amount of footage for *Superman II* (the sequel was eventually released in 1980), he parted ways with the Salkinds before the film could be completed. Richard Lester was brought in to finish the picture, and along for the ride was Ken Thorne, a composer Lester had collaborated with on previous movies.

Written in around six weeks, Thorne's job was to maintain Williams' cues and sound but reduce the size of the orchestra. Given the constraints imposed on him, Thorne's score manages to fit the patchwork sequel effectively. And given that the sequel was really meant to continue where the first film left off (with a nuclear bomb triggering the release of General Zod and his gang), not a ton of new thematic material was necessary. Zod's crew had already been given some creepy, atonal string writing in the first installment during the Krypton scenes, which

was reused here to represent the three supervillains, such as when they first arrive to kick some astronaut ass on the moon.

One standout track is Thorne's more spritely take on the *Superman* theme, which ups the tempo slightly for a lighter feel (as the opening credits provide a recap of the first film). Meanwhile, Thorne cleverly inserts bridging material between the Williams-penned music, such as during the Eiffel Tower sequence that opens the film. The music first appeared on a 1980 LP from Warner Bros., though expanded editions on CD would follow later (see below).

Lester and Thorne reunited for *Superman III* (1983), which sees the Kryptonian doing battle with a "supercomputer," along with an evil doppelganger, and with Richard Pryor along

ORIGINAL SOUND TRACK

for the ride. With this installment Thorne was given free rein to provide original music while s till maintaining Williams' Superman march where necessary. So, while *Superman II* adheres more closely to the template established by Williams (and Donner), with *Superman III* you can hear (and see) the unencumbered approach from the director and composer – Lester clearly enjoys adding more gimmicky humor, while Thorne adds more synthesizers into the mix (e.g. "Boxes in the Canyon").

Additionally, Giorgio Moroder produced several pop songs that didn't make it into the final film, including a fairly lackluster take on Williams' march that's short on the kind of booty-shaking beats that propelled most of Moroder's output. The album, released in 1983 from Warner Bros., splits Thorne's score on the A-side with a series

of songs produced by Moroder on the B-side. In 2018, a 3000-edition three-CD set for parts *II* and *III* emerged from La-La Land Records, and includes all of the source music used in the first three films.

The initial *Superman* series petered out with *Superman IV: The Quest For Peace* (1987), in which a returning Lex Luthor creates Nuclear Man (Mark Pillow) to do battle with Reeve's caped wonder. Produced this time by Golan-Globus, the initial plan was to once again involve Williams, who provided sketches for a few themes, such as the Nuclear Man music, but was reportedly unable to commit to the project. Enter *Star Trek*'s Alexander Courage, who had previously worked as an orchestrator for Williams (among others), and was ideally suited to flesh out the new thematic material, mix it with the established motifs and weave it together with his own compositions.

The movie, which ended up getting sliced and diced down to a scant 89 minutes, had many more scenes and pieces of music written that never made the final cut, and a subsequent LP release never happened until the two-inch master tapes were unearthed for the 2008 presentation of *Film Score Monthly*'s mammoth eight-CD set, which provided extended editions for all of the *Superman* films and marked the first release of Courage's music for *Superman IV*.

TANK GIRL

Tank Girl was a box office bomb in 1995, but 25 years later it's a movie everyone seems to recall fondly, and a big part of that has to be the music. Though the titular comic book character is pretty punk rock, the music in the film is very much of its time, that is, very alt-rock and grunge with some feminist leanings, reflecting the movie's themes. In an inspired move, Courtney Love was given the task of assembling the album, ultimately playing a key role in creating an attitude for the film.

Tank Girl opens with Devo's sexy and rocking new version of "Girl U Want" playing over a cool comic book credit sequence, essentially defining the film's anti-heroine (reportedly the band members were big fans of the comic). Though it features vocals by Jula Bell of riot grrrl group Bulimia Banquet, this version did not end up on the album. Bjork contributed "Army of Me" before it became the successful lead track on her sophomore effort Post later that year. Love contacted friend Scott Weiland, of Stone Temple Pilots, for music and he offered "Mockingbird Girl" under the side project name The Magnificent Bastards; not surprisingly, it sounds very much in the grungy vein of STP. Elsewhere, L7, Joan Jett (in a duet with The Replacements' Paul Westerberg), Veruca Salt,

and Hole (naturally) made the Tank Girl soundtrack a spotlight on '90s female-driven alt-rock. The album is also noted for featuring tracks by then-relatively unknown UK artists Bush and Portishead, just months before they broke through on radio. Despite all of that, the album wasn't massively successful, peaking at 72 on the Billboard 200.

There was no vinyl market for the Tank Girl soundtrack when it was released on CD and cassette in March of 1995, but the wax revival lead to nice aqua blue and yellow with red splatter editions in 2018, via Real Gone Music.

 174 Label: Real Gone Music / RGM 0679 Format: LP Year: 2018 Art: Barbie / Suzanne Tenner / Jamie Hewlett

Music from the Motion Picture Soundtrack "Howard The Duck"

Songs Produced By Thomas Dolby
Music Score Composed And Conducted By John Barry
This is a digital recording

HOWARD THE DUCK

Highly-maligned at the time of its release, the George Lucas-produced *Howard the Duck* isn't nearly as bad as everybody recalls. Though overblown and hampered by strange animatronic work for its anthropomorphic character, the 1986 movie entertains, often on the strength of its title character's weird antics and the film's fun songs.

Thomas Dolby was hired to write and produce the songs used in the film, and he collaborated with Allee Willis on the lyrics. To their credit, the songs have a distinctive vibe, and you can't go wrong with immortal lines such as "The fellow with the

beak has stole my heart." Performed by the band Dolby's Cube (featuring Joe Walsh on guitar), some tracks are credited to the film's fictional band Cherry Bomb – featuring star Lea Thompson on lead vocals, with backing from bandmates Dominique Davalos, Holly Robinson, and Liz Sagal, who appear in the film as well.

Film opener "Hunger City" is a strong minor-chord piece of power pop that does much to imbue Howard's nighttime descent to Earth with a feeling of danger, but admittedly does sound a lot like Cyndi Lauper's "She Bop." "Don't Turn Away" has a more contemplative feeling, bolstered by a breezy harmonica solo from Stevie Wonder. The film closes with the title track "Howard The Duck," which has an earworm of a chorus.

The soundtrack was initially issued on vinyl by MCA in 1986, coupling the Dolby's Cube songs (on the A Side) with selections from John Barry's score (on the B Side). Quacky completists are encouraged to track down the three-CD (!) set from Intrada, which brings together both Barry's score, the rescore from Sylvester Levay, and Dolby's songs.

BATMAN

In fashioning his 1989 live-action blockbuster duel between Batman and the Joker in Gotham City, Tim Burton turned to Oingo Boingo's Danny Elfman, who had scored the director's *Pee-wee's Big Adventure* and *Beetlejuice* with great success. Although producer Jon Peters was not a fan of the idea, that quickly changed once he heard Elfman's "The Batman Theme," a suite that has since gone on to achieve renown status in film music.

Peters wasn't done meddling with the score, however, as he concocted an idea in which Michael Jackson would contribute music for Batman while pop star Prince would write songs around The Joker. Burton flat out rejected the idea and a compromise was reached in which Prince, who was at the time signed to Warner Bros. Records, wrote an album of marketable songs for the soundtrack, while Elfman would orchestrate a separate score.

Though it's occasionally been derided in the annals of pop culture (hammered home by a joke in *Shaun of the Dead*, in which the record is favored as a projectile), Prince's *Batman* soundtrack is today praised by scholars of the late pop icon as another innovative concept album in the master showman's career. Warner essentially duplicated its successful concept of 1984's *Purple Rain*, this time using the *Batman* property to create two hit products. The soundtrack sat on top the Billboard 200 for six consecutive weeks, and its closing single "Batdance" hit #1 on the Hot 100.

Like Elfman's score, each of the songs are written around the film's three main characters, Batman, The Joker and Vicki Vale (the track "Vicki Waiting" was originally written as "Anna Waiting," named after Prince's then girlfriend). "Batdance" uses a collection of samples from the film, and in the album liner notes is credited to all three characters. The song famously ends with a "STOP!" – a sample from when Batman tells the Batmobile to halt.

Warner released Prince's album on vinyl in 1989. Because the legal ownership of the Batman property is so complex, he was not permitted to include any of the singles from the album on his greatest hits compilations until 2016's posthumous *4Ever*.

 Label: Warner Bros. Records / 925 936-1 Format: LP Year: 1989 Art: Anton Furst / Tom Recchion

DICK TRACY

The summer of 1990 was all about *Dick Tracy*, the live-action blockbuster based on the 1930s comic strip character, produced and directed by Warren Beatty, who also starred in the titular role. Audiences' appetite for Tracymania was tested by a total of three soundtrack albums for the film. Co-star Madonna's *I'm Breathless* was a collection of twelve songs featured in, or inspired by, the movie in a joint promotional effort. Her LP included the Oscar-winning "Sooner or Later" and her iconic single "Vogue." Danny Elfman's score was released to critical

acclaim with the composer firmly in the prime of his career as Hollywood's go-to music talent. Finally, a 1990 soundtrack album (shown here) was compiled by veteran producer Andy Paley, featuring several artists attempting the film's era by doing 1930s-style tracks. All three albums were released by Sire, where Paley was a staff producer.

If smokey jazz bars, trench coats and Tommy guns are your thing, the Dick Tracy soundtrack provides a serious slice of that era, and is about as far away from a summer blockbuster pop album as you can get. Patti Austin delivers sultry blues number "The Confidence Man," August Darnell provides classic scat singing on "Wicked Woman, Foolish Man" and Jerry Lee Lewis brings old school country 'n' western tomfoolery on "It Was the Whiskey Talkin'

(Not Me)." Showcasing true diversity, the album kicks off with k.d. lang and Take 6 crooning "Ridin' the Rails," and later Ice-T shows up with "Dick Tracy," which really doesn't fit with the rest of the album, though the chance to hear the gangster rap innovator spinning tales about 1930s mob life in his trademark delivery is delicious.

Sire and Warner Bros. Records released the *Dick Tracy* LP around the world in 1990. Though it doesn't compare artistically to Elfman's masterful film score, nor did it sell anywhere near the units of Madonna's *I'm Breathless*, it remains an innovative and energetic concept album for film music lovers.

Label: Sire / 7599-26279-1 Format: LP Year: 1990 Art: Christine Cano

CHAPTER

8

TELEVISION

DO NOT ADJUST
YOUR SET

ORIGINAL MUSIC FROM THE ADDAMS FAMILY
COMPOSED BY **VIC MIZZY**

THE ADDAMS FAMILY

You only need to hear the finger-snapping, harpsichord-dominated theme song to the TV adaptation of *The Addams Family* once to have it lodged in your head. Initially played by composer Vic Mizzy for creator David Levy, just Mizzy's solo demo of the theme brought a smile to Levy's face, and he knew he had a winner on his hands.

Mizzy had a larger hand in the production of the show than most people might initially recognize. It was his idea to open up on the members of the Addams family for the main credit sequence – which he ended up personally directing, and he

accompanied Levy to pick out props used on set to contribute to the show's look. Furthermore, his music had a role in shaping the feel of the characters. Interviewed by Randall D. Larson for *Soundtrack Magazine* in 1992, Mizzy noted, "Before we started shooting, I told John Astin, who played Gomez, to walk a certain way...when his theme came on...Then, Caroline Jones, who was Morticia, had her own theme and I told her how to walk across the floor so the melody would match what she was doing."

The title track was first released as a 7-inch from RCA Victor in 1964, with a full follow-up album in 1965 (reissued on vinyl in 2015 from Spacelab9). As with Nelson Riddle's *Batman* album, the soundtrack is a playful curio from the era full of groovy nuggets. For example, "Uncle Fester's Blues" is buoyed by fuzzed out guitar, organ, and flute – and sounds like an outtake from a Booker T. & the M.G.'s album. Beyond the themes for the characters are a series of quaint jazzy pieces with hilarious track titles, including "On Shroud No. 9" and "Hide and Shriek."

Label: Spacelab9 / SL9-2022-1-3 **Format:** LP **Year:** 2015 **Art:** N/A

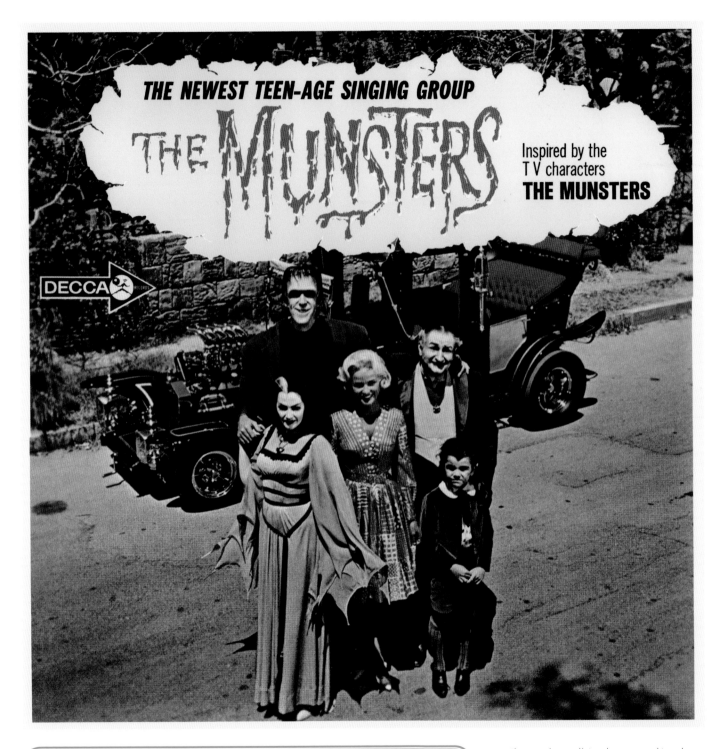

THE MUNSTERS

If you don't believe that the '60s was the decade that would forever change the world, look no further than television in 1964 when there was not one but two monster-themed situational comedies duking it out for ratings. *The Munsters* were winning against *The Addams Family*, so what better way to celebrate than release their own LP of garage rock and surf tunes?

The front cover of Decca's self-titled *Munsters* LP proclaimed it to feature "The Newest Teen-Age Singing Group," and whether this was a brilliant parody of the teen music scene of the time or just

flat out lying, the actual musicians on the record were actually renowned guitarist Glen Campbell and keyboardist Leon Russell. Cheap marketing ploy aside, *The Munsters* record is actually pretty good if you're into old-school garage, surf and Jan and Dean-style pop tunes. With titles "Munster Creep," "You Created a Monster" and "Frankenstein Had a Hot-Rod Car," the vibe here is pure fun. Now, if you're wondering who sang the parts of Lily and Marilyn Munster, the vocals were all handled by The Go-Gos – no, not those Go-Gos, Belinda Carlisle was barely out of diapers. These Go-Gos

were three male vocalists who managed to release one other LP, also in 1964.

In 2018 Real Gone Music reissued *The Munsters* LP exactly as-is, though pressed on Herman Green, Ghoulish Gray and purple color variants. Unfortunately, the sound wasn't cleaned up, but maybe old-school monster kids will appreciate that kind of low-fi quality.

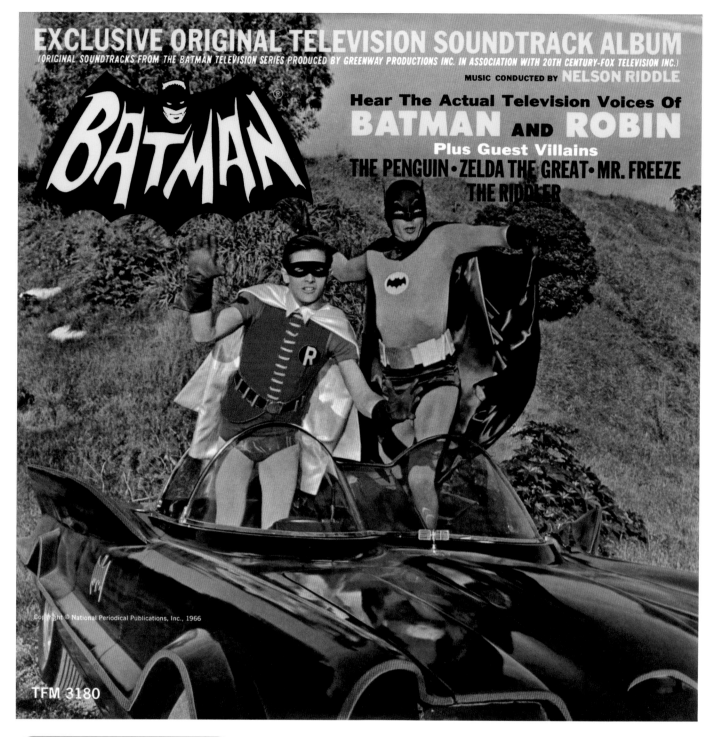

EXCLUSIVE ORIGINAL TELEVISION SOUNDTRACK ALBUM

(ORIGINAL SOUNDTRACKS FROM THE BATMAN TELEVISION SERIES PRODUCED BY GREENWAY PRODUCTIONS INC. IN ASSOCIATION WITH 20TH CENTURY-FOX TELEVISION INC.)

MUSIC CONDUCTED BY **NELSON RIDDLE**

Hear The Actual Television Voices Of
BATMAN AND ROBIN
Plus Guest Villains
THE PENGUIN • ZELDA THE GREAT • MR. FREEZE
THE RIDDLER

Copyright © National Periodical Publications, Inc., 1966

TFM 3180

BATMAN

Most likely you've seen the above artwork and you already have Neal Hefti's infectious *Batman* theme playing through your head.

Hefti had written and arranged for the likes of jazz legends like Count Basie, as well as film scores including *The Odd Couple*. But he's best known for the simple surf-rock theme for the *Batman* TV series (1966 – 1968) that apparently proved a challenge to compose. As he noted to Forrest Patten in a 2004 interview for *Journal Into Melody*, the theme "...took me a couple of months to write. I had seen some footage and I knew

how outrageous it had to be. When I first took the theme to demonstrate it for Lionel Newman, I had to sing it and play it on the piano. My first thought was that they were going to throw me out, very quickly, but as I was going through it, I heard them both reacting with statements like, 'Oh, that's kicky. That will be good in the car chase.'"

The incidental music for the series was composed by Nelson Riddle, a jazz arranger who previously worked for Frank Sinatra and Nat King Cole. On the *Batman* TV series, Riddle (not the Riddler, guys), gets the opportunity to score the campy antics with an array of jazz grooves that fit the swinging go-go-infused spirit of the mid-'60s. That only made sense given that the show allowed screen time for star Adam West "shaking a mean cape" and doing the hilarious "Batusi."

A substantial amount of 1960s *Batman* TV music has been issued. Due to the success of Hefti's theme (and the original RCA single), he ended up penning the album *Hefti in Gotham City* (RCA, 1966). The soundtrack was initially released from Twentieth Century Fox in 1966 (and reissued by Mercury in 1989 to tie in with the Batmania surrounding Tim Burton's film), complete with dialogue snippets from West and Burt Ward (who played Robin). *Film Score Monthly* also issued a CD of Riddle's music for the 1966 *Batman* film (based on the television series) in 2000.

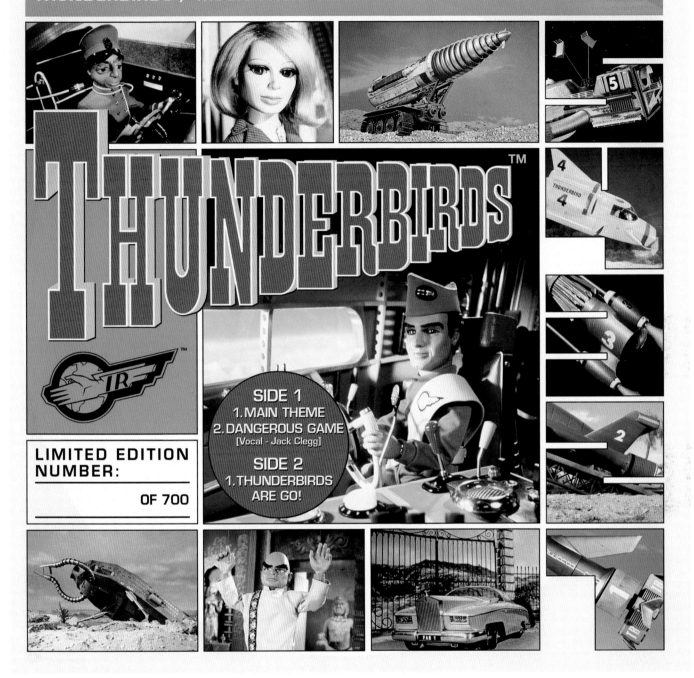

THUNDERBIRDS™

LIMITED EDITION
NUMBER:

OF 700

SIDE 1
1. MAIN THEME
2. DANGEROUS GAME
[Vocal - Jack Clegg]

SIDE 2
1. THUNDERBIRDS
ARE GO!

THUNDERBIRDS

Opening with the famous countdown and "Thunderbirds are go!" exclamation from Peter Dyneley (playing the voice of astronaut Jeff Tracy), Gerry Anderson's *Thunderbirds* followed the adventures of the IR (International Rescue), as the Tracy family and their high-tech Thunderbird machines help save lives — puppet lives to be sure. Running two seasons from 1964 to 1966, *Thunderbirds* once again employed Anderson's "Supermarionation," the clear inspiration for the very naughty *Team America: World Police* (2004).

As usual, Anderson relied on the musical talents of Barry Gray to pump up the action and excitement on an auditory level, particularly helpful as viewers were subjected to an hour-long puppet show with some way-cool props. Gray's spritely theme — one of his best — is led by a propulsive drum march, over which strings and brass busily exchange exciting phrases.

Gray's incidental cues are diverse, and play with a range of instrumentation to suggest the various locales, often in broad, but effective, strokes (accordion is used to paint a picture of the French setting for "The Perils of Penelope," for instance). But a chunk of Gray's music was re-used throughout the episodes, allowing room in the budget for Gray to score for a larger orchestra (he'd eventually get a 70-piece orchestra for the

1966 film, *Thunderbirds Are GO*). And the music, like much of Gray's oeuvre, is an interesting auditory time capsule of where pop music was at the time; his spy-fi themes fit with the mid-60s Zeitgeist. Musically, Gray's approach would change radically by the end of the decade with the funkier edge he'd take on *UFO* and *Space: 1999* (also profiled in this chapter).

The theme song was first released as a 7-inch from Pye Records in 1965, and appearing again on the film soundtrack that was issued from United Artists in 1967 (and reissued by Silva Screen in 1987). Silva eventually released a pair of CDs of Gray's series music in 2003 and 2004, and in 2012, Silva Screen issued a limited edition 7-inch single of Gray's *Thunderbirds* music (pictured above).

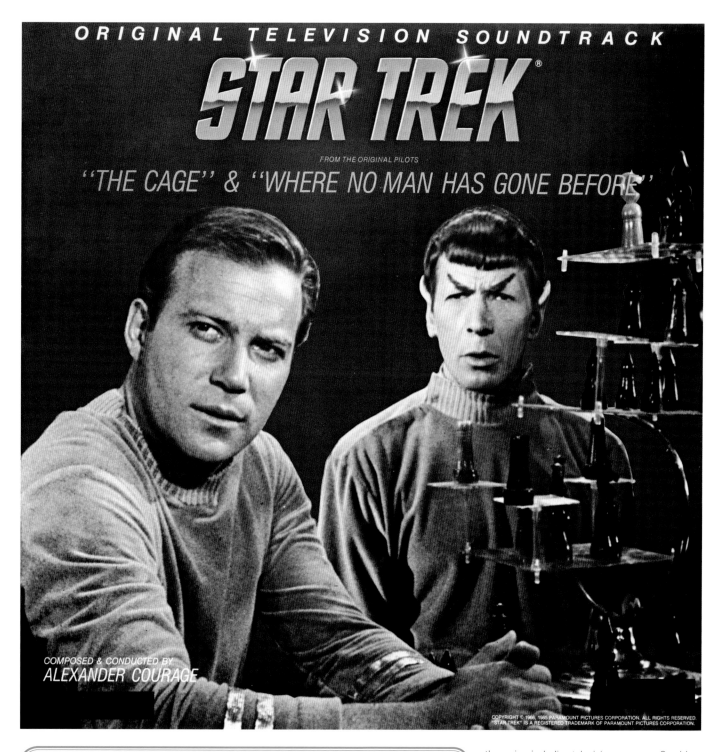

STAR TREK: THE ORIGINAL SERIES

Wherever you were the first time you heard Alexander Courage's iconic four-note ping while William Shatner intones "Space – the final frontier..." it likely started you on your discovery of one of the most iconic and important sci-fi series ever made. The unsung hero behind the all-important *Star Trek* theme was an up-and-coming talent who was willing to dedicate his efforts on a show whose likelihood of success (and thus reruns and royalties) was initially bleak. In a cruel and ironic twist, Kirk and Spock's adventures would in fact go on to be replayed countless times over the decades, but unfortunately for Courage, he had a handshake deal with Gene Roddenberry, in which the series creator could contribute lyrics to the music. It made no difference that the lyrics were utter nonsense and were never intended to be used, it gave Roddenberry a 50 percent split of royalties that otherwise belonged to Courage.

Thanks in part to this unethical, albeit legal, move, Courage stayed on to score only two more episodes in the first season after openers "The Cage" and "Where No Man Has Gone Before." Eight other composers were hired for the remainder of the series, including television composer Gerald Fried (*The Man From U.N.C.L.E.*), with the largest contributions coming from Fred Steiner (who would help score *Star Trek: The Motion Picture* in 1979), composer of thirteen of the show's 79 episodes. That said, only 31 episodes of the original series actually featured complete and original scores, with the majority of them recycling music from other entries. Courage did come back to record an entire 30-minute library of cues in one day during June 1967, which were employed during the second season.

For diehard Trekkers, the music for the original show marked a high point for the entire property, with several episodes standing out. Season One established the major themes of the series, as well as for lead Captain Kirk. Things get interesting on episode "The Man Trap," which uses doomy organ

 Label: GNP Crescendo / GNPS 8006 Format: LP Year: 1985 Art: Ed Francis / Neil Norman

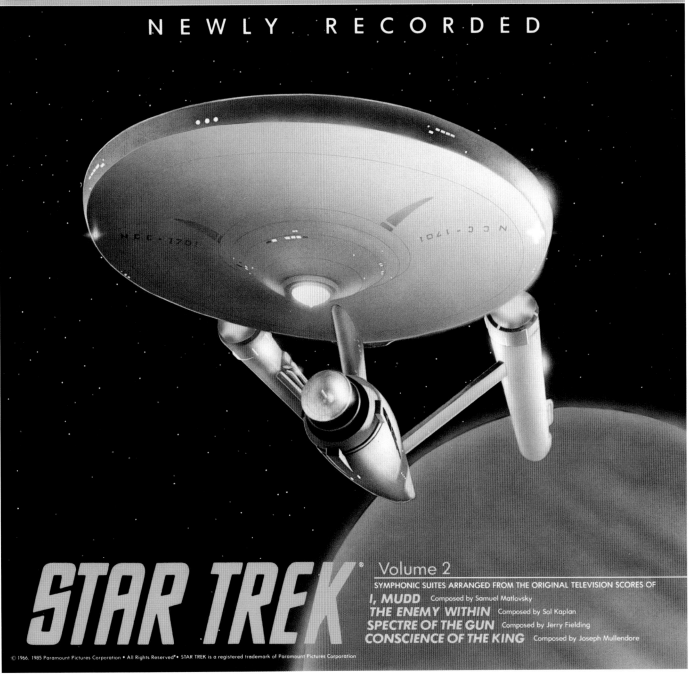

and electric violin to create an eerie atmosphere. Although the music in the first season is generally considered the strongest, perhaps the most revered entry in the entire series comes in Season Two's "The Doomsday Machine," a fan-favorite episode composed by Sol Kaplan. action and high emotion are both at play in this tragic telling of Commodore Matt Decker and the mental trauma he suffers at the hands of a giant planet-killing machine. While Season Three definitely reflects a drop in quality (as well as some bad '60s songs), Courage again returned to score "The Enterprise Incident" and "Plato's Stepchildren."

Over the years, scores from *The Original Series* have popped up on vinyl, making for cool collector items. GNP Crescendo released Courage's original episodes and others, while Steiner and Sol Kaplan teamed up with the Royal Philharmonic Orchestra

to re-record some of their episodes for Varèse Sarabande, including "The Corbomite Maneuver," "Charlie X," "The Doomsday Machine" and "Mudd's Women." In addition, Tony Bremner conducted the Royal Philharmonic on a series of vinyl releases, providing renditions of "Is There No Truth in Beauty," "Conscience of the King" and more. Fans willing to look beyond this will find more *Star Trek* scores on vinyl than a space station full of tribbles.

Label: Label X / LXDR 704 Format: LP Year: 1985 Art: Ron Wong / Walter W. Lee

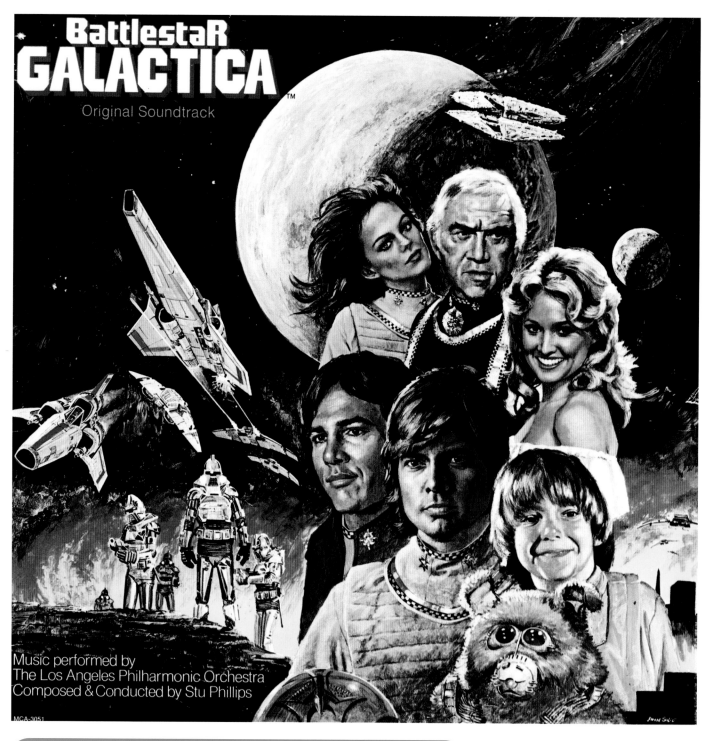

Music performed by
The Los Angeles Philharmonic Orchestra
Composed & Conducted by Stu Phillips

MCA-3051

STU PHILLIPS INTERVIEW

For decades, Stu Phillips was a ubiquitous voice on the TV scoring scene, stretching as far back as the 1950s with *Gidget* and *The Donna Reed Show*, while his film credits include collaborations with cult directors Russ Meyer (*Beyond the Valley of the Dolls*) and Jess Franco (*Paroximus*). But he's best known in genre circles for his work on '70s and '80s TV series *Battlestar Galactica*, *Buck Rogers* and *Knight Rider*, which he discusses here.

Battlestar Galactica and Buck Rogers were pilots for TV series that ended up getting some kind of theatrical release. Did this change the amount of time or resources you had to write the scores?

[With *Battlestar Galactica*], they told me it was coming out in the U.S. as a TV series but they were going to release the longer version of the pilot as a film in Canada. With that in mind, there was music written that could be extended for a longer version of it. For *Buck Rogers*, nobody mentioned a film for that – they just put

it together a film for merchandising purposes to make some extra money.

So you had a larger budget to work with on Battlestar?

Glen Larson and the advertisers kept saying it was the first television show [with a budget of] 13 million dollars, which is nothing nowadays, but I definitely had a bigger budget. TV shows then generally didn't have 85 to 100 musicians. That wasn't the norm. *Buck Rogers* had about the usual budget they'd give out for a pilot, maybe a bit more because it was Glen Larson, and Glen always wanted a bigger sound.

Did you do the orchestrations yourself?

On *Battlestar Galactica* I did all the orchestrations

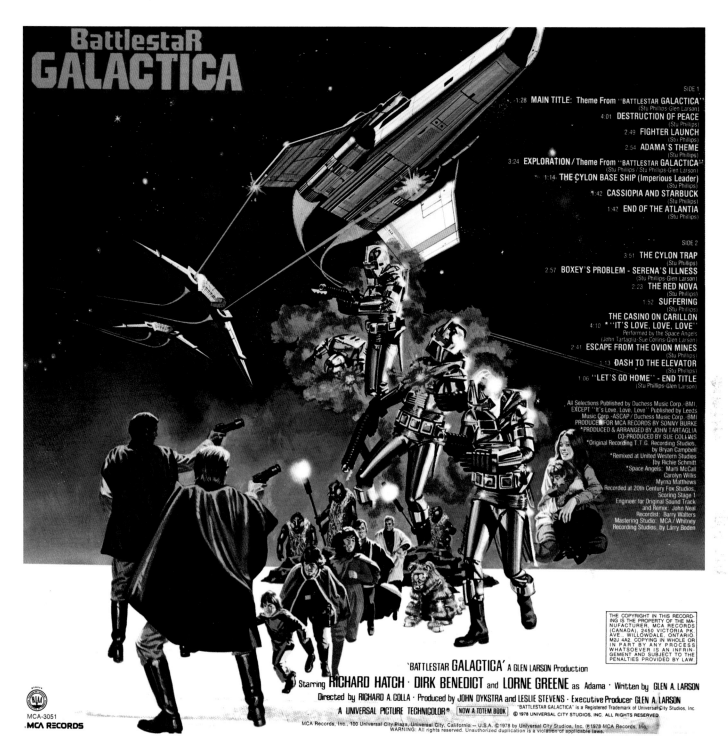

BattlestaR GALACTICA

except for a few bridges. I never had a team in my whole life. I had a helper on *Battlestar* named Nathan Scott and he did a few very short cues to help me out so I had the time to [finish scoring]. With *Buck Rogers*, pretty much I did all of that. When things got tight or I needed something, he'd come over and I'd give him some short things. I'd made a much more detailed sketch for him, so basically it was orchestrated by sketch. When I did sketches they were so brief because I knew I was going to be doing it and therefore I could compose on the score paper.

On Battlestar Galactica you were tasked with turning in a ton of material on very short deadlines. How did you get it all done?

Hard work. There was a period of time where I was doing *B.J. and the Bear*, *Sheriff Lobo* and the

beginning of *Knight Rider*, or *Buck Rogers* – one or the other. And then I had a movie of the week with Glenn Ford. I was up to my neck. At that time, Nathan Scott helped me out on one show. Bruce Broughton's brother, Bill Broughton, helped me out on *B.J. and the Bear*. I had two guys helping me out on three shows. But I wrote all of the music. There were times, even in *Galactica*, where we'd have a battle scene that was basically the same as the one the week before and the one the week before that. I had a fake brick wall in my office that you could put pins in, and I would pin up a bunch of music sketches and I would re-use it during the series. Sometimes I'd get an extended cue [to write]. I'd use 30 seconds of [one of my musical sketches] and 40 seconds of this other sketch and 30 seconds of this one, and I would write a bar in between to connect them all.

Your title theme to Battlestar Galactica *is considered by some to be your most memorable. How did that come to be written?*

The theme was written fairly quickly, however it evolved while I started writing [incidental] cues and using the theme. I went back to the way I had originally written it and changed it, deciding to harmonize it a certain way. There were some slight modifications, but the theme went rather quickly. It wasn't a big deal.

There was even a disco version of Battlestar Galactica!

[Giorgio Moroder's version] was kind of nice. It was kind of different. I did do a disco version of the theme. I can't recall whether I did it before Giorgio's album, or after. Giorgio didn't do the *Battlestar* theme on that record, though – Harold

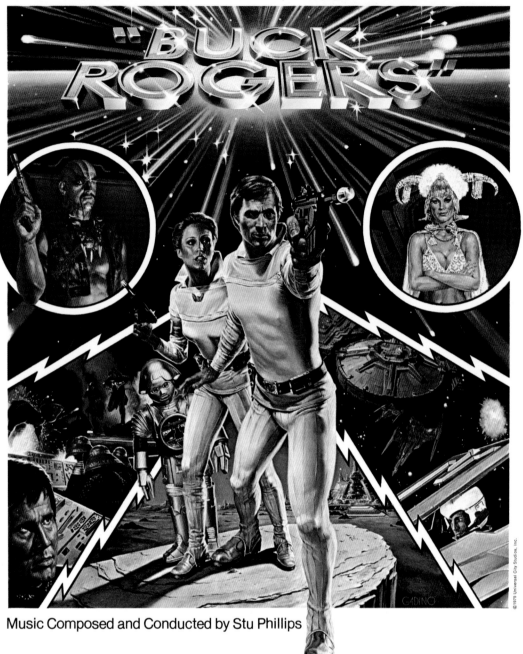

ORIGINAL MOTION PICTURE SOUNDTRACK

"BUCK ROGERS"

Music Composed and Conducted by Stu Phillips

MCA-3097

Faltermeyer did it. I did call Giorgio out of courtesy to say thank you, and he never called me back!

Did each of these series have their own specific sound palette you were after?

Buck Rogers was a whole different treatment from *Galactica*. I only had 40 to 45 players [on *Buck Rogers*] and had to make it sound like it was still the philharmonic. I avoided flutes and oboes and hired three clarinet players because they had larger ranges and different timbres. I'd have a guy double on flute if I desperately needed a flute, but [flutes] tended to get buried in the mixes so I went with the clarinets. I wouldn't take any violins because there's nothing worse than six violins playing – it sounds like chamber music. The worst thing in the world was listening to six violin players trying to compete with three trumpets and

three trombones. I'd ignore violins and just have six or eight cellos, and use those as the string section. The cellos have a bigger body, bigger sound and there was definitely a more reliable register on the cellos –three octaves easily without [the sound] getting thinned out. When violins get high they get very thin. I devised a lot of different orchestral settings to cover the different episodes, still trying to retain the original L.A. Philharmonic sound. It was tricky, but it worked.

There is a certain amount of "camp" factor with Buck Rogers. *Did that affect your approach when it came to composing?*

The music was more fun on *Buck Rogers*. He was not a serious character. *Galactica* was supposed to be a serious show with comical moments. There couldn't have been anyone more serious than

Commander Adama on *Battlestar*. Whereas in *Buck Rogers* everybody was playing it tongue in cheek, almost. With that in mind, the music was kind of tongue in cheek. With *Buck Rogers*, we purposely had a little more contemporary [sound], with a rhythm section occasionally with the cues. We didn't want to go as classically oriented as *Galactica* was. *Buck Rogers* was basically just a little classical with pop orientation, if I can make that distinction.

I understand that one of your favorite cues is the sultry theme for Princess Ardala.

I treated her kind of like Scheherazade [from the Middle Eastern story collection *One Thousand and One Nights*], doing some kind of things with a guitar and with the strings, and having them moan a little bit. It worked because, once again,

Label: MCA Records / MCA-3097 Format: LP Year: 1979 Art: Victor Gadino

ORIGINAL TELEVISION SOUNDTRACK

KNIGHT RIDER

MUSIC BY STU PHILLIPS

against Buck and her, it got campy. They were both putting each other on in the scene. They were both conning each other, so I tried to write conning music both ways.

Finally, can you tell us about Knight Rider, *and its very '80s synth score? Were you influenced by the Zeitgeist at the time?*

On *Knight Rider* I wasn't influenced by anybody. *Miami Vice* came after *Knight Rider* by about six months, I think. I was breaking new territory by going with a theme that was basically synthesized. I did use a guitar and a Fender bass and drums and percussion. All of that was not synthesized, but I had four synthesizer players on *Knight Rider.* So it was kind of like a first to a degree. Other composers had been using synths in films but there wasn't much use of it on television at that

time. Nobody made a record of it, nobody made a single of it – nobody did anything until almost twenty years later when people on the Internet started sampling it and using it and re-discovered it. Now it has a whole new life.

Label: Varèse Sarabande / 3020675561 **Format:** 2xLP **Year:** 2019 **Art:** Florian Mihr / Universal Studios

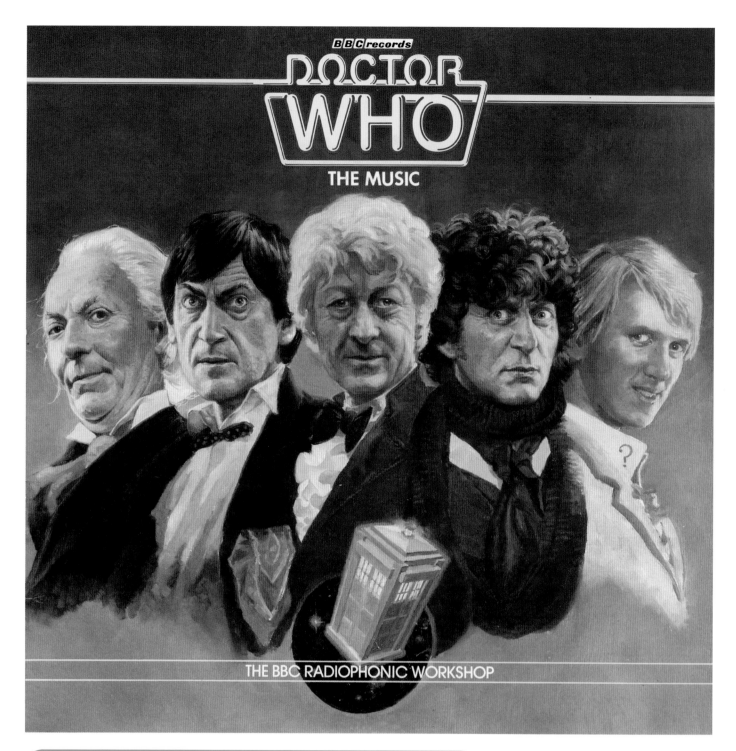

PETER HOWELL ON DOCTOR WHO

BBC's *Doctor Who* has changed drastically since its 1963 debut, including the lead actor on at least numerous occasions. One thing that's been kept in place is the iconic theme, written by Ron Grainer, and first realized by Delia Derbyshire and Brian Hodgson. In addition, composers such as Tristram Cary, Dudley Simpson and Geoffrey Burgon have all provided unique music for the classic series. Peter Howell, of the BBC Radiophonic Workshop, discusses his radical update of the theme in the '80s, along with his work on scoring the show.

Your time on the show stretches all the way back to the mid-'70s with some incidental cues from "Revenge of the Cybermen." Can you tell us about your role on this?

[Composer] Cary Blyton's score was very acoustic and the producers were concerned it would be seen as a bit of a shock in terms of style. So he and I worked on adding electronics to it, mainly using an ARP Odyssey.

When John Nathan-Turner took over the show in 1980, he envisioned a new look and a new sound,

which included your take on the theme. How did your version come about?

I went into reworking the theme with certain areas that I felt were untouchable, one of which was the "oo-ee-oo" sound that is really unmatchable. Nobody who has done a version of the title music has strayed very far from that because it's so iconic. I felt that it had to be there, up at the top. On the bottom, Delia Derbyshire had realized the bassline fantastically well. One thing she'd done is she'd got this "gulp" sound before each bass phrase that was a reverse sound of the incoming note. I loved that, so I reproduced it using the synths I had. Those were the sounds I couldn't touch, not that I was using the original [recordings], but paying homage to the way she'd done it.

 Label: BBC Records / REH 462 Format: LP Year: 1983 Art: Ian McCaig / Mario Moscardini

I felt that everything else was up for grabs. There were two things running through my mind. One of them was absolute fear! I was tampering with something of a holy cow. The theme was institutionalized by the time I got to it. I was conscious of the fact that if my attempt to do it did not go down well with my colleagues then we would actually not even admit that we'd done it! So it was all done in a fair amount of secrecy just in case it didn't work. The other thing I was conscious of when Delia did her title music, what people were excited about was that they had no idea how it had been done. The public were not at all aware of what was possible using rudimentary electronic devices; it took them by surprise. I didn't want people to listen to my version and say, "Oh, I know how he's done it." People were more aware of the

sound equipment when I did my version. I started with the intention of using every bit of gear at the workshop, just to ensure it didn't come across as being one single synth version.

It took you around five and a half weeks to record the theme, is that correct?

About six weeks, that's right.

Do you know if Ron Grainer had a chance to hear it, and what his thoughts were?

I'm not sure about Ron, but Delia Derbyshire was nice about my version. There had been a version that had only ever been used on one single episode [for an Australian print of the episode "Carnival of Monsters"]. She was only too aware of that, and that it had not succeeded at all. It made

it even nicer for me that she was complimentary of my version. She liked the idea that I went back to Ron Grainer's score and had taken it from there, rather than imitating her [work]. As far as Ron was concerned, I never knew if he approved of my version. He was totally amazed at Delia's version because he'd only scored the topline and the bassline.

What did Ron Grainer's score actually look like?

There were no harmonies on the score I saw at all. He'd done it quite quickly in the office and gone on holiday [back in 1963]. And Delia did the version she did. Ron came back from holiday and he couldn't believe what he'd heard. He wasn't terribly possessive about it. He was a prolific composer.

Label: BBC Records And Tapes / 12RXL193 Format: 12-inch Year: 1986 Art: Sid Bank, Light Fantastic [Hologram], Mario Moscardini 191

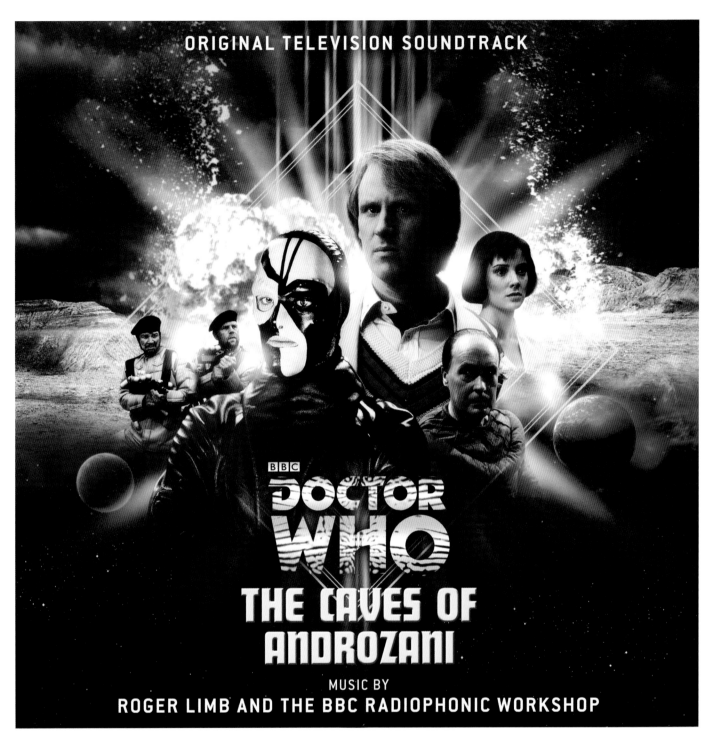

ORIGINAL TELEVISION SOUNDTRACK

BBC
DOCTOR WHO
THE CAVES OF ANDROZANI

MUSIC BY
ROGER LIMB AND THE BBC RADIOPHONIC WORKSHOP

You provided incidental music for several stories. How long would you typically have to score a serial?

The deadlines were very tight. Say it was a four-part adventure. When you worked on episode one, you'd have about ten days to do it, but by the time you got to episode four, there'd be less than a week. You'd be looking at five days of actual work, with the sixth day in the final mix. You were, under normal circumstances, producing up to two minutes of finished music per day. Writing it, arranging it and recording it, and syncing it to picture. That's a lot to get done in a day.

Your score for "Meglos" uses what sounds like a vibraslap as a percussive effect; how often would traditional instruments be used in incidental scores?

It is a vibraslap. We were in the same building that the BBC made available for the symphony orchestra, which had a vast store of percussion instruments. "Meglos" was recorded during a period when using found sounds was not as possible. [Recording found sounds] was more time-consuming in that period, prior to sampling coming in. Once sampling was with us, then using found sounds was a lot easier. In later episodes I did sample sounds when I was able to use the Fairlight [digital synthesizer], for instance with "The Five Doctors" [1983].

In that episode, there's the distinctive use of the Queen Mary foghorn.

I loved that. I just liked the fact that it was so prominent in the show. It was nice to talk about at cocktail parties. What you do when you're

looking for an original sound is that you go around the [Radiophonic Workshop] trying out sounds, blowing things, etc. Then I started looking at the BBC sound effects library, and I came across a recording of the foghorn. I used the Fairlight to sample it, and there was quite a lot of fiddling around with it. What you're hearing in the show are several [horn blasts] at once, but detuned to give it a raspy sound.

A lot of composers have shied away from making reference to the main theme in the incidental music, but you've done it on a few occasions.

I quite liked doing that, especially in "The Five Doctors," because the whole *raison d'être* of the program is that there's a whole team of Doctors. Using the theme was relevant, really.

 Label: Silva Screen / SILLP1370 Format: 2xLP Year: 2013 Art: Clayton Hickman

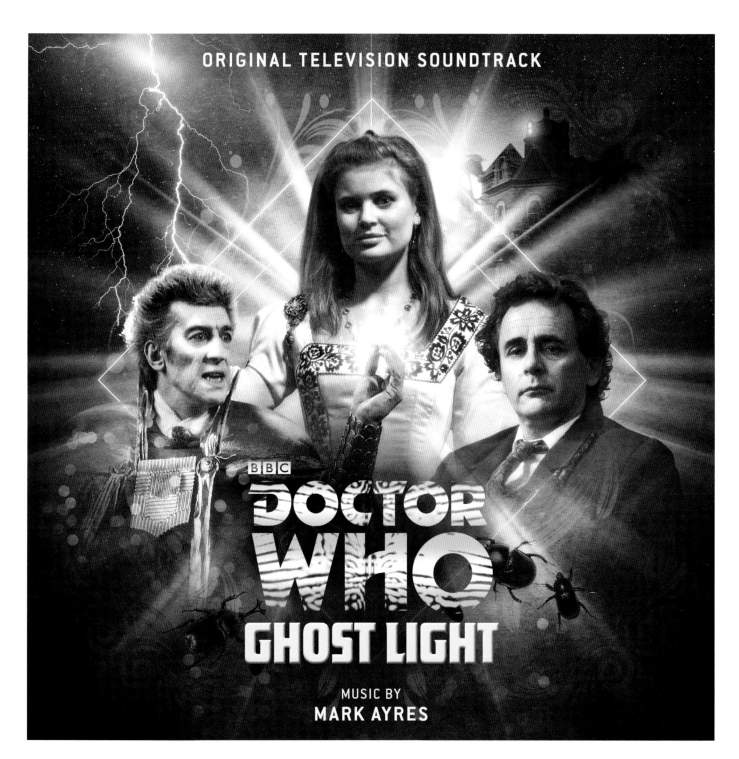

ORIGINAL TELEVISION SOUNDTRACK

BBC

DOCTOR WHO

GHOST LIGHT

MUSIC BY
MARK AYRES

How closely would you work with the sound design team (e.g., Dick Mills) when scoring?

Dick Mills' studio was next door to mine. We collaborated in the sense that we talked about what he was doing in a scene and what I was doing. There wasn't in the workshop itself a point at which he and I put the stuff together because, quite frankly, time was quite short. We would do what we suggested. The next time when it was put together was at the dub in the final mix, which we would both attend. That's a whole day out of your schedule for each episode to go to the [BBC] television center to the final mix. In terms of the collaboration, that is the most time efficient way we could work out how to do it.

The fabled BBC Radiophonic Workshop always summons up images of this mythical workspace

where the most amazing sounds were created, but I'm curious what it actually looked like.

Funnily enough it's a question that not enough people ask. I don't know if it's because they want their illusions shattered or not. In actual fact, it was single rooms down a long corridor in a BBC building. There were about twelve rooms of about fourteen square feet each, and each room had a different composer in it. There were different sorts of equipment in each room and people would be borrowing things. There was never a single space with lots of fantasy-like gear; it was spread in lots of different rooms. It just wouldn't be practical otherwise. The actual reality of it was inevitably never as visually exciting as people thought.

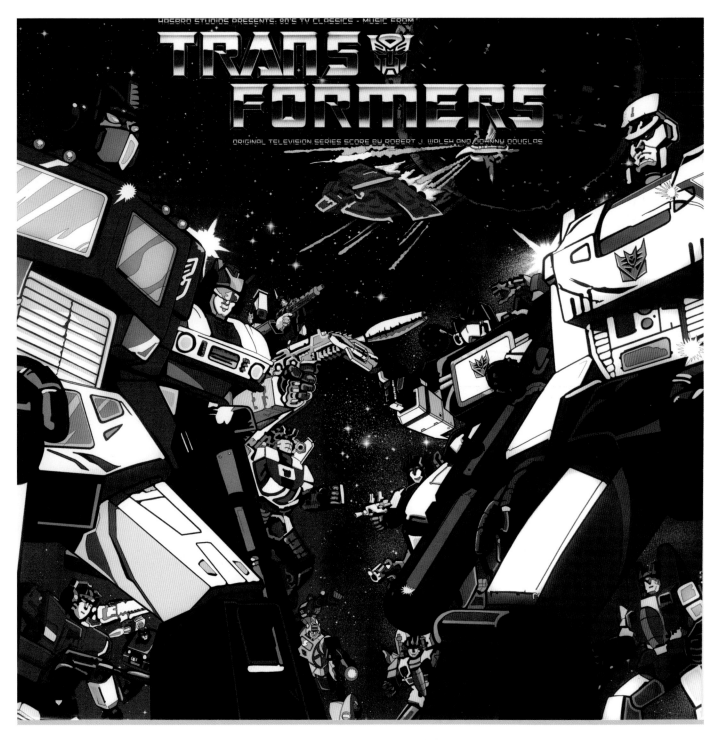

HASBRO STUDIOS PRESENTS: 80'S TV CLASSICS - MUSIC FROM

TRANSFORMERS

ORIGINAL TELEVISION SERIES SCORE BY ROBERT J. WALSH AND JOHNNY DOUGLAS

THE TRANSFORMERS

The soundtrack for *The Transformers* TV series is more than meets the ear (sorry, we have a quota on bad puns to reach in this book). Scored by Robert J. Walsh and Johnny Douglas, the album reveals a rich dramatic underscore that accompanies the catchiest theme song this side of *G.I. Joe: A Real American Hero* (also written by Douglas).

Douglas seemed to have the monopoly on a decade's worth of Saturday morning cartoon scores. His dramatic fusion of pop and orchestral idioms graced no less than the animated *Incredible Hulk*, *Dungeons & Dragons* and *Spider Man and His*

Amazing Friends, which partially accounts for the similar vibe these shows all share.

As far as *The Transformers* (1984 - 1987) goes, sometimes cues amount to just stings, but they're distinctive enough to have sat in the memory of a generation for years. "Something is Wrong" is a 24-second piece that repeats a five-note motif that pretty much has the musical effect of its title. "No More Worries" uses winds and strings to fashion an authentically wistful moment. And in "Battle" the composers juggle a ton of ideas (played out on thundering timpanis, electric guitars, and triumphant

brass) and a call-out to the theme song, resulting in the kind of hyperactive action cue that fuelled this kind of animated TV in the '80s. But hands-down, winner of the Sickest Track in a Cartoon EVER Award must go to the electro-funk of "Mad Planet." It's a far cry from, say, the jazzy underscore of the '60s *Spider-Man* animated series, culled from library tracks.

Most of the cues don't run longer than a minute or two, which is fitting given that they were underscoring myriad robotic battles that had to end in time for commercial breaks. It helps that the composers had an autobot army's worth of musical ideas to fill the series with, filling album, *80's TV Classics - Music From Transformers*, and released in 2018 by Enjoy The Toons Records. The initial limited edition pressing featured vinyl variants of either Optimus Prime and Megatron (e.g., gray vinyl with a purple splatter pattern).

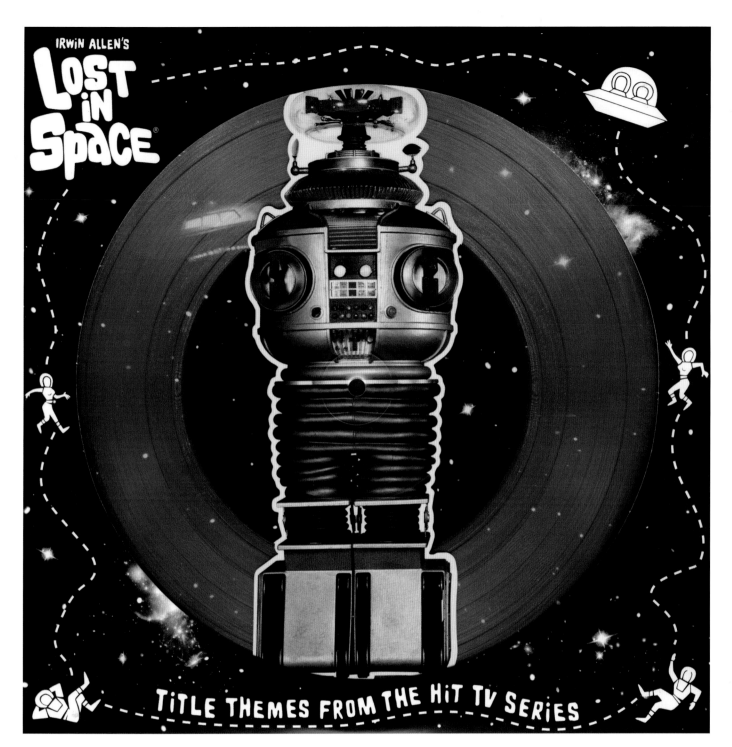

IRWIN ALLEN'S
LOST IN SPACE®

TITLE THEMES FROM THE HIT TV SERIES

LOST IN SPACE

Long before he composed the most famous space opera music of all time, not to mention becoming the most recognized composer in Hollywood, "Johnny" Williams created the theme music for the oh-so-'60s science fiction family series *Lost in Space*, which aired from 1965 to 1968. Using jazz, funk and futuristic sounds, it was this main theme that got Williams noticed and gave him credibility as a composer (even though the original pilot and much of season one actually recycled Bernard Herrmann's spooky score from 1951's *The Day the Earth Stood Still*).

Williams also scored four episodes of the show: "The Reluctant Stowaway," "Island in the Sky," "The Hungry Sea" and "My Friend, Mr. Nobody." As the story goes, the original tapes of these recordings were discovered stacked on pizza boxes on a soundstage, more or less in a state of decomposition, half eaten by insects. While the first episode was lost, the other three were rescued and successfully digitized (music from "The Reluctant Stowaway" was preserved from the original Fox music and effects split tracks). The result is a multi-colored four-LP set by Spacelab9, which presented this rare John Williams music and gave fans the chance to enjoy it on its own for the first time. *Irwin Allen's Lost In Space – The Complete John Williams Collection* was released in 2017. For Record Store Day 2017 the label released *Lost In Space: Title Themes From The Hit TV*

Series picture disc, pressed on clear vinyl with the famous *Lost in Space* robot "floating" in the record (shown above).

Yes, the main theme is drenched in schmaltz, but the rest of the tracks from this show offer a precursor of what was to come – even at this point Williams was operating a little beyond everyone else around him. "The Chariot Continues," from "The Hungry Sea," has just a touch of that epic might that would come to fruition on *Star Wars*, and "My Friend, Mr. Nobody" holds that sense of wonder and imagination that became a hallmark of his career. Rounded out with a starload of bonus library cues, *Irwin Allen's Lost In Space – The Complete John Williams Collection* is one of the more vital yet affordable collections for sci-fi's considerable fanbase.

THE TWILIGHT ZONE

ZONE

Produced & Arranged by Rusty Egan

THE TWILIGHT ZONE

There are TV show themes and there are TV show themes, and then there's *The Twilight Zone* main title theme. One of the most iconic in history, the show's intro is up there with *Jaws* and the *Psycho* shower scene music in the sense that when people make *that* sound, you know exactly what they're referencing. In this case, it's that something weird and mysterious is at work, the type of spooky happening that could only occur within this seminal sci-fi/horror show's five seasons (1959-1964).

It didn't exactly begin that way, however. Instead using a far more subtle, yet no less eerie orchestral intro by *Psycho*'s own Bernard Herrmann, who would go on to score seven of the show's episodes, including the premiere, "Where is Everybody?" and "Walking Distance," a sentimental look at fading youth. From the beginning, *The Twilight Zone* was all class. Sure, much of the first series used stock library music, including Herrmann's own "Outer Space Suite," but other notable names popped up, including Franz Waxman (*Bride of Franken-stein*) on "The Sixteen-Millimeter Shrine," Leonard

Rosenman (*Star Trek IV*) on "And When the Sky Was Opened" and even Hollywood legend Jerry Goldsmith with "The Four of us are Dying."

The '80s witnessed renewed interest in the series, leading to a brand new *Twilight Zone* in 1985, and a series of singles and LPs collecting suites from some of the very best entries, as well as the iconic intros, end credit sequences and various cues. Other *Twilight Zone* collections have popped up on CD over the years, including a four-disc set organized by composer, so opportunities for more *Twilight Zone* are out there. What better show to re-experience over the warm and eerie sound of crackling static?

UNSOLVED MYSTERIES

Before the truth was out there with *The X-Files*, there was the paranormal reality series *Unsolved Mysteries*, in which all manner of unexplained phenomena (UFOs, ghosts, unusual disappearances, etc.) were dramatized with sobering introductions by Robert Stack. His deadpan delivery works to terrifying effect, all thanks to what remains, quite possibly, the scariest theme show in television history, courtesy of Gary Malkin and Michael Boyd.

How scary? According to the liner notes from the eventual album release, the producers of *Unsolved*

Mysteries were barraged with letters asking them to find a less unsettling theme song, which they thankfully ignored. Isolated from the weird credits imagery and Stack's moody introduction, it's still enough to make you listen with the lights on. The music is based around an insanely catchy ostinato (two seven-note motifs) – one of the main theme's creepiest moments comes from the bending of the chords that play over the ostinato, which would later turn into a '90s horror trope heard in, amongst other things, *The X-Files*.

Remaining music for the series was primarily

composed by Malkin, but also with contributions from Dan Alvarez, Jeff Beal, Michael Boyd and Pete Scaturro. The producers asked the composers to create a music library with an assortment of cues written for specific types of episodes, such as ones dealing with ghosts, UFOs, etc. that could be slotted in as needed. This catalogue of synthesized textures and moods ranges from melancholic to crap-your-pants scary, and elevated the dramatized spooky stories to a whole other level for a couple generations of kids, as the show ran from 1987 to 2010. Perhaps the biggest mystery is how it went unreleased until Terror Vision Records got in on the action with the first of its *Unsolved Mysteries* soundtrack albums, focusing on "Ghosts / Hauntings / The Unexplained" (2018), with a 2019 follow-up on "Bizarre Murders / UFOs / The Unknown." Listen at your own peril!

Label: Terror Vision / T.V.020 **Format:** 2xLP + 7-inch **Year:** 2019 **Art:** Earl Kess

ORIGINAL TELEVISION SOUNDTRACK

A GERRY ANDERSON PRODUCTION

UFO

MUSIC BY BARRY GRAY

UFO

Some of the tightest grooves in this entire book can be found buried within the tracks of Barry Gray's score for the 1969 Gerry Anderson TV series *UFO*. The show focuses on hilariously acronymed S.H.A.D.O. (Supreme Headquarters Alien Defence Organisation), whose secret base is hidden below a film studio, and who fend off an alien invasion of earth. Lasting only a year, it featured Anderson's penchant for cool model work, although the emphasis was on more violent storylines, sexy provocative clothing, purple wigs and *no* marionettes.

Gray's music here is a tuneful complement to his later work for Anderson on *Space: 1999*. Initially composing a theme that was deemed too militaristic for the series, Gray composed three takes on the theme before settling on the one used onscreen. Once again, Gray focuses on period-era pop to keep the soundtrack cooking, making effective use of Hammond organ and a spritely brass section in his main theme, which plays over a montage of then-future 1980 – depicting various sea, land and moonbase S.H.A.D.O. crew mobilizing, along with excitedly-whirring typewriters. Interestingly, the end title theme is a complete 180-degree flip from that caffeinated opening montage; here Gray composes a spacey, ethereal soundscape, heard as the camera slowly pulls away from a close-up of Earth until it's just a dot amongst the solar system, making use

of music originally recorded for Gray's *Fireball XL5*. Meanwhile, the incidental scores play to both of Gray's musical approaches. Cues such as "S.H.A.D.O." offer a bluesy take on Gray's theme on the Hammond, while the '70s jazz-pop is balanced with more nervy strings on cues such as "Alien."

Save for a Japanese 7-inch issued in 1970, the music went unreleased on vinyl until Trunk Records put out a 500-edition LP in 2004, with Silva Screen following suit with its full-length 2xLP in 2019.

An Original Television
Soundtrack Recording
Music composed by
Barry Gray

ABL1-1422

SPACE: 1999

Fluctuating between traditional orchestral themes and groovy guitar licks, Barry Gray's *Space: 1999* is one of those sci-fi soundtracks that balances on the precipice of geeky TV score and booty-shaking club mix. This pop-based approach is something Gray also brought to Gerry Anderson's *UFO* series (both being live-action standouts among Anderson's Supermarionation series such as *Thunderbirds* and *Captain Scarlet and the Mysterons*), although you can thank guitar player Vic Elms for the funky guitar work on the title track.

Elms sometimes receives a co-writing credit on *Space: 1999*, and reportedly the two did not get along well. Nevertheless, it's Elms' funky edge to the music that makes it stand out from other genre efforts. Interviewed by Jerry Scott in 1998 for a fan website, Elms noted that his guitar riffs were "based upon the overall mood of music which Barry Gray was composing. I used a bass player [John McCoy], and drummer [Liam Genocky] from a very good rock band named Zzebra, and I played the lead guitar part." (Nerd alert: Zzebra also penned a 1974 7-inch inspired by John Boorman's crazy space epic *Zardoz*.)

What this means is that, as a listening experience, *Space: 1999* sounds pitched somewhere between *Buck Rogers* and Meco's *Star Wars* album, so you've got tracks that feature orchestra, but there's also a substantial amount of bongos, jazz organ and wah-wah guitars – used on episodes such as "Ring Around the Moon," with a score that blends Isaac Hayes grooves with some trippy instrumentals. That said, Gray only scored four complete episodes – the balance of the music was taken from Gray's other Anderson shows and spliced into the other episodes.

The show's original soundtrack was released on vinyl from RCA in 1976. In 2017, Death Waltz released Ennio Morricone's score (designed for an Italian feature-length cut of a few episodes). Meanwhile, longer editions of Gray's TV soundtracks were reissued on CD from Silva Screen in 2004, but without the strange comic bell sounds that appeared between tracks on the vinyl.

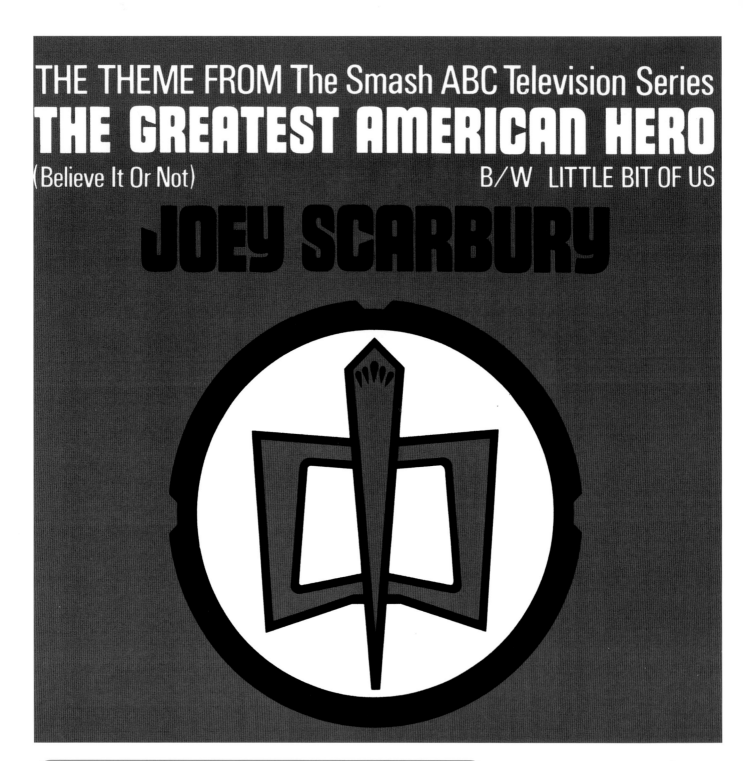

THE THEME FROM The Smash ABC Television Series
THE GREATEST AMERICAN HERO
(Believe It Or Not) B/W LITTLE BIT OF US
JOEY SCARBURY

THE GREATEST AMERICAN HERO

Composer Mike Post was known for his punchy TV themes, but with Stephen J. Cannell's *The Greatest American Hero*, viewers were treated to a song that worked against the action – ideal for a goofy sci-fi series about a hapless high school teacher (William Katt) bestowed with superpowers in the form of an embarrassing red suit. Having lost the instruction manual, Katt spends much of the series crash-landing after his flights and discovering the nature of his alien abilities by happenstance. The premise was ratings gold (enough for a three-year run, from

1981 to 1983, anyhow), as there's something endearing about a superhero that doesn't fully know the extent of his powers, trying to do good in the world.

The hit theme song, "Believe It or Not" – which was composed by Post, but has lyrics by Stephen Geyer and vocals by Joey Scarbury – reached #2 on Billboard's Hot 100 at a time when you could have an extended vocal over a mid-tempo song. It does much to smooth over the antics and silliness sometimes present in the show, in large part due to Geyer's contemplative lyrics, which address

our hero's uncertainty from the get-go ("Look at what's happened to me / I can't believe it myself / Suddenly I'm up on top of the world / It should have been somebody else"). Also to help is Post's syrupy arrangement, with its wistful piano-led intro and chorus underscored with soaring strings that play more like John Williams' *Superman* love theme than the kind of rousing fanfare found in Post's action themes (*The A-Team*, *Magnum P.I.*). But what sells the song is the warm, earnest delivery from Scarbury, who'd also contribute one other vocal for the pilot, a take on Elton John's "Rocket Man."

The theme was released as a 7-inch single from Elektra, coupled with the equally tuneful country-tinged "Little Bit of Us," but also is featured on Scarbury's hidden gem of an album, *America's Greatest Hero*, from 1981.

Label: Elektra / E-47147 **Format:** 7-inch **Year:** 1981 **Art:** N/A

SPIDER-MAN

TV's animated *Spider-Man* series boasted the catchiest 1960s superhero theme this side of *Batman* (penned by Bob Harris and Paul Francis Webster). It was first produced in 1967 from Grantray-Lawrence Animation, although the company subsequently went bust a year into the series' production, and then was salvaged by Ralph Bakshi for the remaining two. The show, chronicling the friendly neighborhood web-slinger, required scaling back on the budget for original music, which had been provided in the first season by Ray Ellis.

Instead, Bakshi turned to the KPM music library for some crime-jazz underscore of the highest order. KPM's library had been used in genre films before: Keith Mansfield, for instance, penned the moody "Summer's Coming" that pops up as the theme to David Cronenberg's 1977 film *Rabid*. On *Spider-Man*, Mansfield's contributions include "Funky Flight," running a minute and change, but full of enough driving rhythms, funky bass, and a dash of groovy organ to sustain far more.

It wasn't until 2018 that Trunk Records plundered the KPM vaults to present *Spider-Jazz*, an LP sampling the funky cuts that propelled the web-slinger through the colorful and evocative cityscapes (and whose artistic style is emulated on Paul Flack's cover). The album opens with Syd Dale's "The Hellraisers," heard in the second season's "King Pinned" episode, in which crime

lord Kingpin knocks Spidey out with sleeping gas. It's fueled by some percussive cowbell and the kind of punchy brass stabs that would make John Barry proud.

In today's day and age, when a Marvel blockbuster requires the output of a symphony orchestra at full blast, there's something endearing, even comforting, in this random collection of period grooves, which imbue the young superhero with the kind of hipster coolness he never had in the movies – Trunk's musical mélange of fuzzed out guitars, jazz flute, and tight jams will definitely have you slinging and swinging across your living room floors and walls.

Label: Trunk Records / JBH070LP **Format:** LP **Year:** 2018 **Art:** Paul Flack

CHAPTER

9

UNIDENTIFIED OBJECTS

SCI-FI MASH-UP

SPACEBALLS

So, you already have *Spaceballs*: **The Coloring Book,** *Spaceballs*: **The Toilet Paper** *and* *Spaceballs*: **The Flame Thrower? By the balls of President Skroob, you're not living until you've tracked down a copy of** *Spaceballs*: **The Soundtrack!**

Mixing pop songs with a few choice nuggets of John Morris' score, the *Spaceballs* soundtrack was certainly in heavy rotation for at least one of this book's writers in the summer of 1987 (and possibly the ensuing 30 years). And with good reason: Morris' score is well-represented with three tracks

on the album, featuring his amusing pastiche of the *Star Wars* theme, complete with laser blast effects, along with a tender love theme on the strings that plays just before Dot Matrix's virgin alarm goes off.

Most of the actual songs smack of late-'80s pop sensibility, and are therefore awesome. You can't go wrong with Van Halen's "Good Enough" (playing on the jukebox in the diner near the film's conclusion), and there are two power ballads worthy of a slow dance, though Ladyfire's "Wanna Be Loved by You" deserved more time in the film than just having its final coda play as Lone Starr and Barf arrive at the diner. Best of all is the lively, original title song heard during the escape from Mega Maid, performed by The Spinners (and co-written by Mel Brooks, may the Schwartz be with him). It's built around a catchy riff and features an

earworm of a chorus suggesting maybe Brooks should stage a *Spaceballs* musical.

The only glaring omissions on the album are the "Colonel Bogey March," as sung by the Jawa-like Dinks, along with the Tin Pan Alley classic "Hello, My Baby," hilariously crooned in the film by the embryonic alien xenomorph, in a nod to both the Ridley Scott film and famous Warner Bros. cartoon character Michigan J. Frog.

The album was released in 1987 from Atlantic Records and is as essential for life as the air from Planet Druidia. Seek it out this moment with ludicrous speed.

ORIGINAL MOTION PICTURE SOUNDTRACK

INNERSPACE

Music Score by JERRY GOLDSMITH
Featuring songs by ROD STEWART, WANG CHUNG, NARADA MICHAEL WALDEN, BERLIN and SAM COOKE

INNERSPACE

With *Innerspace*, director Joe Dante continued his collaboration with Jerry Goldsmith – a composer who could deftly balance moments of action and comedy (as he proved on their previous work for *Gremlins*, *Explorers* and *The Twilight Zone* movie). And, as with *Gremlins*, Goldsmith's score shares space on the soundtrack album with the film's array of pop songs.

The 1987 movie has the class to use at least two Sam Cooke songs. Cooke's recording of "Cupid" is featured on the compilation, although more memorably used (but not on the album) is "Twistin'

the Night Away," playing during a hilarious scene in which Martin Short slugs back some booze so that miniaturized soldier Tuck Pendleton (Dennis Quaid) can collect some as it spills down his esophagus, raising big questions: if Tuck has been miniaturized, how can his body process the much larger alcohol molecules? (You better believe we're using up our 350-word allotment on these mind-benders, and while we're at it, the two Cooke songs are best heard on one of the greatest live R&B albums out there, *Live at the Harlem Square Club*, 1963). Rod Stewart's take on "Twistin' the Night Away" graces the end credit sequence, and while agreeable, we still think you should go buy that Harlem Square Club album once you've given *Innerspace* a spin.

The A-side is rounded out with a trio of bouncy '80s pop tracks: Nerada Michael Walden's "Is It Really

Love," Wang Chung's "Hypnotize Me" and Berlin's "Will I Ever Understand You," taken from the 1986 album *Count Three & Pray* – an album that also includes "Heartstrings," used in *Spaceballs*, and "Take My Breath Away," from *Top Gun*, possibly making it the apex of mid-'80s movie pop songs. Mind blown again!

There's also that neat suite of Goldsmith's music on the A-side, in which the maestro balances electronics with orchestra on the extended cues, such as ten minute action cut "Gut Reaction," while "Let's Get Small" opens with a call-out to the trumpet motif used on *Patton* (sans Echoplex). Geffen's song compilation was issued in 1987 on vinyl, and La-La Land put out a more complete CD of Goldsmith's score in 2009.

Label: Geffen Records / GHS 24161 Format: LP Year: 1987 Art: John Alvin

DAN AYKROYD * KIM BASINGER

starring in

My Stepmother Is An Alien

ORIGINAL MOTION PICTURE SOUNDTRACK.

MY STEPMOTHER IS AN ALIEN

Stuck in the cultural milieu of the late 1980s lurks the soundtrack to *My Stepmother is an Alien*, complete with its album cover of what we can assume is a body double's leg jutting over a backdrop of stars. The soundtrack, released from Polydor in 1988, is pretty representative of where pop was headed by the late '80s and features songs that were hits outside of the film, to give the album some serious street cred. Case in point: M.A.R.R.S.' "Pump Up the Volume" was a pretty ubiquitous four minutes of house music after getting released in the summer of '87, and still

holds up as tight mashup of samples, including Criminal Element Orchestra's "Put the Needle to the Record" and Israeli singer Ofra Haza's dreamy "I'm Nin'Alu," among others.

Also notable is Animotion's new wave hit "Room to Move," a re-recording of vocalist Climie Fisher's original take on the song from 1987 (for which Mercury issued both 7-inch and 12-inch singles). The album leaves out the peppy Art of Noise/ Tom Jones collaboration on Prince's "Kiss," but does include "Hot Wives," performed by stars Kim Basinger and Dan Aykroyd (and co-written with

his brother Peter). It's the boogie-woogie number in which Aykroyd is channeling some serious Bachman-Turner Overdrive (especially in his vocal delivery), and is the most likely cut to get stuck in your head (even if you'd rather it didn't).

Thankfully the album is rounded out with three score cues from composer Alan Silvestri that call out to his work from earlier in the decade. "Enjoy" is a playful piece of synthesized jazz, with rhythms and saxophone musically similar to his approach on *Romancing the Stone*. "The Klystron" sounds like an orchestral outtake from Silvestri's *Back to the Future* sessions, with a similar melodic, even orchestral, approach (heavy on the drums and punchy brass accents). But best of all is the serene "The Celeste," with a delicate melody that looks ahead to the composer's work on *Forrest Gump*.

Label: Polydor / 422 837 798-1 Format: LP Year: 1988 Art: N/A

STV 81233

STARMAN

Music Composed By
JACK NITZSCHE

©1984 Columbia Pictures Industries, Inc.

STARMAN

John Carpenter was at the top of his game in 1984, cranking out successful films in the studio system after striking gold as an independent maverick. *Starman* is a unique film in the director's canon, a tender sci-fi romance that netted star Jeff Bridges an Oscar nomination for his portrayal of a friendly alien. Like 1982's *The Thing*, Carpenter got to work with an actual composer this time, instead of contributing his own minimalist score. Here he had the services of Jack Nitzsche, the famed Rolling Stones session musician who was riding a similar wave of

success after *An Officer and a Gentleman* (1982), which netted him an Academy Award nomination. Like *The Thing* however, *Starman*'s music still bore the mark of Carpenter's lush synth work.

Built around a recurring main theme, *Starman*'s music is heavy on dream-like atmosphere, eerie with wonder but awash in warm, sensual textures. A memorable six-note melody features prominently in the film, its frequency increasing as the romance between Bridge's alien and widow Jenny (Karen Allen) grows. As well, a repeating pulse pops up, placing *Starman* firmly in '80s sci-fi territory while reminding audiences of the alien's need to return home. Though romance and tender melodies are really at the heart of Nitzsche's score, it has its share of dark and threatening moments, including the choppy tones of "Here Come the Helicopters"

and "Road Block" representing the predictably nefarious government forces that attempt to intersect the alien. There's also the dissonant "Jenny Shot," the soundtrack album opener, and the (now hilariously-titled) "Balls," written of course for *Starman*'s powerful silver orbs. *Starman*'s musical score absolutely takes listeners back to a time when the thought alone of seeing aliens on the big screen was mind blowing, and interspecies love affairs were nothing new.

Starman was put out on vinyl by Varèse Sarabande at the time of the film's release, and while it was reissued by the label on CD in 2010, the content did not change. Why mess with a classic?

ORIGINAL MOTION PICTURE SOUNDTRACK
COMPOSED AND CONDUCTED BY DAVID NEWMAN

DAVID NEWMAN ON BILL & TED'S EXCELLENT ADVENTURE, GALAXY QUEST AND CRITTERS

Academy Award-nominated composer David Newman – who happens to be the son of legendary composer Alfred Newman, brother of Thomas Newman and cousin to Randy Newman – got his start as a violinist for soundtracks to films, such as *Star Trek: The Motion Picture* and *E.T.*, before jumping into film scoring with genre titles such as *Critters* and *The Kindred*. Here, he discusses scoring classic sci-fi comedies *Galaxy Quest* and the *Bill & Ted's* films.

For Bill & Ted's Excellent Adventure, *I'm curious, did you know beforehand how your score was going to be interacting with pop songs, or were they inserted into the sound design at a later point?*

I didn't know what the songs were, but that point [the late '80s] was the era of pop songs in movies. And especially in a movie like that, about a band, there was definitely going to be songs. But I've almost never done a film where I knew what the songs were going to be in advance; the logistics are so hard in terms of licensing them.

In the score, there are moments using a full orchestra, while aspects of Bill and Ted's lives in San Dimas, California have a more pop-style feel. What's it like trying to balance these two approaches in the music?

When you're scoring movies, you're there to serve the film, and it sometimes needs really eclectic textures. So the stuff that I did was an '80s kind of faux pop: some electronic stuff with orchestra. It was "filmic pop," if that makes sense. It wasn't influenced by pop music, it was just using a pop texture. You'd use rhythm, drum machines and synths, and sometimes you'd do a

 Label: Enjoy The Ride Records / ETR077 Format: LP Year: 2018 Art: Josh Bodwell

pop structure, which would be an eight-bar melody or groove contrasting eight bars; pop forms are simple in nature.

Is there a specific time travel sequence that was the most fun to score?

I enjoyed scoring the Western stuff. My father was Alfred Newman, and he scored *How the West was Won*, which was such an iconic western. It's a huge trope in Hollywood movies, with a [specific] musical syntax: lots of open strings, lots of references to Appalachian fiddle music.

Who came up with Bill and Ted's iconic air guitar riff sound?

That was in the script, which was fantastic, by the way... John Williams says he hates reading scripts because if you read it, that's your first impression

of a movie that's never going to be like what the script is, because of the way movies are made. The original *Bill & Ted's* script to me read very sophisticated and smart. When you read it and then see it, it's so different.

What were the challenges when scoring the film?

A lot of the difficulty on a film like *Bill & Ted's* is [musically] not making it so silly but still allowing it to be silly on its own without you pushing the silliness of it. It was just kind of schizophrenic, the music: a big orchestra here, pop songs here, an '80s piece here that sounded like a pop song... It was difficult to do, as I recall. It's also one of the original bromance movies. It spawned *Wayne's World*, which was way more popular because it came out at the right time.

For Galaxy Quest, *a* Star Trek *parody, you initially developed two themes, is that correct?*

I'm a huge *Star Trek* fan from the '60s, when my brother Tom and I were kids. On Sunday nights we would watch *Star Trek;* It was the biggest friggin' thing in the world. We saw all of it, and so I know *Star Trek* backwards and forwards. The first theme for *Galaxy Quest* was very close [to the TV series]; it was a parody of it, with the voice and the theremin, and then I wrote the theme that got in the movie. As soon as [director Dean Parisot] heard the second theme, he said that's the theme that he wanted, then I knew what to do with the whole movie. It was completely clear to me.

You had more freedom when it came to composing for Galaxy Quest. Why is that?

Label: Real Gone Music / RGM-0887 **Format:** LP **Year:** 2019 **Art:** N/A

CRITTERS

ORIGINAL MOTION PICTURE SOUNDTRACK

With *Galaxy Quest*, they had no idea how to market the film. The first test screening was to 7 and 8 year olds. This was their brilliant idea – that it was a movie for 7 and 8 year olds who had never seen *Star Trek*, and even if they had, would have no idea of what was going on. Of course it was a horrible screening, and so the marketing people threw up their hands and the head of the studio said, "Go ahead and make your movie." The great thing is that after that screening everyone left us alone. There were just four of us working in close production: me doing the music, Don Zimmerman doing the editing, Dean Parisot, who's just brilliant, and Jeff Carson, the music editor. Nobody said "boo." We could do anything we wanted. I don't think I've ever been on a film like that. It's really a film made by filmmakers.

***Galaxy Quest** both mocks and honors fan culture, and walks a tricky tightrope of being comedic but staying true to these characters. How do you go about doing that through the music?*

I've conducted the score to that film live. People are laughing from the beginning to the end. Laughing, laughing, laughing. That's how you know it worked. Music can't make anything funny, but it can wreck funny. It can ruin people's ability to laugh. So you have to be careful in a movie like that. The main thrust of that music isn't the comedy, anyway. It's the heart of the movie. It's that trajectory of...aliens and humans being together. There are things that bend "dark" and things that bend "light" and bend "weird" and bend "quirky." You have to be careful and use all of that. I've had practice with [Danny] DeVito movies that

were really dark comedies, where it's even more difficult, like *War of the Roses* or *Throw Momma From the Train*. You have to be careful to allow it to be funny but not pander to the comedy.

***Critters** combines sci-fi and horror, with an emphasis on the humor. How do you play up to these aspects of the films? And how did "Critter Skitter" come to be?*

Critters was tricky because it was a comedic horror film, and it was very early on for me. And there was no money in it. The end of the movie was a redo, but it was fun. I produced ["Critter Skitter"] for [sound engineer] John Vigran. I didn't have any of the gear at the time to do that; I was just an orchestra guy at the time. *Critters* was one of the first films I'd scored, but ["Critter Skitter" turned out to be] the best music in the thing.

 Label: Restless Records / 72154-1 **Format:** LP **Year:** 1986 **Art:** N/A

MUTANT

Music Composed and Conducted by
RICHARD BAND
THE NATIONAL PHILHARMONIC ORCHESTRA,
LONDON

©1984 FILM VENTURES INTERNATIONAL

MUTANT

Released in 1984 as *Night Shadows*, this sci-fi horror film about a small town whose inhabitants are turned into ravenous killers after a toxic waste spill (what else?) is better remembered by its VHS release title *Mutant*. Directed by John "Bud" Cardos (*Kingdom of the Spiders*) and starring Cole Hauser, *Mutant* is, quite frankly, a chore to sit through, with its slow pacing, not-so-special effects, and completely derivative zombie-esque narrative. However, as is the case with much of his career, composer Richard Band turned in not just a competent score, but a great score, one that sounds elevated far above the film for which it was written.

"Josh Walks Through Town," "Josh & Holly," and the "End Title" are all beautiful, stirring suites of music that offer more drama and emotional resonance than the film ever comes close to bearing. For the film's action and suspense sequences, Band conjures up "Billy Gets It/Josh & Holly Escape," "Car Attack/Escape," and "Mutant Onslaught & Finale," all of which create images of epic sci-fi battles far removed from the clunkiness of *Mutant*.

As Band explained in the liner note to a recent CD reissue of the score through Dragon's Den: "I've always put a big emphasis upon thematic material as opposed to ambiance...I just believe that themes are what creates a sense of continuity within a film, dramatically. You have to assign themes to certain characters or situations so that the audience has something to come back to or to look forward to or to recognize on an emotional level. It's especially important in a horror film to use themes."

Though it has seen a few different CD released over the years, there is no mistaking the cool factor of owning the original 1984 Varèse Sarabande LP. With its cool poster art, this a record that offers the two memorable aspects of *Mutant*, and represents one of Band's finest works.

Label: Varèse Sarabande / STV 81209 Format: LP Year: 1984 Art: N/A

LIQUID SKY

Like the cocaine and heroin featured prominently in the film, Slava Tsukerman's 1982 cult movie *Liquid Sky* isn't for everyone, and that includes Brian Eno, who was initially offered the job of scoring the film. As the story goes, he showed up to a viewing and abruptly stood up and left halfway through. *Plan 9 from Outer Space*-level special effects, a gender bending lead and hard drugs all add up to a film that can only be appreciated by the outer fringes of cinema lovers. Undeterred by Eno's rejection, Tsukerman chanced upon sound artists Clive Smith and

Brenda Hutchinson at Manhattan's Public Access Synthesizer Studio (PASS), who had recently acquired a Fairlight CMI, an early digital sampling synthesizer.

Armed with the ability to record sounds and then play them back at any pitch through the Fairlight, Tsukerman combined forces with Smith and Hutchinson to create something that was, well, not easily forgotten. Okay, the score to *Liquid Sky* makes for one of the most excruciating listens in film music history. It's a jarring, seemingly disconnected collection of notes and sounds devoid of harmony and melody. And yet, it's become a must-listen for electronic music buffs, a bizarre new wave classic that should be experienced at least once. Tsukerman's goal was to combine the circus music from Frederico Fellini's surrealist films with current electronic music in the style

of Kraftwerk, as well as digital renditions of lesser known classical music pieces. Though it's nearly impossible to sit down and enjoy, *Liquid Sky*'s music is key in making this extraterrestrial narrative feel that much more as though it comes from another world.

Varèse Sarabande released *Liquid Sky* on vinyl around the world in 1983, and in 2019 Death Waltz stepped up to return the score to its analog format, pressing it on hallucinatory tricolor "starburst space splatter" vinyl. Even if it becomes the least played record in your collection, *Liquid Sky* is one that belongs on everybody's shelves.

ERS 6517 Stereo

ENTR'ACTE TM

ORIGINAL MOTION PICTURE SCORE

TIME AFTER TIME

Composed by
MIKLÓS RÓZSA
Conducting the Royal Philharmonic Orchestra

NICHOLAS MEYER ON TIME AFTER TIME

Writer/Director Nicholas Meyer (*Star Trek II & VI*) worked with a childhood hero when he collaborated with composer Miklós Rózsa for *Time After Time* (1979). Here he speaks about his experience with Rózsa.

How did you end up working with Rózsa on your directorial debut?

When it came time to choose a composer for *Time After Time*, I felt that as our protagonist, H.W. Wells, came from the 19th century, and his musical identity would best be expressed in older music,

leaving all "modern" sounds (i.e. rock) to be as experienced by him as a kind of sound effect.

Time After Time has an old-Hollywood sense of classicism, making use of the old Warner Brothers fanfare. Whose idea was it to approach the score in this manner?

Mine. I also insisted on the Warner Bros shield logo and Max Steiner fanfare at the beginning. There was a lot of resistance to both at the time by the studio, but at the first preview, the audience broke into cheers and applause when one

appeared and the other was heard.

Bill Conti was, at one point, going to write a more "modern" re-score of the movie. How close did that come to happening?

Until its triumphant first preview, WB hated the film and everything about it. (Later they went overboard in the opposite direction.) Among the objects of their ire was Rózsa's music and they contemplated replacing the score with something more "hip" by Conti. I suggested to producer Herb Jaffe that we write Rózsa a letter about how much we loved his score - and then publish the letter with a full page ad in *Variety*. This is what we did and Warner Brothers was stuck with our choice and we saved the music.

ORIGINAL MOTION PICTURE SOUNDTRACK

WOW 735
DIGITAL MIX

Jackal
WOW
RECORDS

Music Composed and Conducted by
MAURICE JARRE

ENEMY MINE

One of the famous Hollywood bombs of the '80s, *Enemy Mine* stars Dennis Quaid and Lou Gossett Jr. as a human and an alien soldier, respectively, who get stranded on the same planet and must overcome their instincts to kill one another in order to survive. Though no one would mistake it for a classic, 20th Century Fox secured the great Maurice Jarre to handle the score, and what he delivered is excellent.

Essentially a character-driven film, albeit a clunky one, Jarre focused on musical suites that plot a musical journey from conflict to cooperation,

through an inventive mix of electronics and orchestra. Opening with the warm and eerie "Fyrine IV," Jarre uses synthesizers to create a tense atmosphere with militaristic undertones. Things lighten up significantly by "The Birth of Zammis," a suite that invokes wonder and hope, and even includes sounds to mimic the breathing of new life. The score concludes with the fairly brilliant "Before the Drac Holy Council," which features more electronics and a chorus, building ominously to something more akin

to what you'd hear in a horror film, before the bombastic orchestra takes over with its message of optimism.

Varèse Sarabande released *Enemy Mine* as an LP and CD in 1985 and, much later, a Deluxe Edition CD in 2012, containing the original album and a crater full of previously unreleased music and alternate takes. Maybe we will all learn to live in peace once this version gets the deluxe vinyl treatment.

Original Sound Track
Music Composed and Conducted by Jerry Goldsmith

OUTL1ND

EVEN IN SPACE
THE ULTIMATE ENEMY IS STILL MAN

OUTLAND

In this overlooked 1981 sci-fi/western mash up, Sean Connery plays a Federal Marshal assigned to a mining outpost on one of Jupiter's moons, where he discovers the miners are being fed drugs to make them work harder – only it turns them to psychotic killers instead. For the score, director Peter Hyams turned to Jerry Goldsmith, with whom he had worked previously on the science fiction thriller *Capricorn One* (1978). Goldsmith had just completed one of his most famous scores in *Alien* (1979) and here he continues in a similar vein with a mostly

dissonant, atonal work with slightly cheesier sounds sprinkled throughout.

You might say *Outland* is mostly atmosphere over style, as the score is completely understated and used sparsely throughout the picture (Hyams, as he had a reputation for doing, cut several of Goldsmith's cues in favor of silence or music from other composers). The dominant theme heard in the movie is comprised of a series of paired notes on woodwinds at the beginning of "The Mine" that represents the imposing industrial alien complex. Elsewhere, "Early Arrival" employs some harsh brass, as does "Spiders," making the experience that much more uneasy. One of the composers brought in to redo Goldsmith's cues was Michael Boddicker, who would go on to score *The Adventures of Buckaroo Banzai Across*

the 8th Dimension (1984), and here he helped create a seedy atmosphere for the film's alien sex bar scenes through futuristic synth rthythms and sounds, particuarly on "The Rec Room." Overall, *Outland* remains one of Goldsmith's most atmospheric and interesting – if not completely essential – scores.

Released in a truncated LP through Warners Bros. at the time the film came out, *Outland*'s full score was later released as a double CD through *Film Score Monthly*, which incorporated the music by Boddicker and other composers, and included bonus tracks as well as the original release on the second disc. This piece of forgotten Goldsmith lore is worthy of being rescued from the outer limits.

Label: Warner Bros. Records / HS 3551 Format: LP Year: 1981 Art: N/A

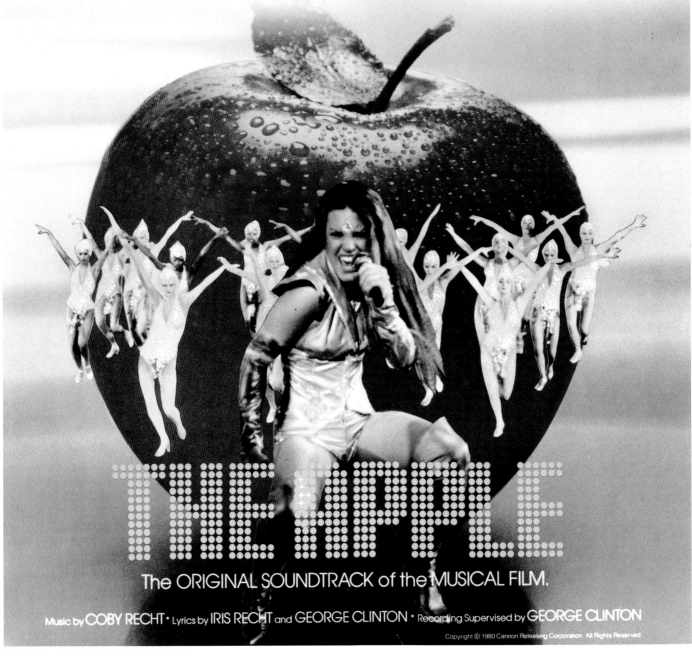

THE POWER OF ROCK...IN 1994.

THE APPLE

The ORIGINAL SOUNDTRACK of the MUSICAL FILM.

Music by COBY RECHT · Lyrics by IRIS RECHT and GEORGE CLINTON · Recording Supervised by GEORGE CLINTON

THE APPLE

As the end of the '70s represented the beginning of a whole brave new world of future anxieties, several dystopian visions made their way to the big screen. For writer/director Menahem Golan, the future battle between good and evil would take place at the 1994 Worldvision Song Festival (1984 was too soon), where two future hippies Bibi and Alphie lose out to the evil record label Boogalow International Music (BIM), despite being the two most talented contestants. Eventually the duo must decide between accepting the conformity of big business or the individuality of their own art, in what is now generally viewed as one of the worst movies ever made, 1980's *The Apple*. In retrospect however, the movie did produce some pretty spectacular disco numbers courtesy of Israeli rock producer Coby Recht and Golan.

The London Philharmonic Orchestra was hired to perform on both the songs and the film score, conducted by George S. Clinton (no, not that George Clinton) a composer who would eventually go on to work on more respectable fare like *Austin Powers* and *Mortal Kombat*. Clinton was so intimidated by the gig that he forgot his baton and instead used chopsticks from a nearby Chinese restaurant.

Distributed by infamous low budget factory Cannon Group, *The Apple* made its debut at the 1980 Montreal World Film Festival, where attendees received vinyl copies of the soundtrack LP on Cannon Records (they reportedly responded by chucking them at the theater screen). Golan passed away in 2014, but that's recent enough to have seen the day in which everything bad (from the '80s) is good again, and today *The Apple* soundtrack is at least appreciated on that level. "Speed," "Bim" and the subtle double entendre of "Coming" are all fiery anthems in the spirit of Donna Summer, though admittedly the folky numbers are dated and simply cannot survive the ridiculousness of the film. Today the record is easily located in most record shops, so go right ahead and bring it up to the counter, if you're brave enough to face up to the man, that is.

DARK STAR

Co-written by future *Alien* scribe Dan O'Bannon, *Dark Star* is a rough sci-fi black comedy that helped launch the career of John Carpenter both as a director and composer. As with several of his subsequent films, Carpenter took on musical duties as a cost saving measure (the overall budget of the 1974 film is estimated at $60,000), recording the entire score in about four hours in the apartment of a friend who happened to own a modular synthesizer. Carpenter has long praised Bernard Herrmann's *The Day the Earth Stood Still* (1951) and Louis and Bebe Barron's *Forbidden*

Planet (1956) as groundbreaking scores, so sci-fi was a good place for the future master to begin.

Ultimately the primitive bleeps and bloops of *Dark Star* don't hold a candle to later efforts *Assault on Precinct 13* (1976) and *Halloween* (1978), but fans will hear a number of techniques and sounds that would form the basis of the classic Carpenter sound, namely designing harmony and melody to put the audience on edge (horror fans will recognize certain segments as precursors to *Halloween*'s stalking sequences).

Interestingly, the film's title credits use a country and western song written by Carpenter and special effects artist Bill Taylor called "Benson, Arizona," giving the film a humanistic feeling as opposed to the epic soundscapes normally associated with space operas. The song is obviously used for

comedic effect, and if the joke falls flat, well, so does much of the humor in the film.

Citadel released a strange soundtrack for *Dark Star* in 1980 containing one track of score, songs and dialogue on each side of the LP, which was then reissued in Germany by Colosseum in 1989. Carpenter completists received their wish in 2016 with a deluxe package from We Release Whatever The Fuck We Want Records that contains the original 1980 LP as well as a "beach ball alien" 7-inch containing cover versions of *Dark Star*'s original songs, including one by future Carpenter collaborator Alan Howarth and a locked groove of endless sound effects.

THE ABYSS

MUSIC COMPOSED AND CONDUCTED BY
ALAN SILVESTRI

THE ABYSS

Riding the hot streak that led him to two of the most enduring '80s properties in *The Terminator* and *Aliens*, James Cameron returned to the director's chair for another groundbreaking, if somewhat less dark, sci-fi special effects extravaganza, 1989's *The Abyss*. Given the fighting that took place between him and composer James Horner on the set of *Aliens*, it's not surprising that the composer was suddenly too busy to take on the director's latest film, so enter the up and coming Alan Silvestri, who had just made waves with his work on *Back to the*

Future (1985) and *Predator* (1987). Silvestri was tasked with creating a score that would mirror the two narrative halves of the film : the humans' adventure down into the underwater abyss, and the rise of alien creatures to the surface.

The first part of Silvestri's score functions just fine in the film, though it's so subtle that it's sometimes barely noticeable, based mainly around choral and orchestral arrangements. Delivered mostly electronically, this section of the score highlights the wonder of the deep, offering atmosphere above all else. In the rare instances where he feels to need to bring in the orchestra, as on "The Crane" and "Sub Battle," he reaches into the aforementioned '80s hits for inspiration to add to the action and suspense.

Of course, no discussion of *The Abyss* is complete without the extended special edition of the film, which saw an additional 28 minutes added. Silvestri was no longer available to score the footage, so Robert Garrett, who composed the temp music for the film, was brought in, though his electronic compositions are obviously inferior.

The original 1989 Varèse Sarabande LP reduces Silvestri's score to 47 minutes, though this album captures all of *The Abyss*' key moments. The label put out a 2xCD in 2013 that included more material and expanded versions of the original cues, but it mostly just adds in extra ambience, making it a release for completists only.

TWO-RECORD SET

J.R.R. tolkien's

The Lord of the Rings

COMPOSED AND CONDUCTED BY LEONARD ROSENMAN

THE LORD OF THE RINGS

Compared to the scale and budget of Peter Jackson's *Lord of the Rings* trilogy, Ralph Bakshi's 1978 animated take on Tolkien's books feels rushed. (His planned sequel never happened.) While it may not be the definitive cinematic version of the epic journey, Bakshi's feature gets a major lift from Leonard Rosenman's score.

That said, an almost completely different take on the music nearly happened. Members of Led Zeppelin were reportedly keen to work on the project, and Bakshi sought them out, but securing

the rights proved too challenging a task. "He had a good reputation," Bakshi remarked of Rosenman when interviewed by *The Hollywood Reporter* in 2018, "but Led Zeppelin would have blown off the roof of the picture."

Still, Rosenman's approach is worthy. Rosenman has spoken to the challenges of composing eerie music for the Tolkien epic without the 80 minutes of score sounding boring, by building to the film's climax that ends up introducing the final march, parts of which had been planted earlier in the soundtrack. The score is a world apart from the

leitmotif approach that Howard Shore takes in Jackson's trilogy. To be sure, Rosenman's *Lord of the Rings* makes for a dense listen, but there are standout cues and ideas. His major-key theme is a moment of light in a fairly dark score, which is highlighted by the use of a male chorus standing in for the Ringwraiths, who provide some spine-chilling chants of "Mordor" throughout the film. One of the score's highlights is the "Helm's Deep" action cue, in which the male chorus even chant Rosenman's name backwards.

Utilizing 100 plus musicians and chorus, the score is big. However, the initial double LP from Fantasy Records had a clipped sound that was remixed for a better sound mix on the 1991 CD release from Intrada.

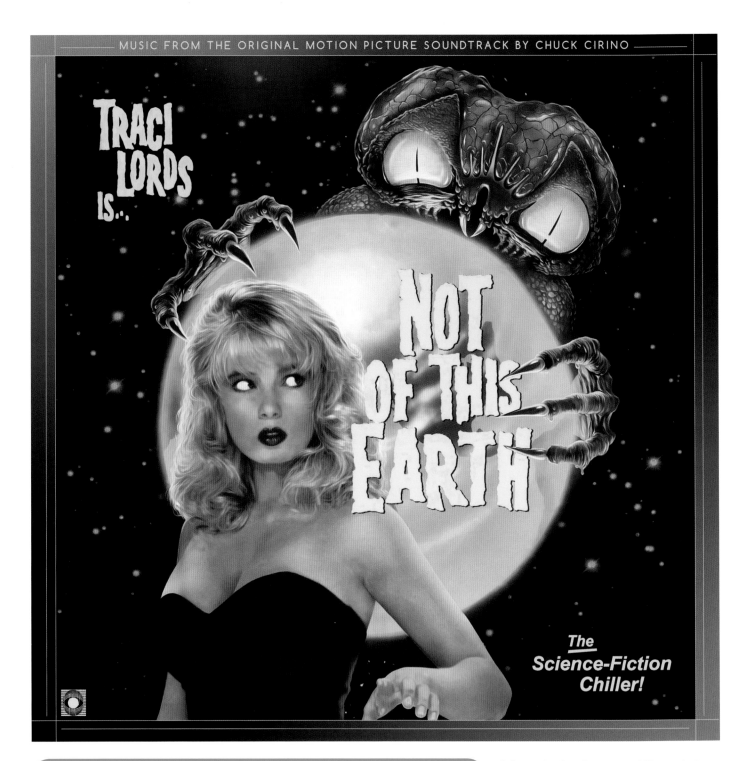

CHUCK CIRINO ON NOT OF THIS EARTH

Director Jim Wynorski and composer Chuck Cirino collaborated on numerous low-budget genre pics, including *Chopping Mall*, *Deathstalker 2* and *Return of the Swamp Thing*. Here, Cirino discusses his score for Wynorski's 1988 remake of Roger Corman's *Not of this Earth*, notable for featuring Traci Lords in her first mainstream starring role.

I understand that the film was remade with the intention of using the same budgetary restrictions as the 1957 original. What did that mean for you as a composer?

News of Jim Wynorski's bet with Roger came up years later, and not while I was working on the film. However, at the time it was rather curious that my regular fee was chopped in half on this film, which led to positive circumstances in the long run. I was able to renegotiate my contract. In my new agreement I ended up owning the music for the rest of the movie scores I did for Roger. I turned a negative into a positive and ended up winning in the long-run.

Is it true that it took you around fifteen minutes to compose the theme? How about the music that plays over the opening title sequence?

Actually, this is the first score I was rushing to get through. The delivery date was looming and the composer is almost always the one holding up the works. I was working fast and with minimal synths. I spent two days on that...at least. The cold opening, where the spaceship approaches Earth, is the cue which took no time. I polished that off almost in real time. Once the muse gets started it's hard to stop.

 Label: Terror Vision / T.V.001 **Format:** LP **Year:** 2015 **Art:** Earl Kess

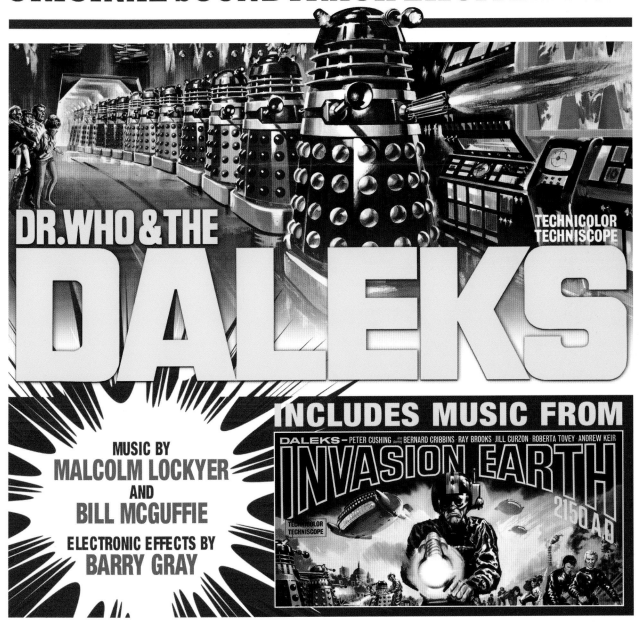

ORIGINAL SOUNDTRACK EXCITEMENT!

DR. WHO & THE DALEKS

TECHNICOLOR
TECHNISCOPE

MUSIC BY
MALCOLM LOCKYER
AND
BILL MCGUFFIE

ELECTRONIC EFFECTS BY
BARRY GRAY

INCLUDES MUSIC FROM

DALEKS – PETER CUSHING also starring BERNARD CRIBBINS · RAY BROOKS · JILL CURZON · ROBERTA TOVEY · ANDREW KEIR

INVASION EARTH 2150 A.D.

TECHNICOLOR
TECHNISCOPE

DR. WHO AND THE DALEKS

The two Amicus-produced *Doctor Who* films of the 1960s brought us a different Doctor (Peter Cushing) and adapted a black-and-white TV series into a pair of brightly-colored theatrical films. They also sidestepped the infamous Ron Grainer theme for a pair of scores that owe more to mid-'60s jazz scoring than the often groundbreaking sound design and music that lent the BBC-TV series a distinctive air of mystery.

Malcolm Lockyer scored *Dr. Who and the Daleks* (1965), while Bill McGuffie scored the 1966 sequel, *Daleks – Invasion Earth 2150 A.D.*, and each

composer approached the material from vastly different perspectives. If anything, Lockyer's score is more in keeping with the drama and flow of the TV series, although there's a world of difference from his almost romantic take on the petrified jungle sequences in the movie and TV series composer Tristram Cary's otherworldly music for the Dalek city on Skaro.

Bill McGuffie, meanwhile, seems to have a ball playing up the campy nature of the sequel, particularly around the comic antics of Bernard Cribbins as policeman Tom Campbell. His

style shifts from big band swing to dramatic underscore on the turn of a dime, such as on the cue "Daleks and Robomen." Though highly entertaining, the loosey-goosey style has a distancing effect on the dramatic impact of the film, which probably explains why the proposed third Dalek movie never materialized.

There were 7-inch singles for both films issued in the '60s. Lockyer's "The Eccentric Dr. Who" was coupled with an uptempo "Daleks and Thals" from the initial film, and McGuffie's "Fugue for Thought," the latter of which is a minor-key jazzed up take on Toccata and Fugue, with a mournful solo trumpet over a jazz combo led by piano, sounding like a close cousin to a Vince Guaraldi Charlie Brown piece. But it wasn't until 2009 that Silva Screen coupled the two scores for a CD release, and then for a double LP in 2016.

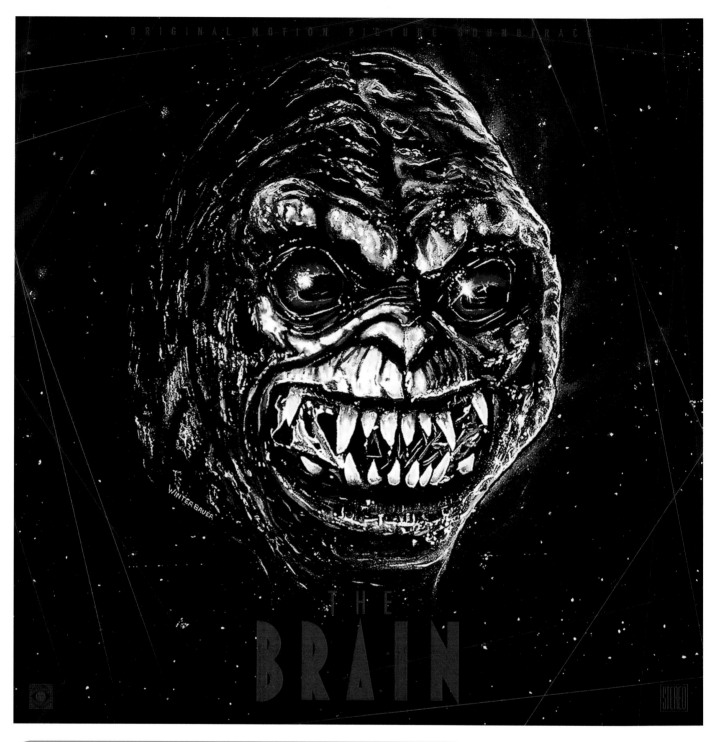

PAUL ZAZA ON THE BRAIN

Ed Hunt's *The Brain* – about a self-help TV show host using an alien to brainwash viewers – was yet another weird low-budget sci-fi/horror movie partially funded through the Canadian tax shelter system. Part of the 1988 film's low-fi charm comes from Paul Zaza's zippy score. Zaza describes the challenges of working under a tight deadline to deliver the music.

I understand that you never met director Ed Hunt. Is that correct?

I wouldn't know what Ed Hunt looked like if he was sitting in this room. Producer Anthony Kramreither

called me up and said he needed a score for this movie called *The Brain* in two weeks. I said, "Tony, that's not a lot of time." He said, "Well, I know you are good and you are fast." I said I wanted it to be good. He said it didn't need to be good. It had to be [done by] Friday.

And you took it on.

At one point I said in the conversation that I would just use a pseudonym, and would he mind? [Kramreither] said "I don't care what name you put on it, I just need to deliver the score. I don't care what you do." And he really didn't. My studio

was on Dufferin Street [in Toronto]. I said, "'Peter Dufferin' is the composer."

So what was your approach with the project?

I just remember thinking, okay I've got this movie, what does a brain sound like? I took some whale sounds, subsonic sounds, and I slowed them down and I put that into the music score and it sort of became this breathing, ugly, nasty organic-sounding thing.

Ultimately it's still your name on the project, so what happened?

I delivered it, and I thought, it's Friday, it's good... [Kramreither] says, "I like it!" and I said, "You know what, I like it, too; forget 'Peter Dufferin,' my name's going on it!" This movie was so bad it's good.

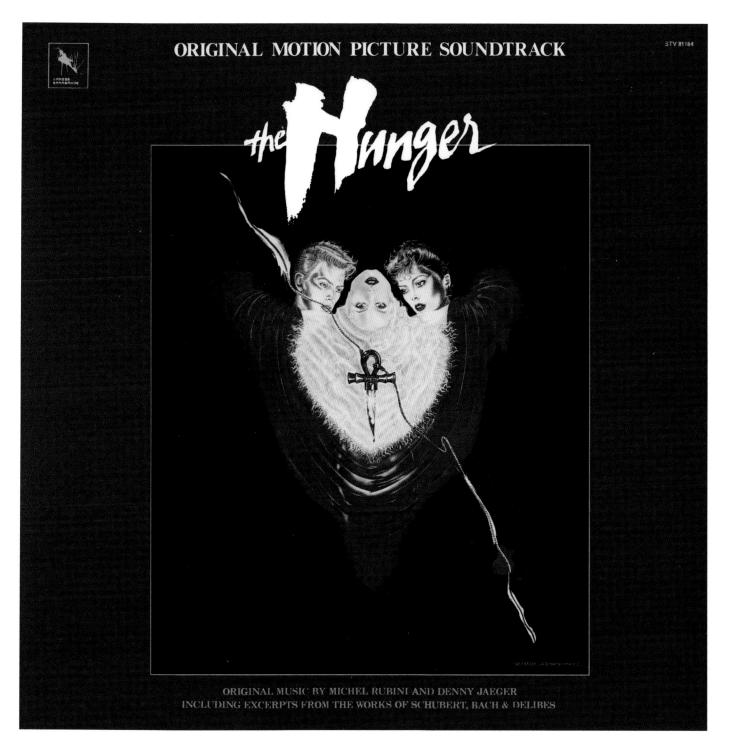

ORIGINAL MOTION PICTURE SOUNDTRACK

STV 81184

the Hunger

ORIGINAL MUSIC BY MICHEL RUBINI AND DENNY JAEGER
INCLUDING EXCERPTS FROM THE WORKS OF SCHUBERT, BACH & DELIBES

THE HUNGER

Thanks to its opening scene featuring UK outfit Bauhaus playing their legendary single "Bela Lugosi's Dead" in a dark nightclub, Tony Scott's *The Hunger* (1983) has become *the* hallmark film of goth subculture. (Casting David Bowie in a starring role as an aging vampire didn't hurt either.) Before *Interview with the Vampire*, it was *The Hunger* that posited vampires as modern aristocrats, embracing fanciful and decadent lifestyles where love and sex are equally free. *The Hunger* also made its mark, however, with the idea that vampirism isn't so

much supernatural as a blood condition, one that can be resolved through science and medicine. As such the film is as much a sexy sci-fi flick as it is horror.

Bauhaus' music never made it to any of *The Hunger*'s soundtrack releases, not that it couldn't easily be found elsewhere. Instead it focused on a number of classical pieces selected by musical director Howard Blake (*Flash Gordon*) as well as an orchestral score by Michel Rubini and Denny Jaeger with added electronics. These incidental music that gives *The Hunger* its bleak atmosphere and menacing tone. Delibes' "Lakmé," featuring a duet for two sopranos, speaks to the elegance and sadness of the film's bloodsucking vampire couple. Unfortunately only an excerpt appears on the soundtrack album. Schubert's "Trio in E-Flat" is a haunting piano piece while Bach's "Partita

#3 In E-Major" provides further sophistication on the violin. Not to be outdone is Rubini and Jaeger's own compositions, serving as storytelling companion pieces as another lover enters the vampire couple's lives, confronts, and ultimately embracing their sickness. So forget about its lack of goth punk, pick up Varèse Sarabande's 1983 LP, sip some red wine, and let yourself fall under *The Hunger*'s dark and painful spell.

Label: Varèse Sarabande / STV 81184 Format: LP Year: 1983 Art: N/A

TWILIGHT ZONE: THE MOVIE

Twilight Zone became hugely popular after its initial run from 1959-1964, and by the late '70s Hollywood was pushing for a feature length film. It finally happened under Steven Spielberg, who became the producer for 1983's *Twilight Zone: The Movie*. Jerry Goldsmith, fresh off of music duties from *First Blood*, composed the soundtrack.

There was no question that this new *Twilight Zone* should open with a variation of Marius Constant's immortal theme from the show, and those eerie tones make their presence felt on the movie's "Main Title." From there Goldsmith essentially composed four separate scores for the film's segments, intended to work with the style of directors John Landis, Joe Dante, George Miller and Spielberg himself. "Time Out" opens with a suite composed on four pianos, synthesizers and percussion; it's overall light in tone despite the story's dark subject matter. Spielberg's "Kick the Can" is naturally the film's soft and tender segment, so here Goldsmith provides another uplifting and airy score full of magic and wonder, courtesy of an orchestra propped up by synthesizers. Dante's bizarre cartoon-themed episode "It's a Good Life" understandably receives a mostly electronic treatment. Punctuated by odd effects, it's the most middle-of-the-road musical segment of the film. The movie saves the best for last with a remake of "Nightmare at 20,000 Feet" and Goldsmith pulls out all the stops here with frantic bass strings, brass and timpani to reflect the mental meltdown of John Lithgow's character as he witnesses a demon-like creature ripping apart the plane in which he is a passenger. Goldsmith uses strings to emulate the sound of the creature's claws, making this piece the most classically horror-sounding of the picture.

Twilight Zone: The Movie was issued as a 45-minute LP by Warner Bros at the time of the film's release. In 2009 *Film Score Monthly* released a much more complete version of the score with alternate takes, as part of its Silver Age Classics series.

 Label: Warner Bros. Records / 1-23887 **Format:** LP **Year:** 1983 **Art:** N/A

ORIGINAL MOTION PICTURE SOUNDTRACK

The Day Time Ended

Music Composed and
Conducted By
RICHARD BAND

THE DAY TIME ENDED

1980's *The Day Time Ended* recounts a family's attempts to fend off monsters from beyond time that invade their desert farmhouse. It's certainly a yawn of a plot, produced by Charles Band and with music composed by his brother Richard. *Time* is typical low-budget genre filmmaking, in that larger orchestra funds were funneled aside for a bigger, epic sound to match the ambition of the script – even though the execution on screen ultimately fell flat. You can hear it from the get-go in on a cue like "Nova and Main Titles," a highly atmospheric opening title cue, introducing

a four-note motif that's woven through the rest of the score. Band uses a wide palette of sound and orchestral color to signify the impending apocalyptic happenings in the American desert, culminating with dissonant tremolo strings that harken to Béla Bartok's *Music For Strings, Percussion, and Celesta.*

Hearing the music isolated from the film (especially if your experience of the movie comes from seeing the hilarious take from *Mystery Science Theater 3000*) is the best way to appreciate Band's contribution to the film. The music works

against the failings of the script, acting, and general silliness of monsters from beyond time attacking the desert bunker, where Band tries his best to elevate this picture to a whole other level. This is a feat he'd attempt time and time again (i.e., listen to his massive score for 1983's *Metalstorm: The Destruction of Jared-Syn*, written in just days).

The Day Time Ended was initially released on vinyl by Varèse Sarabande in 1980, and reissued on CD in 2018 from Intrada, who coupled it with Band's *The Dungeonmaster* (1984).

RAY HARRYHAUSEN SPOTLIGHT

Working in conjunction with producer Charles H. Schneer, special effects legend Ray Harryhausen (1920 – 2013) created a string of influential films beginning in the 1950s (*It Came From Beneath The Sea, Earth vs. The Flying Saucers*) through to the early '80s, with *Clash of the Titans*. Harryhausen's impact on the genre can't be understated; his pioneering stop-motion work was an influence on filmmakers ranging from George Lucas to J.J. Abrams.

Often advertised as being filmed in "Superdynamation," a process that incorporated backgrounds, live

action and Harryhausen's trademark animation, an equally important part of the success of those films came from the quality of the scores. Schneer and Harryhausen lucked out by drafting Bernard Herrmann for the first entries in their run of fantasy films. His evocative scores (often incorporating unique orchestration) helped to cement these as classics, as he crafted distinctive themes that set each one apart musically.

Herrmann's first collaboration was for *The Seventh Voyage of Sinbad* (1958), and owes a big tip of the hat to Nikolai Rimsky-Korsakov's *Scheherazade*,

such as in the main theme, a fandango in the style of an *Arabian Nights* adventure. The score employs the use of a larger percussion section, along with additional brass and wind instruments. The film is most remembered for the cavalcade of Harryhausen monsters, which are made all the more corporeal from Herrmann's brass and percussion-heavy orchestrations., For example, the famous skeleton duel is backed by wooden instruments (two xylophones, castanets and wood blocks) to simulate Sinbad's bony opponent.

Herrmann creates a playful theme for 1960's *The 3 Worlds of Gulliver* (a direct contrast to his previous work on Hitchcock's *Psycho*), which is accentuated by huge cymbal crashes – a musical staple in the Harryhausen films. In this tale of Lemuel Gulliver's travels to Lilliput and Brobdingnag, Herrmann used three different configurations of the orchestra

 Label: Cloud Nine Records / CN 4003 Format: LP Year: 1985 Art: N/A

BERNARD HERRMANN
MYSTERIOUS ISLAND

Adventure beyond imagination... A world beyond belief!

MUSIC FROM THE ORIGINAL MOTION PICTURE SCORE
COMPOSED AND CONDUCTED BY BERNARD HERRMANN

to represent the three worlds. For Lilliput, Herrmann incorporated harps and celeste to suggest the inhabitants' miniature size. Larger, contrabass tubas are meanwhile used to showcase the massive world of the Brobdingnags. Keeping the music similar in nature, Herrmann simply rearranged the orchestration to match the scale of each world.

Mysterious Island (1961), a sequel to *20,000 Leagues Under The Sea*, represents Herrmann at a creative peak in the fantasy genre. The score begins with thunderous crashes of cymbals for the prelude, along with its ominous three-note motif that signals Danger with a capital D. The film, chronicling the escape of Union soldiers from a Confederate prison during the Civil War – kicks off with some action as they make a prison break via hot air balloon. Here, Herrmann uses an edgy ostinato to signal the danger of their pursuers and the

wild weather, as the balloon is blown off course over the ocean, coming to land on – you guessed it – a mysterious island. Before meeting Captain Nemo of the Nautilus, the group encounters a huge crab and a bizarre giant bird called the Phorusrhacos. Here, Herrmann takes the opportunity to score each particular creature. The Phorusrhacos gets a humorous fugue (utilizing pizzicato strings and wind instruments) that sounds like it influenced Danny Elfman's "Kidnap the Sandy Claws" number from *The Nightmare Before Christmas*. Meanwhile, giant bees are accompanied by a buzz-like flutter-tonguing of the brass similar to the more menacing version of Rimsky-Korsakov's "Flight of the Bumblebee."

Suites of these scores were conducted by an ageing Herrmann (with slower tempos than the original recordings) for the 1975 Decca LP *The*

Mysterious World of Bernard Herrmann. Cloud Nine records issued longer LPs of *Gulliver* (1984) and *Mysterious Island* (1985), making use of the original recordings. The latter received a full CD re-recording in 2007 from William Stromberg and the Moscow Symphony Orchestra on the Tribute Film Classics label, with a fidelity that does justice to Herrmann's massive, thunderous score.

Label: Cloud Nine Records / CN 4002 **Format:** LP **Year:** 1984 **Art:** N/A

There's no place on Earth to hide.

MUSIC FROM THE FILM COMPOSED BY DAVID STORRS

CHRISTOPHER YOUNG ON INVADERS FROM MARS

Though he is generally thought of as one of the key horror movie directors of the '70s and '80s, in 1986 Tobe Hooper (*The Texas Chainsaw Massacre*) made a memorable foray into science fiction with a remake of the '50s drive-in classic *Invaders from Mars*. Beloved genre composer Christopher Young was hired, who would go on to score the first two *Hellraiser* films, but for reasons beyond his control, his unique orchestral-electronic suite was replaced with an entirely electronic-based one by David Storrs. Now in an exclusive Record Store Day edition of this book, fans have a chance to hear Young's music in an

all-new version on an exclusive 7-inch EP, the way he intended it to sound. We revisited this moment in Young's career with an interview.

Your original score is a combination of both symphonic orchestral and electronic. How did you decide upon this divide?

If my memory is not failing me, the initial hope was for the entire score to be orchestral but they simply didn't have the money to do that, so the orchestral cues were picked for the important moments and the rest was designated as synth.

The electronic portion of the score, particularly around the alien spacecraft, utilizes some unique recorded sounds like drills and waterfalls, along with various percussion instruments. How did you put together this portion of the score, and what was your thinking behind it?

When I was hired to do the score I was over the hill excited about having the opportunity to work with the great director Tobe Hooper. He had just finished directing *Poltergeist*. Tobe encouraged me to follow in the footsteps of what was done for *The Texas Chainsaw Massacre* score, which was

Label: Enigma Records / SJ-73226 **Format:** LP **Year:** 1986 **Art:** N/A

INVADERS FROM MARS

basically sound design music, and non-melodic. When he gave me permission to do that, it was like being given a one-way ticket to heaven because at the time I was very much into the musique concrète approach to film scoring. Tobe left to start shooting the third installment of his three-picture deal with Cannon. I believe he had to leave even before the spotting session was finished, but his direction encouraged me to go off the deep end. I started by going out and recording natural sounds - machines, pile drivers, power drills, waterfalls and Grand Central Station in New York City during rush hour.

A replacement score was written by David Storrs. What's the story behind how the music came to be, and then came to be replaced?

I didn't hear from anybody after delivering the electronic cues and was really worried. Tobe was long gone and I finally got a call from someone who let me know that they decided it sounded "too weird." In retrospect, I understand why they threw it out. I've often humorously said what they were looking for was music about Mars, not from Mars. What I was doing was nothing that I've ever heard in any movie and at that time it was just not going to fly. When the movie *Gravity* won the Academy Award for Best Original Score in 2013, it finally signaled that writing a score like this is accepted.

What I remember most about this period is that I was incredibly depressed. This was undoubtedly the biggest movie I scored up to that time and turned out to be my first rejected score. I thought

my career was over. I have since cooled down on over-experimenting and have since recognized that I am scoring to picture, not the concert stage. David Storrs had extremely little time to replace what I wrote and he pulled it off, so I tip my hat to him.

Now for this 7-inch, can you talk about how you decided what portions of music you chose? How do you feel this new version reflects your original vision of Invaders from Mars?

I would say that within the restrictions of it being ten minutes of material, I selected what I thought represented the intention of the rejected score by segueing four cues. Side one was intended to directly connect to side two so it would be one continuous track. It is so different, and not like anything else I've done.

Label: 1984 / 1984-005 Format: 7-inch Year: 2020 Art: HagCult

THE ORIGINAL SOUNDTRACK RECORDING

DEF-CON 4
Music by Chris Young

◉ A NEW WORLD PICTURE

CHRISTOPHER YOUNG ON DEF-CON 4 AND THE FLY II

Christopher Young will forever be remembered for his grandiose scores for *Hellraiser* and *Hellbound: Hellraiser II*, but he lent his chops to dark sci-fi throughout the years including Canadian post apocalyptic film *Def-Con 4*, an early effort where he first honed his chops as a film composer, and *The Fly II*, where he had the dubious task of following up on Howard Shore's brilliant score from the first installment. Christopher Young revisits these science fiction scores.

I understand that **Def-Con 4** *director Paul Donovan instructed you to aim for something "modern yet primitive" in the music – can you elaborate on this?*

I never even met Paul Donovan until after I had finished working on the score. It was a New World Pictures film and was a pickup project from a group of pictures that they bought from a company in Canada. Tony Randall, who was the head of post-production at New World Pictures at that time, ended up becoming my mentor and was single handedly responsible for getting my career

rolling. Tony wanted to get rid of the pre-existing electronic score, and replace it with an orchestra. At that time my job at New World was to increase the perceived production value of their pictures. He wanted the score to create the illusion that this was a big-budgeted movie. This was my first science fiction film and I was in a semi-state of panic. I'll be the first to admit that there were times when my hand was held by my composer heroes, but there's also a couple of cues in that score that show my own voice emerging.

So the movie is a post-apocalyptic thriller set in

VARESE
SARABANDE
Distributed in the US by MCA Distributing Corp.

ORIGINAL MOTION PICTURE SOUNDTRACK

THE FLY II

MUSIC COMPOSED BY CHRISTOPHER YOUNG

©1989 Twentieth Century Fox Film Corporation. All Rights Reserved.

Nova Scotia, Canada – and one of your earlier scores – how were you thinking of representing this time frame and setting musically?

I used this concept of a wall of sound. Here it was the juxtaposition between the orchestra playing white note clusters, then black note ones and the friction between the crossing. I used a massive percussion section, including six marimbas, whirly tubes, mixing bowls, tuned metal springs, four tam tams, water gongs...you name it, it was there!

Some of your music ended up in the American cut of Godzilla 1985*. How did this happen, and did you ever see the film?*

Tony Randall again thought that some of the cues for *Def-Con 4* would help *Godzilla 1985* for its American release. I feel bad for the original composer. I'm sure the score he did was great,

but it wasn't my business to tell Tony that he couldn't use it. It's weird having done a Godzilla movie but not having done it at the same time.

With The Fly II*, you were working on a sequel to a movie that has a pretty iconic theme, and then taking the material in a new direction. What were your goals for* The Fly II?

Howard Shore did the first *Fly* remake, the one that was directed by David Cronenberg. I was hired by Chris Walas who won an Academy Award for Special Effects Make-up on *The Fly*. Chris was a fan of my scores for *Hellraiser* and *Hellbound* and wanted me to come on board. He gave me permission not to embrace the score that Howard did, but rather go off and do my own thing. What I liked about *The Fly II* was like all great monster stories, it was a tragedy. Under the ugly exterior

lies the heart of somebody that just wants to be loved. I always tried to inject the tragic element into every cue so they wouldn't be just scary.

Did you have any desire to build upon the work that Howard Shore established in the first film?

No, I didn't because I was told not to, even though I really love what Howard did in the first *Fly*. It's always best to allow a composer to follow his own voice in a sequel, free from having to follow his predecessor's score.

THANKS

Christophe Beck, Peter Bernstein, Howard Blake, Bruce Broughton, Robbie Buchanan, Stan Bush, Chuck Cirino, Mason Daring, Josh Deck, Richard Donner, Dennis Dread, Enjoy The Ride Records, Brad Fiedel, Devon Goldberg, Ryan Graveface, Michele Gruska, HagCult, Mark Hasan, Jonathan Hertzberg, Lee Holdridge, Erik Homenick, Rachel Hopkins, Peter Howell, Craig Huxley, Earl Kessler, Desiree Lewis, Shane Lewis, Limahl, Nicholas Meyer, Mondo, Dave Neabore, David Newman, Stu Phillips, Gary Pullin, Real Gone Music, Mike Reno, Rey Roldan, Laurence Rosenthal, Craig Safan, Danielle Saint-Onge, Barry Schrader, David Shire, Silva Screen Records Ltd., Billy Squier, Terror Vision Records, Varèse Sarabande, Harry Waters Jr., Wyrd War, Christopher Young, and Paul Zaza.

All images are from the personal libraries of Mark R. Hasan, Aaron Lupton, Matthew Chojnacki, Devon Goldberg, and Jonathan Hertzberg

AARON LUPTON

Aaron Lupton has been writing for *Rue Morgue* magazine since 2001. He moved into the role of Music Editor in 2013, where he is responsible for the "Audio Drome" section and his regular "Listen to My Nightmare" column. An avid horror and sci-fi fan, his attic functions as an ever growing library of music on vinyl. It also serves as the recording home of *From My Parents' Basement* podcast, which he hosts with Eric Gaudet and Gary Pullin. He hosts interviews with composers at live movie screenings, is a regular guest on podcasts, and speaks at horror and sci-fi conventions. He co-wrote *Blood on Black Wax: Horror Soundtracks on Vinyl* (2019) with Jeff Szpirglas for 1984 Publishing, works as an Academic Librarian at York University in Toronto, and lives in Hamilton with his girlfriend and a growing collection of children to go along with his records.

JEFF SZPIRGLAS

Jeff Szpirglas has been rabidly listening to film soundtracks since picking up an audio cassette of *Return of the Jedi* back in 1983. Over the years, he has contributed to *Film Score Monthly*, penned a *Doctor Who*-themed music column, and now regularly writes for *Rue Morgue* magazine. He is also the author of over twenty books for young readers, ranging from horror novels to nonfiction tomes about fear, flatulence, and the human brain. He lives in Kitchener, Ontario with his wife (and frequent co-author) Danielle Saint-Onge, is the father of twins, and spends most of his non-writing time as a classroom teacher. Visit him at JeffSzpirglas.com.

INDEX

SIDE A

INDEX

PLANET WAX:
SCI-FI/FANTASY
SOUNDTRACKS ON VINYL

1984 PUBLISHING
Cleveland, Ohio / USA
1984Publishing.com
info@1984Publishing.com

PRINTED AND BOUND IN THE UNITED STATES OF AMERICA.